THE END

AN ILLUSTRATED GUIDE TO THE
GRAVES *of* IRISH WRITERS

RAY BATESON

IRISH GRAVES PUBLICATIONS

TO PHIL

First published in October 2004
by Irish Graves Publications
Warrenstown, Kilcock, County Meath

 This publication has received support from the Heritage Council
under the 2004 publications grant scheme

Design and layout: Temple of Design, Dublin.

Map of Dublin by permission of the Ordnance Survey Ireland.

ISBN 0-9542275-1-4

Contents

The Beginning

My very first grave, almost the last in this book, lies under bare Ben Bulben's Head. For many years my cold eye has been cast on life and death in cemeteries, graveyards and churches up and down Ireland, throughout Europe and beyond, in search of the graves of Irish writers.

Not long ago in the drizzle of a November day, I stood where Ezra Pound and countless others have stood, in the cemetery where you could hear the lions roar, to pay homage to the greatest of all our writers — James Joyce.

I have walked through the summer fields to the house where Shaw remains. I have felt the chill of the columbarium where Dracula's author has found a niche. I have been to Paris in the spring to see Sam Beckett and Oscar Wilde.

I have taken the train down the coast from Nice to Genoa to stand with Oscar before the grave of his wife. I have fought my way through the undergrowth to visit his mother in London and one beautiful spring morning in Monaghan I sat on the graves of his half sisters who had burned to death in a winter fire.

It wasn't always glamorous, fighting the wind and rain in every season, betrayed by locked churches, missing records, closed cemeteries, covered graves, and my camera raging against the dying of the light on winter afternoons or worse still cursing the strong sun behind the gravestones.

On some graves the flowers were still fresh, the stone not yet in place. Sometimes a verse, a few words, but mostly just the name and plain stone. On others the names of the poets were as faded as the words they had written.

I have travelled with many friends throughout Ireland in search of graves but mostly I have gone alone. I have met so many people who have dropped what they are doing to help me with my search. I have written to complete strangers throughout the world who have offered their help and sent me photographs of graves.

I have read hundreds of biographies and sat for endless hours in libraries poring over columns of death stretching back two hundred years and more. I have searched burial records and tramped the muddied paths of cemeteries to fill the pages of this book.

I first found these names on the covers of the books in my mother's library. I have read their stories, recited their rhymes, lost myself in their words. So these are my writers, this is my book. They reflect my place, my time, my taste.

Lastly, never judge a book by its title. For not in all cases are there graves and not all are Irish and not all are thought of as writers. Come with me and I will show you their graves.

Ray Bateson
October 2004

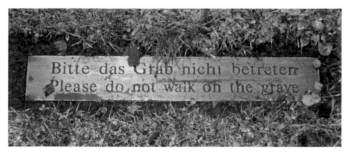

Sign on James Joyce's grave in Zurich

CEMETERY ETIQUETTE

Most cemetery visitors are those attending funerals or visiting the graves of their loved ones. Anyone using this book should:

- respect the cemetery and its visitors
- obey all the posted rules and regulations of the cemetery
- leave the cemetery as they find it
- do nothing to the gravestones that damage them in any way by walking, standing or climbing on them
- not disturb items in or around the graves
- not take anything from the cemetery except litter

Lastly, be safety conscious. Many of the older gravestones and kerbings can be loose and there may be ground subsidence, so tread warily. Also be aware of personal safety and exercise common sense, particularly if you are visiting a cemetery on your own.

Blessed are the Dead which die in the LORD

St Peter and St Paul Parish Church, Shoreham, Kent

Let time
not diminish their words
nor weeds obscure their graves

THE GRAVES OF IRISH WRITERS

Cecil Frances Alexander 1818-1895

Born in Dublin. She was a hymn writer whose works include *Verses for Holy Seasons* and *Hymns for Little Children*, which was reprinted 69 times before the end of the 19th century. Her most famous hymns are *All Things Bright and Beautiful*, *There is a Green Hill Far Away* and *Once in Royal David's City*. She was married to Bishop William Alexander who became Archbishop of Armagh and Protestant Primate of Ireland in 1896.

Her death was widely reported and was greeted with dismay by both Catholics and Protestants. Valerie Wallace, in her biography, mentions a report in the *Northern Whig* that the day before the funeral, a local builder was killed by the cathedral bell which he was trying to fix, so that it could be rung for the funeral.

An enormous crowd gathered around the cathedral and the cemetery for Mrs Alexander's burial which was attended by nearly a hundred clergymen, including the Lord Primate.

She is buried in the City Cemetery, Derry. Go in the main entrance and take the first path to the right past the office. Almost immediately take the path to the left. Go up the hill until you see a large Celtic cross on your left. The grave is one row over from that. At present it has a white marble cross which is wearing away and the plan is to replace this with a granite cross. Every Good Friday a group of parishioners hold a memorial service at the graveside. She was the first Protestant to be buried in the City Cemetery with a cross over the grave.

At the top of the cross is the inscription: YOUR DAUGHTERS SHALL PROPHESY/YOUR OLD MEN SHALL DREAM DREAMS/YOUR YOUNG MEN SHALL SEE VISIONS/JOEL 2 28

At the base of the cross is the inscription:
CECIL FRANCES ALEXANDER/(C.F.A. HYMN WRITER)/WIFE OF WILLIAM BISHOP OF DERRY/AND RAPHOE, DIED OCT 12. 1895/WILLIAM ALEXANDER/BISHOP OF DERRY AND RAPHOE 1867-1896/ARCHBISHOP OF ARMAGH AND PRIMATE OF ALL IRELAND/1896-1911.BORN APRIL 13 1824 DIED SEPT 12 1911

Eleanor Jane Alexander 1857-1934

Born in Strabane, County Tyrone. She was the daughter of Cecil Frances and William. She wrote poetry and novels. Her works include *Lady Anne's Walk*, *The Rambling Rector* and *The Lady of the Well*. She is buried with her parents. There is an inscription to her on the right-hand side of the memorial as you look at it. (See above)

William Alexander 1824-1911

Born in Derry. Besides his theological works such as *Primary Convictions*, William also wrote several books of poems including

St Augustine's Holidays and *The Finding of the Book.* He is buried with his wife Cecil Frances in Derry City Cemetery, see above.

William Allingham 1824-1889

Born in Ballyshannon, County Donegal. He was a customs officer in Killybegs and other Irish ports before going to England. He left the service after 24 years and became sub-editor of *Fraser's Magazine*. His work includes the long narrative poem *Laurence Bloomfield in Ireland*, his poetry and his *Diaries*. Most people will remember him for his poem *The Fairies* (Up the airy mountain etc). He influenced W.B. Yeats who acknowledged Allingham as his 'master in Irish verse'.

He died in London and was cremated in Woking Cemetery. He had expressed a desire to be buried in Ballyshannon and his ashes were brought there for burial in the grounds of St Anne's Church of Ireland. The church is clearly visible on the hill overlooking the town. As you approach the church, the grave is outside, on the left-hand side of the church, about two thirds down and two from the path. It has a white slab and is raised about a foot off the ground. The inscription reads: WILLIAM ALLINGHAM/ POET/ BORN AT BALLYSHANNON, MARCH 19, 1824/ DIED IN LONDON, NOVEMBER 18, 1889

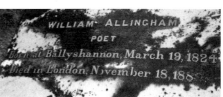

The churchyard is usually locked and the railings are a bit too high to clamber over. Either wait for the Sunday service or ask locally about access.

Christopher Stephen (Todd) Andrews 1901-1985

Born in Dublin. He fought in the War of Independence and against the Treaty. He held CEO positions in many state bodies

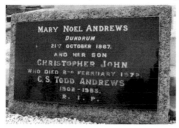

including Bord na Móna and CIE. Two of his sons and a grandson became TDs. He wrote two autobiographical books — *Dublin Made Me* and *Man of No Property*. He is buried in grave number 119-120L, St Patrick's, Deansgrange Cemetery, Dublin. *(See map page 250)*.

The inscription reads: MARY NOEL ANDREWS/ DUNDRUM/ 21ST OCTOBER 1967/ AND HER SON/ CHRISTOPHER JOHN/ WHO DIED 2ND FEBRUARY 1972/ C S TODD ANDREWS/ 1902-1985/ R.I.P.

Mervyn Archdall 1723-1791

Born in Dublin. He was educated at Trinity College Dublin. After ordination, he took up a position as chaplain to the Bishop of Ossory. Other various postings followed before he became

rector at Slane where he died. He is best known for his work *Monasticum Hibernicum*. He also worked on Lodge's *Peerage of Ireland* and increased it to seven volumes. He is buried in the churchyard of St Patrick's Church of Ireland, Slane, County Meath. Go in the gate and the grave is situated in the right-hand corner at the rear (in the foreground of the photograph). The inscription is still quite legible: WE SHALL ALSO BEAR THE IMAGE OF THE/ HEAVENLY/ SACRED TO THE MEMORY/ OF/ MERVYN ARCHDALL A.M./ RECTOR OF THIS PARISH/ WHO DIED THE 6TH OF AUGUST/ 1791/ AGED 68 YEARS.

Sarah Atkinson 1823-1893

Born in Athlone, County Westmeath. She wrote memoirs of Hogan, Foley and O'Curry and was a contributor to various periodicals. She is also remembered for her work with the poor. She is buried in Glasnevin Cemetery, Dublin. *(See map page 246)*. The Atkinson cross is on the left in the photograph. The cross behind belongs to John and Rosa Gilbert (*q.v.*).

The inscription is still legible with a little effort. It reads: THIS MONUMENT WAS ERECTED BY/ THE CATHOLIC CEMETERIES COMMITTEE/ OVER THE REMAINS OF/ S. A./ THE WIFE OF GEORGE ATKINSON/ WHO HAD BEEN FOR 51 YEARS/ A TRUSTED MEMBER OF THIS COMMITTEE/ BENEATH THIS CROSS LIE THE REMAINS/ OF A SAINTLY WOMAN/ SARAH THE REVERED WIFE OF/ GEORGE ATKINSON, A.M./ SHE HAD A LARGE INTELLECT, A SWEET NATURE, A GREAT HEART./ HER PRAISE IS ON THE TONGUES OF THE POOR/ THE OLD WHOM SHE PROTECTED./ THE YOUNG WHO HAD EVER HER COUNSEL, HER HELP AND HER SYMPATHY./ SHE DIED 8TH JULY 1893./ R.I.P.

John Banim 1798-1842

Born in Kilkenny.
He was a novelist,
dramatist and poet.
After a short career
as an art master he
turned to writing
full-time. His
tragedy *Damon and
Pythias* was produced
at Covent Garden.
Several other plays
were rejected and he

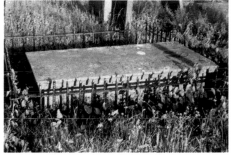

turned to collaborating with his brother Michael in writing a
series of tales of Irish life and history. These were known as *The
Tales by the O'Hara Family* and ran to 24 volumes. In an obituary
written for the *Nation*, Carleton describes him as "Ireland's finest
historical novelist". He is buried in St John's Churchyard,
Kilkenny. See next entry.

Michael Banim 1796-1874

Born in Kilkenny. He was the older brother of John. He ran the
family grocery business in Kilkenny and from 1852-1873 he was
the Postmaster for Kilkenny. He wrote half of the collected works
of *The Tales by the O'Hara Family* and supplied John with much
background material. Both brothers are buried in St John's
Churchyard, Kilkenny.

John Banim requested "to lay me so that I may be nearest to
my mother with my left side next to her". His biographer
lamented that after 15 years he could only with difficulty discover
the grave as there was no marker or stone for him. Michael
Banim died in 1874 and was buried in the same grave and again
without a mark or stone for him. It was only in 1956 that the

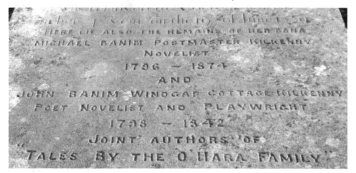

Kilkenny National Monuments Committee with the help of
Bord Fáilte repaired the tomb, which was identified only by the
inscription for their mother. The two brothers were
commemorated with the following inscription: HERE LIE ALSO
THE REMAINS OF HER SONS/MICHAEL BANIM POSTMASTER,
KILKENNY/NOVELIST/1796 −1874/AND/JOHN BANIM WIND GAP

COTTAGE, KILKENNY/POET, NOVELIST AND PLAYWRIGHT/1798-1842/JOINT AUTHORS OF/TALES BY THE O'HARA FAMILY

When I went to Kilkenny, this was all the information I had. I was with a couple of friends and we met a priest who directed us to the graveyard and told us their stones were side by side. That didn't tally with my information but a lot can happen in 50 years. So we went to the Church of Ireland graveyard which was locked and well protected by a high railing on one side and an even higher wall on other sides. There was no way in and all enquiries about a key proved fruitless. We identified the likeliest stones through the railings and to get a better shot we went round the side where I stood on the hands of my two friends and they hoisted me high enough into the air to take a shot over the eight foot high wall.

The following week, my two friends had cause to stay in Kilkenny and right opposite their bed and breakfast there was another graveyard called St Johns which had a plaque on the wall stating that the Banims were buried there! It was only a couple of hundred metres from where we had carried out our circus act.

This graveyard is on the right-hand side of the road to Dublin just past the Catholic church. The grave is not easily located. It is almost diagonally across from the opening and two thirds of the way down. Look for the railings. Also buried in the graveyard are **Dr Thomas De Burgo**, Bishop of Ossory and historian of the Dominican Order, the writer **Dr Robert Cane 1807-1858** and **P.M. Egan 1843-1903**, a novelist who also wrote guides to Kilkenny and Waterford.

Tom Barry 1897-1980

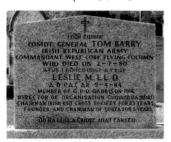

Born in Roscarberry, County Cork. He was Commandant General of the 3rd Cork Battalion, IRA. He fought on the Republican side in the Civil War and was interned. After the war he worked for the Cork Harbour Commission from 1927-1965. He wrote his account of the War of Independence in *Guerrilla Days in Ireland*. He is buried just behind the Republican Plot in St Finnbarr's Cemetery, Cork.

Sir Arnold Bax 1883-1953

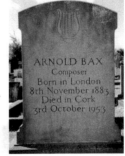

Born in London. He was inspired by the poetry of Yeats which revealed 'the Celt within him'. He wrote symphonies, concertos and chamber music. He was made Master of the King's Musick in 1942. He wrote poems, short stories and novels under the name of Dermot O'Byrne. These include *Seafoam and Firelight*, *The Sisters and Green Magic*, *Children of the Hills* and the

autobiography *Farewell My Youth*. His *Dublin Ballad-1916* was banned by the British government. He is buried in St Finnbarr's Cemetery, Cork. Go in the main gate and take the road past the front of the chapel, between Sections H and I. Nine rows and ten graves over on the right-hand side is the grave of Bax. Just behind him are the graves of **Aloys Fleischmann**, **Joan Moriarty**, **Charles Lynch** and **Sean Neeson.**

Piaras Béaslaí 1881-1965

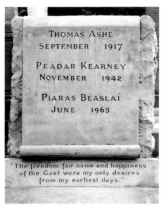

Born In Liverpool. He moved to Ireland in 1904. He commanded the Battalion at North King Street during the Easter Rising. He was pro-Treaty. From 1924 on, he devoted himself to writing and promoting the Irish language.

He introduced the Fáinne. He wrote plays, poems and a biography of Michael Collins.

His works include *Fear na Milliún Punt*, *An Danar* and the novel *Astronár*. He won a gold medal for a play at the Tailteann Games. He is buried in the Republican Plot in Glasnevin Cemetery, Dublin. *(See map page 246)*.

Samuel Beckett 1906-1989

Born in Dublin. From 1930 onwards he lived mostly in Paris. In 1938 he was stabbed while walking in the street and almost died. He stayed in Paris during the war and was awarded the Croix de Guerre for his work with the Resistance. His early works were written in English but his later works were written in French and then translated by himself into English. In 1969 he was awarded the Nobel Prize for Literature. His works include: *More Pricks than Kicks*, *Murphy*,

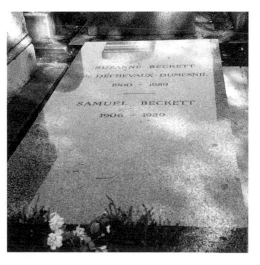

Molloy, *Malone Dies*, *The Unnamable*, *Waiting for Godot*, *Krapp's Last Tape*, *Endgame*, *How It Is* and *Eh Joe*.

He is buried in Montparnasse Cemetery in Paris. He died on 22nd December and was buried on St Stephen's Day. There was no announcement about his death in order to keep the funeral small and

private. Only ten people attended the funeral. There were no speeches and there was no priest. Later it was reported that he had died of respiratory failure.

He was buried, as he had wanted, near Suzanne, his companion for over 50 years. Only four months previously he had attended her funeral along with a few close friends. There was no service.

The inscription on the stone reads: SUZANNE BECKETT/NÉE DÉCHEVAUX DUMESNIL/1900-1989/SAMUEL BECKETT/1906-1989 It is possible to obtain a map of the cemetery from the office. The grave is situated between the Avenue de l'Est and the Allée Chauveau Lagarde. It is on the right-hand side coming from the Avenue de l'Est.

William Bedell 1571-1642

Born in Black Notley, Essex. He was Provost of Trinity in 1627. He became the Protestant Bishop of Kilmore in 1629 and supervised the translation of the Old Testament into Irish. It wasn't printed however until 1685 and it became known as Bedell's Bible. He was captured by the O'Reillys for sheltering Protestant refugees from the 1641 Rebellion and died of a fever. He is buried in the grounds of Kilmore Cathedral. He was held in high esteem by the O'Reillys and they accompanied his funeral to the graveyard where they fired a volley of shots over the grave.

Kilmore Cathedral is about five kilometres south west of Cavan at Kilmore on the road to Killeshandra. The church and cemetery are on the right-hand side and are signposted. The sycamore that overhangs his grave was said to have been planted by him. The gravestone at the front reads: BEDELL/BISHOP OF KILMORE/1629-1642/SIT ANIMA MEA CUM BEDELLO

Behind the wall there is a large plot for other bishops of the diocese. There is also a plaque there for Bedell. Another plaque is found just outside the churchyard.

Brendan Behan 1923-1964

Born in Dublin. He left school at 14 and not long after that, he joined the IRA. He spent three years in a Borstal institution in England and another five years imprisoned in the Curragh Camp. It was in the Curragh that he learned to speak Irish. His works include *The Quare Fellow*, *The Hostage*, *Borstal Boy*, *Brendan Behan's New York* and *Richard's Cork Leg*. He enjoyed the fame that his works brought him but he was not able to handle it well and in the end it destroyed him.

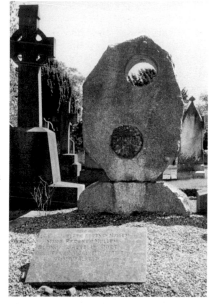

He is buried in Glasnevin Cemetery, Dublin. *(See map page 246 - the grave is on the path edge)*. His death was reported worldwide. His funeral mass was attended by the Lord Mayor, representatives of the President, the Government and the Church as well as the plain people of Dublin. The IRA acted as pallbearers after the mass and the *Last Post* and *Reveille* were sounded.

Later after the mourners had gone, the IRA fired a salute over the grave. The inscription on the circular plaque reads: 1923-1964/ BREANDÁN/Ó BEACHÁIN/FILE/FIÁIN/FEARÚIL/FEADÁNACH *(see entry for Blanaid Salkeld)*.

Behan's grave remained unmarked for fifteen years. An article in the *Sunday Press* drew attention to this state of affairs and the Dublin branch of Conradh na Gaeilge decided to erect a monument over the grave as part of their Seachtain na Gaeilge. The sculptor Cliodhna Cussen created the memorial. The inscription was taken from Behan's own writings. The opening at the top of the memorial originally held an image of a man bent over writing furiously. Unfortunately it was stolen within days of the dedication. Some years later it was replaced but this replacement also failed to survive.

Brian Behan 1926-2002

Born in Dublin. He was overshadowed by his brothers Brendan and Dominic but he had a relatively successful literary career. His works include *Mother of All the Behans* and *Boots for the Footless*. His remains were cremated at Wood Vale Crematorium, Brighton. As the curtains closed the congregation sang the *Red Flag*.

15

Dominic Behan 1929-1989

Born in Dublin. He was the brother of Brendan. From 1947 onwards he spent most of his life outside Ireland, working as a writer and a singer. His work spans ballads, fiction, plays, autobiography and biography. These include *Teems of Time and Happy Returns*, *The Public World of Parable Jones*, *Posterity Bedamned*, *The Folksinger*, *My Brother Brendan* and the ballads *The Patriot Game* and *Liverpool Lou*. He died in Glasgow and was cremated. Two weeks later, the *Irish Times* reported that his ashes were scattered on the waters of the Royal Canal behind Russell Street. The ceremony was attended by over 100 friends and relatives. The General Secretary of the Workers' Party, Sean Garland, officiated and the ceremony began with a playing of the *Red Flag (Internationale)* and was followed by a recording of Dominic singing *James Connolly*. After the ashes were scattered, a bouquet of roses was similarly cast upon the water. Dominic, Brian and Brendan's mother, **Kathleen**, 'the Mother of all the Behans' is buried in an unmarked grave, number 19, Row H, St Kevin's, in Deansgrange Cemetery, Dublin. *(See map page 250 – the grave is on the path parallel to the road, near the top of the section)*.

Sam Hanna Bell 1909-1990

Born in Glasgow. After various jobs, he worked for the BBC, as a scriptwriter and producer. He wrote short stories, novels and plays. His best work sympathetically portrays the Ulster working class Protestant. His works include *Summer Loanen*, *December Bride*, *The Hollow Ball*, *A Man Flourishing*, *Across the Narrow Sea*, *Erin's Orange Lily*, *The Theatre in Ulster* and other books about folklore, the arts and the theatre. He died in Belfast and was cremated at Roselawn Crematorium.

Osborn Joseph Bergin 1872-1950

Born in Cork. He was Professor of Early and Medieval Irish at UCD from 1909-1940. He edited many old Irish texts and was general editor of the Royal Irish Academy's *Dictionary of the Irish Language*. His works include *Stories from Keating's History of Ireland, Lebor na hUidre: Book of the Dun Cow* and *Maidin I mBéarra agus Dánta Eile*. He is buried in grave number 23, Row 16, Section I, St Finnbarr's Cemetery, Cork. Go in the main gate and take the road before the chapel between Section A and I. The grave is 16 rows up on the left-hand side and 23 over. There is no marker on the grave.

George (Bishop) Berkeley 1685-1753

Born at Dysert Castle, County Kilkenny. He was a philosopher and educationalist whose works include *An Essay towards a New Theory of Vision*, *A Treatise Concerning the Principles of Human Knowledge* and *Three Dialogues between Hylas and Philonous*. He travelled widely in Europe and in 1724 he was made

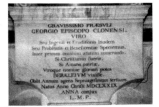

Bishop of Derry. He then went to America to establish a missionary college in Bermuda. He promoted his ideas there and made gifts to both Yale and Harvard. The University of California, Berkeley, is named after him. He returned to Ireland where he became Bishop of Cloyne. He questioned the economic and social conditions in Ireland in his three volume work — *The Querist*. He resigned due to ill health in 1752 and went to Oxford where his son was an undergraduate at Christ Church at the time. He died there a year later and is buried at Christ Church Cathedral, Oxford.

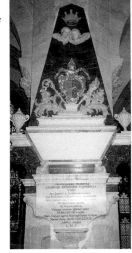

The monument has the following inscription: GRAVISSIMO PRAESULI/ GEORGIO EPISCOPO CLONEN SI/VIRO/ SEU INGENII ET ERUDITIONIS LAUDEM/SEU PROBITATIS ET BENEFICENTIAE SPECTEMUS/INTER PRIMOS OMNIUM AETATUM NUMERANDO/SI CHRISTIANUS FUERIS/SI AMANS PATRIAE/ VIROQUE NOMINE GLORIARI POTES/BERKLEIUM VIXISSE/OBIIT ANNUM AGENS SEPTUAGESIMUM TERTIUM/NATUS ANNO CHRISTI MDCLXXIX/ANNA CONJUX/L.M.P.

The translation by Dr M.G. St.A. Jackson reads: To that most eminent public figure George Bishop of Cloyne a man — whether we look to the praise afforded him for his genius and learning or his integrity and kindness — to be numbered among the foremost of all ages, whether you are a Christian or as a lover of your country, you could boast that Berkeley lived as both. He died in his seventy-third year, born in A.D. 1679. This memorial was erected by Anne his wife.

A floor slab beneath the monument marks the site of his grave. The epitaph by Alexander Pope is quite worn and reads: TO BERKELEY EV'RY VIRTUE UNDER HEAVEN.

Richard Irvine Best 1872-1959

Born in Derry. He was Director of the National Library of Ireland 1924-1940 and Senior Professor of Celtic Studies at the Dublin Institute of Advanced Studies 1940-1947. His major work was the *Bibliography of Irish Philology and Manuscript Literature, Publications 1913-1941*. Other works include *The Irish Mythological Cycle and Celtic Mythology*, *The Martyrology of Tallaght* and he co-edited *The Book of Leinster*. Best appears as the librarian in the Scylla and Charybdis episode in *Ulysses*. He is buried in grave number 66-H-South West, Deansgrange Cemetery, Dublin.

(See map page 250). Before you come to Augustine Henry *(q.v.)*, take the second path to the left, before the Glorney mausoleum. The grave is three rows before the Nutting monument, the grandest in the cemetery).

The inscription on the gravestone reads: EDITH OLDHAM/ ASSOCIATE AND HON ASSOCIATE/ OF THE ROYAL COLLEGE OF MUSIC LONDON/ DEARLY LOVED WIFE OF/ RICHARD IRVINE BEST/ DIED 9TH MARCH 1950/ IN THE 85TH YEAR OF HER AGE/ AND THE 45TH YEAR OF HER WEDDED LIFE/ THE SETTING SUN AND MUSIC AT THE CLOSE/ RICHARD IRVINE BEST/ "DIRECTOR OF THE NATIONAL LIBRARY OF IRELAND/ "PRESIDENT OF THE ROYAL IRISH ACADEMY/ "SENIOR PROFESSOR IN THE DUBLIN INSTITUTE OF ADVANCED STUDIES/ "CHAIRMAN OF THE IRISH MANUSCRIPTS COMMISSION/ DIED 25TH SEPTEMBER 1959/ IN THE 88TH YEAR OF HIS AGE.

Francis Joseph Bigger 1863-1926

Born in Belfast. His main interests were archaeology and local history and at his own expense he helped restore many ruined castles and churches. He revived the *Ulster Journal of Archaeology* and was its editor until his death. His works on history, biography and memoirs include, *The Ulster Land War of 1770*, *The Northern Leaders of '98*, *Irish Penal Crosses* and biographies of William Orr and Amyas Griffiths. He donated his large collection of Irish books to the Belfast Central Library.

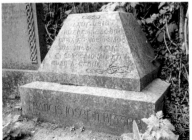

He is buried in Mallusk, County Antrim. Go in the main gate of the cemetery and take the path slightly to the left. Go to the end and the Bigger plot is facing you.

The inscription on the base of the cross reads: AGUS BÉIDH/ LUATHGHAIREACH DO/ BHRÍGH GO MBÉID SIAD/ SUAIMHNEACH AGUS/ TREORÓCHAIDH IAD GO/ CUAN A TTOÍLE/ FRANCIS JOSEPH BIGGER.

On the right-hand side of the grave is the large vertical stone for the weaver and United Irishman Jemmy Hope *(q.v.)*.

George A. Birmingham (Canon James Owen Hannay) 1865-1950

Born in Belfast. After graduating from Trinity College Dublin, he was ordained and took up a position in Westport where he began his prolific writing, using the nom-de-plume George Birmingham. After a local production of his play, *General John Regan*, caused controversy he considered it wiser to leave Westport. He served in the British Army as a chaplain during the First World War and he later served in various parishes in England. He wrote over 80 works including novels, plays and religious works. These include *Spanish Gold*, *The Seething Pot*, *Two*

Scamps, *The Major's Niece*, *The Inviolable Sanctuary*, *The Red Hand of Ulster*, *The Northern Iron* and *Up the Rebels*.

He is buried in Mells, Somerset where he was rector from 1924-1934. Go in the gate and go to the right-hand side of the church. There is a row of graves belonging to past rectors. The inscription reads: JAMES OWEN/ HANNAY/ BORN JULY 16 1865/ DIED FEB 2 1950/ RECTOR OF/ MELLS 1924-34

Helen Blackburn 1842-1903

Born in Valentia Island, County Kerry. She was one of the first to campaign for women's rights. She was secretary of The National Society for Women's Suffrage 1874-1895. Her many works include *A Handbook for Women Engaged in Social and Political Work* and *A Record of the Women's Suffrage Movement in the British Isles with Biographical Sketches of Miss Becker*. In 1899 she co-founded the Freedom of Labour Defence League.

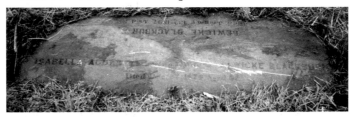

She is buried in grave number BR 165559, Compartment E, Brompton Cemetery, London. The grave is not easily found as it is low lying and is often covered with cut grass. The names of the family are legible but her name is not on the stone. To find the grave go towards the Old Brompton Road and take the path between Compartments E and C and the grave is 13 rows up and 4 rows in on the left-hand side.

E. Owens Blackburne c. 1845-1894

Born Elizabeth Owens Blackburne Casey in Slane, County Meath. She went blind as a child and was cured by Sir William Wilde. She became a journalist and went to London. She wrote over 20 novels including *A Woman Scorned*, *The Way Women Love*, *The Glen of Silver Birches* and *The Heart of Erin: an Irish Story of To-day*. She also wrote some poetry and *Illustrious Irishwomen — Being Memoirs of Some of the Most Noted Irish Women from the Earliest Ages to the Present Century*.

The death notice on Thursday 5th April 1894 in the *Irish Times* states "Casey. April 5th at Park Villas, Phillipsburgh Avenue, Fairview, Elizabeth Casey (nee K Owens Blackburne). Funeral private".

An obituary two days later recorded "She had lived with her mother, an elderly lady and some nights ago, when her mother was returning to rest a paraffin lamp at the side of the bed in her room was upset and the flames set the room on fire. The old lady's screams caused Miss Casey to rush in her nightdress from her own bedroom into that of her mother where she made brave

efforts to save her mother and the property from destruction. Unhappily Miss Casey's gown caught fire and she was severely burned, the injuries proving fatal on Wednesday. Her mother happily escaped injury but it need hardly be said that the sad death of her daughter has left her in a broken hearted condition. The dreadful occurrence caused a profound sensation in the locality. The house was considerably injured by the fire.

"The Rev Carleton, an old friend of the deceased lady, officiated yesterday at the grave.

"It may be mentioned that on Wednesday last, an inquest was held on the remains of the deceased and after hearing the evidence of Dr Gibbs and Mrs Casey the jury returned a verdict to the effect that her death was the result of an accident."

She is buried in St John The Baptist Church of Ireland, Church Avenue, Drumcondra, Dublin. *(See map page 256)*.

I searched the graveyard for a couple of hours but was unable to locate any gravestone. The records for the cemetery are held by Charlie Brown who confirmed she was buried in the graveyard but he was unable to give me a location as that information was not available. I later found out that the Dublin Archaeological Society in association with AnCo had carried out a survey in 1983. Mary McMahon informed me that the survey was not completed and her records showed no sign of any stone to the writer. Lastly I was put in touch with a local historian Brian Freeman who had also searched for the grave but without success. It is possible that there was no stone as the writer died in poverty.

Ernest Blythe 1889-1975

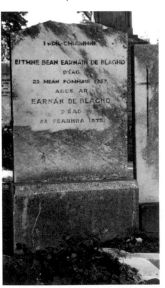

Born in Magheragall, County Antrim. His involvement with the Irish Volunteers led to him spending time in prison. He was pro-Treaty and held various government ministries from 1919-1932 but is best remembered for his support of the Irish language. He founded An Gúm. He was Managing Director of the Abbey Theatre from 1941-1967 but it was said that his devotion to the Irish language took precedence over artistic matters. He wrote two autobiographical volumes *Trasna na Bóinne* and *Slán le hUltaibh*. Other works include *The Abbey Theatre*, a book of poems and a study of partition *Briseadh na Teorann*. He is buried in Glasnevin Cemetery, Dublin. *(See map page 246 – the grave is on the path edge)*.

The inscription reads: I NDÍL CHUIMHNE/ EITHNE BEAN EARNÁIN DE BLAGHD/ D'ÉAG/ 25 MEÁN FÓMHAIR 1957/ AGUS AR/ EARNÁN DE BLAGHD/ D'ÉAG/ 23 FEABHRA 1975.

Thomas Patrick Bodkin 1887-1961

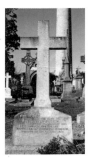

Born in Dublin. He was Director of the National
Gallery of Ireland 1927-1935 and then became
Barber Professor of Fine Arts in Birmingham.
His works include *Hugh Lane and His Pictures*, *The
Approach to Painting* and works on Vermeer and
Rembrandt. He is buried in Glasnevin
Cemetery, Dublin. His name is mentioned on
the side of the cross. *(See map page 246 – the grave is
four rows behind that of Eugene O'Curry, q.v.).*

George Boole 1815-1864

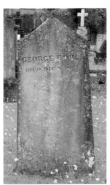

Born in Lincoln. He was a cobbler's son who
despite being self-taught and not having a
degree, became Professor of Mathematics at
the University of Cork in 1849. He
developed a system, using mathematical
symbolism, to represent logical
propositions. Boolean logic is the basis for
computerised search mechanisms.

His best known works are *Mathematical
Analysis of Logic* and *Laws of Thought*. He is buried
in the churchyard of St Michael's Church of
Ireland, Church Road, Blackrock, Cork.
To find the grave, go in the main gate and it
is situated on the left-hand side, almost
opposite the first window and two rows in. The inscription reads:
GEORGE BOOLE/ DIED DEC 8 1864

Miss (Elenor) Booth died 1717

She inspired Cearbhall Ó Dálaigh to compose *Eibhlín a Rúin (Eileen

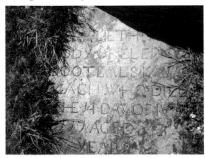

Aroon)* the oldest Irish
harp tune where the
original words survive.
She is buried in the
graveyard at Kilmyshall
south of Bunclody,
County Wexford. Take
the road from Bunclody
to Enniscorthy and
Kilmyshall is signposted
to the right. Go down
this road and the
cemetery is on the right-hand side before the village. It is easy to
miss it as it is set back from the road behind hedges. Further on,
close to the village there is a track that goes past the top of the
cemetery. The cemetery is on a slope and she is buried at the
bottom of the slope in the middle. The inscription reads: HEAR
LIETH THE/ BODY OF ELENOR/ BOOTE ALS KAVA/ NAGH WHO
DIED/ THE 14 DAY OF JUNE/ 1717 AGED 63/ YEARS

There is an annual Eileen Aroon festival in Bunclody.

Dion(ysius Lardner) Boucicault 1820-1890

Born in Dublin. His mother was a sister of George Darley. He
spent his whole adult life around the theatre, first as an actor
then as a playwright and theatre manager. He wrote over 150
plays, the most famous of which is *The Colleen Bawn*. He also starred
in many of them. Other works include: *The Octoroon*, *The Poor of New
York*, *Arrah-na-Pogue or The Wicklow Wedding*, *Led Astray*, *Forbidden Fruit* and
The Shaughraun. But money troubles and women troubles led
eventually to his death in straitened circumstances.

His funeral took place in the Little Church Around the

Corner in New York.
Long before the
funeral arrived, the
streets were crowded
with mourners.
He was buried in
Woodlawn Cemetery,
Bronx, New York.
A few months later
the remains were
removed to Mount

Hope Cemetery, Saw Mill River Road, Hastings On Hudson, New
York. Take route 9 or the Sprain Parkway and take the Jackson
Avenue exit. Head West on Jackson until you see the cemetery on
your right. The grave is located in the middle of lot 43, which is
in the middle of the grounds, a little towards the west.

An *Irish Times* article around the
time of Cyril Cusack's *(q.v.)* death
mentions Cusack visiting the Mount
Hope Cemetery, borrowing a wreath
from another grave and being
photographed saying the rosary in
front of the grave. He especially liked
Boucicault.

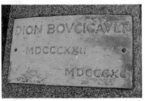

Canon Ulick Bourke 1829-1887

Born in Castlebar, County Mayo. After
ordination he taught at St Jarlath's, Tuam and
then he became parish priest in Kilcolman,
Claremorris where he remained until his
death. He was one of the most active promoters
of the Irish language. He was one of the
founders of the Society for the Preservation
of the Irish Language and also of the Gaelic
Union. His works include *The College Irish
Grammar* (published while he was still a student),
The Aryan Origins of the Gaelic Race and Language and
Pre-Christian Ireland. He is buried in
Barnacarroll church grounds, County Mayo.
The grave is situated to the right of the path.

Elizabeth Bowen 1899-1973

Born in Dublin. She spent her early
years in Dublin and at Bowen's Court,
the family seat, in County Cork. She
married in 1923, the same year her
collection of short stories, *Encounters*, was
published. She wrote over 25 books
including *The Death of the Heart*, *The Heat of the
Day*, *Bowens Court*, *The Last September*, *A World
of Love* and *Eva Trout*.

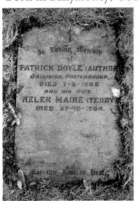

She died in London and is buried in
the churchyard in Farahy, near
Kildorrery on the Mitchelstown-Mallow
road, County Cork. If you are coming
from Doneraile, there is a dip in the
road with a signpost to Farahy, where
Bowen's Court used to be. The church
isn't visible from the road. Go through the white gates, straight up
the path. The grave itself is directly opposite the main entrance to
the church and against the far wall.

The day of the funeral was cold and it snowed. All day long,
local people brought flowers.

Patrick Boyle 1905-1982

Born in Ballymoney, County Antrim. He worked in banking for

45 years. His first collection of
stories, *At Night All Cats are Grey*, was
published in 1966. Other collections
include *All Looks Yellow to the Jaundiced Eye*
and *A View from Calvary*. His only novel
was entitled *Like Any Other Man*. He is
buried in grave number R13, St
Assam's, St Fintan's Cemetery,
Sutton, Dublin. *(See map page 256)*.
There is a map of the cemetery as you
go in the main entrance. Go to the
very end of the road and turn left and
the grave is on the right-hand side
almost immediately against the hedge.
The inscription reads: IN LOVING
MEMORY/OF/PATRICK BOYLE AUTHOR/DRUMNIGH,
PORTMARNOCK/DIED 7-2-1982/AND HIS WIFE/HELEN MARIE
(TEDDY)/DIED 27-10-1984/MAY THEY REST IN PEACE

Teresa Brayton 1866-1943

Born in Kilbrook, near Kilcock, County Kildare. She was a
teacher before she went to America where she became involved with
the Irish Republican Brotherhood. She was a poet whose works
include *The Flame of Ireland*, *Song of the Dawn* and *Christmas Verses*. Her
most famous poem was *The Old Bog Road* which was put to music and
became one of the best known of Irish songs.

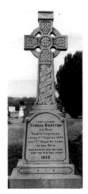

She is buried in the cemetery attached to the church at Cloncurry, County Kildare. Coming from the Dublin direction, the church is visible from the main Dublin road just over two kilometres before Enfield. There is a signpost on the left for Newtown and then another on the right for Rathmoylan. The church is just past the last sign on the right-hand side. It is behind farm buildings. The entrance is by a gate between two whitewashed buildings. There is a narrow passage and then another gate. The grave is situated beside the path on the left-hand side between this gate and the church.

Dan Breen 1894-1969

Born in County Tipperary. He took part in the first action of the War of Independence. His experiences during the years that followed were written down in *My Fight for Irish Freedom*, published in 1924. He was anti-Treaty and was elected TD for Tipperary 1923-1927. He is buried in Donohill Cemetery, County Tipperary. As you go in the gate of the cemetery, it is on the left-hand side, three rows in and four stones along.

The inscription reads: DANIEL BREEN/ 1894 1969/IRISH/REPUBLICAN/ARMY/ SUAIMHNEAS/SÍORAÍ/TABHAIR/DO A THIARNA

When I visited the cemetery there was a group of about a dozen men around a grave. They were encouraging another who was deep in the trench. A neighbour had just died and each had come armed with a spade and a small bottle to dig the grave for her. As I was leaving a few more men arrived, each carrying a spade and small bottle.

John Broderick 1927-1989

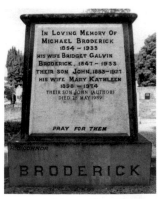

Born in Athlone, County Westmeath. He ran the prosperous family bakery in Athlone for a number of years, which gave him financial independence. He wrote eleven books as well as book reviews and criticism. He lived out his final years in Bath where he died. His works include *The Pilgrimage*, *The Fugitives*, *The Waking of Willie Ryan*, *An Apology for Roses*, *The Trial of Father Dillingham* and *London Irish*.

He is buried in Cornamagh Cemetery, Athlone. Coming from Dublin take the by-pass and take the first slip road to the N55. Turn right at the junction and then left at the next

junction. There is a school at the corner. Then take the next turn right and the cemetery is about 500 metres on the right-hand side. It is easy to miss as it is behind a field.

I almost wept when I saw the size of it and the impossibility of finding a grave there. Fortunately two men were spraying the ground and one of them had worked in the bakery and knew exactly where the Broderick family plot was located. It was a good start to a day of grave hunting.

Go in the gate and just before the parking area take the road to the right. The grave is about 20 metres down and 3 rows back on the right-hand side. The previous day I had been carrying out research to find the grave of Cyril Holland (*q.v. Constance Wilde*) who had died fighting with the Royal Field Artillery. I was struck by the large number of gravestones in the cemetery commemorating those from the area who had also died fighting with the various regiments of the Royal Field Artillery.

Patrick Brontë 1777-1861

Born in Ballynaskeagh, County Down. He was ordained in 1806 and became curate of Haworth, Yorkshire, in 1820. He is remembered as the father of Charlotte, Anne and Emily Brontë. His own works include *Cottage Poems*, *The Rural Minstrel* and *The Maid of Killarney*. He outlived all his children. He is buried in the family vault at St Michael and All Angels Parish Church, Haworth. The old church except for the tower, was demolished in 1879.

The new church was dedicated two years later. There is a plaque on a pillar, near the chancel which marks the burial spot.

Patrick Brontë's parents are buried at Drumballyroney Churchyard, near Rathfriland, County Down. At the side of the schoolroom there is a grassy mound which marks the spot.

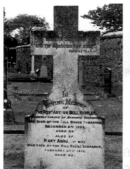

Rev Arthur Bell Nicholls 1818-1906 was curate to Patrick Brontë. He married Brontë's daughter, Charlotte and they spent part of their honeymoon in Banagher, County Offaly. After her death he eventually returned to Banagher, remarried and settled and died there. He is buried in the grounds of St Paul's Church of Ireland, Banagher.

The church is situated on the right-hand side as you enter the town from the Birr direction. Take the path on the left-hand side of the church and almost opposite at the end, on the left-hand

25

side towards the wall, facing away, is the four grave plot encircled by railings. Standing in front of the plot, the Nicholls grave is the one on the right.

The inscription reads: UNTIL THE DAY BREAKS/AND THE SHADOWS FLEE AWAY/CANTICLES CH 21:17/IN/LOVING MEMORY/OF/THE REVD ARTHUR BELL NICHOLLS/FORMERLY CURATE OF HAWORTH YORKSHIRE/WHO DIED AT THE HILL HOUSE BANAGHER/DECEMBER 2ND 1906/AGED 88/ALSO OF/MARY ANNA HIS WIFE/WHO DIED AT THE HILL HOUSE BANAGHER/FEBRUARY 27TH 1915/AGED 85

Charlotte Brooke c1740-1793

Born in Rantavan, County Cavan. She was the daughter of Henry Brooke and edited his works. She is best known for collecting Irish poems and songs which she translated into English. These were published as *Reliques of Irish Poetry*.

She died in Longford and it is presumed locally that she was buried in St John's Church of Ireland on Battery Road.

Unfortunately the burial records only start in 1796 and there is no marked stone to her within the graveyard.

Henry Brooke 1703-1783

Born in Rantavan, County Cavan. He wrote plays, poems, novels and political pamphlets. His works include *Universal Beauty*, *Gustavus Vasa* and *The Fool of Quality* (five volumes) for which he is best remembered.

He is buried in an unmarked grave beside the ruined church of Teampull Ceallaigh near Mullagh, County Cavan. The church is just outside the village, beyond the Heritage Centre.

Stopford Brooke 1832-1916

Born near Letterkenny, County Donegal. He took holy orders and became a celebrated preacher. He was appointed chaplain to

Queen Victoria in 1867. He wrote religious works, poems and literary studies but he is best known for his *Primer of English Literature*. He is buried in the cemetery adjoining Saint John–at–Hampstead, London. The grave number is J 30. Go in the gate at Holly Walk and the grave is 10 rows down and 30 plots up on the left. The inscription reads: SACRED ALSO TO THE MEMORY OF/ STOPFORD AUGUSTUS BROOKE/ 1832-1916/ IN YOUTH AND AGE HE LIVED JOYOUSLY/ WITH NATURE AND HUMANITY, BELIEVING BOTH/ TO BE OF GOD AND LOVING CHRIST AS HIS LORD/ SO BELIEVING AND SO LIVING HE PREACHED THE GOSPEL/ OF LIFE AND IMMORTALITY. A SERVANT OF THE TRUTH/ A WORKMAN APPROVED OF GOD/ THE BEAUTY OF THE LORD WAS UPON HIM/ HIS WORD WAS A KINDLING FIRE/ GIVING STRENGTH TO THE WEAK, COMFORT TO THE TROUBLED/ REFRESHMENT TO THE WEARY AND WINGS TO THE STRONG/ HE WAS THE JOY AND INSPIRATION OF HIS CHILDREN/ WHO REMEMBER HIM WITH UNDYING LOVE

Christy Brown 1932-1981

Born in Dublin. He was paralysed from birth and he used the

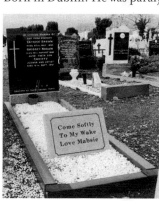

toes of his left foot to write and type. His books include *Down All the Days*, which was translated into many languages and *My Left Foot* which was made into a successful film. Other works include several volumes of poetry and three other novels. He is buried in the family plot, number IF50, in the St Paul's section of Glasnevin Cemetery, Dublin. (*See map page 249*). Go in the main entrance, take the first road to the right and go through the next intersection. The grave is located nine rows further down on the left-hand side and ten graves in.

The inscription reads:
IN LOVING MEMORY OF/ OUR DEAR PARENTS/ PATRICK BROWN/ DIED 27TH MAY 1955/ BRIDGET BROWN/ DIED 8TH AUGUST 1968/ ALSO THEIR SON CHRISTY/ AUTHOR AND ARTIST/ DIED 6TH SEPTEMBER 1981/ ERECTED BY THEIR LOVING FAMILY

A recently added stone has the title of one of his volumes of poems – COME SOFTLY TO MY WAKE.

Stephen Brown 1881-1962

Born in Holywood, County Down. He was a Jesuit priest who produced two important books on Irish literature — *A Guide to Books on Ireland* and *Ireland in Fiction — A Guide to Irish Novels, Tales, Romances and Folklore*. He died as a result of a car accident in London and is buried in the Jesuit plot, grave number DH 33½, Glasnevin Cemetery, Dublin. *(See map page 246)*. His name is on the stone to the left of the cross as you stand in front of it. The name is second from the bottom. Nine rows above is the name of the photographer, Fr Francis Browne.

> P. STEPHANUS BROWN OB. MAII 8 1962 ÆT. 80.

William Bulfin 1864-1910

Born in Derrinlough, County Offaly. He went to Argentina as a young man and worked on the pampas. He then went to Buenos Aires and edited a paper before returning to Ireland. He wrote a popular book of his journeys in Ireland called *Rambles in Eirinn*. He was father-in-law to Seán MacBride.

He is buried in the cemetery attached to the church located on its own on the road from Birr to Tullamore, about five kilometres on the left-hand side. On the right-hand side of the church is a famine memorial. Further round at the back of the church, almost facing you, is the large grave plot of the Bulfins. There are nine flagstones on the area in front of the cross. A metal wreath lies on the middle flag. The inscription on the wreath reads: IN LOVING MEMORY/ OF/ WILLIAM BULFIN/ FROM/ THE BUENOS AIRES HURLING CLUB/ FEBRUARY 1ST 1910.

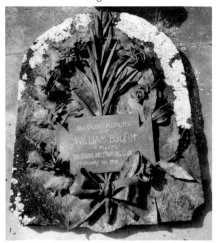

The inscription on the cross reads: ERECTED BY/ WILLIAM BULFIN/ IN MEMORY OF HIS BELOVED/ WIFE MARGARET/ WHO

DIED 7TH APRIL 1879/ AGED 44YEARS/ ALSO HIS SON EDWARD P BULFIN/ DIED 27TH MARCH 1878/ AGED 19 YEARS/ ALSO HIS MOTHER/ ELLEN BULFIN/ DIED 5TH MAY 1867 AGED 68 YEARS/ AND HIS BROTHER ROBERT BULFIN/ DIED 22ND DEC 1894/ AGED 66 YEARS/

WILLIAM BULFIN/DIED 1892 AND HIS SON/SENOR WILLIAM
BULFIN CHE BUENO/DIED R.I.P. FEB 1910

The tablet to the left is for Eamon Bulfin. The inscription
reads: IN MEMORY OF EAMON BULFIN/DIED XMAS EVE 1968/HE
WAS IN COMMAND OF PEARSES'/RATHFARNHAM COMPANY
DURING/THE RISING OF EASTER WEEK 1916/AND WAS
PRIVILEGED TO RAISE THE/IRISH FLAG OVER THE G.P.O. ON/
EASTER MONDAY MORNING

Edward Bunting 1773-1843

Born in Armagh. He was the
first to collect and record the
music of Ireland in a systematic
way. He began in Belfast where
he was living with Mary Ann
and Henry Joy McCracken,
who commissioned him to
transcribe the music at the
Harp Festival organised in
Belfast in 1792. In 1796 he
published *A General Collection of
the Ancient Irish Music* which included 66 airs. A second edition in
1809 added a further 77 airs. A third edition in 1840 contained
a further 120 new airs. He is buried in grave number B30 161,
Mount Jerome Cemetery, Dublin. *(See map page 252)*. The grave is
not easily found. Go towards the wall and six rows from the wall
and on the left-hand side and five in, on the right-hand side of
the path is the unmarked grave of Edward Bunting. It is between
the Parker and Collins graves. This is the grave number given out
by the office. It is a common grave and there are others buried
with him but just behind the grave and to the right, is a
gravestone with an inset with the following inscription: TO THE
MEMORY OF/EDWARD BUNTING/WHO DIED 21ST DECEMBER
1843/AGED 70/MARY ANNE BUNTING/HIS WIFE/WHO DIED
27TH MAY 1865/AGED 72/AND THEIR ONLY SON/ANTHONY
BUNTING/WHO DIED 10TH JULY 1849/AGED 25

Edmund Burke 1729-1797

Born in Dublin. He was one of the foremost political thinkers of
the age. His early works include *Vindication of Natural Society* and *A
Philosophical Enquiry into the Origin of our Ideas of the Sublime and Beautiful*. He
became quite active in politics and was considered the most
eloquent orator in Westminster. He supported many causes
including the abolition of slavery, Catholic emancipation, reform
in India and conciliation with America.

His *Reflections on the Revolution in France* (1790) went into many
editions and was read throughout Europe. Thomas Paine's *The
Rights of Man* was a reply to this work. There is a statue of Burke by
John Henry Foley outside Trinity College Dublin.

On Burke's death, Charles James Fox proposed in the House
of Commons that the Nation should pay the cost of his interment
in Westminster Abbey and this was unanimously agreed. However,

Burke stated in his will that no unnecessary expense be gone to over his funeral and he strictly forbade any posthumous honours beyond a simple inscription on his tombstone. He was buried in St Mary and All Saints Church, Beaconsfield. The pallbearers included the Secretary of State for War, the Speaker of the House of Commons and the Lord Chancellor.

There is a regular train service to Beaconsfield from Marylebone station. The church is in the old part of the town about 20 minutes walk from the railway station. There are three memorials. Two are on the right-hand wall and the plaque on the tomb is on the floor of the nave at the next pillar up from the tablets. It is beneath a pew.

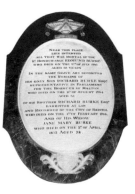

The higher of the two plaques on the wall is an oval marble tablet in a frame with the inscription: NEAR THIS PLACE/ LIES INTERRED/ ALL THAT WAS MORTAL OF THE/ RT HONOURABLE EDMUND BURKE/ WHO DIED ON THE 9TH OF JULY 1797/ AGED 68 YEARS/ IN THE SAME GRAVE ARE DEPOSITED/ THE REMAINS OF/ HIS ONLY SON RICHARD BURKE ESQR/ REPRESENTATIVE IN PARLIAMENT/ FOR THE BOROUGH OF MALTON/ WHO DIED ON THE 2ND OF AUGUST 1794/ AGED 35/ OF HIS BROTHER RICHARD BURKE ESQR/ BARRISTER AT LAW/ AND RECORDER OF THE CITY OF BRISTOL/ WHO DIED ON THE 4TH OF FEBRUARY 1794/ AND OF HIS WIDOW JANE MARY BURKE/ WHO DIED ON THE 2ND OF APRIL/ 1812, AGED 78

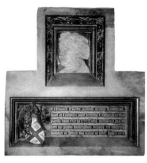

The lower memorial is in two pieces. The upper one is a relief of the bust of Burke with a coloured frame and the lower one is a plaque in a coloured frame with a coat of arms and the inscription: EDMUND BURKE, PATRIOT, ORATOR, STATESMAN/ LIVED AT BUTLERS COURT, FORMERLY GREGORIES, IN THIS/ PARISH FROM 1769 TO 1797. THIS MEMORIAL, PLACED/ HERE BY PUBLIC SUBSCRIPTION, RECORDS THE UNDYING/ HONOUR IN WHICH HIS NAME IS HELD. JULY 9TH 1898.

The plaque on the floor simply states EDMUND BURKE. This was close to the family pew. The pew was of the old high-sided style and when open seats were introduced in their place, the oak of the Burke pew was used to make a cabinet which was kept in the vestry.

McDonagh in his book, *Irish Graves in England*, describes a large brass plate in the form of a Celtic cross, set into the flags. The plate contained the following inscription: IN THE VAULT BENEATH IN A WOODEN COFFIN/ LIE

THE REMAINS OF/ THE RIGHT HON EDMUND BURKE/+/ THIS
CROSS HAS BEEN PLACED/ IN THE YEAR OF OUR LORD AND
SAVIOUR, 1862/ (UNDER THE AUSPICES OF THE REV JOHN
GOULD, B D./ RECTOR OF BEACONSFIELD)/ BY/ EDMUND
HAVILAND BURKE, GREAT GRAND/ NEPHEW OF EDMUND BURKE
AND BY/ SIR ULYSSES DE BURGH, C C B, LORD DOWNES./ SIR
BERNARD BURKE, ULSTER KING-AT-ARMS./ PETER BURKE,
SERGEANT-AT-LAW./ JOSEPH BURKE, ESQ, ELM HALL, CO.
TIPPERARY./ RICHARD BURKE, THORNFIELD, CO. LIMERICK./
REV MICHAEL BOURKE, BALLYVAUGHAN, CO. GALWAY./ THEIR
OBJECT BEING TO MARK THE GRAVE/ OF THE GREATEST OF
THEIR NAME.

I saw no trace of this plate.

Butler, Hubert 1900-1991

Born in Maidenhall, Bennetsbridge, County Kilkenny. He was a
teacher, journalist, essayist and translator. He travelled
extensively in the 1930s before returning to Ireland in 1941. His
views were not always well received in the conservatism of his time
but his reputation continues to grow. His works include
Ten Thousand Saints: A Study in Irish and European Origins, *Escape from the*

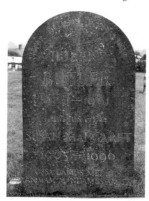

Anthill, *The Children of Drancy*,
Grandmother and Wolfe Tone and
translations from the Russian. He is
buried at Ennisnag about 12
kilometres from Kilkenny on the
road to Waterford. The church and
graveyard are opposite an inn. The
grave is on the right-hand side of the
path as you go in the gate. The
inscription reads: TIMOR DOMINI
FONS VITAE/ HUBERT/ BUTLER/ 1900-
1991/ AND HIS WIFE/ SUSAN
MARGARET/ 1905/ 1996/ OSSA
DAMUS MEDICIS/ ANIMAM
MANDAMUS AMICIS

Isaac Butt 1813-1879

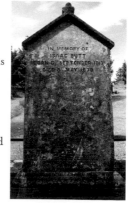

Born in Glenfin, County Donegal. He
was a politician and a barrister who
defended William Smith O'Brien, the
Young Irelanders and the Fenians. He was
founder of the Irish Home Rule party in
1870. He also wrote fiction, translations
and books on politics and history. These
include *Land Tenure in Ireland — A Plea for the
Celtic Race*, *The Problem of Irish Education — An
Attempt at Its Solution*, *The Gap of Barnesmore* and
Chapters of College Romance.

He is buried in the grounds of the
Church of Ireland, Stranorlar, County
Donegal. The church is located on the

right-hand side of the town coming from the Strabane direction. Entering the church grounds from the car park, the grave is located in the top left-hand corner, near the gate.

Donn Byrne 1889-1928

He was born Brian Oswald Donn-Byrne in New York and raised in Ireland. He was quite a popular writer and his works include *The Stranger's Banquet*, *The Foolish Matrons*, *Messer Marco Polo*, *Blind Raftery*, *Hangman's House*, *The Power of the Dog*, *Brother Saul*, *Destiny Bay* and *The Wind Bloweth*. He died after his car went into Courtmacsherry Bay.

He is buried in Rathclaren, Coolmain, County Cork. It is near Kilbrittain, which is close to Ballinspittle, County Cork.

In Kilbrittain, with the cemetery on your right-hand side, go towards the church and take the right turn before the church. When you come to a crossroads (where four unequal roads meet) turn left. Then take the first to the right and go some considerable distance down and you come to Holy Trinity Church of Ireland, Rathclaren.

The inscription, in Irish and English, is from one of his favourite songs and reads: "Tá Mé 'Mo Chodladh/ Is Ná Dúisigh Mé"/ Donn Byrne/ Born 20th Nov. 1889/ Died 18th June 1928/ I Am In My Sleeping/ And Don't Waken Me

Richard Hayward in his book *Munster and the City of Cork* writes movingly of a visit to the grave and singing one of his friend's favourite songs.

Joseph Campbell 1879-1944

Born in Belfast. He collaborated with the composer Herbert Hughes and they published *Songs of Uladh* in 1904. Included in this collection was *My Lagan Love.* He went to London where he wrote other books of poems including *The Rushlight*, *The Gilly of Christ* and

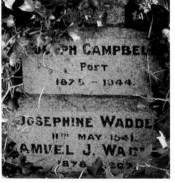

The Mountainy Singer. After the Easter Rising, he was elected to Wicklow County Council and became it's Chairman. He took the anti-Treaty side and was interned for 18 months. He went to America before returning to Wicklow where he died. *The Poems of Joseph Campbell* was published in 1963. Austin Clarke wrote "In the spring of 1944 his nearest neighbours in the glen noticed that no turf smoke was coming from the

chimney and became alarmed. The poet was found dead where he had fallen across the hearth stone". He is buried in grave number 91, C North, Deansgrange Cemetery, Dublin. *(See map page 250 - the grave is on the path edge and is beside a Celtic cross over the Caulfield plot)*. Campbell's plot is shared with his brother-in-law Simon Waddell (Rutherford Mayne *q.v.*) and other relatives. The cross was completely covered with ivy in January 2004.

Ethna Carbery 1866-1902

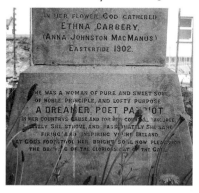

Born Anna Johnston in Ballymena, County Antrim. She founded the *Shan Van Vocht* periodical with Alice Milligan. She wrote many poems, stories and ballads. She married Seamus MacManus in 1901. Her works include *The Four Winds of Eirinn*, *The Passionate Hearts* and *In the Celtic Past*. She wrote the ballads *Roddy McCorley* and *The Passing of the Gael*. She is buried with Seamus MacManus (*q.v.*) in Frosses, County Donegal. The cemetery is located on the main street. Go in the gate and the grave is almost in front of you behind railings. The inscription in the photograph is on the back of the base of the cross.

William Carleton 1794-1869

Born in Prillisk, County Tyrone. His first stories appeared in the *Christian Examiner*, and they were extremely popular. He described what he saw — the indolence, the poverty, the drunkenness, landlordism, the famine. His works include *Traits and Stories of the Irish Peasantry*, *Fardorougha the Miser*, *Redmond Count O'Hanlon*, *The Black Prophet — A Tale of the Irish Famine*, *Valentine M'Clutch The Irish Agent*, *The Party Fight and Funeral* and *Parra Sastha*. He is buried in Mount Jerome Cemetery, Dublin. *(See map page 252 - the grave is situated at the white steps and about three rows in on the left-hand side)*.

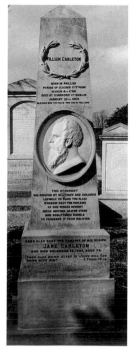

The inscription reads: WILLIAM CARLETON/ BORN IN PRILLISK/ PARISH OF CLOGHER Co TYRONE/ MARCH 4TH 1794/ DIED AT SANDFORD Co DUBLIN/ BLESSED ARE THE DEAD WHO DIE IN THE LORD/ THIS MONUMENT/ WAS ERECTED BY HIS WIDOW AND CHILDREN/ LOVINGLY TO MARK THE

PLACE/WHEREIN REST THE REMAINS/OF ONE WHOSE MEMORY/
NEEDS NEITHER GRAVEN STONE/NOR SCULPTURED MARBLE/TO
PRESERVE IT FROM OBLIVION

James Patrick Carney 1914-1989

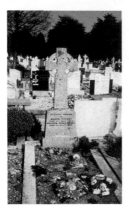

Born in Portlaoise, County Laois. He
held various posts in the School of Celtic
Studies in the Institute of Advanced
Studies including that of Senior
Professor. He edited *Poems on the Butlers of
Ormond, Cahir and Dunboyne* and *Poems on the
O'Reillys*. He published essays, translations
and other works including *The Problem of St
Patrick* and *Studies in Irish Literature and History*.
He was honoured by his colleagues in
*Sages, Saints and Storytellers, Celtic Studies in
Honour of James Carney (1983)*. He is buried
in grave number 13 H, St Anne's,
Deansgrange Cemetery, Dublin. *(See map
page 250)*.

Paul Vincent Carroll 1900-1968

Born in Dundalk, County Louth. He worked as a teacher and
wrote poems, stories and plays. His success allowed him to
become a full-time playwright and his plays won many prizes. His
works include *The Watched Pot, Shadow and Substance, The White Steed, The
Wise Have Not Spoken, Goodbye to the Summer* and *Beauty Is Fled*. He is
buried in grave number E7 (unconsecrated ground), Plaistow
Cemetery, Burnt Ash Lane, Bromley, Kent.

The cemetery is only a five minute walk from the station. The
entrance is on Burnt Ash Lane. I
obtained the grave number and
was advised to ring when I arrived
at the cemetery to get the
directions to the grave.
Unfortunately when I arrived and
rang the number I got an
answering machine. It was four
o'clock in the afternoon and I

had come a long way. Fortunately the local library is situated
beside the cemetery and eventually they were able to connect me
with Mick Dibley who gave me very precise directions and I found
the grave easily. Go in the main entrance and go straight to the
end of the road and then take the path to the left. Go up sixteen
graves and one row in.

The inscription is quite worn and barely legible. On one side
it reads: PAUL/VINCENT/CARROLL/DIED 1968/R.I.P. On the
other side it reads: MARY/PEARL

Arthur Joyce Lunel Cary 1888-1957

Born in Derry. He was educated in England. He served in the
colonial service but came back to England due to ill health. He

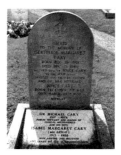

began to write using his experiences as material. Altogether he wrote 16 novels. In 1941 his novel *A House of Children* won the James Tait Black Memorial Prize. Other works include *A Fearful Joy*, *The African Witch*, *Charley Is My Darling*, *Not Honour More*, *Mister Johnson*, *Herself Surprised*, *To Be a Pilgrim* and *The Horse's Mouth*.

He is buried in grave number C2-19, Wolvercote Cemetery, four kilometres north of Oxford. Walk up the drive to the chapel and take the tarmac path that leads away from the chapel to the north. Turn left at the next gravel path, and continue to the end. His grave is on the left-hand side.

John Keegan Casey 1846-1870

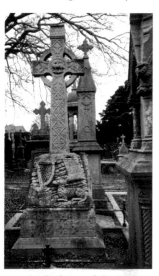

Born at Mount Dalton in County Westmeath. He was the poet of the Fenian movement and wrote under the pen-name of Leo. He wrote for a number of Irish papers and spent six months in prison because of his work. He wrote a number of poems and songs which were well received, the most famous being *The Rising of the Moon*.

He died after an accident involving a cab. The cross over his grave was erected by the Monuments Committee of the Young Ireland Society. It is said that over 50,000 people followed his coffin to Glasnevin Cemetery to the sound of *The Rising of the Moon*. (*See map page 246 - the grave is to the side and behind the large corner monument to the Fenians*).

At the base of the cross, on one panel are the words of the last verse of the Rising of the Moon. A second panel has another of his poems: STAND FORTH YE EAGLE EYED AND YOUNG/WHOSE VEINS ARE HOT, WHOSE SOULS ARE TRUE/STAND FORTH OUR BATTLING HOST AMONG/WHO WAGE THE ANCIENT FIGHT ANEW/AND YOU THE WEARY IN THE STRIFE/WHO BRAVED THE BURSTING OF THE GALE/RISE UP, REFRESHED TO YOUTHFUL LIFE/AND AID THE CAUSE THAT SHALL NOT FAIL.

On the base of the cross is the inscription: IN MEMORY OF JOHN KEEGAN CASEY/"LEO"/PATRIOT POET NOVELIST/MEMBER OF THE IRISH REPUBLICAN BROTHERHOOD/AUTHOR OF THE RISING OF THE MOON/AND MANY SOUL STIRRING NATIONAL BALLADS AND SONGS/BORN 22 AUGUST 1846 DIED ST PATRICK'S DAY 1870./FROM HIS YOUTH HIS LIFE WAS DEVOTED TO THE CAUSE OF IRISH FREEDOM./HIS LAST WORDS WERE A PRAYER OF INTERCESSION FOR HIS COUNTRY'S LIBERTY/AND HIS SOULS SALVATION/THIS CROSS IS ERECTED BY THE MONUMENTS

COMMITTEE OF THE YOUNG IRELAND SOCIETY/ AS AN HUMBLE
TRIBUTE OF LOVE AND TO COMMEMORATE HIS PRINCIPLES/ HIS
NOBLEST MONUMENT IS HIS WORKS IN WHICH HIS SPIRIT MUST
EVER LIVE/ MAY HE REST IN PEACE

Another plaque lists his songs: THE RISING OF THE MOON/
OUR PLEDGE/ THE FINAL CAST/ THE CONVICT LAY/ A CRETAN
SONG/ THE SAGGARTH AROON/ DECKING THE GRAVES

There are a further two plaques in Irish.

Seathrún Céitinn (Geoffrey Keating) c. 1570/80-c. 1644/50

Born in Burges, County Tipperary. After his ordination he
studied in Bordeaux and Rheims. He returned to Tubrid around

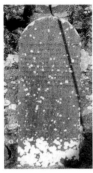

1610 where, except for his research and a
period when he had to go into hiding, he
stayed until his death. He wrote a famous
History of Ireland (Foras Feasa ar Éirinn), travelling all
over the country examining the manuscripts
in the hands of the Gaelic nobility. He was also
a talented poet. He is buried at Tubrid,
County Tipperary. Take the Cahir to
Clogheen road and the grave is well
signposted. There is a plaque on the outside
wall of the churchyard, another one over the
church entrance and the grave is inside against
the far wall. The plaque over the church

entrance is in truncated Latin and
reads: ORATE PRO AIABS/ P EUGENIJ:
DUHY/ VIC DE TYBRUD ET/ D DOCT
GALF KEA/ TING HUIS SACELLI/
FUNDATORU NEC NO/ ET PRO OIBS
ALIJSTA/ SACERD QUAM LAICIS QUORU
CORPA IN EOD JACET/ SA AO DONI 1644

The inscription in Irish on the
gravestone reads:
DO CHUIMHNINGHADH SHEATRÚIN
CHÉITINN/ AN LEAC SO/ AR DUINE DO
BA MHO EAGNA/ D'FHEARAIBH

ÉIREANN IN A CHOMH-AIMSIR/ SAOI I nGAEDHILG AGUS I
LAIDIN/ AGUS AN SAGART LÁN CRAIBHTHEACH/ ÍODHAN
URNUIGHTHEACH GEANMNAIDH/ DIADHA CEANN FOIRCEADAIL
AGUS FÍR EAGNA/ AGUS SOIBHEUR AGUS REULTANN AN/ EOLAIR
DO CLAINN NA nGAEDHEAL

This translates roughly as: This stone is to the memory of

Seathrún Céitinn (one of) the
greatest Irish intellects of his time,
an expert in the Gaelic and Latin
languages, a devoted, virtuous,
prayerful, modest and pious priest;
an authority on doctrine and true wisdom and good manners,
and guiding star of the Irish nation.

Susannah Cent(i)livre 1667-1723

Possibly born in Ireland. She lost a couple of husbands in duels before eventually marrying a French chef. Despite the prejudice against women writing, she wrote nearly 20 plays in all. Her works include *The Wonder! A Woman Keeps a Secret*, *A Bold Stroke for a Wife*, *The Busy Body*, *The Gamester* and *The Ghost*. Various sources state she was buried in St Martin-in-the-Fields in London, with the inscription "HERE LIES SUSANNA CENTLIVRE (NEÉ FREEMAN) FROM IRELAND. PLAYWRIGHT, 1 DECEMBER, 1722".

I could find no trace of her in St Martin's and the verger knew nothing about her being buried there.

I suspected that she might have been buried in St Paul's in Covent Garden and I went and searched there but with the same result. In August 2003 I checked the burial registers of both St Martin-in-the Fields and St Paul's. There was no mention of any Centlivre in St Martin's for the years 1722 or 1723, but the entry in St Paul's for the 4th December 1723 mentions Susannah, wife of Joseph Centlivre from St Martin-in-the-Fields.

Unfortunately I could still find no trace of her in St Paul's. There is no plaque and most of the stones are either against the walls of what is now a small park or else they are part of the pathway. I could not find anyone in the church who was able to provide further information.

Peter Cheyney 1896-1951

Born Reginald Evelyn Peter Southouse-Cheyney. All the Irish sources I consulted stated he was born in County Clare. The non-Irish sources stated he was born in London. A colleague of mine searched the birth records for County Clare but there was no Southouse-Cheyney-Chesney for that period. However it is possible that the birth was not registered.

Southouse-Cheyney served in the First World War and was severely wounded. After that he worked as a journalist and ran a

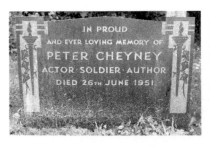

detective agency. His first book *This Man is Dangerous* was an immediate bestseller. He wrote over 50 crime novels and sold millions of copies. Other works include *Calling Mr Callaghan, Dark Duet, Dark Wanton, Lady Behave, Sorry You've Been Troubled, Dangerous Curves, Urgent Hangman* and *Ladies Won't Wait*. He is buried in grave number 1809, Section AS, Putney Vale Cemetery, London.

Take the metro to Putney Bridge station and then take bus number 85 or 265 to Putney Vale Cemetery. The bus journey takes about 25 minutes. Go in the pedestrian entrance on the Kingston road, go past the chapel and follow the road. Just past Greenwood Road, on the left-hand side, on the edge of the road is the grave of Sir John and Hazel Lavery. Fifty rows past this and close to the hedge is the grave of Peter Cheyney.

Robert Erskine Childers 1870-1922

Born in London. He wrote *The Riddle of the Sands* in 1903, a book still in print. He became sympathetic to the Irish cause and brought guns to Ireland aboard his yacht, the *Asgard*. Despite this, he served in the Royal Navy during the First World War. He was elected to the Dáil in 1921 and was secretary to the Irish delegation during the Treaty negotiations. He was against the final settlement and was

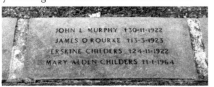

arrested for carrying a gun, given to him by Michael Collins. He was executed in Beggars Bush Barracks. He shook hands with each member of the firing squad and asked them to step forward to make the work easier. He is buried in the Republican Plot in Glasnevin Cemetery, Dublin. *(See map page 246)*.

Austin Clarke 1896-1974

Born in Dublin. He lived in London 1922-1937, working as a journalist and critic before returning to Ireland. He wrote poetry, plays, novels and autobiographies. These include *The Vengeance of Fionn, Night and Morning, Ancient Lights, The Bright Temptation, The Sun Dances at Easter, The Son of Learning, Black Fast, Twice Around the Black Church* and *A Penny in the Clouds*. In 1941 he co-founded the Dublin Verse Speaking Society, which later developed into the Lyric Theatre. He won many awards and was considered to be a leading light in modern Irish literature. The *Irish Press* in an editorial on his death noted that Clarke was the first poet in their New Irish Writing page. One of the poems they published ended with *"We part with a shy So long"*. His remains were taken to Belfast for cremation.

Brian Cleeve 1921-2003

Born at Thorpe Bay, Essex. He ran away to sea at the age of 17 and served in the merchant navy during the Second World War. After the War he worked as a salesman, journalist and broadcaster. He wrote short stories, novels and works on metaphysical speculation. His works include *The Far Hills*, *Birth of a Dark Soul*, *The Horse Thieves of Ballysaggart*, *Cry of Morning*, *Tread Softly on This Place*, *The House on the Rock*, *The Seven Mansions*, *The Fourth Mary*, as well as a three volume *Dictionary of Irish Writers*.

At his request, the funeral was private and the death notice

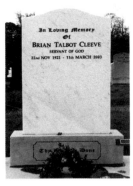

did not appear until eleven days after his death when the funeral had already taken place. He is buried in grave number 7, Row G1, St Ciaran's Section, Shanganagh Cemetery, Dublin. *(See map page 256)*. Go in the main gate and St Ciaran's Section is immediately located on the right-hand side. The rows are in alphabetical order and A1 onwards is after row Z. The temporary grave marker has the inscription BRIAN CLEEVE/ 11TH MARCH 2003. A permanent gravestone has now been erected.

Sigerson Clifford 1913-1985

Born in Cork. He worked as a civil servant in Dublin and wrote poetry, stories, radio scripts and plays. His works include *The Great Pacificator, The Red-haired Woman, Death Sails the Shannon* (with W. MacLysaght), *Travelling Tinkers* and *Ballads of a Bogman*. He is buried in Kilnavarnogue Cemetery, Caherciveen. There is a memorial to Sigerson Clifford just beside Bridge Street and the cemetery is located down this street and across the

bridge. There are in fact two cemeteries and Clifford is buried in the older one which is down a small lane opposite the newer cemetery. When I saw how large it was and how few paths there were, I despaired of finding it. But something drew me to the far right-hand corner and there was the grave. The inscription on the back of the stone is taken from one of his poems: I TAKE MY SLEEP IN THESE/ GREEN FIELDS/ THE PLACE I GREW A MAN/ WITH THE BOYS OF/ BARR NA SRAIDE/ WHO HUNTED FOR THE WRAN

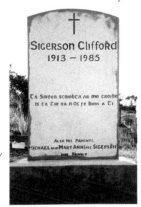

Kitty Clive 1711-1785

She appears to have been born in the North of Ireland, although some sources suggest London as her birthplace. At an early age,

she became involved in the theatre and soon established herself as the most famous comic actress of the period. She wrote a number of plays including *The Rehearsal* and *The Faithful Irishwoman*. She was buried in the burial ground attached to St Mary the Virgin in Twickenham, London. As McDonagh reported in *Irish Graves in England*, her grave was unknown and 'even the sexton was unable to tell whether she had been buried in the church or in the grounds.' There is however a small marble tablet on the east gable of the church. The inscription is extremely legible and reads: Sacred To The Memory Of/ Mrs. Catherine Clive/ Who Died/ December The 7th, 1785/ Aet 75 Years/ Clive's Blameless Life This Tablet Shall Proclaim/ Her Moral Virtues And Her Well-Earned Fame/ In Comic Scenes The Stage She Early Trod/ "Nor Sought The Critic's Praise Nor Feared His Rod"/ In Real Life Was Equal Praise Her Due/ Open To Pity And To Friendship True/ In Wit Still Pleasing As In Converse Free/ From Aught That Could Afflict Humanity/Her Generous Heart To All Her Friends Was Known/ And E'en The Stranger's Sorrows Were Her Own/ Content With Fame, E'en Affluence She Waived/ To Share With Others What By Toil She Sav'd/ And Nobly Bounteous From Her Slender Store/ She Bade Two Dear Relations Not Be Poor/ Such Deeds On Life's Short Scences True Glory Shed/ And Heav'nly Plaudits Hail The Virtuous Dead.

Earlier in the day I had visited the grave of John Wilson Croker. The rail connection from Kingston to Twickenham goes through Teddington where Peg Woffington is buried.

The Irish born **Peg Woffington c. 1714 - 1760** was the best known actress of her day. I hadn't expected to come here so I had taken no information from McDonagh's book with me. After I spent an hour searching fruitlessly in the graveyard, I met a very pleasant lady, Eve Gamble. She informed me that Peg Woffington was buried within the church which unfortunately was

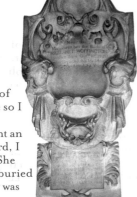

closed that afternoon. However, she kindly offered to take a photograph of the memorial for me and I have included it here.

Brian Coffey 1905-1995

Born in Dublin. He spent over 30 years teaching in America and England. His early poetry in the 1930s was followed by a gap of 20 years before his later work appeared. His works includes *Poems* (with Denis Devlin), *Three Poems*, *Third Person*, *The Big Laugh*, *Death of Hektor*, *Advent* and various collections.

He is buried in grave number K 19/208, Hollybrook Cemetery, Southampton. A map can be obtained from the Council Offices.

Enter the cemetery from Lordswood road and take the main road. The grave is roughly behind the fourth large tree on the right-hand side and eight rows back.

Mary Colum 1884-1957

Born in Collooney, County Sligo. She was a member of Cumann na mBan and worked as a teacher under Pearse in St Enda's. She married Padraic Colum in 1912 and went to America with him where they stayed until they died. She was a writer whose works include *From These Roots*, *Life and the Dream* and with her husband *Our Friend James Joyce*. She is buried with Padraic.

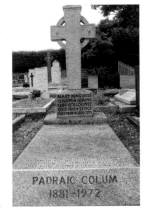

Padraic Colum 1881-1972

Born in Longford. He was a poet and playwright whose works include *The Land*, *The Fiddler's House* and *Thomas Muskerry*. His *Collected Poems* was published in 1953. He also wrote the lyrics for *She Moved through the Fair* and *Cradle Song*. He moved to America in 1914 and lived the rest of his life there. He died in Connecticut. The Colums are buried in St Fintan's Cemetery, Sutton, Dublin. (*See map page 256*). From the lowest part of the cemetery, go up the steps into the next section and walk towards the top. Take the last path to the right and almost facing you on the left-hand side is the grave.

The inscription at the base of the cross reads: MARY MAGUIRE/ COLUM * 13 JUNE/ 1884 COLLOONEY/ CO SLIGO + 22 OCT/ 1957 NEW YORK CITY/ R.I.P.

The inscription on the grave slab reads: PADRAIC COLUM/ POET DRAMATIST NOVELIST/ * LONGFORD/ 8 DECEMBER 1881/ +

41

Enfield Connecticut/ 11 January 1972/ Dream Of Me
There In Stirless Air/ Beyond The Seagull's Range/ Above
Enshadowed Beings We Name/ Time And Loss And Change

Michael Comyn c. 1688-1760

Born in Kilcorcoran,
County Clare. He was a
Gaelic poet and scholar.
Unfortunately most of his
manuscripts were burnt
after his death and very
little of his work survives.
This includes *Laoi Oisín Ar
Thír na nÓg* and *Eachtra
Thoirdhealbhaigh Mhic Stairn*.

He is buried in the churchyard of St Laichtin at Kilfarboy,
near Milltown Malbay, County Clare. My information was that
the graves of both Michael Comyn and Andrew MacCurtain (*q.v.*)
were unmarked. I searched the graveyard and was unable to find
the grave. Sometime later I was in touch with Michael de Barra of
the local historical society, who informed me that the grave was
marked and he kindly sent me on the above photograph.

Helena Concannon (née Walsh) 1878-1952

Born in Maghera, County Derry.
She was a prolific writer and was also
a senator and TD. Her works
include *Defenders of the Ford, Irish Nuns in
Penal Days, Women of Ninety Eight* and a
biography of Oliver Plunkett.

She is buried in grave
number 4, Row 7, Section E,
Bohermore Cemetery, Galway. Go
in the main entrance past the church
and take the first road to the right.
Section E is on the left-hand side
and begins with a cross within
railings more or less opposite the
middle point of the church. About eight rows further down and
eight or nine graves in, is the grave of Helena Concannon.

The inscription reads: Go Déana Dia Trócaire Ar Anam/
Eibhlín Uí Concheanainn/ A Rugadh I Macaire Ratha I
Ndoire/ An 28 Dheire Foghmhair 1878/ A Fuair Bás An 27 De
Feabhra 1952/ Agus Ar A Cheile/ Tomas O Concheanainn/ A
Rugadh I N-Inismeain Arainn/ An 16 De Mhí Na Samhna
1870/ A Fuair Bás An 20 D'aibreán 1961/ Solus Na
Bhflaitheas/ Dá N-Anamnacha

James Connell 1852-1929

Born in Kilskyre, County Meath, he wrote the words to the *Red
Flag*. The lyrics were originally written to the tune of the *White*

Cockade, although it is more often sung to the tune of *Tannenbaum*. Both airs were sung at his funeral.

His ashes were dispersed in the Garden of Remembrance at the Golders Green Crematorium, London. According to a note in the cemetery records the ashes were scattered in section 3S, although the cemetery tradition would suggest section 3C.

James Connolly 1868-1916

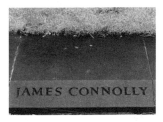

Born in Edinburgh. He served for a number of years in the British Army. He was mostly self-taught. He studied Marx's theories and tried to apply them to Ireland. He founded the Irish Socialist Republican Party, launched The Workers Republic and helped found the International Workers of the World (Wobblies). He went to America and returned to Ireland in 1910. He became the organiser of the Irish Transport and General Workers Union in Ulster. In 1914 he became General Secretary of the Union when Larkin went to America. He also became head of the recently formed Irish Citizen Army. He took part in the Easter Rising, commanding the forces in the GPO, where he was wounded. He was sentenced to death for his part in the Rising and was shot propped up in a bath chair. He wrote *Labour in Irish History*, *Socialism Made Easy*, *Erin's Hope*, *The Reconquest of Ireland*, a play *Under Which Flag?* and poetry. He is buried with the other executed leaders of 1916 in the Church of the Sacred Heart, Arbour Hill, Dublin. *(See map page 255)*. The graves are located close to the back wall of the churchyard.

Daniel Corkery 1878-1964

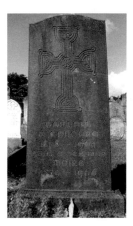

Born in Cork. He was a teacher, novelist, short story writer, dramatist and scholar who had a profound influence on Irish writing. Among those he either taught or influenced were Frank O'Connor, Seán O'Faolain and Séamus Murphy. He was a strong supporter of the Irish language and caused controversy for his views on the Anglo-Irish tradition and the Celtic revival. Corkery's works include *A Munster Twilight*, *The Hounds of Banba*, *The Stormy Hills*, *Earth out of Earth*, *The Threshold of Quiet*, *The Hidden Ireland* and *Synge and Irish Anglo Irish Literature*. He is buried in St Joseph's Cemetery, Cork. Go in the main gate and immediately to your left, the grave is three rows back. The stone is by Séamus Murphy. The inscription reads: DOMHNALL/ O CORCORA/ 1878-1964/ AGUS A DEIRFIÚR/ MÁIRE/ 1879-1966

Walter "Watty" Cox c. 1770- 1837

Born in County Westmeath. There is doubt about his birth date and the Glasnevin Cemetery records note his age as 84! He established the *Union Star* for the United Irishmen in 1797 and ran the *Irish Monthly Magazine* from 1807-1815. The latter publication was quite hostile to the government and he was frequently prosecuted and fined. He even remained an additional 18 months in Newgate prison rather than pay a fine of £300. Peel, who was Chief Secretary for Ireland 1813-1818, stated that "Cox's object was to ferment a bitter hatred against England". He was such a thorn in the side of the government he was given a pension to leave the country which he did in 1816, returning in 1835. Lecky describes Cox as "one of the most peculiar individuals to be met with in Irish history". He is buried in Glasnevin Cemetery, Dublin. *(See map page 246)*. The grave number is S 1501/2 and is situated more or less between the trees in the photo. The row letters are marked on the wall.

Fitzpatrick stated (*History of the Dublin Catholic Cemeteries, 1900*) that the resident officials in the cemetery were unaware that he was even buried there until they discovered "in an early register that an unmarked grave, shaded by the foliage of the Botanic Gardens covers the remains of a man who disturbed the repose of successive governments". Most of the older graves contained several bodies but Cox rests all alone.

Sam Cree 1928-1980

He was a writer of domestic farces which were extremely popular

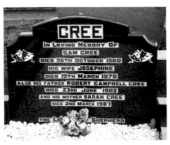

in his day and even yet are a favourite with amateur drama groups. His work includes *Cupid Wore Skirts*, *Married Bliss*, *Widow's Paradise*, *Don't Tell The Wife*, *Second Honeymoon*, *Family Fever*, *Wedding Fever* and *The Love Nest*. The well-known English comedian, Sid James, died on stage while acting in one of Cree's plays, *The Mating Season*. Sam Cree is buried in New Blairis Cemetery, Blairis Road, Lisburn, County Antrim. Go in the main gate to the roundabout area before the road ends. The grave is two rows in on the left and five graves down.

Creggan Poets

The Creggan poets, **Art MacCooey**, **Padraic Mac A Liondain** and **Seamus MacMurphy**, are buried in Creggan graveyard near

Crossmaglen, County Armagh. Go in the main gate at the visitors'
centre, which is open from June to September 3-5.30p.m.
Sundays only. Take the path to the left past the visitors centre and
straight in front is a plaque on the wall facing you to Mac A
Liondain. On your right-hand side is a vault to the Eastwoods.
Continue on the path and straight in front of you there is
another plaque on a wall to a priest ordained by Oliver Plunkett,
Father Gilmurray. The enclosed walled graves behind are to the
Johnstons of the Fews.

Continue on the path all around until, near the end on the
left-hand side and three rows in, is a striking cross to Art
MacCooey. From there with your back to MacCooey, the O'Neills
of the Fews have a vault near the church wall. There is a block with
the name and the vault has a railed enclosure. To the right of it
there are a number of memorials to Murphys. The one to the poet
is slightly raised. If you are on the path heading towards the gate,
just as you turn the corner, on the right-hand side there is a
horizontal stone with another stone on top marking the grave of
Father Quinn who excommunicated MacCooey.

Art MacCooey 1738-1773 was born in Mounthill. He

worked locally as a labourer and gardener. He fell out with the
local clergy and was married in
Creggan instead. This event led to
him having to leave the area and he
wrote about this in one of his
poems. He returned some time later
and made his peace. Many of his
poems were very popular in his day
but only 25 of them survive. The
inscription on the headstone quotes
the last two lines of his best known
poem *Úrchill an Chreagáin*. They were
translated by Sigerson as "in the

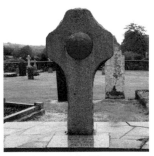

fragrant clay of Creggan let my weary heart have rest". The stone
was unveiled in 1973 by Senorita Conchita O'Neill. The grave of
Art's sister is in the same graveyard.

Padraic Mac A Liondain 1665-1733 was born in

Creggan parish, County Armagh. One of his better known
compositions was a lament for Eoghan Rua O'Neill. He was also
a harpist. A commemorative
plaque on the wall reads: A
PRAYER FOR THE SOUL OF/
PADRAIC MAC A LIONDAIN,
POET OF THE FEWS/BURIED IN
THIS CHURCHYARD MARCH
1773 R.I.P./PLAQUE ERECTED
BY EIGSE OIRIALLA 1987.

Seamus MacMurphy 1720-1750, according to his

headstone, was a poet and a tory. The word "tory", originally
meaning robber or pursuer, was also applied to those who
supported the Jacobean cause. MacMurphy founded a school for
Gaelic poetry and was a supporter of the Stuart cause. He found

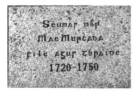

himself on the run from John Johnston, the Chief Constable of (the barony of) the Fews. He was betrayed by Molly McDacker, who was in love with him but believed he was unfaithful. MacMurphy was hanged, allegedly for stealing, but more likely because of the rhyme ascribed to him "Jesus of Nazareth, King of the Jews, Save us from Johnston, King of the Fews". Johnston is buried in the same graveyard.

John Wilson Croker 1780-1857

Born in Galway. He was called to the Irish Bar in 1802. He achieved great success with his satires — *Familiar Epistles on the Present State of the Irish Stage* and *An Intercepted Letter from J...T...Esq. Written at Canton to His Friend in Dublin, Ireland*. In 1808 *A Sketch of the State of Ireland Past and Present* attracted a similar response. From 1807-1832 he represented various Irish constituencies in the House of Commons and was Secretary of the Admiralty from 1809-1830. He wrote hundreds of articles for the *Quarterly Review* which he

helped to found. He figured as a character in books by Disraeli, Thackeray, Morgan and Peacock. He is buried in the churchyard attached to the parish church at West Molesey, about five kilometres from Hampton in Surrey, England. His only son died at three years old and was buried at Wimbledon. After many years Croker had the remains re-interred in the shadow of the church in the grave where he lies himself. He wrote the words for his son which were to be inscribed after his own death.

When McDonagh (*Irish Graves in England*) visited the churchyard in 1887, the grave had 'a white marble stone lying flat on the ground and was surrounded by high iron railings ... entwined with rose bushes brilliant with blossoms.' The railings are now gone, so too the roses and the white marble stone he spoke about is more pink in shade. The grave is situated around the left of the church, underneath the window of the church hall.

The inscription is extremely clear and reads: HERE REST/ THE MORTAL REMAINS OF/ THE RIGHT HON JOHN WILSON CROKER/ BORN 20TH DECEMBER 1780/ DIED 10TH AUGUST, 1857/ ALSO HIS WIFE/ ROSAMOND CARRINGTON CROKER/ BORN 1ST MARCH 1789/ DIED 7TH NOVEMBER 1830/ AND OF/ SPENCER PERCIVAL CROKER/ ONLY SON OF JOHN WILSON CROKER AND ROSAMOND/ HIS WIFE/ BORN 31ST JANUARY 1817/ DIED 15TH MAY 1820/ OH PITY US WHO LOST WHEN SPENCER DIED/ OUR CHILD, OUR HOPE OUR PLEASURE AND OUR PRIDE/ IN HIM WE

SAW OR FANCIED ALL SUCH YOUTH/ COULD SHEW OF TALENTS,
TENDERNESS AND TRUTH/ AND HOPED TO OTHER EYES HIS
RIPENED POWERS/ WOULD KEEP THE PROMISE THEY HAD MADE
TO OURS/ BUT GOD A DIFFERENT BETTER GROWTH HAS GIVEN/
THE SEED WE PLANTED HERE NOW BLOOMS IN HEAVEN.

I went to West Molesey via Kingston station and caught a bus
directly to the village from the nearby bus station, getting off in
the village at the war memorial.

Thomas Crofton Croker 1798-1854

Born in Cork. He was a folklorist and the first significant
collector of Irish folk narrative. His *Fairy Legends and Traditions of the
South of Ireland* went into six editions and was translated into
German by the Brothers Grimm. Other works include *Legends of
Cork*, *Legends of Kerry*, *Ireland Myths and Legends*, *Popular Songs of Ireland*, *The
Adventures of Barney Mahoney* and *My Village Versus Our Village*. He was a
member of both the Swedish and Danish Antiquary Societies and
was registrar of the Royal Literary Society. He was a son-in-law of
the painter Francis Nicholson.

He was buried in Brompton Cemetery, London. McDonagh
(*Irish Graves in England*) writes of going to the Superintendent's
Office and after a search among dusty tomes, being accompanied
to the section of the cemetery and locating the grave after some
time. I went armed with three separate maps (all unfortunately
giving slightly different locations within the section), a
photograph of the grave and a sketch of the gravestone as it
looked over 100 years ago. I spent a very frustrating two hours
without success. A few months later, in November 2002, I went
back to the cemetery and like McDonagh visited the
Superintendent's Office. After a search through the
computerised files we found the reference and he accompanied
me to locate the grave. This time we found it easily, not least
because the bush that had covered the gravestone was now bare.
The grave is located in Section AI and is number 984 in the

burial register. It is two rows in
and is situated behind a grave
belonging to Chamberlain.

McDonagh gives the
inscription as: THE PRIVATE
GRAVE/ OF/ FRANCIS
NICHOLSON/ LANDSCAPE
PAINTER/ DIED 6TH MARCH
1844/ AGED 91 YEARS/ HERE
ALSO LIES/ THOMAS CROFTON
CROKER/ SON-IN-LAW OF
FRANCIS NICHOLSON/ HE DIED
8TH AUGUST 1854/ AND/
MARIANNE/ WIDOW OF THOMAS
CROFTON CROKER/ WHO DIED
6TH OCTOBER 1854.

The inscription now reads:
FRANCIS NICHOLSON 1752-
1844/ LANDSCAPE PAINTER/

THOMAS CROFTON CROKER 1797-1854/ANNE CROFTON CROKER 1792-1854/THOMAS FRANCIS DILLON CROKER 1832-1912.

The stone was either recut or replaced. There is a smaller stone almost buried, at the foot of the grave and this may be the original one.

Rev George Croly 1780-1860

Born in Dublin. He went to London in 1810. He had strong sympathies with his native land although he was well disposed to Orangeism. He once stated that the remedy for all the ills in Ireland was Protestantism. He was made rector of St Stephen's Walbrook, London in 1835. He published over 40 works of religious material, poetry, romance writing and biography including *Salathiel the Immortal*, *Cataline*, *May Fair* and *Marston*.

By permission of the Home Secretary, Croly's remains were interred in the chancel of St Stephen's Church Walbrook, London. There is a monument to Croly on the left-hand wall, about two thirds down, as you enter the church. It consists of two marble tablets surmounted by a bust of Croly. The left-hand tablet reads: SACRED TO THE MEMORY OF/THE REVEREND GEORGE CROLY L.L.D./FOR 25 YEARS RECTOR OF THESE UNITED PARISHES/THANKFUL TO ALMIGHTY GOD FOR THE BEST BLESSINGS OF LIFE/HEALTH PROLONGED TO AGE, COMPETENCE, A NOT INACTIVE MIND/A LOVED AND LOVING WIFE, KIND FRIENDS AND EXCELLENT SONS/HE DIED 24TH NOV, 1860 AGED 80,/IN THE FULL FAITH OF THE MOST HOLY TRINITY,/AND IN THE UNSHAKEN HOPE OF A RESURRECTION/THROUGH JESUS CHRIST OUR LORD AND SAVIOUR/SACRED ALSO TO THE MEMORY OF/HIS WIFE MARGARET HELEN WHO DIED 25TH JAN 1851/AND OF HIS DAUGHTER HELEN LOUISA MARY WHO DIED 8TH SEPT 1851

The other tablet reads: THE BUST/FORMERLY GIVEN BY HIS PARISHIONERS AND FRIENDS/WAS BY HIM BEQUEATHED TO THIS CHURCH./THE FOUR LARGER AND THIRTEEN SMALLER/PAINTED WINDOWS/TOGETHER WITH THIS/MONUMENT/(INSCRIBED WITH THE EPITAPH WRITTEN BY HIMSELF)/HAVE BEEN PLACED IN THIS CHURCH/IN HONOUR OF HIS GENIUS/AND IN TESTIMONY OF AFFECTION/BY HIS SORROWING FRIENDS AND PARISHIONERS./

ALL OF HIM THAT WAS MORTAL RESTS WITHIN THESE WALLS.

To the right of the altar as you face it, is a marble tablet to the memory of his eldest son who was killed in India in 1845, aged 23 years.

Eric Cross 1903-1980

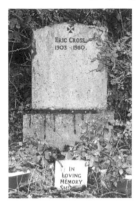

Born in Newry, County Down. He was educated in England and became an engineer. He was the inventor of a synthetic marble. He is best known for his book, *The Tailor and Ansty*, which arose from conversations between a seanchaí from Gouganebarra, Tim Buckley and his wife Anastasia and their friends and neighbours. The book was banned. Other works include *Silence is Golden and Other Stories*.

He is buried in St Thomas's, Church of Ireland, Knappagh which is marked on the Ordnance Survey map. The cemetery is on the left-hand side of the road coming from Westport. The grave is at the top right-hand corner of the cemetery.

The tailor and his wife are buried in the Buckley plot in the cemetery overlooking Gouganebarra, County Cork. Their stone is on the right of the photograph below.

The inscription reads: TADHG O BUACHALLA/AN TAILIÚIR/ 1860-1945/A STAR DANCED/AND UNDER THAT WAS I BORN/ AINSTÍ/A BHAINCHÉILE/1872-1947

The stone is by Séamus Murphy.

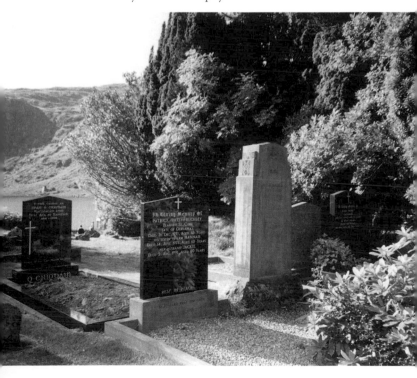

Constantine Curran 1883-1972

Born in Dublin. He was the author of
*Dublin Decorative Plasterwork of the Seventeenth
and Eighteenth Centuries*, *James Joyce
Remembered* and *Under the Receding Wave*.

 He is buried in grave number
K121, St Patrick's, Deansgrange
Cemetery, Dublin. *(See map page 250)*
The inscription reads: IN MEMORY OF/
HELEN CURRAN/ 1874-1957 & OF/ HER
HUSBAND/ CONSTANTINE/ PETER
CURRAN/ S.C. D.LITT M.R.I.A./
1883-1972/ REQUEISCANT IN PACE

Alice Curtayne 1901-1980

Born in Tralee, County Kerry. She wrote biographies of Francis
Ledwidge, Catherine of Siena, Patrick Sarsfield and the lives of
the Irish saints as well as a novel *House of Cards* and poems. She was
married to Stephen Rynne (*q.v.*). They are buried together in
Killybegs Cemetery, Prosperous, County Kildare. Coming from
Clane turn left at the crossroads at the edge of the village of
Prosperous. Take the next left and the cemetery is located on the
right-hand side. Go in the gate, turn right and the grave is located
in the last row on the left-hand side.

Cyril Cusack 1910-1993

Born in Durban, Natal, South Africa.
He was one of the most famous of Irish
actors, performing with the Abbey, the
Gate, the Royal Shakespeare Company
and the English National Theatre. He
appeared in many films including
Shake Hands with the Devil, *Fahrenheit 451*,
The Day of the Jackal and *My Left Foot*. He
also wrote three volumes of poetry –
Timepieces, *Poems* and *Between the Acts*. He is
buried in Mount Venus Cemetery,
Mount Venus Road, Dublin. *(See map
page 256)* Go in the main gate and the
grave is located on the third path on
the right and about 15 gravestones in on the left.

John D'Alton 1792-1867

Born in County Westmeath. He graduated from Trinity College
Dublin and became a barrister. He was the author of *The History of
the County of Dublin*, *History of Drogheda*, *Memoirs of the Archbishops of Dublin*,
The History of Dundalk, *Illustrations, historical and genealogical, of King James
II's Irish Army List, 1689* and *The History of Ireland from the Earliest Period to
1245*. He is buried in Glasnevin Cemetery, Dublin. *(See map page
246)*. The carving of the Last Supper is by James Pearse, father of
Patrick and William.

The inscription lists a number of family members: ALSO THE BODY OF THE SAID/JOHN DALTON WHO DIED/ON THE 20TH DAY OF JANUARY 1867/AGED 74 YEARS

Louis D'Alton 1900-1951

Born in Dublin. He formed his own company for which he wrote and produced plays. His works include *The Man in the Cloak*, *Tomorrow Never Comes*, *Lovers Meeting*, *The Money Doesn't Matter*, *The Devil a Saint Would Be* and two novels. He died in London where his remains were cremated at Marylebone Crematorium, London.

George Darley 1795-1846

Born in Dublin. He left Dublin for London in 1820 in order to become a writer. Although he wrote stories he is better remembered, for his poetry. His best known work is *Nepenthe*. Other works include *The Errors of Ecstasie*, *Sylvia, or the May Queen* and *Thomas à Beckett: A Dramatic Chronicle*. Darley was also a mathematician and published popular textbooks such as *Popular Algebra* and *Familiar*

 Astronomy. He is buried in grave number 6646/36/PS (pathside), Kensal Green Cemetery, London. Go in the main road until you reach, on the left-hand side, a large red granite tomb of His Excellency Ras Messai of Ethiopia. Darley's grave is almost behind this on the far side of the next path. The gravestone lies horizontal on the ground and was covered when I first visited it. The inscription is still legible. GEORGE DARLEY/DIED NOVEMBER 1846/AGED 50 YEARS/POET

Francis Davis 1810-1885

His birthplace and early life are in dispute. He was largely self-taught. He became a muslin weaver and wrote poetry. After a spell in Scotland he returned to Belfast and became editor of the *Belfastman's Journal* and contributed poetry to other journals. He was later appointed an assistant librarian at Queen's College, Belfast. His collected poems were published in 1878.

He is buried in Milltown Cemetery, Belfast. The monument was erected by The Memorial Committee of the Belfast Young Ireland Society "in token of admiration for his brilliant genius and purity of purpose". His monument has the following inscription on the front: THE BELFASTMAN/IN MEMORY OF/FRANCIS DAVIS/IRELAND'S WEAVER POET/BORN 1810 DIED 1885/REQUIESCAT IN PACE/"WITH THE SOUL OF A LOVING AND CHIVALROUS KNIGHT/WHOSE INSTINCT IS GENIUS WHOSE LANGUAGE IS LIGHT/A CHILD OF THE PEOPLE HAS BUILDED A NAME/AND THE WEAVER HAS WOVEN A GARMENT OF FAME"

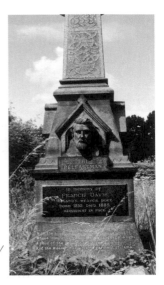

Thomas Davis 1814-1845

Born in Mallow, County Cork. Along with John Blake Dillon and Charles Gavan Duffy he was a founder of the paper the *Nation*, the beginning of Young Ireland. He wrote many ballads, poems and essays which were published in the *Nation*. Among his best known works are *A Nation Once Again*, *My Grave*, *The Sack of Baltimore*, *The Lament for Owen Roe O'Neill* and *The West's Asleep*. His early death of a fever shocked Ireland.

Charles Gavan Duffy wanted him buried in Glasnevin to be with the other patriots but the Davis family wanted him to be buried in Mount Jerome. They also wanted to discourage mourners so the funeral was arranged for eight o'clock in the morning and the route was not made known. It didn't stop thousands from crowding the pavements and jamming the city streets as the funeral made its way to Mount Jerome Cemetery. The procession that walked behind the coffin included the Lord Mayor and other members of Dublin Corporation, members of parliament, representatives of scholarly bodies and various historical and literary societies and the ordinary people of

Dublin. At the graveside were such figures as Samuel Ferguson, John Mitchel, William Wilde, William Carleton, George Petrie, Alfred Webb and John O'Donovan. The remains were originally buried in a temporary vault in the catacombs area before they were transferred to the present site in 1880. *(See map page 252)*. Find Rowan Hamilton *(q.v.)* on the Mount Jerome map and about a dozen more rows further on and to the right, is the grave of Thomas Davis.

The inscription on the cross over the grave reads: THEM ALSO WHICH SLEEP IN JESUS/WILL GOD BRING WITH HIM/IN LOVING MEMORY OF/CHARLOTTE/WIDOW OF JOHN FREDERICK RIDLEY, SURGEON R.A./BORN 6TH NOV 1776. DIED 12. FEB 1844/ALSO OF/THOMAS OSBORNE DAVIS/BARRISTER AT LAW/BORN 24. OCT 1814, DIED 16. SEP 1845/"HE SERVED HIS COUNTRY AND LOVED HIS KIND"/ALSO OF MARY WIDOW OF/JAMES THOMAS DAVIS R.A./DEPUTY INSPECTOR GENERAL OF ORDNANCE HOSPITALS/BORN 14. MARCH 1774, DIED 25. OCTOBER 1859/ALSO OF/JOHN NICOLAS CROFTS ATKINS DAVIS R.A./DEPUTY INSPECTOR GENERAL OF ARMY HOSPITALS/BORN 28. APRIL 1803, DIED 11.DECEMBER 1879/ALSO OF/CHARLOTTE ELIZA/THE BELOVED WIFE OF JAMES ROBERT DAVIS/BORN 21. SEP 1805 DIED 2 NOV 1882/ALSO OF JAMES ROBERT DAVIS SOLICITOR/BORN 11.MAY 1806, DIED 12. MAY 1891

The line under his name comes from *My Grave*, a poem he had written some years earlier: "Be my epitaph writ on my country's mind/ He served his country and loved his kind". The memorial was restored by the Mount Jerome Historical Project in October 1998.

The sculptor John Hogan was commissioned by Sir William Wilde to produce a marble statue of Davis. This work was finished in 1852 and it was erected over his grave. The statue however developed a fault due to weathering and it was brought indoors to the Municipal Gallery in 1934.

Ten years later the statue was transferred to the rotunda of Dublin City Hall where it is still situated and can be viewed by the public. **Annie Hutton** was the fiancée of Thomas Davis and she was reunited with him eight years after his death. She is buried in the family tomb in St George's Cemetery, Whitworth Road, Drumcondra, Dublin. *(See map page 256)*. The cemetery is presently being renovated and Alan Flood brought me to the grave which is situated near the back wall and over to the left. The grave was completely covered with ivy. The inscription for her reads: ANNIE HUTTON/DIED 7TH JUNE 1853 AGED 28 YEARS

Michael Davitt 1846-1906

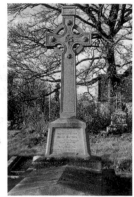

Born in Straide, County Mayo. His family was evicted when he was only four years old and they went to England. Davitt worked in the mills and lost an arm there when he was only eleven years old. He joined the Fenians in 1865 and became an arms (!) organiser for the IRB in England. In 1870, he was sent to jail for fifteen years for arms smuggling but was released after seven years. He founded the Land League in 1879 and spent more time in prison. He was twice elected to Westminster. His works include *Leaves from a Prison Diary*, *The Boer Fight for Freedom* and *The Fall of Feudalism in Ireland.* He died in Dublin from septic poisoning after having two teeth removed. His remains were taken to the church of the Carmelite Fathers in Clarendon Street. There followed a train journey to Foxford and a funeral, followed by a large cortege, to Straide, County Mayo where he had requested to be buried.

A plaque and a high cross mark his grave close to a ruined friary. If you take the path to the community centre, there is a gate into the cemetery. The grave is on the left-hand side of this path.

The inscription on the front of the cross is in Irish. The

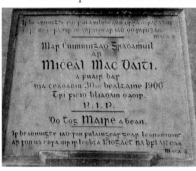

translation reads:
BLESSED ARE THEY WHO HUNGER AND THIRST AFTER JUSTICE FOR THEY SHALL HAVE THEIR FILL. IN LOVING MEMORY OF MICHAEL DAVITT, WHO DEPARTED THIS LIFE ON THE 30TH DAY OF MAY 1906 AT THE AGE OF 60 YEARS. R.I.P. THIS MONUMENT IS ERECTED BY HIS WIFE MARY DAVITT. BLESSED ARE THEY THAT SUFFER PERSECUTION FOR JUSTICE SAKE FOR THEIRS IS THE KINGDOM OF HEAVEN.

Cecil Day-Lewis 1904-1972

Born in Ballintubbert, County Laois. His family moved to England when he was still an infant. He was educated at Oxford. He was Professor of Poetry at Oxford 1951-56 and in 1968 he was appointed Poet Laureate. His work includes *Beechen Vigil and Other Poems*, *From Feathers to Iron*, *A Time to Dance*, *World Over All* and *The Buried Day*. He also wrote 20 crime novels including *The Beast Must Die,* using the name Nicholas Blake.

He is buried in St Michael's Churchyard, Stinsford, Dorset. He wished to be buried as close as possible to Thomas Hardy. Only Hardy's heart is buried in the cemetery, the rest of his remains are buried in Westminster Abbey. Day-Lewis' tombstone has the inscription: CECIL/ DAY LEWIS/ 1904-1972/ POET LAUREATE/ SHALL I BE GONE LONG?/ FOR EVER AND A DAY/ TO WHOM THERE BELONG?/ ASK THE STONE TO SAY/ ASK MY SONG.

Colm De Bhailís 1796-1906

Born in Leitir Mealláin, County Galway. He was a stonemason. His songs were collected and published just before his death. He is buried in the same Oughterard cemetery that James Joyce visited in 1912 to find the grave of Michael Bodkin. Go in the gate and the grave is situated about four rows down and over to the left-hand side. It is almost level with the edge of the right-hand side of the bungalow across the road. The plaque has a line drawing of his face and the following inscription: COLM DE BHAILÍS/ 12-5-1796/ 27-2-1906/ FILE AGUS FEAR CEIRDE/ RIP

Tomás De Bhaldraithe 1916-1996

Born in Dublin. He is best known for his *English-Irish Dictionary*. He also worked on the *Foclóir Gaelige-Béarla* and edited numerous works such as *Nuascéalaíocht*, the stories of Pádraic Ó Conaire and a translation of *Cín Lae Amhlaoibh* which is the diary of an Irish countryman. He is buried in grave number 67 J, St Patrick's, Deansgrange Cemetery, Dublin. *(See map page 250 - the grave is two paths down from Frank O'Connor q.v.).*

Aodh De Blácam 1890-1951

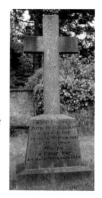

Born in London. He worked as a journalist for various papers including the *Enniscorthy Echo*, the *Irish Times* and the *Irish Press*. He wrote novels, plays, short stories, biographies and historical works. His works include *Towards the Republic*, *Gaelic Literature Surveyed*, *The Black North*, *Songs and Satires*, *From a Gaelic Outpost*, *Holy Romans* and *The Life Story of Wolfe Tone*. He is buried in the grounds of New Mellifont, County Louth. New Mellifont is situated on the right-hand side of the road, coming from the direction of Slane, just

outside the village of the Collon. Drive into the grounds and the cemetery is situated almost opposite the front entrance of the house. Go in the cemetery gate and the grave is almost straight in front at the far end.

Monsignor Pádraig De Brún, 1889-1960

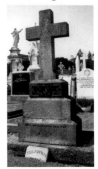

Born in Grangemockler, County Tipperary. He was ordained in 1913. He was Professor of Mathematics at Maynooth, then President of University College Galway and Vice-Chancellor of the National University of Ireland. He is best known for his translations of the classics into Irish. These include *Antigone*, *Oedipus Rex*, *Athalie*, Plutarch's *Lives*, *The Divine Comedy — The Inferno*, as well as Homer's *Odyssey* using Irish rhythms. He is buried in the MacEntee plot in Glasnevin Cemetery, Dublin. *(See map page 246)*.

Teresa Deevy 1894-1963

Born in Waterford. Despite being almost deaf from Ménière's disease, she wrote a number of plays for the Abbey Theatre. She had little success until 1930 but in the next six years she wrote a number of very successful plays. These include *The Reapers*, *Temporal Powers*, *The King of Spain's Daughter*, *Katie Roche* and *The Wild Goose*. After 1937 she concentrated mostly on radio. *Within a Marble City* was considered to be her best piece in this genre. She is buried in the family plot in St Mary's Cemetery, Ballygunner, County Waterford.

Before going to look for the grave, I rang the parish office to try to obtain the location. I was informed that Teresa Deevy's nephew would be coming in later that day and perhaps he might contact me. Sure enough I got a call from Jack Deevy who arranged to meet me at the cemetery the following day and to show me the grave. Despite a horrendous tailback at the bridge which lasted an hour and the rainy conditions, it was a pleasure meeting Jack. He showed me the family plot and recalled memories of his aunt. The personal contact with a family member gives the visitation to the grave an extra dimension.

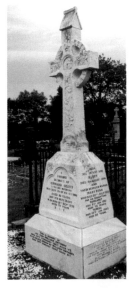

The cemetery can be reached via the Dunmore Road. Follow the signs from the centre of Waterford to Dunmore East and about two kilometres past the Regional Hospital, there is a signpost for Ballygunner church, just before a pub, presently called Orpens. Take the road to the right and the church is a little way up on the left-hand side. Go up the steps and take the first path to the left. There

is a cross in the middle of this path. When you reach the cross, take the path to the left and the Deevy plot is about one third of the way down on the left-hand side and three rows back. It is the only white cross in the area. Teresa's name is located on the right-hand side panel of the cross.

Mrs Mary Delany 1700-1788

Born in Coulston, Wiltshire. She was a letter writer and diarist. She lived in Dublin 1731-1733 and her diary gives a vivid picture of the social scene in 18th century Dublin. After the death of her first husband she married Dr Patrick Delany (see next entry) in 1743 and lived in Dublin until his death in 1768. She then returned to London where she died some years later. Her will stated that as little as possible should be spent on her burial.

She is buried in the church of St James' Piccadilly, London. The tablet is on the left-hand wall almost in line with the altar and was partially hidden behind candelabra when I visited it in 2002. It reads: NEAR THIS PLACE LIE THE REMAINS OF/ MARY DELANY/ DAUGHTER OF BERNARD GRANVILLE ESQR./ AND NIECE OF/ GEORGE GRANVILLE, LORD LANDSDOWNE./ SHE WAS MARRIED FIRST TO/ ALEXANDER PENDARVES OF ROSCROW/ IN THE COUNTY OF CORNWALL, ESQR.:/ AND SECONDLY TO PATRICK DELANY D.D./ DEAN OF DOWN IN IRELAND./ SHE WAS BORN THE XIVTH OF MAY MDCC/ AND DIED THE XVTH OF APRIL, MDCCLXXXVIII/ SHE WAS A LADY/ OF SINGULAR INGENUITY AND POLITENESS/ AND UNAFFECTED PIETY/ THOSE QUALITIES/ HAD ENDEARED HER THROUGH LIFE/ TO MANY NOBLE AND EXCELLENT PERSONS/ AND MADE THE CLOSE OF IT ILLUSTRIOUS/ BY PROCURING FOR HER/ MANY SIGNAL MARKS OF GRACE AND HONOUR/ FROM THEIR MAJESTIES.

Patrick Delany 1685-1768

Born in Dublin. He took holy orders and after his wife's death he married again - the socialite and diarist, Mrs Delany. Through her connections he was appointed to the Deanery of Down. Swift considered him the finest wit in Ireland. He was also a fine preacher and he founded quite a few papers to express his opinions. His writings include *Revelations Examined with Candour*, *Twenty-two Sermons Upon Social Duties* and *Observations upon Lord Orrery's Remarks on the Life and Writings of Dr. Jonathan Swift*. He died in Bath.

He is buried in the grounds of St Mobhi's Church, Church Avenue, Glasnevin, Dublin. *(See map page 256)*. As you go in the main gate Dr Delany's grave is situated on the back wall on the left-hand side of the graveyard. The inscription on the tablet reads: HERE LYETH THE BODY OF PATRICK DELANY D.D./ FORMER SENIOR FELLOW OF/TRINITY COLLEGE DUBLIN/LATE DEAN OF DOWNE/AN ORTHODOX CHRISTIAN BELIEVER/AN EARLY & LEARNED DEFENDER OF REVELATION/A CONSTANT AND ZEALOUS PREACHER OF THE DIVINE LAWS/FOR MORE THAN FIFTY YEARS/AND AN HUMBLE PENITENT/HOPING FOR MERCY IN CHRIST JESUS/HE DIED THE SIXTH DAY OF MAY/ MDCCLXVIII/IN THE EIGHTY FOURTH YEAR OF HIS AGE

Sir John Denham 1615-1669

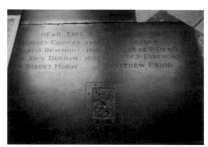

Born in Dublin. He was a poet, playwright and soldier. His works include *The Sophy*, *Cooper's Hill* (his best known work) and *The Anatomy of Gaming*. Dr Johnson described him as one of the fathers of English poetry.

He is buried in Poets' Corner, Westminster Abbey, London. His name is recorded on Abraham Cowley's gravestone, along with seven others on the stone next to Browning. This was recut in 1993.

Thomas Dermody 1775-1802

Born in Ennis, County Clare. He had his first book of poems published when he was just 17 years old. However, his drinking lost him friends and sponsors. He joined the army but when he returned to London, he resumed his old way of life which eventually killed him. He died in poverty in Kent in 1802. His works were collected under the title *The Harp of Erin*.

He is buried in the graveyard of St Mary the Virgin in Lewisham, London. Take the Docklands line to Lewisham. The church is on the main street beyond the library and on the other side of the road. The

grave is to the left-hand side of the church. There is a small enclosed area with a centre circle. The grave is the only altar type tomb around this circle. The inscription according to Kirby and Duncan, *The Monumental Inscriptions of Saint Mary Lewisham*, is slightly different from that quoted by McDonagh in *Irish Graves in England*. The lines were written by Dermody. The inscription read: IN MEMORY OF/THOMAS DERMODY/WHO DIED 15 JULY 1802/AGED 28 YEARS/NO TITLED BIRTH HADST THOU TO BOAST/SON OF THE DESERT, FORTUNE'S CHILD,/YET NOT BY FROWNING FORTUNE CROSS'D/THE MUSES ON THY CRADLE SMIL'D./NOW A COLD TENANT DOST THOU LIE/OF THIS DARK CELL, ALL HUSHED HIS SONG,/WHILE FRIENDSHIP BENDS WITH STREAMING EYE,/AS BY THY GRAVE SHE WENDS ALONG,/ON THY COLD CLAY LETS FALL A HOLY TEAR,/AND CRIES, THOUGH MUTE, THERE IS A POET HERE!/RENOVATED, 1848/BY SOME ADMIRERS OF/HIS GENIUS/RESTORED, NOV 1886/BY SUBSCRIPTION.

Today the inscription is almost totally gone. It is only possible to barely make out the first two lines. As far as I could ascertain there was no acknowledgement either locally or in Ireland of the 200th anniversary of his death. I tried to organise an event in November 2002 at his graveside but no one seemed very interested so I made do with an informal ceremony attended by a couple of local people whom I met by chance on the day.

Sinéad De Valera 1878-1975

Born in Balbriggan, County Dublin. She was a teacher who taught Irish to Éamon and later married him. She translated fairy stories for children from Irish into English and wrote over a dozen plays as well as poems for children. Her works include *Fairy Tales of Ireland* and *More Irish Fairy Tales*. She is buried in Glasnevin Cemetery, Dublin, along with her husband Éamon. (*See map page 246*)

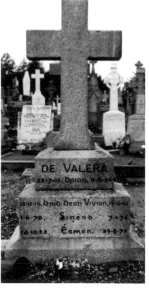

The inscription reads: DE VALERA/25-7-15 BRIAN 9-2-36/15-12-10 BRÍD BEAN VIVIAN 19-6-51/1-6-78 SINÉAD 7-1-75/14-10-82 ÉAMON 29-8-75

Also buried here is **Ruaidhrí De Valera 1916-1978** who was Professor of Celtic Archaeology in UCD. His most important work, with Seán Ó Nualláin, was the four volume *Survey of the Megalithic Tombs of Ireland*.

Aubrey De Vere 1814-1902

Born in Curragh Chase, County Limerick. He became a Catholic in 1851 and many of his poems were devoted to religious themes.

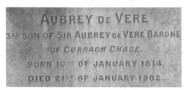

Probably his most successful poem was *Inisfail*. Other works include *The Waldenses with Other Poems*, *English Misrule and Irish Misdeeds*, *The Legends of St Patrick*, *Critical Essays*, *May Carols* and *Recollections*. His brother Stephen was instrumental in drawing attention to the terrible conditions endured during the famine and on board the famine ships. Aubrey assisted his brother in famine relief schemes.

He is buried in the graveyard of St Mary's Church of Ireland, Askeaton, County Limerick. The grave has a Celtic cross and it is the sixth plot on the left-hand side as you go in the gate.

Denis Devlin 1908-1959

Born in Greenock, Scotland. His family returned to Ireland in 1918. After attending UCD he became a diplomat and served in many countries. He was appointed Ambassador to Italy in 1958.

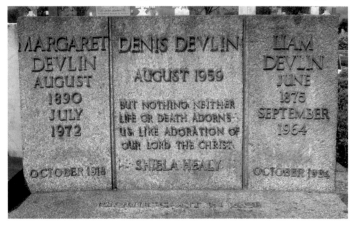

He wrote poetry throughout his life and his works include *Intercessions*, *Lough Derg*, *The Heavenly Foreigner* and *Memoirs of a Turcoman Diplomat*.

He is buried in grave number 189, Row I, St Patrick's Section, Deansgrange Cemetery, Dublin. *(See map page 250)*

John Devoy 1842-1928

Born in Kill, County Kildare. He was a member of the Fenian movement in Ireland in the 1860s. He was arrested in 1866 and sentenced to fifteen years penal servitude but was released after five years on condition he moved abroad. He emigrated to America where he became a leading light in Clan na Gael. On behalf of the Fenian Brotherhood he commissioned the first modern submarine from John Philip Holland. *Recollections of an*

Irish Rebel was published after his death. He is buried in Glasnevin Cemetery, Dublin. *(See map page 246 – the grave is on the path edge of the Republican Plot)*
The inscription on the front of the cross reads: JOHN DEVOY/ 1842-1928/ FENIAN/ A NAOM MHUIRE A MHÁTHAIR DÉ/ GUIDH ORAINN and on the left side as you look at it, is the word REBEL and on the right side is the word PATRIOT. On the back is the inscription: JOHN DEVOY/ THE GREATEST OF THE FENIANS/ P.H. PEARSE

Eilís Dillon 1920-1994

Born in Galway. She was a writer of children's stories, at first in Irish and then in English. These include *Children of Bach*, *The Island of Horses*, *The House on the Shore*, *The Cruise of the Santa Maria*, *The Singing Cave* and *The Island of Ghosts*. She also wrote adult books including *Across the Bitter Sea*, *Wild Geese*, *Citizen Burke* and *Blood Relations*.

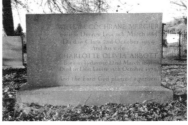

She is buried in the Mercier family plot in St Brigid's churchyard, Clara, County Offaly. The grave is located on the right-hand side of the path as you enter the churchyard. Neither her name nor that of her husband, Vivian Mercier, is mentioned on the stone which is by Séamus Murphy.

Michael Doheny 1805-1863

Born near Fethard, County Tipperary. He was one of the founders of the Fenian Brotherhood in America. He wrote *The*

Felon's Track, the poem *A Cushla Gal Mo Chree* and the song *The Shan Van Vocht*. He was buried after a huge public funeral, in Section 4, Laurel Hill Boulevard, First Calvary Cemetery, Woodside, New York. His grave was unmarked until 7th October 1989 when New York Tipperary-men's N & B Association erected a monument to him. The photo shows the unveiling of the gravestone.

Edward Dowden 1843-1913

Born in Cork. He became Professor of English Literature in Trinity College Dublin 1867. He wrote several important books on Shakespeare including *Shakespeare, A Critical Study of His Mind and Art*. Other works include biographies of Southey, Shelley, Browning and Montaigne, volumes of poems and a *History of French Literature*. He is buried in grave number C5 14017, Mount Jerome Cemetery, Dublin. *(See map page 252 – the grave is two rows back from the road)*. The inscription reads: EDWARD DOWDEN/BORN MAY 3RD 1843/DIED APRIL 3RD 1913/AND HIS WIFE/ELIZABETH D DOWDEN/DAUGHTER OF VERY REV JOHN WEST/DEAN OF ST PATRICKS/DIED MAY 2ND 1932/NEAR THIS GRAVE LIES THE BODY OF/MARY CHERISHED FIRST WIFE OF/EDWARD DOWDEN

His second wife **Elizabeth Dickinson West c. 1840-1932**, wrote under the pseudonym of E.D.W. Her works include *Verses* and *Verses, Part 2*.

Lynn C. Doyle 1873-1961

Born Leslie Montgomery in Downpatrick, County Down. His working life was spent in banking. He wrote novels, short stories, poems, plays, an autobiography and he earned a reputation as a broadcaster. His writings include the Ballygullion series of books, an autobiography *An Ulster Childhood* and the plays *Love and Land*, *The Lilac Ribbon* and *Turncoats*. He died in Malahide, County Dublin. On the subject of death he is quoted as saying "They say we'll be glad to die. I'm not too sure. No doubt there's rest in the grave but the craic is poor". This was one of the most difficult of all the graves to find.

The death notices stated the service and funeral were private and no indication of the burial place was given. I rang every major cemetery in Dublin and Belfast, examined hundreds of gravestones in Malahide and

contacted publishers, libraries and even old neighbours. Eventually one of his neighbours rang me to say that Robert Turner, the verger of St Andrew's, Malahide, had confirmed that Lynn Doyle was buried in an unmarked grave in St Andrew's between the Burrows' and Evans' plots. When I went back to the cemetery I met Robert who had looked after the cemetery for 47 years and had been at the funeral. He showed me the location of the grave. *(See map page 256)*.

William Drennan 1754-1820

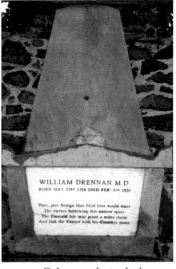

Born in Belfast. He studied medicine in Edinburgh and after graduation, he practised in Newry. In 1791 he went to live in Dublin. He was one of the founders of the Society of United Irishmen and was it's first secretary and later it's president. After standing trial for seditious libel in 1794, he took little further part in the movement. He was one of the founders of the Royal Belfast Academical Institution. He wrote a number of poems and ballads, perhaps the most famous being *When Erin First Rose*. This was the first time that Ireland was referred to as the Emerald Isle, the appropriate lines being inscribed on his gravestone. Other works include *Fugitive Pieces* and *The Wake of William Orr*.

He is buried in Clifton Street Cemetery, Belfast. The grave number is UWL 48. He requested that his coffin should go past the school he helped found and "let six poor Protestants and six poor Catholics get a guinea piece for carriage of me and a priest and a dissenting clergyman with any other friends that chuse". The grave is situated at the furthest wall from the entrance. The inscription reads: WILLIAM DRENNAN M.D./BORN MAY 23RD 1754 DIED FEBRUARY 5TH 1820/"PURE, JUST, BENIGN THUS FILIAL/LOVE WOULD TRACE, THE VIRTUES/HALLOWING THIS NARROW SPACE/THE EMERALD ISLE MAY GRANT A/WIDER CLAIM AND LINK THE/PATRIOT WITH HIS COUNTRY'S NAME".

Clifton Street Cemetery is nearly always locked and I had tried on three occasions without success to find the person holding the key. On a very wet and windy Monday I called at the local surgery where I was told that they no longer had the key but they named a local man who would have one. He wore a grey coat and was always outside in the street. I expressed a degree of scepticism as it was raining quite heavily, but they assured me he would be there. After about ten minutes I spotted him but he said it was too much trouble keeping the key and he gave it up. He directed me to a community centre but I had no luck there either

and I went back to find the man in the grey coat. He said he couldn't help but after some time explaining what I was doing, he gave me the name of a woman who kept the key and pointed me to the block of flats where she lived.

I knocked on every door in the complex but got no reply despite the noise of televisions in the background. There was no one else about as it was still raining heavily so after hanging around for another ten minutes I decided to give up. A woman came around the corner but claimed she didn't know the woman I was looking for. We talked a bit and I explained what I was doing and eventually she led me back into the same block of flats and stopped at a door. The woman I was looking for came out and after I told her the purpose of my visit she gave me the key. The first lady asked me if I had a guidebook. When I replied in the negative, she went upstairs to the flat above and gave me a signed copy as she had two of them.

There was no let up in the rain or wind however and I struggled to hold the umbrella while I consulted the guidebook and took my photographs.

Frank Duff 1889-1980

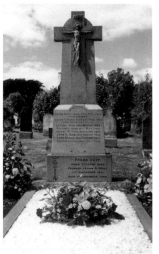

Born in Dublin. He was the founder of the Legion of Mary in 1921. His written works – *The Legion of Mary Handbook* and *The Spirit of the Legion of Mary* – influenced thousands of people all over the world. He is buried in Glasnevin Cemetery, Dublin. *(See map page 246 – the grave is about eleven rows behind that of Brendan Behan (q.v.) and facing away)*. The inscription for Frank Duff, beside the symbol of the Legion of Mary, reads: FRANK DUFF/ BORN 7TH JUNE 1889/ FOUNDED LEGION OF MARY/ 7TH SEPTEMBER 1921/ DIED 7TH NOVEMBER 1980

I have visited the graves of almost everybody mentioned in this book but one of the few funerals I have attended was the one for Frank Duff. In the huge crowd overflowing onto the street I came across my mother, a dedicated Legionary.

Sir Charles Gavan Duffy 1816-1903

Born in Monaghan. He was one of the founders of the *Nation* along with Thomas Davis and John Blake Dillon. In 1843 he was sent to prison along with Daniel O'Connell. He became involved with the Young Irelanders and further imprisonment followed and after 1849 he decided that the policy of force had failed. Disillusionment over the next few years saw him quit Ireland for Australia in 1855 where he quickly involved himself in political life. After holding several ministerial posts, he became Prime

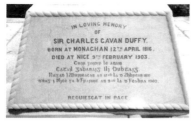

Minister of Victoria in 1871. His published works include *The Ballad Poetry of Ireland*, *Young Ireland A Fragment of Irish History 1840-50*, *Four Years of Irish History 1845-49*, *My Life in Two Hemispheres*, *A Bird's Eye View of Irish History* and a biography of Thomas Davis. He died in Nice. A committee was set up to bring the remains back to Ireland where a public funeral was held and he was laid to rest in Glasnevin Cemetery, Dublin. *(See map page 246 - his tall Celtic cross is on the path edge of the O'Connell circle)*. The inscription in English (and Irish) reads: IN LOVING MEMORY/ OF/ SIR CHARLES GAVAN DUFFY/ BORN AT MONAGHAN 12TH APRIL 1816/ DIED AT NICE 9TH FEBRUARY 1903/ REQUIESCAT IN PACE

Seán Dunne 1956-1995

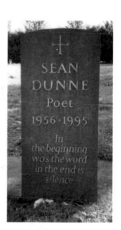

Born in Waterford. He worked as a journalist and was literary editor of the *Cork Examiner*. He wrote poetry and spiritual books, and edited anthologies. His works include *Against the Storm*, *The Sheltered Nest*, *Time and the Island*, *In My Father's House*, *Poets of Munster* and *Something Understood: A Spiritual Anthology*. He is buried in St Gobnait's Cemetery, Ballyvourney, County Cork. There are two cemeteries here and he is buried in the newer one. Go in the gate and take the first path to the right. The grave is on the left-hand side near the back.

Lord Dunsany (Edward John Plunkett) 1878-1957

Born in London. He wrote novels, short stories, poems, plays and an autobiography. He was associated with the Irish Revival. His

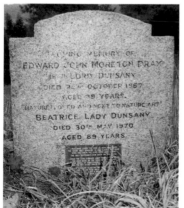

works include *The King of Elfland's Daughter*, *The Curse of the Wise Woman*, *Patches of Sunlight*, *A Dreamer's Tales*, *Five Plays*, *Time and the Gods*, *Tales of Wonder* and the series on *Mister Joseph Jorkens*. He is buried in the grounds of St Peter and St Paul Parish Church in Shoreham, Kent.

I arrived at the church at 7.30 one glorious summer evening having already visited the graves of Paul Vincent Carroll and Charles Read earlier in the day. I was looking for a hat trick but the

65

size of the graveyard and the state of some of the stones made that outcome unlikely. Perhaps Lord Dunsany did not want me to go away disappointed from a place he loved, for I found the grave almost immediately. Go up the path and stand in front of the church. The grave is about 30 paces to the left of the church and about four metres back towards the road.

The inscription reads: IN/ LOVING MEMORY OF/ EDWARD JOHN MORETON DRAX/ 18TH LORD DUNSANY/ DIED 25TH OCTOBER 1957/ AGED 79 YEARS/ NATURE I LOVED AND NEXT TO NATURE ART/ BEATRICE LADY DUNSANY/ DIED 30TH MAY 1970/ AGED 89 YEARS

A plaque underneath reads: I, THAT HAVE LOVED THE SUN, LIE HERE AND LOVED/ THE GREAT GREY SHADOWS OF THE CLOUDS THAT PASS/ OVER THE EARTH. THE SOFT CRISP ENGLISH AIR,/ THE GREY SEPTEMBER DEW THICK ON THE GRASS./ I LOVED THE COOL STRANGE LIGHT THE RAINBOW GIVES./ THE DEEP NOTE OF THE BEES UP IN THE LIME./ THE SMELL OF HONEYSUCKLE AND SWEET BRIAR./ AND THE HOT SCENT, UNDER MY FEET OF THYME./ LATE SUNLIGHT SLANTING ON THE IRISH PLAIN/ THE LINE OF LOW BLUE HILLS AGAINST THE SKY/ I LOVED WHILE SIGHT AND MEMORY WERE MINE/ OTHERS WILL LOVE THEM STILL, WHILE HERE I LIE.

Maria Edgeworth 1767-1849

Born in Black Bourton, Oxfordshire. Her early works on education and children's stories were written in collaboration with her father. Her first and most famous novel was *Castle Rackrent* which brought her immediate success. Further works were also well received. These include *Belinda*, *Tales of Fashionable Life*, *Helen*, *Patronage*, *The Absentee* and *Ormond*. *Castle Rackrent* was a very influential novel not only in England but beyond, and authors like Walter Scott acknowledged the debt

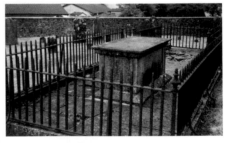

they owed to Edgeworth. She is buried in the family vault, St John's Church of Ireland, Edgeworthstown, County Longford. The vault is situated on the left-hand side of the church, close to the wall. See next entry.

Richard Lovell Edgeworth 1744-1817

Born in Bath. He was a landlord and inventor as well as being an author and promoter of educational ideas well before their time. These were written in collaboration with his daughter, Maria and include *Practical Education* and *Essays on Practical Education*. He greatly influenced and contributed to Maria's writing and his *Memoirs* were completed by her after his death.

He is buried in the family vault, St John's Church of Ireland, Edgeworthstown, County Longford. The church is located just

before the end of the town, coming from Dublin direction. It is on the right-hand side and off the main road. When I visited the church an elderly man was cutting the grass along with two young men. He asked me if he could be of assistance and he then proceeded to show me round the church and the grave. He told me that there were few clergymen between Dublin and Galway, and with the help of his grandsons he kept the grounds neat and tidy in the hope that a passing clergyman without a parish might see what a fine parish it was and be tempted to stay.

Francis A. Fahy 1854-1935

Born near Kinvarra, County Galway. After his education he went to England where he joined the Civil Service. He took an active role in Irish literary and language groups making many contributions to various periodicals. He wrote many songs including *The Ould Plaid Shawl*, *The O'Donovans*, *The Queen of Connemara* and *Haste to the Wedding*. He died in London and is buried in Putney Vale Cemetery, London. There is an active society devoted to him.

Take the metro to Putney Bridge station and then take bus number 85 or 265 to Putney Vale Cemetery. The bus journey takes about 25 minutes. Go in the pedestrian entrance on the Kingston road, go past the chapel and follow the road. Just past Boulter's Path on the right-hand side is Section M and Fahy's grave is number 329. Go down Boulter's Path and turn left and the grave is situated on the second row about a quarter way down. The inscription reads: IN LOVING MEMORY OF/ FRANCIS ARTHUR FAHY/ IRISH POET AND SONGWRITER/ DIED 1 APRIL 1935/ AND OF HIS WIFE/ AGNES MARY FAHY/ DIED 3 JUNE 1945/ R.I.P.

Padraic Fallon 1905-1974

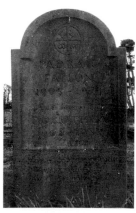

Born in Athenry, County Galway. He worked in Customs and Excise and although he wrote much and contributed to various journals, his work was not collected and published as *Collected Poems* until after his death. He wrote 17 plays for radio and a couple of stage plays. These include *Diarmuid and Gráinne*, *The Vision of Mac Conglinne*, *The Seventh Step* and *Sweet Love Till Morn*. He died in Kent and is buried in Kinsale, County Cork. The cemetery is on the road to Charles Fort just before you come into Kinsale. To find the grave, go in the

main gate, turn immediately left by the wall and go eight rows down and four plots in to the right. The inscription reads: PADRAIC/ FALLON/ 1905-1974/ AND HIS WIFE/ DOROTHEA/ 1908-1985/ I HAVE MADE A MAGIC STUDY/ OF THE GOOD THING/ THAT ELUDES NOBODY

George Farquhar c1678-1707

Born in Derry. He took up acting but gave it up after a stage accident and went to London. His first play, a comedy, was called *Love and a Bottle* and was quite successful as was his next play, *The Constant Couple*. Other works include *Sir Harry Wildair*, *The Inconstant*, *The Twin Rivals* and *The Stage Coach*. He joined the army in 1704, leaving after two years. *The Recruiting Officer* is based on his experiences but was not well received. His last play *The Beaux Stratagem* is his best known work but he didn't live to see its success.

He was buried in St Martin-in-the-Fields, London. The National Gallery now stands on the site of the graveyard, which was attached to the church, but all traces of the graveyard are gone. The whereabouts of Farquhar's remains are unknown.

J(ames) G(ordon) Farrell 1935-1979

Born in Liverpool. He was a teacher for a number of years in France. His works include *A Man from Elsewhere, Troubles, The Siege of Krishnapur* (which won the Booker Prize), *The Singapore Grip* and *The Hill Station*. He died in a drowning accident in County Cork. He is buried in St James' Church of Ireland, Durrus, County Cork. The grave is situated close to the roadside wall, just as the road bends on the Durrus side of the churchyard.

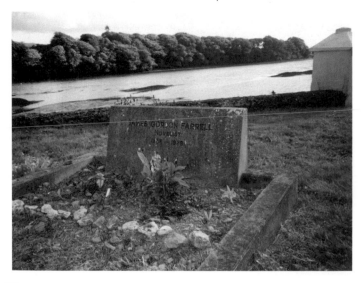

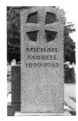

Michael Farrell 1899-1962

Born in Carlow. He is known for his autobiographical novel *Thy Tears Might Cease*. It was edited by Monk Gibbon and was published after Farrell's death. It became a best seller. He is buried in grave number 15G2, St Mary's, Deansgrange Cemetery, Dublin. *(See map page 250).*

Piaras Feiritéar c1600-1653

He was one of the four Kerry poets. He was hanged in Killarney for his part in the 1641 rebellion and for subsequent activities. He is best known for his love poetry, although not many of his poems survive. These were published in 1903 under the title *Dánta Phiarais Feiritéir.*

According to tradition he is buried somewhere in or near Muckross Abbey, Killarney, County Kerry.

Sir Samuel Ferguson 1810-1886

Born in Belfast. He was called to the Bar in 1838 and became a QC in 1859. He was appointed Deputy Keeper of the Public Records of Ireland in 1867. He was a poet and antiquary. His interest in antiquities led to him writing many papers for the Royal Irish Academy and he became President of that society in

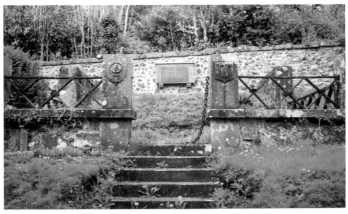

1882. His works include *Ogham Inscriptions in Ireland, Wales and Scotland* and his poems include *Congal, Aideen's Grave, The Cromlech of Howth, The Tain-Quest* and *The Death of Dermid.* His songs include *The Coolin* and *The Lark in the Clear Air.*

He was buried, at his wish, in the Churchyard of St John's, Donegore, five kilometres from Antrim. Follow the path to the church. Go down the steps and veer right to the side of the church. The grave is about half way down on the right, against the wall. It is a large plot with a low wall and it has an opening with a

chain across it. There is a plaque on the wall opposite. It reads:
SACRED TO THE BELOVED MEMORY/OF/SIR SAMUEL FERGUSON
KNT Q.C. LL.D./WHO DIED 9TH AUGUST 1886 AGED 76 YEARS/
PRESIDENT OF THE ROYAL IRISH ACADEMY/DEPUTY KEEPER OF
THE PUBLIC RECORDS OF IRELAND/AND OF HIS WIFE MARY
CATHERINE/WHO DIED 5TH MARCH 1905 AGED 81 YEARS

Percy Fitzgerald 1834-1925

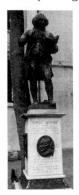

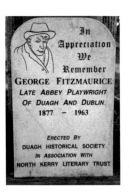

Born in Fane Valley, County
Louth. He was a painter and
sculptor as well as a writer. He
wrote over 200 books including
*Bella Donna or The Cross Before the
Name* and biographies on Irving,
Sterne, Garrick, Johnson and
Lamb. His sculpture lasted a
little longer than his books and
these include a statue of Dr
Johnson in the Strand, at St Clement Danes church
and a statue of Boswell at Lichfield. He is buried in
vault 38 in the O'Connell Circle in Glasnevin
Cemetery, Dublin. *(See map page 246)*.

George Fitzmaurice 1877-1963

Born near Listowel, County Kerry. He
worked in the Civil Service for most of his
working life. He wrote 17 plays in all and
his works include *The Country Dressmaker*, *The
Pie-Dish*, *The Magic Glasses*, *The Dandy Dolls*, *The
Moonlighter* and *The Crows of Mephistopheles and
Other Stories*. His later plays were a bit too
experimental for his audiences and he
became disillusioned and died a recluse.
He is buried in Mount Jerome Cemetery,
Dublin. *(See map page 252 – the grave is three
rows in from the road)*.

William John Fitzpatrick 1830-1895

Born in Dublin. He was a
biographer who wrote the lives
of Bishop Doyle, The Sham
Squire, Lady Morgan, Charles
Lever and others. He also wrote
Ireland Before the Union, *Secret Service
Under Pitt* and *A History of the Catholic
Cemeteries of Dublin*. He is buried in
Glasnevin Cemetery, Dublin.
(See map page 246).

 Just past the Atkinson and
Gilbert crosses there is a path
and the Fitzpatrick sarcophagus
is about 20 rows in and is

covered with a large tree.

The inscription reads: HERE REST THE REMAINS OF/ WILLIAM JOHN FITZPATRICK FSA LL.D/BIOGRAPHER AND HISTORIAN/BORN AUGUST 31ST 1830 DIED DECEMBER 24TH 1895/HE LED A LIFE OF PIETY AND GENTLENESS/HE WAS BY PRECEPT AND EXAMPLE A MODEL FATHER AND TRUE FRIEND/OF YOUR CHARITY PRAY FOR THE REPOSE OF HIS SOUL/AND ALSO OF HIS WIFE AND CHILDREN HERE INTERRED/PAULINE, LOFTUS AND IRENE/R.I.P.

Robin Ernest William Flower 1881-1946

Born near Leeds, England. He was a Deputy Keeper of Manuscripts in the British Museum. He encouraged islanders from the Blaskets to record their memories and stories and published these as well as poems and translations. He wrote several collections of poems himself and his own memoir is called *The Western Island*.

He was cremated and as MacConghail reported in his book on the Blaskets, his ashes were scattered from the great prehistoric fort site, An Dún, which was his favourite place on the island. The island community attended the ceremony.

Donal Foley 1922-1981

Born in Ring, County Waterford. He was a journalist with the *Irish Times*. His weekly column *Man Bites Dog* was extremely popular and was published annually as a book. He also wrote an autobiography called *Three Villages*. He is buried in grave number 46-J, St Anne's Section, Deansgrange Cemetery, Dublin. (*See map page 250*). The grave is unmarked but is covered with small white stones and surrounded by kerbing.

John Frazer c. 1804-1852

Born in Birr, County Offaly. The cemetery records note his age at death as 48 years old. He was a cabinetmaker by trade. He wrote poetry for the *Nation*, the *Irish Felon* and other journals, using the name of Jean de Jean or De Jean Frazer or J de Jean. He died poor and was buried in Glasnevin Cemetery, Dublin. (*See map page 246*). The records show that the grave was used subsequently for another burial. It is not marked by any stone. The photograph shows the general area where he is buried.

William Percy French 1854-1920

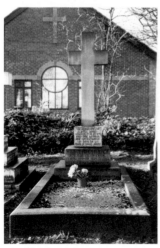

Born in Cloonyquinn, County Roscommon. He began work as a civil engineer but after being laid off he edited a comic journal and then became a full-time entertainer using his own material. His works include *The First Lord Liftinant and Other Tales*, *The Irish Girl* and the songs *Phil the Fluther's Ball*, *Come back Paddy Reilly to Ballyjamesduff*, *The Mountains of Mourne*, *Are You Right There Michael?* and *Slattery's Mounted Fut* among many. He was also a painter. His funeral service was carried out by his friend and collaborator Dr Collison who had frequently gone on tour with him. Dr Collison obviously wished to accompany Percy on his very last tour, for he himself died a few days later.

He is buried in St Luke's Protestant churchyard in Formby, England. There is a fairly regular train service from Liverpool. Coming out of the station turn right and keep going until you come to the church on the right-hand side. The grave is on the left-hand side almost opposite the door and against the wall. The upper inscription reads: IN MEMORY OF/A WELL LOVED/ SONGWRITER, POET/PAINTER, AUTHOR/AND ENTERTAINER/AR DHEIS DÉ GO/RAIBH A ANAM. AMEN

The middle inscription reads: WILLIAM PERCY FRENCH/ BORN AT CLOONIQUIN/CO. ROSCOMMON. MAY 1ST 1854/DIED AT FORMBY. JAN 24TH 1920

The bottom inscription is from a favourite hymn *Lead Kindly Light* - SO LONG THY POWER HATH BLEST ME, SURE IT STILL/ WILL LEAD ME ON/O'ER MOON AND FEN O'ER CRAG AND TORRENT TILL/THE NIGHT IS GONE

There is a further inscription that covers both sides of the granite plinth. It reads: ON 24TH JAN 1970/THE 50TH/ ANNIVERSARY/ OF THE DEATH OF/PERCY FRENCH/THIS PLINTH OF/MOURNE GRANITE/WAS PLACED BY/ THE IRISH CENTRE/ OF LIVERPOOL/ ON BEHALF OF A/ GRATEFUL NATION

Ethel French was the wife of Percy French. She is buried in Mount Jerome Cemetery, Dublin. *(See map page 252 - the grave is situated about 23 rows before the wall).* The gravestone was there in the summer of 2001 but had disappeared by November 2001. The inscription read: ETHEL/THE BELOVED WIFE OF/W. PERCY FRENCH/WHO DIED JUNE 29TH 1891/REST- SLEEP CAME EARLY BETTER SO/SINCE WAKING MEANS BUT WEEPING/AND WE WHO STILL THE

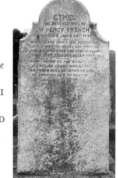

STRUGGLE KNOW/ HAVE ENVIED THEE THY SLEEPING/ REST-
NEVER TO THE SILENT SOD/ A KINDLIER HEART WAS GIVEN/ NO
PURER SOUL RETURNS TO GOD/ NO SWEETER LIFE TO HEAVEN

Thomas Furlong 1794-1827

Born in Scarawalsh, County Wexford.
He translated poetry from the Irish
and wrote mostly in English. His
works include *The Misanthrope with Other
Poems*, *The Doom of Derenzie* and *The Plagues
of Ireland*. He is buried in St John the
Baptist Church of Ireland, Church
Road, Drumcondra, Dublin. *(See map
page 256)*. Walk up the path and turn
right. Looking straight ahead towards
the wall there is a pyramid structure
on a large square base which was
erected to his memory.

The inscription reads: TO THE MEMORY OF/ THOMAS
FURLONG/ IN WHOM THE PURIST PRINCIPLES OF/ PATRIOTISM
AND HONOUR/ WERE COMBINED WITH/ SUPERIOR POETIC
GENIUS/ THIS MEMORIAL OF FRIENDSHIP/ WAS ERECTED BY
THOSE WHO VALUED AND ADMIRED/ HIS VARIOUS TALENTS
PUBLIC INTEGRITY/ AND PRIVATE WORTH/ HE DIED 25TH JULY
1827 AGED 33 YEARS/ MAY HE REST IN PEACE

Patrick (Paddy the Cope) Gallagher 1873-1966

Born in Cleendra,
County Donegal. He
established the
Templecrone Co-
operative Society,
despite the opposition
of local merchants.
The success of the
society led to other
endeavours. He wrote
the story of his life, *My
Story*, which was
published in 1939. He
is buried in the
cemetery adjoining
what is now the library in Dungloe, County Donegal. It is a large
cemetery and is full of Gallaghers, nearly all of whom are called
"The Cope". Go in the main entrance from the road, go left
around the building and follow the path until it straightens out.
The grave is three rows down and three rows to the right. The
location was given to me by Packie Feary from behind the bar of
Patrick, Johnny, Sally's. He said the Copeman was well ahead of
his time and had done a great job for the area and he proceeded
to list all of Paddy the Cope's achievements.

Agnes Galt died 1834

She was the eldest sister of Robert Burns. A memorial was erected as a tribute to Robert Burns in the grounds of St Nicholas' Church of Ireland, Dundalk, County Louth. The memorial has the following inscription: AS A TRIBUTE/TO THE GENIUS OF/ROBERT BURNS/THE NATIONAL BARD OF SCOTLAND/AND IN RESPECT FOR THE MEMORY/OF HIS ELDEST SISTER/AGNES/WHOSE MORTAL REMAINS ARE/DEPOSITED IN THIS CHURCH-YARD/ERECTED/BY THE CONTRIBUTIONS OF THE/POETS NUMEROUS ADMIRERS/IN DUNDALK AND ITS VICINITY/25TH JANUARY 1839/TIME BUT THE IMPRESSION STRONGER MAKES/AS STREAMS THEIR CHANNELS DEEPER WEAR

There is another inscription on the other side. It reads: SACRED/TO THE MEMORY OF/AGNES BURNS/ELDEST SISTER OF ROBERT BURNS/WHO DEPARTED THIS LIFE AT/STEPHENSTOWN ON THE 17TH OCTOBER 1834/AGED 73 YEARS/HER MORTAL REMAINS LIE INTERRED/IN THE SOUTH EAST CORNER OF/THIS CHURCHYARD

Agnes' grave is beside the sexton's house at the rear. Go in the

gate on the main road and the grave is in the bottom right-hand corner. It is a table top tomb and has the following inscription: UNDERNEATH/LIE THE REMAINS OF/AGNES BURNS/SISTER OF/ROBERT BURNS AYRSHIRE POET/(SEE MONUMENT)/25TH JANUARY AD 1859

The gates to the churchyard are almost always locked. However the grave can be easily viewed from the road at the back. Go round the church and the grave is just inside the railings where they adjoin the house. Local legend has it that the sexton used to have his boiled eggs every morning sitting on this tomb.

William Monk Gibbon 1896-1987

Born in Dublin. He worked as a teacher. He wrote poetry, travel books, biography and autobiography. He won the silver medal for poetry at the Tailteann Games in 1928. His works include *For Daws to Peck At*, *This Insubstantial Pageant*, *The Velvet Bow*, six volumes of autobiography including *The Seals* and *Mount Ida*, and travel

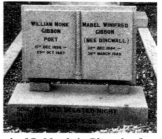

books. He is buried in the churchyard of St Naithi's Church of Ireland, Dundrum, County Dublin. *(See map page 256. The grave is on the left-hand side as you go in the gate).*

The inscription on the front of the grave reads: SING IN THAT SCENTED NIGHT/ INVISIBLY/ AND AS YOU ALWAYS DO/ SING CHEERFULLY

Sir John Gilbert 1829-1898

Born in Dublin. He was librarian of the Royal Irish Academy for 30 years and his works include *A History of the City of Dublin*, *History of the Viceroys of Ireland* and *The Celtic Records and Historical Literature of Ireland*. His library was purchased by Dublin Corporation. He is buried in Glasnevin Cemetery, Dublin. *(See map page 246)*. His wife Rosa Mulholland Gilbert is buried with him. See next entry.

Rosa Mulholland Gilbert 1841-1921

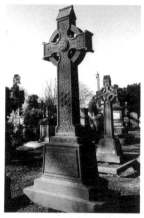

Born in Belfast. She was encouraged to write by Charles Dickens who published her early stories in the periodical *Household Words*. She was a prolific writer who achieved great popularity. Her works include *The Daughter in Possession*, *A Fair Emigrant*, *The Wild Birds of Killeevy* and *Marcella Grace*. Her poetry was published in three volumes. She is buried with her husband Sir John Gilbert whose biography she wrote after his death. The inscription on the cross reads: PRAY FOR THE SOUL OF/ SIR JOHN J GILBERT LLD F.S.A./ VICE PRESIDENT OF THE ROYAL IRISH ACADEMY/ IRISH HISTORIAN/ BORN 23RD JANUARY 1829 DIED 23RD MAY 1898/ HONOURED AND BELOVED/ HIS LIFE WAS DEVOTED TO IRELAND/ IN THE RESEARCH FOR TRUTH IN HER HISTORY/ AND THE DEFENCE OF THE CATHOLIC FAITH/ HER LIGHT IN DARKEST DAYS/ ROSA MULHOLLAND GILBERT/ WIFE OF THE ABOVE DIED AT VILLA NOVA/ BLACKROCK CO DUBLIN 21ST APRIL 1921/ BLESSED ARE THEY THAT HUNGER AND THIRST AFTER JUSTICE/ FOR THEY SHALL HAVE THEIR FILL/ ST MATTHEW CHAPTER V VERSE VI

Patrick Sarsfield Gilmore 1829-1892

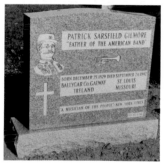

Born in County Dublin. He emigrated to America where he fought in the American Civil War. He was the author of *When Johnny Comes Marching Home Again* and other pieces. He is buried in Old Calvary Cemetery, Long Island, New York. His grave was unmarked until 1992 when the Patrick Sarsfield Gilmore Society unveiled a stone to him.

Tom Glynn died 1969

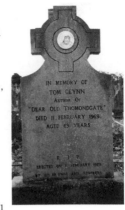

"You can't go to Limerick" I was told "and
not include the author of *Dear Old
Thomondgate*. Tom Glynn was a native of
Thomondgate and besides his best known
ballad, his other works include *My Dog Bran*,
The Road to Killaloe and *Where the Streams of
Meelick Flow*. He is buried in Mount St
Laurence Cemetery, Limerick. Take the
main path from the gate and the grave is
about 6 rows before the first main
intersection and about 27 rows in.

The inscription on the stone reads:
In Memory Of/Tom Glynn/ Author
Of/"Dear Old Thomondgate"/Died 11
February 1969/Aged 69 Years/R.I.P./Erected On 11th
February 1979/By His Friends And Admirers

Oliver St John Gogarty 1878-1957

Born in Dublin. He was a poet, writer, politician and surgeon.
He was the model for the stately, plump Buck Mulligan of Joyce's
Ulysses. He wrote for the *United Irishman*, was pro-Treaty and made a
famous escape from his enemies by swimming across the Liffey.
He also carried out the autopsy on Michael Collins. In 1924 he
was one of the organisers of the Tailteann Games.

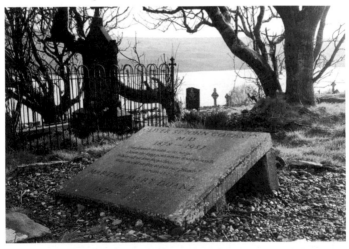

His works include *As I Was Going Down Sackville Street*, *Tumbling in the
Hay*, *It Isn't This Time of Year at All* and *Collected Poems*. He spent much of
his later years living away from Ireland. He died in New York and
a service was held in St Patrick's Cathedral. He had wanted to be
buried near Renvyle and his remains were returned to Shannon
and brought to a chapel near Renvyle.

He is buried in Ballinakill Graveyard, Ballinakill, County
Galway. At Moyard, on the road from Letterfrack to Clifden,

take the first signpost for Cleggan. There is also a signpost for Ballinakill R.C. church. At the end of this road turn right and continue until you come to the cemetery which is situated on the left. Go in the gate and the grave is on the right-hand side of the path, just past the first intersection. The grave is on the path edge, overlooking the lake. The inscription on the stone reads: OLIVER ST JOHN GOGARTY/M.D./1878-1957/OUR FRIENDS GO WITH US AS WE GO/DOWN THE LONG PATH WHERE BEAUTY WENDS/WHERE ALL WE LOVE FORGATHERS, SO/WHY SHOULD WE FEAR TO JOIN OUR FRIENDS?/NON DOLET O.ST.J.G./MARTHA MARY DUANE/HIS WIFE/1876-1958

Ulick O'Connor, in his biography of Gogarty, relates the humourous asides of Monsignor Pádraig De Brún during the burial service and how a swan appeared in the middle of Shanbollard Lake as if to bear him home.

Oliver Goldsmith 1728-1774

Born in Pallas, County Longford. He was a poet, playwright, essayist and novelist. He graduated from Trinity College Dublin but failed to complete other studies. After several failed careers he became a writer for journals and magazines. His works include *She Stoops to Conquer*, *The Vicar of Wakefield* and *The Deserted Village*. There is a statue of him, by John Foley, in front of Trinity College Dublin.

He was buried in the Temple Church, Temple, (off) Fleet Street, London. There is an archway opposite Chancery Lane. Take the first turning left at Goldsmith Buildings. The grave is almost opposite, beside the wall. A stone was not erected until 1860.

The inscription reads: HERE LIES/ OLIVER GOLDSMITH And on the opposite side is the inscription: BORN 10TH NOV 1728/ DIED 4TH APRIL 1774

John Forster in his book *Life and Adventures of Oliver Goldsmith* (1848) writes – "No memorial indicates the grave to the pilgrim or the stranger. Nor is it possible any longer to identify the spot which received all that was mortal of this delightful writer". In a later edition of the book (1853) he states that he and Sir Frederick Pollock went back to the Temple burial ground and "examined unavailingly every spot beneath which interment had taken place and every stone and sculpture on the ground, nor was it possible to discover any clue in the register of burials which we also looked through with the minister of the Temple. It simply records as – "Buried 9th April, Oliver Goldsmith, M.B., late of Brick Court, Middle Temple."

McDonagh, *Irish Graves in England*, wrote that in 1842, the churchyard was closed for burials and a large portion of it was paved over. An alder tree was removed and T.C. Noble the historian of the Temple, mentioned that there was information coming from a very old sexton that this tree marked the grave of Goldsmith. The stone is not on the site of the tree.

The tomb was erected in 1860, near the west boundary bollard which still exists. David Lewer, Hon. Archivist, Temple Church, wrote to me stating that the tombstone was moved in 1868 to the position shown in line drawings available in *The Story*

of the Temple and in Bellot's *The Temple*. After the church fire of 1941, the tombstone was bricked up until it was moved after the War to its present position.

In 1837 the Benchers of the Temple 'placed a marble tablet in the recess east of the choir in the Temple church' (*McDonagh*).

The inscription read: THIS TABLET, RECORDING THAT/ OLIVER GOLDSMITH/ DIED IN THE TEMPLE, ON THE 4TH APRIL 1774/ AND WAS BURIED/ IN THE ADJOINING CHURCHYARD,/ WAS ERECTED BY THE BENCHERS OF THE NOBLE/ SOCIETY OF THE INNER TEMPLE, A.D. 1837/ SIR FREDERICK POLLOCK, TREASURER.

McDonagh visited the church to try and find the tablet only to discover that it had been removed 'to a dark and dingy gallery of the passage over the church.' David Lewer informed me that the tablet was removed from the original location to the basement of the new organ chamber and then, possibly in 1868, to the triforium. In 1941, it was destroyed, along with nearly all the monuments in the triforium.

Perhaps all this could have been avoided had Goldsmith been buried in Westminster Abbey as his friends had intended but which his debts of over £2,000 prevented. However two years after his death, Sir Joshua Reynolds proposed the idea of a monument in the Abbey and money was collected for this purpose. The monument consists of a bust of the poet in profile in high relief on a medallion with an inscription in Latin by Dr Johnson. The inscription includes the line - NULLUM QUOD TETIGIT NON ORNAVIT (He touched nothing which he did not adorn). The memorial is situated in Poets' Corner.

Eva Gore-Booth 1870-1926

Born at Lissadell, County Sligo. She was involved in the suffragette movement and in trade union work with women. She wrote ten volumes of poetry and is best remembered for *The Little Waves of Breffny*. She is buried in the grounds of St John-at-Hampstead, Church Row, London. The grave number is B27. Emma Donoghue, in an interview at a conference celebrating Irish women writers in 1999, tells of having to climb over a wall to visit the grave. Eva Gore-Booth is buried with her life-long companion, Esther Roper.

The grave is located in the cemetery

across the road from the church. As you go in the gate on Holly Walk, the first row to the left is row "A" and the Gore-Booth grave is in the next row and 27 plots up on the left. The inscription reads: Eva Gore-Booth/ 22 May 1870 30 June 1926/ Esther Roper/ 4 August 1868 28 April 1938/ Life That Is Love Is God.

There is an excellent guide book, *Buried in Hampstead*, to the churchyard and the burial grounds.

Alice Stopford Green 1847-1929

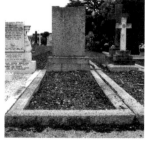

Born in Kells, County Meath. She married John Richard Green, an English historian, helped him with his work and after his death completed his book *Conquest of England*. She then wrote a number of books on Irish history including *The Making of Ireland and Its Undoing*, *Irish Nationality* and *History of the Irish State to 1014*.

She is buried in grave number 91Q, in the South West section, Deansgrange Cemetery, Dublin. (*See map page 250 - the grave is about nine rows from the grave of Flann O'Brien and three rows from the path*). The inscription reads: Alice Sophia Amelia/ Stopford Green/ Historian of the Irish People/ Widow of John Richard Green/ Born 31st May 1847 died 28th May 1929

Lady Augusta Gregory 1852-1932

Born in Roxborough, County Galway. She was co-founder of the Irish Literary Theatre which later evolved into the Abbey, of which she was a director. She was one of the prominent figures in the Irish literary revival and her home at Coole Park became a focus for many of its other members. She was an author and playwright whose works include *Cuchulain of Muirthemne*, *Gods and Fighting Men*, *Visions and Beliefs in the West of Ireland*, *Spreading the News* and

The Rising of the Moon. W.B. Yeats often acknowledged the importance of her role in his life. Her son Robert was the Irish airman of Yeats' poem. Sir Hugh Lane was her nephew and she was to the fore in campaigning to have his pictures displayed in Ireland.

She decided against being buried in the Gregory family vault which she had bricked up after Coole Park was sold in 1927. She chose instead to be buried beside her sister Arabella in Bohermore Cemetery, Galway. She thought it "a beautiful burying place, lying

high, the sun shining on it, on the silver sea". Go in the main gate and follow the road around to the church on the left. The grave is situated almost in line with the rear of the church. It is the middle one of three within a grave plot. The inscription changes a line from one of her plays *Cathleen ni Houlihan* - "They shall be remembered forever" and reads: LADY GREGORY/ 1852-1932/ SHE SHALL BE REMEMBERED/ FOREVER.

Robert Gregory 1881-1918 was born in London. He was the son of Major Robert and Lady Gregory. He joined the Royal Flying Corps in 1916. He was a squadron leader and received the Legion of Honour in 1917 for bravery. His plane was shot down in error by an Italian plane on January 23rd 1918. The anniversary of his death each year was marked in Lady Gregory's diary. His death gave rise to W.B. Yeats' poem *An Irish Airman Foresees His Death*. He is buried in Padua Main Cemetery, grave no A.12. Take the A 13 motorway and exit at Padua West, direction of Vicenza. After several kilometres the cemetery can be seen on the right-hand side. Go in the main gate and proceed to the middle right to the South East part of the cemetery where the Commonwealth plot is. The inscription reads: MAJOR/ ROBERT GREGORY M.C./ ROYAL FLYING CORPS/ 23RD JANUARY 1918/ ONLY CHILD OF THE LATE RT. HON/ SIR W.H. GREGORY K.C.M.G./ OF COOLE PARK, CO GALWAY

Gerald Griffin 1803-1840

Born in Limerick. He went to London to become a full-time dramatist but he had more success as a short story writer and novelist. *The Collegians* is based upon the Colleen Bawn story. Other works include *Holland-Tide, Talis Qualis* and *Tales of the Munster Festivals*. He became a Christian Brother shortly before his death and burned his manuscripts.

He is buried in North Monastery, in the city of Cork. The cemetery is to the left of the main building as you look at it and round the back. It is a small cemetery.

Arthur Griffith 1871-1922

Born in Dublin. He was a journalist who founded the paper the *United Irishman*. His ideas brought Sinn Féin into being and he became President of the movement in 1911. He did not fight in

the Easter Rising but was imprisoned several times subsequently. Following his ideas the Sinn Féiners set up a separate parliament in 1919. He led the delegation which negotiated the Anglo-

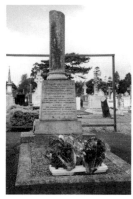

Irish Treaty in 1921. He was elected President of the Dáil and the Irish Republic in 1922 but died shortly afterwards. His works include *The Resurrection of Hungary* and *Ballad History of Ireland*. He is buried in Glasnevin Cemetery, Dublin. *(See map page 246)*. The inscription reads: ARTHUR GRIFFITH TD/ CAVAN & TYRONE/ FIRST PRESIDENT DAIL EIREANN/ OF THE IRISH FREE STATE/ FOUNDER OF SINN FÉIN/ EDITOR OF/ THE UNITED IRISHMAN SINN FÉIN/ ÉIRE (IRELAND) SCISSORS AND PASTE/ NATIONALITY AND ÉIRE ÓG, (YOUNG IRELANDER)/ AUTHOR OF/ THE RESURRECTION OF HUNGARY/ AND BALLAD HISTORY OF IRELAND ETC./ DIED 12TH AUGUST 1922 AGED 50 YEARS/ ERECTED BY HIS LOVING WIFE / R.I.P.

Veronica Guerin 1959-1996

Born in Dublin. She trained as an accountant and worked in her father's firm. After his death she set up a PR company and was active in Fianna Fáil politics. In 1990 she changed career and became a journalist working for a number of papers. She was an investigative journalist who exposed the criminals and gangsters in Irish society. It was as a result of this that she was murdered.

She is buried in Dardistown Cemetery, Collinstown Cross, Swords, County Dublin. *(See map page 256)*. Go in the entrance and turn immediately right. With the office on your left-hand side. take the first path to the left, and at the end of the path is the grave.

The headstone has the following inscriptions: VERONICA GUERIN TURLEY/ 26TH JUNE 1996 VOLUME 1 ISSUE 1/ SUNDAY INDEPENDENT/ JOURNALIST SHOT DEAD

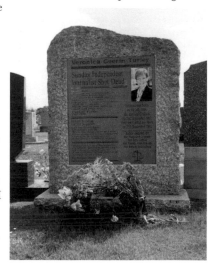

DEAR MUM/ I WISH TO SAY A PRAYER FOR YOU/ UPON THIS LONELY DAY/ BECAUSE IT IS A MONTH AGO/ SINCE YOU WENT AWAY/ I MISS YOU, I MISS YOU SO BADLY/ AND ALL I CAN SAY/ WATCH OVER US AND GUIDE US/ EACH AND EVERY DAY/ CATHAL TURLEY/ JULY 1996

In Life Standing/ Up For Reporters/ Extract From
Acceptance Speech/ For Press Freedom Award 1995/ "We
Write Under Ridiculous Restrictive Laws In Ireland/
These Are The Issues That I Feel I Have To Highlight
Here/ It Is Not The Fact That Journalists May Be Shot/
But The Legitimate Restrictions That We Work Within"

"Veronica's Death Is One Of Those Events When/ A
Nation Stops, Time Stands Still, When We/ Look At
Ourselves As A Society And Ask:/ Where Are We Going?
This Time Of Questioning/ Is A Special Moment Of
History"/ Fr Declan Doyle

Veronica Was Born/ On 5th July 1959,/ She Married
Graham/ On 21st September 1985,/ Their Son Cathal Was
Born/ On 27th September 1989/ Sadly Missed By Her
Husband Graham/ Her Son Cathal/ Her Family And
Friends/ Her Fellow Journalists/ Be Not Afraid

Sir Tyrone Guthrie 1900-1971

Born in Tunbridge Wells, Kent, England. He produced plays in
many European countries and in America. He was Chancellor of
Queen's University Belfast 1963-1970 and was knighted for his
theatrical work. He left his house, Annaghmakerrig, to be used
for the Arts. His works include *Theatre Prospect*, *Top of the Ladder*, *In
Various Directions* and *A Life in the Theatre*.

> ALSO OF HER SON
> SIR WILLIAM TYRONE GUTHRIE
> BORN 2ND JULY 1900 DIED 15TH MAY 1971

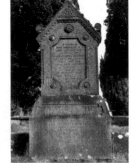

He is buried in the family plot at Aghabog church near
Annaghmakerrig in County Monaghan. His mother, wife and
other relatives are also buried with him.
The inscription to him reads:
Sir William Tyrone Guthrie/ Born
2nd July 1900/ Died 15th May 1971.

To get to the cemetery, take the road
from Cootehill to Monaghan and turn
off for Newbliss. Pass two signs for
Annamakerrig Lake and not far past the
second one, take the next right. The
road is signposted for Aghabog church.
Go in the gate and follow the path to the
left. The grave is on the path edge facing
the wall, before you turn the corner.

Aubrey Gwynn 1892-1983

Born in Dublin. He was the son of Stephen Gwynn. He became a
Jesuit priest and lectured in Ancient and then Medieval History at
University College Dublin. His works includes *The Medieval Province of
Armagh 1470-1545*, *A History of the Diocese of Killaloe* and *The Writings of Bishop*

Patrick 1074-1084. He is buried in the Jesuit plot in Glasnevin Cemetery, Dublin. *(See map page 246)*. His name is mentioned on the second stone to the left of the cross. It is at the very bottom.

P. AUBREY GWYNN ⁓ OB. 18 MAY 1983 ÆT 91
R. I. P.

Stephen Gwynn 1864-1950

Born in Dublin. He worked as a teacher before taking up journalism. He served as a Nationalist MP for Galway 1906-1918, was a Redmond supporter, and fought with the British Army in the First World War, despite his age. He wrote poems, novels, biographies and travel books. These include *A Lay of Ossian and St Patrick with Other Irish Verse*, *The Old Knowledge*, *The Fair Hills of Ireland*, *Beautiful Ireland* and biographies on Moore, Swift and Goldsmith. He is buried in St Maelruain's, Tallaght, County Dublin. *(See map page 256)*. Go round to the back of the church and take the path keeping the hedge on your right-hand side. Where the graves begin further down on the right-hand side, count nine rows down and four graves in. It is in the same row as the grave of **George Otto Simms 1910-1991**.

The inscription reads: STEPHEN LUCIUS GWYNN/ELDEST SON OF/THE REV JOHN GWYNN/BORN AT ST COLUMBAS COLLEGE/FEB 13TH 1864/ DIED IN DUBLIN/JUNE 11TH 1950/ MAY HE REST IN PEACE

Anna Maria Hall 1800-1881
Samuel Carter Hall 1800-1889

Anna Maria Hall was born in Dublin. She was a prolific writer who produced over 500 pieces of work including poems, plays, children's books, novels and sketches. She was more popular in England than in Ireland. Her works include *The Groves of Blarney*, *The Whiteboy*, *Lights and Shadows of Irish Life* and *Ireland, Its Scenery, Characters, etc* which she wrote with her husband. As McDonagh relates in *Irish Graves in England*, her

83

coffin, at her request, was made from an old oak family chest which her mother had brought with her to London when she left Wexford in 1815.

Samuel Carter Hall was born near Waterford. He was a publisher and published Anna Maria's early work. He was later involved in newspapers and was editor of the *Art Union Monthly Journal*. He wrote *Lines Written at Jerpoint Abbey* as well as collaborating with his wife on *Ireland, Its Scenery, Characters, etc.* and on other books. They are buried in the churchyard of St Paul's Parish Church on Church Road, Addlestone, Surrey. The church is a good 20 minutes walk from the railway station. The grave is situated to the left of the church tower near the entrance door. When McDonagh visited it, the name of Mrs Hall was not inscribed on it as her husband was still alive at the time and he wanted a more suitable memorial to her genius.

McDonagh also wrote that the ivy that covered the church was planted by Mrs Hall from roots brought from Killarney. The ivy has now gone.

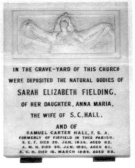

There is a plaque on the inside wall of the church about half way down on the left-hand side as you enter. It reads: IN THE GRAVE-YARD OF THIS CHURCH/WERE DEPOSITED THE NATURAL BODIES/OF SARAH ELIZABETH FIELDING/OF HER DAUGHTER ANNA MARIA/THE WIFE OF S.C.HALL/AND OF/SAMUEL CARTER HALL F.S.A./FORMERLY OF FIRFIELD IN THIS PARISH/S.E.F. DIED 20 JAN 1856 AGED 82/A.M.H. DIED 30 JAN 1881 AGED 81/S.C.H. DIED 16 MARCH 1889 AGED 88

The inscription on the gravestone is still readable: MRS SARAH ELIZABETH FIELDING/THE GOOD AND BELOVED MOTHER/OF MRS S. C. HALL/DIED ON THE 20TH JANUARY 1856/IN THE 83RD YEAR OF HER AGE/HER LIFE WAS A LONG AND CHEERFUL/PREPARATION FOR DEATH AND HER/WHOLE PILGRIMAGE A PRACTICAL/ILLUSTRATION OF THE TEXT THAT WAS/HER FREQUENT PRECEPT AND/CONTINUAL GUIDE/"KEEP INNOCENCY AND TAKE HEED UNTO THE THING THAT/IS RIGHT FOR THAT SHALL BRING A MAN PEACE AT THE LAST"/ANNA MARIA/THE WIFE OF/S.C. HALL/BORN 6TH JANUARY 1800/DIED 30TH JANUARY 1881/SAMUEL CARTER HALL F.S.A./BORN 9TH MAY 1800/DIED 16TH MARCH 1889

Sir William Rowan Hamilton 1805-1865

Born in Dublin. He was appointed Professor of Astronomy in Trinity College Dublin at the age of 22 and Astronomer Royal of Ireland. His greatest achievement is inscribed on a memorial at Broombridge, Cabra — "Here as he walked on the 16th October 1843 Sir William Rowan Hamilton in a flash of genius discovered the fundamental formula for quaternion multiplication and cut it on a stone". Much modern algebra has been developed from

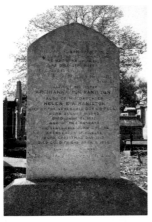

quaternions. His works include *Theory of Systems of Rays* and *The Elements of Quaternions*. Hamilton is buried in Mount Jerome Cemetery, Dublin. *(See map page 252).* Nearly opposite Thomas Caulfield Irwin (q.v.), take the pathway and three rows in, on the right-hand side, is William Rowan Hamilton's grave. The inscription reads: HERE LIE/THE MORTAL REMAINS/OF/SIR WILLIAM ROWAN HAMILTON L.L.D./ROYAL ASTRONOMER OF IRELAND/HE WAS BORN AUG 4 1805/HE DIED SEPT 2 1865/IN THE LOVE OF GOD LOOKING FOR THE MERCY OF/OUR LORD JESUS CHRIST UNTO ETERNAL LIFE JUDE 21/ALSO OF HIS SISTER/ARCHIANNA P.H. HAMILTON/ALSO OF HIS DAUGHTER/HELEN E. A. HAMILTON/WIFE OF THE VENERABLE JOHN O'REGAN/BORN AUGUST 11 1840/DIED JUNE 21 1870/AND OF HER HUSBAND/THE VENERABLE JOHN O'REGAN/ARCHDEACON OF KILDARE/BORN CHRISTMAS DAY 1817/DIED GOOD FRIDAY APRIL 8TH 1898/CONCORDIES ANIMAE/LOVE IS THE FULFILLING OF THE LAW/ERECTED BY HIS SERVING FAMILY

Davoren Hanna 1975-1994

Born in Dublin. He was crippled by cerebral palsy and unable to speak. His mother taught him to read and write. He won many awards for his poetry. In 1990, his collected poems were published as *Not Common Speech*. He is buried in Section F395, Fingal Burial Ground, Dublin. *(See map page 256).*

Frank (James Thomas) Harris 1856-1931

Born in Galway. He went to America at the age of 15. After numerous jobs and a degree, he returned to England and began a career in journalism. He edited a number of papers including the *Evening News* noted for it's dramatic headlines and sensationalism. In 1894 he bought the *Saturday Review* and for a number of years it was the top literary periodical of its day. He sold the paper in 1898 and edited other journals. He encountered financial difficulties and even served time in prison for contempt. He wrote a number of novels and biographies but is probably best remembered for his autobiography in five volumes *My Life and Loves*, which was banned for its explicit sexual content. Other works include *The Man Shakespeare and His Tragic Life Story*, *Shakespeare and His Love* and biographies of Oscar Wilde and George Bernard Shaw. He died in Nice.

I had learnt that Harris was buried in the English Cemetery in Nice but I was unable to establish who was in charge of the cemetery before I went out there. The cemetery wasn't that large

but there were unreadable stones and unmarked graves and while there was a chronological lay out, Harris's grave wasn't in the sequence. I went down to the Caucade Cemetery below and fortunately they had the records. Unfortunately his name wasn't in any of their books. They rang head office and were able to confirm after some time that he had been buried in the cemetery. So they went through their files. Three staff members spent 30 minutes going through the files which were uncomputerised. But they couldn't find any file relating to Harris. There was nothing for it they said, except inspect every stone individually. So two of them accompanied me back to the cemetery and we carefully scrutinised each stone. Just before we gave up, I spotted it. It is the horizontal slab at the bottom of the photograph. If you go in the gate and take the third railed steps, then go across the path and it is on the right-hand corner of the next row. The inscription reads: FRANK HARRIS/BORN FEBRUARY 14TH 1856/DIED AUGUST 26TH 1931/NELLIE HARRIS/BORN MARCH 18. 1887/DIED MARCH 25. 1955

And while you are there, go into the Caucade Cemetery below and at the corner of Sud 31, where there is a signpost near by, there is a communal plot where the sculptor, **John Hughes**, is buried. There is no marker for him.

James Harshaw 1797-1867

Born in Ringbane, Donaghmore, County Down. He kept a diary from 1838-1865 which gave a detailed insight into the lives of people in Counties Down and Armagh. The diaries made their way to America and were nearly destroyed before being rescued and brought back to Northern Ireland in 1996. He is buried in the grounds of the Presbyterian Church at Glascar, County Down. Glascar is signposted

on the B3 between Loughbrickland and Rathfriland. To locate the grave, go in the gate and take the path level with the front of the church. The grave is on the left-hand side of this path, facing away. The inscription reads: Erected/To The Memory Of/ James Harshaw/Of/Ringbane/1797-1867/A Noble Man

Michael Hartnett 1941-1999

Born in Croom, County Limerick. His early work was in English and includes *Anatomy of a Cliché*, *The Hag of Beare* and *Gipsy Ballads*. He grew more confident in Irish and in 1975 he wrote *A Farewell to English*. For the next ten years he wrote only in Irish but after that he published again in English. His work includes *Inchicore Haiku*, *An Lia Nocht*, *A Necklace of Wrens*, *Poems to Younger Women* and *An Damh-Mhac*.

He is buried in Calvary Cemetery, Newcastle West, County Limerick. The cemetery is located on the Newcastle to Rathkeale road. Go in the main gate and take the second path on the right. The grave is eight rows down on the right-hand side. The inscription reads: Michael Hartnett/File/1941-1999/"Beadsa Ann D'ainneoin An Bháis/Mar Labhraíonn Dúch/Is Labhraíonn Pár"/I Will Be There In Spite Of Death/For Ink Speaks And Paper Speaks/Erected By His Wife And Children And Friends And Relatives

The quotation on the stone was recited during the funeral mass and is taken from a poem written for his son. Another poem that was recited at the graveside was one written by fellow poet and friend Nuala Ní Dhomhnaill which she had written after hearing of his death. A piper played traditional airs and many other poets, friends and family attended.

Richard Hayes 1882-1958

Born in Bruree, County Limerick. He was a doctor who joined the Irish Volunteers and fought at Ashbourne during the Easter Rising. He was pro-Treaty and retired from politics in 1924. He

continued his medical work and was film censor from 1940-54. He was also an expert on the Wild Geese and had many publications including *Ireland and Irishmen in the French Revolution*, *Irish Swordsmen of France*, *The Last Invasion of Ireland* and *Biographical*

Dictionary of Irishmen in France. His death notice in the *Irish Times* mentions he was a Member of the Academy of Letters and Legion of Honour. He is buried in grave number 160M, St Patrick's, Deansgrange Cemetery, Dublin. *(See map page 250)*. It is not marked by any stone.

Richard Hayward 1898-1964

Born in Belfast. He was a prolific writer on Ireland. His works include *Where The River Shannon Flows*, *In the Kingdom Of Kerry*, *The Corrib Country*, *Ulster Songs and Ballads*, *In Praise of Ulster*, *Ulster and the City of Belfast*, *Connacht and the City of Galway* and *Munster and the City of Cork*. In the last book there is a reference to his visiting the grave of Donn Byrne *(q.v.)* who died in a car accident. Shortly after this book was finished Hayward himself died in a car crash. Richard Hayward was one of the authors who used to "accompany" us on our holidays. He was a particular favourite of my mother who had collected almost all his books. His remains were cremated at Roselawn Crematorium, Belfast.

John Healy 1930-1991

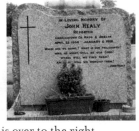

Born in Charlestown, County Mayo. He was a journalist and writer whose works include *Death of an Irish Town* and *Nineteen Acres*. He is buried in grave number 38, Row A1, St Laurence Section, Shanganagh Cemetery, Dublin. *(See map page 256)*. St Laurence Section is immediately in front of you as you enter the cemetery and the grave is over to the right.

Lafcadio Hearn 1850-1904

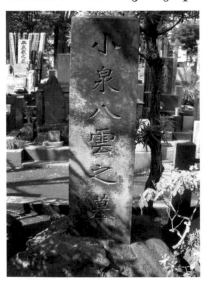

Born in Lefkas, one of the Ionian Islands, to a Greek mother and Irish father. He was given the name of Patrick but dropped it after falling out with his father's family. He lived in Dublin before emigrating to America and then to Japan where he took the name of Yakumo Koizumi. He is very well-known in Japan. His works include *Glimpses of Unfamiliar Japan*, *Japan: An Attempt at Interpretation*, *Exotics and Retrospective*, *In Ghostly Japan*, *Shadowings*, *A Japanese Miscellany*, *Out of the East*, *Kokoro*, *A Japanese*

Miscellany and *Kwaidan*.

His father had been buried at sea and Lafcadio also wished to be buried "in the clean sea and to have his eternal rest surrounded by corals and various fish" (*Toki Koizumi — Irish Writing on Lafcadio Hearn and Japan*). However he was given a Buddhist funeral and his cremains were buried in Zôshigaya Cemetery, Tokyo. The gate to the cemetery is just in front of Zôshigaya station. A map in Japanese may be purchased from the office. Go straight in and take the first turn on the right. Turn left at the small sign and you will shortly arrive at the grave. It is the central one of three. The left is for his wife and the other for the Koizumi family. His Buddhist name is on the right side of the tombstone. This translates as "Believing Man Similar to Undefined Flower Blooming like Eighty Rising Clouds, who dwells in Mansion of Right Enlightenment" (*Translated by Amenomori Nobushige*).

Annie French Hector 1825-1902

Born in Dublin. She was a novelist who wrote under the pen name of Mrs. Alexander. Beginning in 1875, when her husband, the explorer Alexander Hector died, she wrote over 40 books including her most famous - *The Wooing of O't, The Cost of Her Love* and the semi-autobiographical *Kitty Costello*.

She is buried in grave number 22578/125/2 (second row), Kensal Green Cemetery, London, though not in the same grave as her husband. The grave was completely covered with grass when I eventually found it and no trace of any inscription remains. The grave is directly behind that of Deacon which has a cannon, cannon balls, an anchor and a flag portrayed on it. The photograph shows the location of the grave in relation to the church. The grave is the flat slab barely visible in the foreground.

Felicia Hemans 1793-1835

Born in Liverpool. She wrote three volumes of poetry between 1808 and 1812 and after her husband left her she wrote full-time. She was an extremely popular poet in her day. She came to live in Dublin in 1831 and stayed there until her death. She was the author of *Casabianca* which included the famous line - *The Boy Stood on the Burning Deck* — and other works include *The Stately Homes of England*, *Records of Women* and *The Siege of Valencia*. She is buried in St Ann's church in Dawson Street, Dublin. (*See map page 255*). There is a

89

plaque to her on the right-hand wall, which includes her own verse. The inscription on the plaque reads: In The Vault Beneath/Are Deposited The Mortal Remains Of/Felicia Hemans/She Died May 16th 1835/Aged 41/"Calm On The Bosom Of Thy God/Fair Spirit: Rest Thee Now!/E'en While With Us Thy Footsteps Trod./His Seal Was On Thy Brow/Dust To Its Narrow House Beneath/Soul To Its Place On High:/They That Have Seen Thy Look In Death./No More May Fear To Die"

Augustine Henry 1857-1930

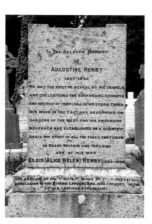

Born in Cookstown, County Tyrone. He worked in the Customs Service in China from 1881-1900 and sent back an important collection of plants to Kew Gardens. On his return he collaborated with Elwes on *Trees of Great Britain and Ireland* (seven volumes). He is buried in Deansgrange Cemetery, Dublin. *(See map page 250).* The inscription reads: To The Beloved Memory/Of/Augustine Henry/ 1857-1930/ He Was The First To Reveal By His Travels/And Collections The Surpassing Richness/And Interests Of The Flora Of Western China/ His Work In The East Has Beautified The/ Gardens Of The West And His Profound/ Research Has Established On A Scientific/ Basis The Study Of All The Trees That Grow/ In Great Britain And Ireland/ And Of His Wife/ Elsie (Alice Helen) Henry (1882-1956)/ Who Carried On His Greatest Work To Its Successful/ Conclusion In Our Botanic Gardens And Who Enriched Our Era/ By Her Gracious Personality

John Hewitt 1907-1987

Born in Belfast. He was Keeper of Art at the Ulster Museum from 1930-1957 and Director of the Herbert Art Gallery and Museum in Coventry from 1957-1972. He was writer-in-residence at the New University of Ulster 1973-6 and then for three further years at Queens University Belfast. He wrote 14 volumes of poetry as well as criticisms and various books on art. His works include *No Rebel Word*, *Collected Poems 1932-1967*, *Out of My Time*, *Time Enough* and he edited *Rhyming Weavers and Other Country Poets of Antrim and Down*. He donated his body to medical science. A stone cairn was erected to his memory in 1989 on the slope of

Tievebulliagh in Lubitavish, between Cushendall and
Cushendun, County Antrim. It shares the same site as Ossian's
grave, a two-chambered court cairn. The site is off the A2 just
before Glencorp, coming from the Cushendall direction. There
is a signpost for Ossian's grave. About one kilometre down this
road, there is an unmarked track and the site is in a field on the
right-hand side at the end of this track.

F.R. (Fred) Higgins 1896-1941

Born in Foxford, County Mayo. For most of his life he wrote and
edited magazines. In his later years he became Managing
Director of the Abbey Theatre. Yeats had considered him the
finest of the younger Irish poets. His works
include *Island Blood*, *Salt Air*, *The Dark Breed*,
Arable Holdings and *The Gap of Brightness*.

He is buried in the cemetery beside the
church at Laracor, south of Trim, County
Meath. The church is now deconsecrated
and is privately occupied. The entrance to
the graveyard is just inside the gate to the
right. The grave is located along the line of
the dividing hedge between church and
graveyard. Under a yew tree at the back of
the graveyard, a black marble stone marks
the grave.

Bulmer Hobson 1883-1969

Born in Holywood, County
Down. He was involved with
many different nationalist
organisations and co-founded
Na Fianna Éireann. He
reorganised, with Tom Clarke,
the Irish Republican
Brotherhood in 1907, the same
year he became Vice –President
of Sinn Féin. He left in 1910
after a disagreement with
Griffith. He was one of the
organisers for the bringing in
of arms to Howth. He opposed
the Easter Rebellion and
became disillusioned after it.
After the Treaty he became a
civil servant. His works include
The Life of Wolfe Tone, *Defence of
Warfare: A Handbook for Irish
Nationalists*, *A Short History of the Irish
Volunteers* and *Ireland Yesterday and
Tomorrow*. He also edited *Saorstát Éirinn*, *Irish Free State Official Handbook*.
He is buried in Gurteen Cemetery, Roundstone, County Galway.
The gravestone records his name and dates. For location of the
grave see entry for Brian Moore.

Michael Hogan 1832-1899

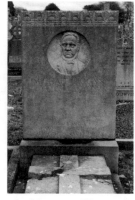

Born in Limerick. He was known as the Bard of Limerick. His works include *Light of Munster*, *Anthems to Mary* and the *Shawn-a-Scoob* series. His early poems were collected under the title of *Lays and Legends of Thomond* which went into several editions. He is best known for the ballad *Drunken Thady*.

He is buried in Mount St Laurence Cemetery, Limerick. Go in the main gate and turn right. The grave is situated about a dozen plots down on the left-hand side. It has a large square stone with an inset and the inscription reads: MICHAEL HOGAN/ BARD OF THOMOND/ 1832-1899/ OH! TWERE/ ASHAMED TO LET HIS NAME/ LIKE OTHER NAMES DECAY/ HIS WIFE/ ANNE/ DIED 1903/ ERECTED BY THE BARD OF THOMOND MEMORIAL COMMITTEE APRIL 1933/ RENEWED 1994

Jemmy Hope c. 1764-1847

Born in Templepatrick, County Antrim. He believed that the political system needed to change in order to improve the lot of the labouring class. He joined the United Irishmen and marched with Henry Joy McCracken on Antrim town. He went into hiding after the failure of the affair. He became involved with Robert Emmet and Thomas Russell and again was lucky to escape with his life. He eventually returned home and lived quietly until his death. His memoirs were published by R.R. Madden. Jemmy Hope was "The Northern Star" in Stewart Parker's play of that name and he featured as a character in George Birmingham's *Northern Iron*. He is buried in Mallusk graveyard, County Antrim, beside the grave of Joseph Bigger. The inscription to him on the stone reads: SACRED/ TO THE MEMORY OF/ JAMES HOPE/ WHO WAS BORN IN 1764 AND DIED IN 1847/ ONE OF NATURES NOBLEST WORKS/ AN HONEST MAN/ STEADFAST IN FAITH AND ALWAYS HOPEFUL/ IN THE DIVINE PROTECTION/ IN THE BEST ERA OF HIS COUNTRY' HISTORY/ A SOLDIER IN HER CAUSE/ AND IN THE WORST OF TIMES STILL FAITHFUL TO IT/ EVER TRUE TO HIMSELF AND TO THOSE/ WHO TRUSTED IN HIM HE REMAINED TO THE LAST/ UNCHANGED AND UNCHANGEABLE/ IN HIS FIDELITY

The stone over the grave was erected by Mary Ann MacCracken and R.R. Madden. On the other side is the grave of **Luke Hope,** who was the editor of Rushlight.

Gerard Manley Hopkins 1844-1889

Born in Stratford, Essex. He was educated at Oxford where he converted to Roman Catholicism. He entered the Jesuit order and worked in parishes in London, Oxford and Glasgow. He was sent to Dublin where he was Professor of Classics at University College Dublin. He didn't particularly like Dublin, Ireland, the Irish or their politics. Most of his work was unpublished until after his death. His works include *Duns Scotus's Oxford*, *Heaven-Haven*, *The Wreck of the Deutschland*, *The Windover*, *Pied Beauty*, *The Loss of the Eurydice* and *Binsey Poplars Felled*. He is buried in the Jesuit plot in Glasnevin Cemetery, Dublin. *(See map page 246)*. His name is directly beneath the cross, at the top of the middle section.

P. GERARDUS HOPKINS OBiiT JUN. 8 1889 ÆTAT.AN.44

Further down is the name of Father Conmee, who was Rector of Clongowes, when James Joyce was a student there. He later became

P. JOANNES CONMEE OBiiT MAii 13 1910 ÆTAT. AN. 63

Prefect of Studies at Belvedere College and arranged for Joyce to attend Belvedere without fees.

Matthew Hughes 1834-1895

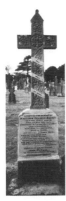

Born in Dublin. He was brought up as a tailor. He contributed poetry under the name of 'Conaciensis', to a variety of papers particularly the paper of the Fenians, *The Irish People*. He is buried in Glasnevin Cemetery, Dublin. *(See map page 246)*.

The inscription reads: SACRED TO THE MEMORY OF/ MATTHEW FRANCIS HUGHES/ 20 YORK STREET DUBLIN/ PURE PATRIOT AND POET/ CONACIENSIS OF THE NATION, IRISH PEOPLE/ LADY'S ALMANAC &c/ WHO DIED 17TH MARCH 1895/ AGED 61 YEARS/ MAY HE REST IN PEACE AMEN/ WHEN MY POOR BODY DIES/ LIKE ALL THINGS MORTAL/ AND IN THE COLD GRAVE LIES/ WITHIN DEATH'S PORTAL/ WHO SHALL GUARD MY

LITTLE RHYMES/FROM DECAY IN FUTURE TIMES/CONACIENSIS/
ERECTED BY HIS OLD FRIEND/JOHN MCCALL/25 PATRICK
STREET DUBLIN.

McCall wanted to put the word FENIAN on the memorial but
the Catholic Cemetery Committee resolutely refused permission
to "allow such an objectionable word to be inscribed on the
monument" and in the end it had to be left out.

Francis Hutcheson 1694-1846

Born at Drumalig, near Saintfield, County Down. He was
educated in Killyleagh and in Glasgow. He became a Presbyterian
minister and opened an academy which he ran for nearly ten
years. He was elected, in 1829, to the Chair of Moral Philosophy
in Glasgow. His works include *An Inquiry into the Original of Our Ideas of
Beauty and Virtue, An Essay on the Nature and Conduct of the Passions and
Affections, A Short Introduction to Moral Philosophy* and *A System of Moral
Philosophy*. He died in Dublin and according to the burial records,
a Mr Hutcheson was buried on the 9th August, 1846, in the
graveyard of St Mary's, Jervis Street, Dublin. *(See map page 255).*

The cemetery was later turned into a park. The gravestones
are presently stacked in rows up against a wall or laid flat on
the ground.

In my searches on the internet I came in contact with an
American, Dermot Foley, who had travelled to Ireland looking for
the grave. He knew that a friend and cousin of Hutcheson,
William Bruce, had asked to be buried with Hutcheson and he
examined every stone in the park. The inscriptions are barely
readable on many of them but he actually found the gravestone for
William Bruce. The stone is fourth from the left on the bottom
row of the photograph. The inscription reads: INTERRED HERE
ARE THE MORTAL REMAINS OF/WILLIAM BRUCE ESQUIRE/
THIRD SON OF THE REV JAMES BRUCE PRESBYTERIAN/
MINISTER OF KILLILEAGH IN THE COUNTY OF DOWN /HE WAS
A ZEALOUS FRIEND OF CIVIL AND RELIGIOUS LIBERTY

The remainder of the stone lies buried in the ground.

Douglas Hyde 1860-1949

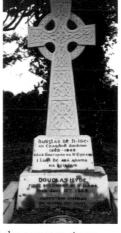

Born in Castlerea, County Roscommon.
He co-founded the Gaelic League with
Eoin MacNeill and others in 1893 to
encourage the speaking of Irish, Irish
music and dance, and Irish games. He
resigned from the League in 1915 because
of its politics. He was Professor of
Modern Irish at UCD from 1909-1932.
He became the first President of Ireland
under the 1937 Constitution. His works
include *Love Songs of Connacht*, *The Story of Early
Gaelic Literature* and *A Literary History of Ireland
From Earliest Times to the Present Day*.

He is buried at Portahard, three
kilometres west of Frenchpark, County
Roscommon. Drive through the village of
Frenchpark from the Dublin direction and the cemetery is on
the left-hand side. The grave is situated on the right-hand side of
the cemetery. The inscription on the stone reads: DUBHGLAS DE
H-IDE/ AN CRAOIBHIN AOIBHINN/ 1860-1949/ CÉAD
ÚACHTARÁN NA H-ÉIREANN/ I LÁIMH DÉ ATÁ ANAMA/ NA
BHFÍRÉAN/ DOUGLAS HYDE/ FIRST PRESIDENT OF IRELAND/ DIED
JULY 12TH 1949/ JUSTORUM ANIMAE/ IN MANU DEI SUNT

Austin Clarke wrote a poem about
the funeral called *The Burial of an Irish
President*. It records that while the
funeral service was being held in St
Patrick's Cathedral, the political
leaders stayed outside, around the

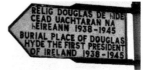

corner, fearing to attend in those less than ecumenical times.
The funeral went down O'Connell Street and down towards
Phoenix Park before heading home to Frenchpark. All along the
route, honour guards and large crowds paid tribute.

H(arford) Montgomery Hyde 1907-1989

Born in Belfast. He was called to the Bar in 1934. After the War,
he began to write up famous trials including *The Trials of Oscar Wilde*
and *The Trial of Roger Casement*. He also wrote biographies of Oscar
Wilde, Lord Castlereagh and Edward Carson among others. He
was cremated at Charing Crematorium, Ashford, Kent. The
death notice in the *Times* asked that donations, if any, be made to
the Fabric Fund of Magdalen College.

John Kells Ingram 1823-1907

Born near Pettigo, County Donegal. When he was 19 he wrote
The Memory of the Dead which includes the lines: 'Who fears to speak
of Ninety-Eight/ Who blushes at the name.' He later became
Professor of Oratory and later still Professor of Greek at Trinity
College Dublin. He was Vice Provost of the College 1898-1899.
The poem was out of character and he had no sympathy for

violence as a political weapon. Other works include *A History of Political Economy*, *Sonnets and Other Poems*, and *A History of Slavery and Serfdom*. He is buried in Mount Jerome Cemetery, Dublin. *(See map page 252)*. Go in the entrance and take the white stone path on the left, past the first road. Take the path to the right and then the second path to the right. On the left-hand side is the grave of Ingram.The inscription on the horizontal slab also commemorates a number of relatives

as well as John Kells – AND/TO THE MEMORY OF/JOHN KELLS INGRAM/SOMETIME SENIOR FELLOW AND VICE PROVOST/ OF TRINITY COLLEGE DUBLIN/

WHO DIED 1ST MAY 1907/IN THE 84TH YEAR OF HIS AGE

Rex Ingram 1892-1950

Born Reginald Ingram Montgomery Hitchcock in Dublin. He was a film director whose films include *Four Horsemen of the Apocalypse*, *The Prisoner of Zenda*, *Scaramouche* and *Baround*. He left Hollywood to devote his time to writing. He wrote two novels – *The Legion Advances* and *Mars in the House of Death*. He is buried in niche 20397, Columbarium of Memory, the Great Mausoleum, Forest Lawn, Glendale, California, U.S.A.

Denis Ireland 1894-1974

Born in Belfast. He was a writer and broadcaster whose works include *From the Irish Shore*, *From the Jungle of Belfast*, *Six Counties in Search of a Nation* and *Red Brick City*. His remains were cremated at Roselawn Crematorium, Belfast.

Valentin Iremonger 1918-1991

Born in Dublin. He was an actor with the Abbey and the Gate Theatres before he joined the Department of Foreign Affairs in 1946. He served as ambassador in a number of different countries before his retirement. He wrote poetry and his works include *Horan's Field and Other Reservations* and *Sandymount Dublin*. He also translated several autobiographies from the Irish language – *The Hard Road to Klondyke* and *An Irish Navvy*. He is buried in grave number

45 B1, St Laurence, Shanganagh Cemetery, County Dublin. *(See map page 256)*. The section is immediately in front of you as you enter the cemetery and the grave is over to the right, close to that of John Healy *(q.v.)*.

Alexander Irvine 1863-1941

Born in Pogue's Entry, Antrim town. He emigrated to America and was ordained a minister. He worked among the down and outs in New York and helped to establish the labour movement. He served as a padre during the war. He is best known as a writer whose works include *My Lady of the Chimney Corner*, *The Souls of Poor Folk* and *The Man from World's End and other stories*.

He is buried in the Church of Ireland All Saints Parish Churchyard, Antrim. Take the path to the left of the church and follow all the way round to the rear. The grave is to the left. It has a raised horizontal slab on four stones on a base. The inscription reads: ANNA IRVINE/ DIED 12 JULY 1889/ "MY LADY OF THE CHIMNEY CORNER"/ JAMES IRVINE/ DIED 17 FEB 1904/ LOVE IS ENOUGH/ DR ALEXANDER IRVINE/ AUTHOR, MINISTER, SOCIAL REFORMER/ DIED 16 MARCH 1941/ CALIFORNIA, U.S.A./ ASHES INTERRED HERE/ ON 27 JULY 1946

On one of his visits back to Antrim, Alexander Irvine visited the churchyard and stood at the grave of the most saintly woman he had ever known (his mother, the Lady of the Chimney Corner) and wrote "Everything I was and hoped to be I owed to her — to her love and faith. Perhaps she heard me as I said this at her grave". (*My Lady of the Chimney Corner, Appletree Press, Introduction Alastair J Smyth*)

Thomas Caulfield Irwin 1823-1892

Born in Warrenpoint, County Down. He wrote verse and prose as well as articles for the *Nation*. *The Faerie's Child* is probably his best remembered work. His poems were collected in eight volumes and he also published some of his prose writings and a biography of Swift. His work included *Irish Poems and Legends*, *Pictures and Songs* and *Winter and Summer Stories*. He is buried in Mount Jerome Cemetery, Dublin. (*See map page 252*). About 36 graves down from the top of the road on the left-hand side is the sarcophagus of Irwin. It is just beside a small pathway.

The inscription on top states that the tomb was erected to 'the best and dearest of mothers from her only son'. Irwin's infant son is also mentioned. The inscription on the front of the tomb reads: HERE REPOSE THE REMAINS/ OF/ ANNE MARIA IRWIN/ WHO DEPARTED THIS LIFE/ DECEMBER 15TH 1845/ THOMAS CAULFIELD IRWIN/ POET/ WHO DEPARTED THIS LIFE FEBRUARY 20TH 1892/ ESTHER

Anna Brownell Jameson 1794-1860

Born in Dublin. She was a travel writer, art historian and author. She was a member of a circle that included the Brownings, the Carlyles and Lady Byron. Her works include *The Diary of an Ennuyée*, *Memoirs of the Loves of the Poets*, *Characteristics of Women*, *Companion to the Public Picture Galleries of London*, *Memoirs and Essays on Art* and *The Communion of Labour*. She is buried in grave number 3449/144/2 (second row), Kensal Green Cemetery, London. There is no legible marking on the gravestone. The photograph shows the location of the gravestone which is third from the left in the foreground.

I had spent nearly an hour looking for the grave when a very attractive lady, who was walking by, stopped to talk with me. It soon became clear that she was interested in more than just passing the time of day! I was sorely tempted to abandon the dead for the living but it was nearly 3:30 on a November afternoon and the light was beginning to fade. If I didn't find the grave I would have to come back to London on another day. So I made my excuses. But as she was walking into the sunset I thought to myself, 'Ray, get a life'!

Denis Johnston 1901-1984

Born in Dublin. He was called to the Bar in 1926 and worked as a barrister. His involvement with the theatre led to him becoming Director of the Gate for a few years and then in 1935 he went to work as a drama producer for the BBC. He worked as a war correspondent and after the war he went to America. His works include *The Old Lady says No*, *The Moon in the Yellow River*, *A Bride for the Unicorn*, *Storm Song*, *The Golden Cuckoo* and *Nine Rivers from Jordan*. He was the father of the writer, Jennifer Johnston. He is buried in St Patrick's Close, Dublin, in the graveyard attached to the Cathedral. *(See map page 255)*. Bernard Adams, in his biography of Johnston, records that before his death the family approached the Dean about having the funeral service in the cathedral and were pleasantly surprised when the Dean proposed he be buried in the Close. Denis Johnston was delighted at this honour and asked also for a peal of bells at the funeral. The request was granted. The inscription reads: DENIS JOHNSTON/ 1901-1984/ AND HIS WIFE/

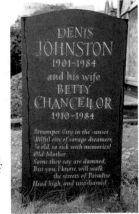

BETTY/CHANCELLOR/1910-1984/STRUMPET CITY IN THE
SUNSET/WILFUL CITY OF SAVAGE DREAMERS/SO OLD, SO SICK
WITH MEMORIES/OLD MOTHER/SOME THEY SAY ARE DAMNED./
BUT YOU, I KNOW, WILL WALK/THE STREETS OF PARADISE/
HEAD HIGH AND UNASHAMED

James Joyce 1882- 1941

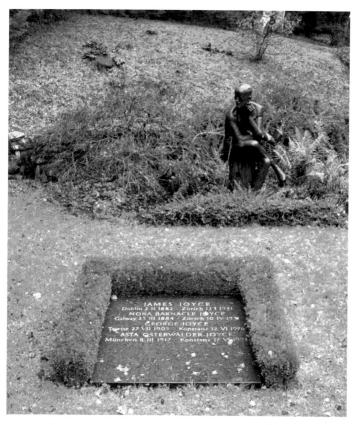

Born in Rathgar, Dublin. He spent most of his life in exile in
France, Italy and Switzerland often in poverty but supported by a
loving wife and an ever-growing circle of friends who believed in
his genius. *Chamber Music* was written in 1907 and *Dubliners*
appeared in 1914. *A Portrait of the Artist as a Young Man* was published in
instalments in 1914-1915. *Ulysses*, now considered one of the
major novels of the twentieth century, was published in Paris in
1922 but it caused much controversy and it was not published in
the U.K. until 1936. His final work, *Finnegans Wake* was published
in 1939. He died of a perforated ulcer in Zurich.

Two death masks were made of his face. His wife Nora chose a
wreath with the shape of a harp for the music that they both
loved. The day was cold and snowy. Nora felt the presence of a
priest at the service would be inconsistent with James' life and

beliefs. Heinrich Straumann, the Professor of English at the University of Zurich, gave a short address and this was followed by Lord Derwent, British Minister to Berne. Maz Geillinger, the poet, also spoke. The tenor Max Meili, sang an aria, *Addio terra, addio cielo,* from Montverdi's opera, L'Orfeo. As the coffin was being lowered into the ground Nora could see his face through the small glass window in the coffin and remarked how beautiful he was.

He is buried in Fluntern Cemetery, Zurich, Switzerland. The number of the grave was 1449 (photograph shows the original grave marker) and according to Fritz Senn, Director of the James Joyce Foundation in Zurich, it was situated on the right side of the first path into the cemetery, about two thirds way down.

Nora used to visit the grave regularly and remarked to a companion that Jim would probably have liked the place as he would be able to hear the lions roar from the adjacent zoo.

In 1948, the Irish government brought the body of W.B.Yeats back to be buried in Sligo. The remains were brought over in an Irish navy ship and a military guard of honour was present at the re-interment. Nora felt that the same honour should be accorded to Jim and she asked a number of people to make inquiries. But the church and the State were against such an event.

The lease of the grave expired after 25 years but the Swiss government provided a grave of honour for Jim and Nora. On Bloomsday 1966, they were reunited. The statue is by the American sculptor Milton Hebald.

The new grave is well signposted and is also included in the map at the entrance to the cemetery. The cemetery can be reached by taking the tram for the zoo. At the terminus the cemetery is situated before the zoo. Go in the first pedestrian entrance, walk to the top and turn right. Close by is the grave of **Elias Canetti**.

The inscription reads:
JAMES JOYCE/DUBLIN 2-II-1882
ZURICH 13-I-1941/NORA
BARNACLE JOYCE/GALWAY 23-
III-1884 ZURICH 10-IV-1951/
GEORGE JOYCE/TRIESTE 27-
VIII-1905 KONSTANZ 12-VI-
1976/ASTA OSTEEWALDER JOYCE/
MUNCHEN 8-III-1917
KONSTANZ 17-VI-1973

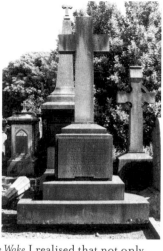

To mark Bloomsday 2004 I
had intended to do a special
section in this book showing the
location of the graves of those
people mentioned in Joyce's
works that are buried in Dublin.
However, after perusing *Before the
Wake* by Bob Williams and
Adaline Glasheen's *Third Census of the Wake* I realised that not only
could you reconstruct the city of Dublin from the information in
Joyce's work, you could nearly people it as well!

Many of Joyce's contemporaries are already mentioned in this
book and the graves of many more are to be found in my previous
book *Dead and Buried in Dublin*. So I content myself with the grave of
John O'Connell (see photograph above), who was Secretary to the
Committee of Glasnevin Cemetery at the time of the first

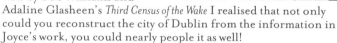

Bloomsday and the grave of **Matthew
Kane** who as the inscription says was the
model for more than one character.
Each year on Bloomsday a mock
funeral is held to his graveside. Both
are buried in Glasnevin Cemetery,
Dublin. *(See map page 246)*. O'Connell's
grave is on the path edge, Kane's grave
is three rows in from the path.

In addition I include the grave of
Davy Stephens who was a newspaper
vendor in Dun Laoghaire. He was a
well-known figure as he had a stand
near the ferry station and he was the
first person many saw when they landed
in Ireland. He is mentioned in Ulysses
and there is a photograph of him by
Robert French. He is buried in grave
number 2, Row T, West Section,
Deansgrange Cemetery, Dublin. *(See map
page 250 - the grave is on the road edge)*.

The grave is located seven plots up from
the beginning of the section and is in the
second row facing out. The inscription on
the gravestone reads: IN LOVING MEMORY
OF/DAVY STEPHENS/AGED 83 YEARS/WHO
DIED AT HIS RESIDENCE/5 ANGLESEA
BUILDINGS DUN LAOGHAIRE/ON 10TH SEPT

1925/SACRED HEART OF JESUS/HAVE MERCY ON HIM/ALSO HIS
DAUGHTERS/MARY MAGDALEN STEPHENS/DIED 30TH APRIL
1957/AND AGNES CAULFIELD/DIED 12TH NOV 1959/DEEPLY
REGRETTED BY HIS DAUGHTER MAY/R.I.P.

John Stanislaus (1849-1931) and **Mary Jane (1859-1903)
Joyce** were the parents of James Joyce.

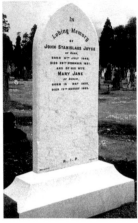

Mary Jane (May) Murray was the
daughter of a Longford wine and
spirit agent who did not think Joyce a
suitable choice for his darling
daughter. Worn out by eleven
children, a difficult husband and
cancer, she died at the age of 44 years.
In *Ulysses* Buck Mulligan chastises
Stephen Dedalus for refusing his
dying mother's wish to kneel down
and pray for her.

John Stanislaus was born into a
prosperous merchant family in Cork.
He was a well-known character in the
hostelries of Dublin. He was also a
spendthrift and his family often lived
in poverty and had to move house frequently. Yet James was very
fond of his father and acknowledged him as a major source for
his characters and his writing. He had promised his father in the
latter years that he would return to see him but he never did.
James wrote the inscription on the stone. Harriet Weaver sent
money to pay for the funeral. She did the same for James less
than a decade later. John Stanislaus and Mary Jane Joyce are
buried in Glasnevin Cemetery, Dublin. *(See map page 246 – the grave
is three rows from the road edge)*.

Nora (née Barnacle) Joyce 1884-1951 was born in Galway. She
went to work in Dublin as a chambermaid and there met James
Joyce. She went with him to Paris, Trieste and Zurich, bore his
children and eventually married him. She was a remarkable
woman who inspired Joyce in many ways and brought him the
love and stability he needed to create his works of genius. Brenda
Maddox's biography of Nora presents her as an individual in her
own right and not just as the wife of James Joyce. Nora died in
1951 and was originally buried on the other side of the path from
James, grave number 1790, about 50 metres away. It is possible
she didn't have the money to buy a double grave when James died.
Her funeral was attended by about 40 people, mostly friends
from the pension. The service was not performed by her regular
confessor and the stand-in priest according to Maria Jolas
referred to her as a great sinner. Maddox argues that the priest
was just using commonly quoted lines, which included that
phrase, from Goethe. The priest considered it a normal funeral.
Mr and Mrs Joyce were eventually reunited in 1966.

Their son **Giorgio** is buried with his second wife in the
same grave.

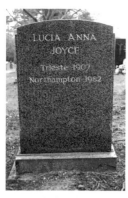

Their daughter, **Lucia** died in 1982 and is buried in plot number 11044, Kingsthorpe Cemetery, Northampton. Peter Mulligan, who photographed the grave for this book, organised a gathering at her graveside for the 100th Anniversary of Bloomsday.

Go in the main gate and follow the path around to the right. Take the first left path and the grave is about 50 yards further down on the left. It is presently under a large tree. Nora Barnacle's father, **Thomas Barnacle**, is buried in grave number 5, Row 14, Section G, Rahoon Cemetery, Galway.

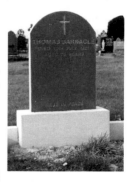

Michael 'Sonny' Bodkin 1880-1900 was a sweetheart of Nora Barnacle. He died

at the age of 20 from TB, although being out in the rain to see Nora off to Dublin didn't help. His unrequited love for her was marked in a poem by Joyce entitled *She Weeps Over Rahoon*. Three times I have visited this grave and three times the dark muttering rain was falling softly, softly falling.

The inscription reads: ERECTED BY PATRICK L AND WINIFRED BODKIN IN LOVING MEMORY OF THEIR DEARLY BELOVED SON/ MICHAEL MARIA WHO DIED ON THE 11TH FEBRUARY 1900 AGED 20 YEARS/LORD JESUS DELIVER HIM. COMFORTRESS OF THE AFFLICTED INTERCEDE FOR HIM/WINIFRED BODKIN DIED 18TH FEBRUARY 1915 AGED 65 YEARS/SACRED HEART OF JESUS RECEIVE HER SOUL/ALSO PATRICK L BODKIN DIED 11TH JUNE 1928/THE LORD GAVE AND THE LORD HAS TAKEN AWAY/ BLESSED BE THE NAME OF THE LORD JOB CHAPTER 1-21

He is buried in Rahoon Cemetery, Galway. There are two gates. Take the higher one and stay close to the wall on the left-hand side. The first raised tomb, about four or five from the start belongs to Michael Bodkin. The inscription is on the top of the tomb but is quite difficult to read from the path. It is clear and quite readable from an angle if the light is in the right place.

In 1912, while on a visit to Galway, Joyce cycled nearly 35 kilometres to Oughterard to find the grave of Michael Bodkin, not realising it was within walking distance of where he was staying. The cemetery at Oughterard was used as the resting place of the character Michael Furey in the story *The Dead*. The character of Michael Furey is based on both Michael Bodkin and

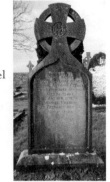

Michael Feeney.

Michael Feeney was another of Nora's admirers and also died young. Feeney is buried in grave number 3 and 4, Section D, Row 4 in the same cemetery as Bodkin. Continue on the path you were on for Michael Bodkin and take the last path before the wall. The letter D is painted on the ground. Turn right and the grave is four rows down on the left-hand side and three/ four in.

Patrick Weston Joyce 1827-1914

Born in Glenosheen, County Limerick. He worked in various teaching positions throughout his career. He published works on linguistics, music, geography and history. These include *English as We Speak It in Ireland*, *The Origins and History of Irish Names of Places*, *Ancient Irish Music*, *The Geography of the Country of Ireland*, *Old Celtic Romances* and *A Social History of Ancient Ireland*. He is buried with his brother Robert Dwyer and other family members in Glasnevin Cemetery, Dublin. *(See map page 246)*. The grave is not easy to spot as it is facing away from the road. Look for three obelisk style monuments beside each other to Horgan, Morgan and Fortell. The Joyce plot is behind the Morgan plot.

Robert Dwyer Joyce 1830-1883

Born in Glenosheen, County Limerick. He was a brother of Patrick Weston Joyce. He worked as a teacher before taking up medical studies which he completed in 1865. He went to America in 1866 where he lectured in Harvard Medical School and also became more closely involved with the Fenians. He wrote poems and prose. His works include *Ballads, Romances and Songs*, *Legends of the Wars in Ireland*, *Ballads of Irish Chivalry*, *The Leaping Leprechaun* and *Deirdre*. His best known ballad is *The Boys of Wexford*. He returned to Ireland shortly before his death. He is buried with his brother, Patrick

Weston, in Glasnevin Cemetery, Dublin. *(See map page 246)*.

The inscription on the front of the gravestone reads: SACRED/ TO THE MEMORY OF/ CAROLINE JESSIE JOYCE/ WHO DIED THE 29TH MAY 1870/ AGED NINE YEARS AND FIVE MONTHS/ AND OF RICHARD JOYCE WHO DIED/ THE 26TH DECEMBER 1875/ AGED ONE YEAR AND FIVE MONTHS/ THE BELOVED CHILDREN OF/ PW JOYCE LLD OF DUBLIN/ A PRAYER FOR/ ROBERT DWYER JOYCE MD/ PRAY FOR THE SOUL OF/ CAROLINE JESSIE JOYCE/ THE DEARLY BELOVED WIFE OF/ P W JOYCE

LL.D OF DUBLIN/WHO DIED 28TH MARCH 1909/ALSO FOR THE
SOUL OF THE ABOVE NAMED/PATRICK WESTON JOYCE LL.D/
WHO DIED 7TH JULY 1914

On the back of the stone is the inscription: A PRAYER FOR/
ROBERT DWYER JOYCE MD/A PRAYER FOR/CAROLINE JESSIE
JOYCE/A PRAYER FOR/PATRICK WESTON JOYCE

Stanislaus Joyce 1884-1955

Born in Dublin. He was the older brother of James. He worked as
an English language teacher and Professor in Trieste. He believed
in his brother's genius and supported him in many difficulties.
He himself wrote *Recollections of James Joyce by his Brother S.J.*, *My Brother's
Keeper*, *The Dublin Diaries of Stanislaus Joyce* and *The Complete Diaries of
Stanislaus Joyce*. He died in Trieste and is buried in the cemetery on
Via della Pace. The inscription reads: PROF. STANISLAUS JOYCE
1884 - 1955/FRIDA LICHTENSTEIGER/VED. SEPPELE 1900 - 1982/
NELLY JOYCE/N. LICHTENSTEIGER 1907 - 1990

Patrick Kavanagh 1904-1967

Born near Inniskeen, County Monaghan. In 1936 his first
collection of poems was published – *Ploughman and Other Poems*. This
was followed by *The Green Fool*. He went to Dublin in 1939 and eked
out a living as a journalist and writer. *The Great Hunger* was
published in 1942, another collection of poems in *A Soul for Sale*
and a novel *Tarry Flynn*. He survived cancer in 1955 and some of
the best poems after this period were collected in *Come Dance with*

Kitty Stobling. His *Collected Poems* published in 1964 established him as a major poet.

He died in Dublin. It was his wish that he be commemorated with no 'hero-courageous' tomb, just a canal seat for the passer-by.

He is buried in St Mary's Churchyard, Inniskeen, 12 kilometres off the Dundalk to Carrickmacross road, County Monaghan. The church is at the Dundalk end of the village and is the older St Mary's which now houses a centre dedicated to Patrick Kavanagh.

The grave is well signposted several times within the cemetery.

The cross has the inscription: PATRICK KAVANAGH/ 21 OCT 1904 – 30 NOV 1967/ AND PRAY FOR/ HIM/ WHO WALKED/ APART/ ON THE HILLS/ LOVING LIFE'S/ MIRACLES.

The stone on his grave reads: THERE WERE STEPPING STONES/ ACROSS A STREAM. PART OF MY/ LIFE WAS THERE. THE HAPPIEST/ PART.

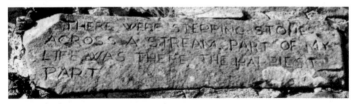

The Taoiseach John A. Costello, was among the thousands of people who attended the funeral mass in Haddington Road Church. After the service the funeral cortege went by his old haunts – Pembroke Road, Raglan Road and Waterloo Road. In Monaghan it took a detour to pass the family home and a huge crowd walked after the cortege for the last half kilometre. The oration was given by Leo Holohan, and Seamus Heaney, John Montague, David Wright and Richard Riordan all recited a Kavanagh poem.

His brother Peter "erected a memorial over his grave made up of flagstones from his favourite haunts with other memorabilia and placed a cross

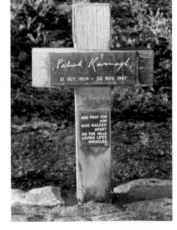

of Burma teak at its head with the inscription." (*Peter Kavanagh, Patrick Kavanagh 1904-1967 A Life Chronicle*)

But Patrick was not to rest in peace. His widow Katherine died in 1989. According to newspaper reports at the time the grave beside Patrick's was opened for the burial. However a dispute arose and the interment was postponed for a few hours. Eventually she was buried in the same single grave as Patrick.

According to Peter, in his biography, Patrick's coffin was damaged and Katherine's coffin set to rest on the poet's bones. The memorial was scattered and the cross was broken.

Peter went on to write that a year later a cromlech type memorial was erected over the grave. In 1998, it was removed and replaced with the original memorial and Peter was arrested on a larceny charge. The schematic diagram of the flagstones on the grave is to be found in Peter Kavanagh's book.

John B(rendan) Keane 1928-2002

Born in Listowel, County Kerry. He spent most of his life in his native town where he ran a pub. He was an extremely popular figure throughout Ireland. His many plays include *Sive*, *Many Young Men of Twenty*, *The Year of the Hiker*, *Big Maggie* and *The Field* which was made into a successful film. He also wrote novels, short stories and other prose material including *The Contractors*, *Durango* and *The Bodhrán Makers*.

He is buried in Listowel, in the cemetery located on the Tarbert road opposite the library. There is an old church tower in the grounds. Go in the main gate, past the intersection and Brian MacMahon's (*q.v.*) grave is third row back on the left-hand side almost opposite a squat tomb erected by Daniel Brown of Listowel. J. B. Keane's grave is almost directly behind MacMahon's grave towards the football stand.

Shops closed on the day of the funeral and many shop windows displayed his books. The Bishop of Kerry, assisted by 15 priests, said the funeral mass which was attended by the President, politicians, entertainers, writers and a large crowd of local people who were immensely proud of their local celebrity. The funeral cortege stopped outside the pub he owned and then again at the new Listowel bypass which bears his name. Crowds lined the streets.

I visited the grave shortly after the funeral in July 2002. The temporary cross had the words: DR JOHN B. KEANE/DIED/ 30.5.2002/R.I.P. A permanent stone was erected in 2003.

One Saturday afternoon in late January 2004, I dropped into the John B. Keane bar in William Street. I met Mary, his widow. She told me the gravestone was the work of Ken Thompson. She also insisted I stay and have a drink or at least a cup of coffee. But alas I was on my way to Clonakilty and couldn't afford the time. But when the book is published I'll make my way to Listowel and to the John B. Keane bar and I'll drink to the memory of a fine Irish writer.

Molly Keane 1904-1996

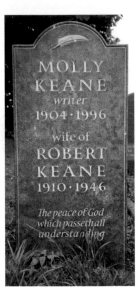

Born in County Kildare. She wrote her first ten novels and several plays under the name of M.J. Farrell. These include *The Rising Tide*, *Two Days in Aragon*, *Loving Without Tears*, *Taking Chances, All Passions Spent* and *Treasure Hunt*. Her plays were directed by Gielgud. After a particularly bitter criticism of *Dazzling Prospect*, she stopped writing for many years. In 1981 *Good Behaviour* was released under her own name. It was short-listed for the Booker Prize and she went on to produce *Time after Time*, *Loving and Giving* and *Conversation Piece*. She was the daughter of Moira O'Neill (*q.v.*). She is buried in St Paul's Churchyard, Ardmore, County Waterford. The graveyard has only a few graves and the grave is easily found.

Peadar Kearney 1883-1942

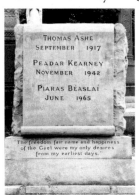

Born in Dublin. A house painter by trade, he wrote the words to *The Soldiers Song* in 1907. It became the anthem for the Volunteers in 1913 and its popularity grew particularly after 1916. Kearney fought with Thomas MacDonagh in Jacob's Factory during Easter Week and was interned in County Down. Other songs he wrote include *The Tri-Coloured Ribbon*, *Down by the Glenside* and *Whack Fol the Diddle*. He is buried in the Republican Plot, Glasnevin Cemetery, Dublin. (*See map page 246*).

John Keegan 1816-1849

Born in Killeaney, Shanohoe, County Laois. He wrote for the *Nation* and other periodicals. He was buried in a common grave in Glasnevin Cemetery. (*See map page 246*). A John Keegan Commemoration Committee was formed in 1999 in order to

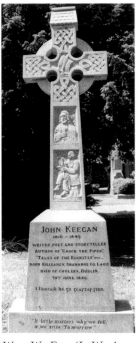

mark his grave with an appropriate memorial. According to their website the location of the grave was identified by Tony Delaney with the assistance of Joe Kenny of Glasnevin Cemetery. Dr Pádraig Ó Macháin designed the cross and Brendan Crowe carved the memorial. The panels show St Peter from an 18th century painting upon which the story *The Dithreoch's Legacy* is based, and an uileann piper to reflect Keegan's best known poem *Caoch the Piper*. The cross was unveiled by Ciarán MacMathúna and Tony Delaney.

The inscription reads: JOHN KEEGAN/ 1816-1849/WRITER, POET AND STORY TELLER/AUTHOR OF "CAOCH THE PIPER"/"TALES OF THE ROCKITES" ETC./BORN IN KILLEANEY, SHANOHOE, CO LAOIS/DIED OF CHOLERA, DUBLIN/30TH JUNE 1849/I LÍONTAIBH DÉ GO gCASTAR SINN/

On the base are lines from Keegan's poem *Tomorrow*: IT MATTERS LITTLE WHY WE FELL/IF WE ARISE TOMORROW

Éamon Kelly 1914-2001

Born in County Kerry. He was a storyteller, a writer and an actor. His works include *In My Father's Time*, *English That For me*, *The Apprentice* and *The Journeyman*. The graveside oration was given by his lifelong friend Éamon Ó Murchú – "Éamon's quintessential voice, imaginative skill, facile expression, sense of timing and powerful restraint have made him one of Ireland's best known actors of stage, television and film". He is buried in grave number M 508 in Fingal Cemetery, Balgriffin, County Dublin. *(See map page 256)*. Go in the main gate and turn left. Take the third road on the right and it is up at

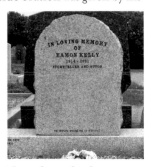

the top in section M on the left-hand side at the path edge.

Patrick Kennedy 1790-1872

Born in County Wexford. He moved to Dublin where he worked as a teacher before opening a bookshop. His periodical writings were published in *Legendary Fictions of the Irish Celts*, *The Banks of the Boro*, *Legends of Mount Leinster* and other books. He is buried in Glasnevin Cemetery, Dublin. *(See map page 246)*. Coming from the old entrance gates you will see a tall monument with four columns to

O'Brien on the right-hand side of the road. Three or four rows before the monument, at the grave of Mary Ann Read, and 14 rows down is the Kennedy grave.

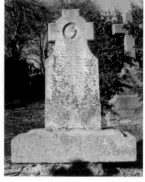

According to O'Duffy's *Historic Graves in Glasnevin*, the inscription reads: THY WILL BE DONE SACRED TO THE MEMORY OF PATRICK KENNEDY, WHO DIED 17TH SEPTEMBER 1872, AGED 82 YEARS AND OF ELIZABETH HIS WIFE, WHO DIED 10TH DECEMBER, 1867, AGED 75 YEARS. The *Glasnevin Cemetery Guide* gives the location of the grave as Ba 72 but this grave inscription reads: SACRED TO THE MEMORY OF/ CATHERINE/THE BELOVED WIFE OF/ LOUIS KENNEDY/WHO DEPARTED THIS LIFE JUNE 1887/AGED 86 YEARS/ALSO IN MEMORY OF/PATRICK AND MARIA KENNEDY/ PARENTS OF THE ABOVE NAMED/LOUIS KENNEDY.

To further complicate matters, Fitzpatrick's *The History of Dublin Catholic Cemeteries*, gives his death date as 28th March 1873.

Thomas Kettle 1880-1916

Born in Artane, Dublin. He was called to the bar in 1905 and was MP for East Tyrone 1906-1910. He joined the Volunteers in 1913. Later he came to the belief that England would honour its commitment to Home Rule and he helped recruit Irishmen to serve in the British Army, although he became disillusioned after the Easter Rising. His writings include *The Day's Burden* and *Poems and Parodies*. There is a memorial to him in St Stephen's Green. The words are taken from a poem he wrote to his daughter Betty shortly before he died:
DIED NOT FOR FLAG, NOR KING, NOR EMPEROR/BUT FOR A DREAM, BORN IN A HERDSMAN'S HUT/AND FOR THE SECRET SCRIPTURE OF THE POOR.

He died in battle at the Somme and his body was not

recovered. Kettle is commemorated on the Thiepval Memorial, Pier and Face 16 C. The Memorial is located on the D73 off the main Bapaume to Albert Road. Turn off at Pozières.

Betty Dooley, his daughter died in 1996 and is buried in the family plot in Swords.

Charles Kickham 1828-1882

Born in Mullinahone, County Tipperary. He was a poet, novelist and patriot. A leading Fenian, he worked on the IRB paper the *Irish People*. In 1865, he was arrested and spent four years in Pentonville prison. After his release he concentrated on writing.

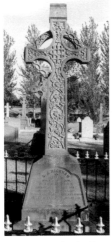

His novel *Knocknagow* is still read today and other works include *Sally Cavanagh* and the song *Slievenamon*. His collected poems were published in 1870. He died in Dublin but it was his wish that he be buried in Mullinahone, County Tipperary. Coming from the Clonmel direction, the church is on the road to Callan.

As Comerford relates in his biography of Kickham, a couple of thousand marchers and eleven bands accompanied the remains from Blackrock to Kingsbridge (Heuston) station. The remains stayed in Thurles for the night, though not in the cathedral as a belated request was turned down. A large crowd turned out as the funeral made its way to St Michael's Churchyard, Mullinahone. The cemetery gates were locked and no priest was waiting. The lock was forced, a priest eventually arrived and John Daly gave the oration. The grave is situated at the back of the church, close to the wall.

The base of the cross has the inscription: C.J.KICKHAM/ BORN 9TH MAY 1828/ DIED 22ND AUGUST 1882/ JOURNALIST, NOVELIST, POET/ BUT BEFORE ALL PATRIOT/ TRAITOR TO CRIME, VICE, FRAUD/ BUT TRUE TO IRELAND AND TO GOD/ R.I.P.

A stone lying on the ground at the foot of the cross has the following inscription: CHARLES KICKHAM/ RARE LOYAL HEART AND STATELY HEAD OF GREY/ WISE WITH THE WISDOM WRESTED OUT OF PAIN/ WE MISS THE SLENDER HAND, THE BRAVE BRIGHT BRAIN/ AND FAITH AND HOPE TO POINT AND LIGHT THE WAY/ OUR LAND SHOULD GO. OH SURELY NOT IN VAIN/ THAT BEACON BURNED FOR US, FOR WE CAN LAY/ FAST HOLD OF THE FAIR LIFE WITHOUT A STAIN/ AND MOULD OUR OWN UPON IT – WE CAN WEIGH/ FULL WELL HIS FATE WHO SUFFERED, SANG AND DIED/ AS NOBLY AS HE LIVED. AH! NOUGHT COULD TAME/ THE TRUTH IN HIM, FOR NOUGHT COULD THRUST ASIDE/ HIS LIFELONG LOVE – THE LAND WHOSE SACRED NAME/ THROBBED TO THE LAST THROUGHOUT HIS LIFE'S EBBING TIDE/ AND LIT THE FACE OF DEATH WITH LOVE'S WHITE FLAME/ ROSE KAVANAGH/ 1859- 1891/ DEDICATED BY THE PEOPLE OF MULLINAHONE/ AND OTHER FRIENDS/ A.D. 1950

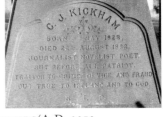

Thomas J Kiernan 1897-1969

Born in Dublin. He served as a diplomat in many countries and was ambassador to West Germany, Canada and America. His works include *A Study in National Finance*, *A History of the Financial Administration of Ireland to 1817*, *The Irish Exiles in Australia* and a novel. He was married to Delia Murphy, the Ballad Queen of Ireland. They

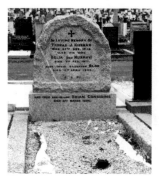

are both buried in Deansgrange Cemetery, Dublin. *(See map page 250)*. The grave is about 40 plots from the cemetery boundary and is behind a 4 grave plot with a white memorial stone to Denis Healy.

The inscription reads: IN LOVING MEMORY OF/THOMAS J. KIERNAN/DIED 27TH DEC. 1969/ALSO HIS WIFE/DELIA (NEE MURPHY)/DIED 12TH FEB 1971/ALSO THEIR DAUGHTER BLON/DIED 17TH APRIL 1992/R.I.P./AND THEIR SON IN LAW BRIAN CONSIDINE/DIED 31ST MARCH 1996

Lord Killanin 1914-1999

Born Michael Morris, in Melbourne. He worked as a journalist, served with the British Army during the Second World War, made films, was involved with the Olympic movement for nearly 50 years and wrote a number of books. These include, with Michael V. Duignan, *The Shell Guide to Ireland* and *My Olympic Years.*

The Shell Guide was the travel bible our family took with us on all our travels throughout Ireland. I still carry it with me on my present travels and even though I have many other guides, I think it is still unsurpassed. We wouldn't have gone on holidays without him.

He is buried in Bohermore Cemetery, Galway. Go in the main entrance and the Killanin monument is at the first intersection on the left on the far side of the path. The inscription for him reads: IN THE VAULT BENEATH/REST THE REMAINS OF/THE RIGHT HONBLE/MICHAEL MORRIS 3RD BARON KILLANIN/OF SPIDDAL/PRESIDENT/INTERNATIONAL OLYMPIC COMMITTEE/1972-1980/DIED 25TH APRIL 1999 AGED 85 YEARS.

Fintan Lalor 1807-1849

Born in County Laois. His ideas would later bring about the Land League. Although his writings were collected, they were not published until 1918. His funeral stretched the length of O'Connell Street.

He is buried in Glasnevin Cemetery, Dublin where his grave lay unmarked for over 60 years. *(See map page 246)*.

The inscription on the gravestone reads:
I NDÍL-CHUIMHNE/SHÉAMUIS FIONNTÁIN UI LEATHLOBHAIR/A

RUGADH AN 10
MHADH LÁ DE
MHÁRTA 1809/
AGUS A
CAILLEADH/AN
27 MHADH LÁ
DE MHÍ NA
NODLAG 1849/
ÉIREANNACH
DÍLIS A THUG A
SHAOGHAL/AR
LORG SAOIRSE
ÁR DTÍRE/AGUS
AG CUR
FEABHSA AR
STÁID NA NGAEDHAEL/I N-A DTALAMH DÚTHCHAIS/AR DHEIS
DÉ GO RAIBH A ANAM/WE OWE NO OBEDIENCE/TO LAWS
ENACTED BY ANOTHER COUNTRY/WITHOUT OUR CONSENT/
CUMANN NA UAGH LAOCHRADH A THÓG SO

Maura Laverty 1907-1966

Born in Rathangan, Co. Kildare. After a few
years in Spain she returned to Ireland to work
in journalism and broadcasting. She wrote
novels, children's books and cookery books.
Her works include *Never No More, Alone We Embark,
No More Than Human* and *Lift Up Your Gates*. Her
play, *Tolka Row*, led to the setting up of a
television series of the same name. She is
buried in Glasnevin Cemetery, Dublin.
(See map page 246).

Mary Lavin 1912-1996

Born in Walpole Massachusetts. She went
to school in Dublin and attended
University College Dublin. Her first
collection of short stories, *Tales from Bective
Bridge*, won the James Tait Black Memorial
Prize. Other collections followed and
established her as one of the finest of
short story writers. Her works include
*Tales From Bective Bridge, A Likely Story, Collected
Stories, A Memory and Other Stories, Happiness, A
Family Likeness, A Single Lady* and the novels
The House in Clewe Street and *Mary O'Grady*.

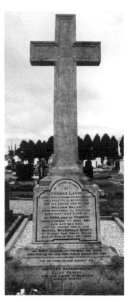

She is buried in the family plot,
along with her two husbands, in St Mary's
Cemetery, Navan, County Meath.
Coming from the Dublin direction,
drive under the railway bridge and take
the next road on the right and then the
next turn on the left. It is signposted.

113

The cemetery is located on the right-hand side and is about one and a half kilometres from the main Dublin road. Go in the main gates and directly in front, at the far end of the cemetery is a crucifix. Head towards it and at the first crossroads turn left. Continue until you come to a path further down on the right-hand side. Five graves past this path and also on the right-hand side, is the Lavin family plot.

There were obituaries in all the major Irish and British papers. Tom MacIntyre spoke at the graveside and was one of many writers who attended. The Taoiseach, John Bruton, spoke of her as a neighbour and a friend.

Mary Leadbeater 1758-1826

Born in Ballitore, County Kildare. Her grandfather taught Edmund Burke in the local Quaker school which he founded. She became the local postmistress and wrote poems and stories and kept a diary of events locally. Her works include *Cottage Dialogues, The Landlord's Friend, Tales for Cottagers* and *Collection of Lives of the Irish Peasantry*. She is best known however for her journals which were published, after her death, as *The Leadbeater Papers*. The house where she wrote the *Papers* is well preserved and currently the local library operates from there. They have a framed map of the cemetery and another document which identifies the graves of particular people.

She is buried in the local Quaker cemetery. Ballitore is just off the main Dublin to Carlow road the N9, on the right-hand side coming from the Dublin direction. It is signposted. The cemetery is just before the village on the left-hand side, more or less opposite the Garda station. There is a signpost and the cemetery is located in a field though there is no path down to it. The grave is located about half way up the walled enclosure on the right-hand side. There is a last row of four upright stones and two beside them on the ground. (Foreground of photograph). Mary's stone is broken at the top left-hand side which has grass presently growing over it. The name Mary and the first part of the surname are recorded in this broken off portion. The inscription is difficult to read but can still be deciphered: MARY LEADBEATER/ DIED/ THE 27TH DAY OF THE/ SIXTH MONTH/ 1826/ AGED 67 YEARS

William Edward Hartpole Lecky 1838-1903

Born in Dublin. He was an eminent historian whose most famous work was *A History of England in the Eighteenth Century (eight volumes)*. Other works include *History of the Rise and Influence of the Spirit of Rationalism in Europe, History of European Morals from Augustus to Charlemagne, Democracy and Liberty* and various poems and essays.

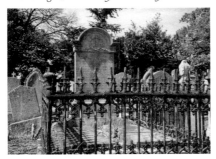 There is a statue of him near the campanile in Trinity College Dublin. He was cremated in London and his ashes were buried in Mount Jerome Cemetery, Dublin. *(See map page 252)*. Go in the main gate, past the memorial works on the left and take the second path on the right which is crescent shaped. On your left, about two thirds down, where the road begins to veer to the right, three rows in is the gray headstone and surround of the grave of the historian, Lecky. There are high railings around this grave.

The inscription reads: SACRED TO THE BELOVED MEMORY OF/THE RIGHT HONOURABLE/WILLIAM EDWARD HARTPOLE LECKY/O.M. L.L.D. D.C.L. LITT. D./HISTORIAN & PHILOSOPHER/A REPRESENTATIVE OF DUBLIN UNIVERSITY/IN THE HOUSE OF COMMONS 1895-1903/BORN 26 MARCH 1838 DIED 22 OCTOBER 1903/"THE MEMORY OF THE JUST IS BLESSED"/AND HIS WIFE/CATHARINA ELISABETH BOLDEWINA/BARONESS VAN DEDEM/BORN 16 APRIL 1842 DIED 23 MAY 1912/"HE GIVETH HIS BELOVED SLEEP"

Francis Ledwidge 1887-1917

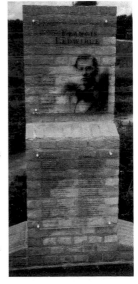 Born in Slane, Co. Meath. He left school at a young age and worked as a labourer, miner and shop assistant. He was interested in poetry from an early age and his works include *Songs of the Field, Songs of Peace* and *Complete Poems*. He was a member of the Irish National Volunteers but he answered Redmond's call and served with the 1st Battalion Inniskilling Fusiliers in the War. He was killed by a shell while laying planks on muddy terrain to make easier the movement of artillery and equipment. A memorial was erected at the spot on 31st July 1998. It has a portrait of him and it records his birth and death place and date as well as his *Soliloquy* in English and in Dutch/ Flemish, translated by Benno Bernhard. Bernhard attended

the unveiling along with Dermot Bolger, The Mayor of Ypres, the poet's nephew Joe Ledwidge, an Irish delegation and 200 local people. The *Last Post* was played.

Ledwidge is buried about 100 metres from where he fell, in grave number 5, plot 2, row B, Artillery Wood Cemetery. The stone over the grave has the following inscription: 16138 LANCE CPL/ F.E. LEDWIDGE/ROYAL INNISKILLING FUS/31ST JULY 1917 AGE 29

The cemetery is about two kilometres east of the village of Boesinge near Ypres, Belgium.

Joseph Sheridan Le Fanu 1814-1873

Born in Dublin. He was a novelist, short story writer and poet but he is best known as a writer of the macabre and supernatural. After being called to the Bar he turned to journalism and edited and owned a number of newspapers. After the death of his wife, he withdrew from society and took to writing novels again. He produced over a dozen novels as well as books of short stories in this period to his death. His works include *The House by the Churchyard*, *Uncle Silas* and *In a Glass Darkly*. He is buried in grave number C122-399, Mount Jerome Cemetery, Dublin. *(See map page 252 – the grave is on the path edge)*.

The official cemetery record describes the monument over the grave as having a granite platform on four balls. In various biographies there are line drawings and photographs of such a monument in the correct general area. The grave shown on this page doesn't correspond to the description in the records but it does have the inscription which marks it as the Bennett/Le Fanu plot. The inscription is very difficult to read. It mentions George Bennett Q.C., his eldest son the Rev George Bennett, his

daughter Susan (Susanna), ALSO HER HUSBAND/JOSEPH SHERIDAN LE FANU/WHO DIED THE 7TH OF FEBRUARY 1873 AGED - (YEARS)

The inscription to Le Fanu is the second one from the end.

Maurice Lenihan 1811-1895

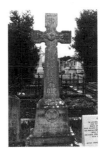

Born in Waterford. He was an historian who became Mayor of Limerick. His best known work was *Limerick: Its History and Antiquities*. He is buried in Mount Saint Laurence Cemetery in Limerick. Go in the main gate and it is on the right hand side close to the church and several rows in from the road.

Desmond Leslie 1921-2001

Born in London. He was the son of Shane Leslie. He co-authored *Flying Saucers Have Landed*, which was translated into more than 50 languages. Other works include *The Jesus File, Pardon My Return* and *The Incredible Mr Lutterworth*. A notice on the back page of the *Irish Times* stated "The Hon. Desmond Leslie passed away peacefully at the break of a Magnificent Mediterranean Dawn on 24th February 2001. He was surrounded by his loved ones, his beloved wife Helen, sons Mark and Sean, daughters Wendyl, Antonia, Samantha and Camilla, his brother Sir John Leslie and Ultan Bannon, Bill Bailey and Jenny Fibbs. Brother Fire will release his atoms to Mother Earth, Goddess Gaia, on 28th February in France".

Sir Shane Leslie 1885-1971

Born in Glaslough, County Monaghan. He was educated at Eton, Paris and Cambridge. In 1908 he met Tolstoy and described him as having the greatest influence on his life. He wrote poetry, prose, religious and philosophical studies and biographies. Pope Pius XI made him a Privy Chamberlain. His works include *The End of a Chapter, The Celt and the World, The Skull of Swift, Doomsland, The Cuckoo Clock and Other Poems, Long Shadows* and *Ghost Book*. He lived mostly in England.

He is buried in St Salvator's, Glaslough, County Monaghan. The church originally was part of the Castle Leslie estate but was taken over by the Church of Ireland. Sir Shane Leslie became a Catholic and was buried outside the church grounds in a walled off area adjoining the church walls.

Charles James Lever 1806-1872

Born in Dublin. He became a doctor and practised medicine in several Irish towns. He also wrote over 30 books which include *Harry Lorrequer, Charles O'Malley* and *The Martins of Cro'Martin.* He went to Brussels and became British Consul in a number of cities before his final appointment to Trieste where he died. He continued to write until his death although his later novels were somewhat bleaker than his earlier work.

He is buried in the English Cemetery, Trieste, Italy. The cemetery is at the very top left of the S. Anna Civil Catholic cemetery (in the very centre of Trieste just below the Ippodrome). There is a separate entrance on Via dell'Istria and Via Fonte Oppia. The grave is at the end of the small pavement just in front of the entrance close to the perimeter wall. Access can also be obtained from the military cemetery. After a visit to the site, Alfred Perceval Graves set up a fund to restore the grave. Lever's grave is in the foreground of the photograph.

The inscription reads:
CHARLES LEVER/ BORN NEAR DUBLIN 31 AUGUST 1809/ DIED AT TRIESTE 1 JUNE 1872

A friend had taken a photo of the grave for me but the sun had been shining directly on the grave and the photo was too bright. A year later I stopped over in Trieste for a half day to obtain a better photo but it rained so heavily I wasn't even able to leave the bus station. Earlier in 2004 a cousin of another friend, provided this photo and the one of the grave of Stanislaus Joyce.

Clive Staples Lewis 1898-1963

Born in Belfast. A critic and writer, he spent most of his working life in Oxford.
His critical works include *The Allegory of Love*, which won the Hawthornden Prize and *English Literature in the Sixteenth Century excluding Drama. The Screwtape Letters* was among his books on religion and *The Chronicles of Narnia* is a seven volume series of books for children. His autobiographical *Surprised by Joy* later inspired the film *Shadowlands.* His novels include *Out of the Silent Planet* and *Perelandra.*

He is buried in Heading Quarry Churchyard, Oxford, Oxfordshire. A.N. Wilson, in his biography of Lewis, wrote that his brother Warnie wanted the funeral private and asked the local vicar not to give any notice of the obsequies. Warnie was unable

to face the funeral and only a small group of friends attended the burial. One of those who attended was George Sayer who gave a moving account of the proceedings in his biography of Lewis. The day was cold but sunny and very still. The flame of a lighted candle on the coffin didn't flicker. After the funeral, the will was read.

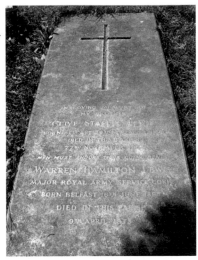

Warnie chose the gravestone and the inscription from *King Lear*, which was on the calendar in their mother's bedroom the day she died (*A.N. Wilson*). The grave is signposted. The inscription reads: IN LOVING MEMORY OF/MY BROTHER/CLIVE STAPLES LEWIS/BORN BELFAST 20TH NOVEMBER 1898/DIED IN THIS PARISH/22ND NOVEMBER 1963/MEN MUST ENDURE THEIR GOING HENCE/ WARREN HAMILTON LEWIS/MAJOR ROYAL ARMY SERVICE CORPS/ DIED IN THIS PARISH/9TH APRIL 1973

J.R.R. Tolkien is buried in the same graveyard. There is a plaque to Joy Davidman, whom Lewis married in December 1956, at the Oxford Crematorium. C.S. Lewis's parents are buried in grave number D687, City Cemetery, Belfast.

Lady Longford (née Christine Trew) 1900-1980

Born in Somerset. She was a novelist and playwright whose works include *Making Conversation, Mr Jiggins of Jigginstown, Printed Cotton* and *The United Brothers*. She is buried with her husband in Mount Jerome Cemetery, Dublin. (*See map page 252 – the grave is on the road edge*). The gravestone is by Séamus Murphy and there are tragic and comic theatre masks on the sides. The inscription reads: EDWARD ARTHUR HENRY/ SIXTH EARL OF LONGFORD/POET AND PATRIOT/BORN 29TH DEC 1902/DIED 4TH FEB 1961/AND/ HIS WIFE/CHRISTINE/WRITER AND DRAMATIST/1900-1980 See next entry.

 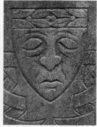

Lord Longford (Edward Pakenham) 1902-1961

Born in England. He played a major role in financially rescuing the Gate Theatre in 1931 and again was responsible for saving it when it was condemned by Dublin Corporation in 1956. He was also a playwright whose works include *Yahoo, The Medians, The Dove in the Castle, Poems from the Irish* and *The Vineyard*. He is buried with his wife in Mount Jerome Cemetery, Dublin. See previous entry.

Samuel Lover 1797-1868

Born in Dublin. He was both a painter and writer. He became a member of the RHA in 1828 and specialised in marine painting

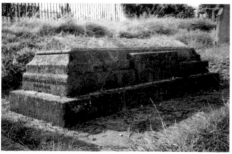

and miniatures. He was one of the founders of the *Dublin University Magazine*. His first book, *Legends and Stories of Ireland*, was a collection of stories based on folklore. He moved to London in 1835 and produced probably his best known novel - *Handy Andy*. With Charles Dickens he co-founded *Bentley's Miscellany* and he developed entertainments called "Irish Evenings" which were immensely successful. He wrote over 300 songs and composed librettos. Other works include *Rory O'More*. There is a plaque to him in St Patrick's Cathedral, Dublin which reads: IN MEMORY OF SAMUEL LOVER POET PAINTER NOVELIST AND COMPOSER WHO IN THE EXERCISE OF A GENIUS AS DISTINGUISHED IN ITS VERSATILITY AS IN ITS POWER BY HIS PEN AND HIS PENCIL ILLUSTRATED SO HAPPILY THE CHARACTERISTICS OF THE PEASANTRY OF HIS COUNTRY THAT HIS NAME WILL EVER BE HONOURABLY IDENTIFIED WITH IRELAND. HE DIED JULY 6 1868, AGED 72, IN FIRM FAITH THAT HAVING BEEN COMFORTED BY THE ROD AND STAFF OF HIS HEAVENLY FATHER IN APPROACHING THE DARK VALLEY OF THE SHADOW OF DEATH HE WOULD BE, THROUGH THE TENDER MERCIES OF THE SAVIOUR, GATHERED AMONG THE FLOCK OF THE GOOD SHEPHERD

He is buried in grave number 64148/13/PS (pathside), Kensal Green Cemetery, London. The inscription records family members on various parts of the tomb. The inscription to him reads: SAMUEL LOVER/ BORN 24TH FEB 1797/DIED JULY 6TH 1868. On the left-hand side is the word COMPOSER and on the right-hand side are the words NOVELIST, PAINTER.

Patricia Lynch 1894-1972

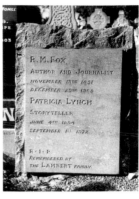

Born in Sunday's Well, County Cork.
She was educated in England and
Scotland. She was sent over to Ireland
by Sylvia Pankhurst to report on the
Rising and her *Rebel Ireland* was widely
circulated in America and Europe.
She won a silver medal at the
Tailteann Games in 1931 for her first
book *The Cobbler's Apprentice*. She went
on to write over 50 books, the best
known of which was *The Turf-cutter's
Donkey*. She was a well-respected
children's writer throughout Europe.

 In 1920, she married **R(ichard) M(ichael) Fox 1891-1969**,
a left wing journalist born in Leeds, England. His works include
*The History of the Irish Citizen Army, Green Banners: The Story of the Irish
Struggle, Rebel Irishwomen* and biographies of Jim Larkin and James
Connolly. They are buried together in Glasnevin Cemetery,
Dublin. (*See map page 246 - the grave is on the road edge*). The inscription
on the stone reads: R.M Fox/ AUTHOR AND JOURNALIST/
NOVEMBER 13TH 1891/ DECEMBER 29TH 1969/ PATRICIA LYNCH/
STORYTELLER/ JUNE 4TH 1894/ SEPTEMBER 1ST 1972/ R.I.P./
REMEMBERED BY/ THE LAMBERT FAMILY

Robert Wilson Lynd 1879-1949

Born in Belfast. He was a journalist for the *Daily News* from 1908
and literary editor from 1911. It was his work as an essayist for the
New Statesman from 1913-1945 that established his reputation. His

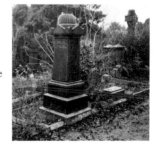

essays ran to over 30 volumes but he
also wrote books on Ireland and
literature which include *Home Life in
Ireland, Galway of the Races, Who Began it?
The Truth About the Murders in Ireland, The
Blue Lion* and *Dr Johnson and Company*. He
was a friend of Casement, Joyce and
other prominent literary figures.

 He is buried in Belfast City
Cemetery along with his wife, **Sylvia
Lynd** who was a poet and novelist.
The inscription reads: ROBERT LYND/ DIED 6TH OCTOBER 1949/
SYLVIA LYND/ DIED 1ST FEBRUARY 1952. The grave is situated in
section M in the old part of the cemetery. If you approach the
steps where sections J and K are located, the grave is on the last
path to the right just before the steps. A map may be obtained
from the city council offices.

Francis Stewart Leland Lyons 1923-1983

Born in Derry. He was Professor of Modern History at the
University of Kent 1964-1974 and Provost of Trinity College
Dublin 1974-81. He was one of the foremost historians of

modern Ireland. His works include *The Fall of Parnell 1890-91, Ireland since the Famine, Culture and Anarchy in Ireland 1890-1939* and biographies on Parnell and John Dillon. His remains were cremated and the ashes rest in Trinity College Dublin. *(See map page 255)*. There is a plaque on the wall at Chaloner's Corner, Trinity College. This is located at the back of the chapel. The plaque has the following inscription: HERE REST THE ASHES/ OF / FRANCIS STEWART LELAND LYONS/ FELLOW AND PROVOST OF THIS COLLEGE/ SOMETIME PROFESSOR OF MODERN HISTORY/ IN THE UNIVERSITY OF KENT AT CANTERBURY/ AND MASTER OF ELIOT COLLEGE/ RENOWNED AS A SCHOLAR, ESTEEMED AS A TEACHER/ BELOVED AS A MAN/ BORN 11 NOVEMBER 1923, DIED 21 SEPTEMBER 1983

Here rest the ashes
of
FRANCIS STEWART LELAND LYONS
FELLOW AND PROVOST OF THIS COLLEGE
Sometime Professor of Modern History
in the University of Kent at Canterbury
and Master of Eliot College
Renowned as a scholar, esteemed as a teacher
beloved as a man
Born 11 November 1923; died 21 September 1983

Donall MacAmhlaigh 1926-1989

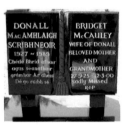

Born in Galway. He went to England in 1951 and worked as a navvy. He also worked as a gravedigger. His mostly autobiographical books reflect the difficulties of Irish emigrants in England around the 1950s. His works include: *Dialann Deoraí, Saol Saighdiúra* and *Diarmaid Ó Dónaill*. He is buried in Kingsthorpe Cemetery, Northampton. Enter through the main gate and follow the path around to the right. Continue until you reach a small roundabout with a small maintenance area in the centre. Walk on the grass to the right and the grave is about four rows in.

I knew he died in Northampton but didn't know where he was buried so I went on the internet and keyed in the name and the town. The only contact I found was for the Northampton Connolly Association. So I e-mailed them asking did anyone know where he was buried and what the possibilities were for obtaining a photo. Peter Mulligan replied the next day with the information and an offer to take some photos. A week later the photos arrived. Peter later sought out the location of the grave of Lucia Joyce and sent me photos.

Dorothy MacArdle 1889-1958

Born in Dundalk. She worked as a teacher. Although she came from a unionist background she became involved with Maud Gonne and Sinn Féin. She took the anti-Treaty side and spent time in prison. She wrote novels, plays for children and history books. Her works include *The Irish Republic, Tragedies of Kerry 1922-23, Uneasy Freehold* and *The Uninvited*. The latter two novels were made into films. She died in Drogheda and is buried in grave number G 52 (1954 extension), St Fintan's Cemetery, Sutton, Dublin. *(See map page 256)*. Go in the main entrance and take the second

road to the left. Go to the top and take the steps into the next section. Go up the main path and take the second path to the left. Go through the intersection and the grave is located on the path edge, five monuments down on the right-hand side.

The inscription reads: IN LOVING MEMORY/ OF/ DOROTHY MACARDLE/ BORN/ 7TH MARCH 1889/ DIED/ 23RD DECEMBER 1958/ HISTORIAN/ NOVELIST/ LECTURER/ SHE FOUGHT FOR FREEDOM

George Mann MacBeth 1932-1992

Born in Shotts, Lanarkshire. He worked for the BBC and was a member of The Group. He was known for his experimental and performance poetry. His poetic works include *The Broken Places, The Night of Stones, The Orlando Poems, Poems of Love and Death* and *Anatomy of a Divorce*. He also wrote a number of novels including *The Samurai, The Seven Witches* and *Anna's Book*. He moved to Ireland a few years before his death. He is buried in the Bohermore Cemetery, Galway.

Go in the main gate, past the house on your left-hand side and follow the road around to the left to the church. On the fourth row and five graves in on the left-hand side, just before you come to the church, is the grave of George MacBeth.

Maud Gonne MacBride 1865-1953

Born near Aldershot, England. She fought against injustice and for Ireland's independence.

In 1887, she fell in love with a French journalist and politician, Lucien Millevoye, who was married. They had a son, Georges, whom she left behind when she came to Ireland and became involved with the Irish cause and W.B. Yeats. She went back to France in 1891 when Georges contracted meningitis. She was grief stricken when he died.

As Margaret Ward writes in her biography of Maud Gonne, she arrived back in Ireland a month after the funeral on the boat that carried Parnell's

body. People thought her grief was a little exaggerated, mistaking that it was for Parnell. She wore black for the rest of her life. She always carried Georges' little boots with her and at her deathbed asked a friend to place them in her coffin. Later, as W.B. Yeats reported in his *Memoirs*, her daughter Iseult was conceived on Georges' grave.

In 1897, she celebrated Queen Victoria's Diamond Jubilee by decorating the graves of Irish patriots. And on Jubilee night in Dublin, she was involved in organising a mock funeral of the British Empire which led to rioting.

She inspired W.B.Yeats but turned down his offer of marriage. She eventually married John MacBride although the marriage lasted only a couple of years. Their son was Seán MacBride. She was interned in 1918 and was again in prison in 1923. She did not support the Treaty and devoted herself to the welfare of prisoner's families. She wrote articles on feminism, politics and social affairs as well as a memoir of her activities until 1903 – *A Servant of the Queen*. She is buried with her son Seán in Glasnevin Cemetery, Dublin. (*See map page 246 - the grave is on the path edge*).

Her own funeral was huge. Veterans of Cumann na mBan and the IRA marched behind the hearse. The coffin, draped with the Irish flag was carried to the Republican Plot by IRA men. The oration was given by The O'Rahilly who paid tribute to her courage, love of justice and persistence. The *Irish Times* described her as "the last of the romantic Republicans". There were tributes from all over the world.

Denis Florence MacCarthy 1817-1882

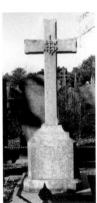

Born in Dublin. He was the first Professor of English at the Catholic University. He was known as the 'Poet of May'. His poems were collected in various volumes such as *Ballads, Lyrics and Poems, Underglimpses* and *The Bell-Founder*. Other works include centenary tributes to O'Connell and Thomas Moore, plays translated from the Spanish dramatist Calderón and *Poets and Dramatists*. He is buried in Glasnevin Cemetery, Dublin. (*See map page 246*). Coming from the old entrance, the grave is on the left, just past the four column monument to O'Brien and four rows in. The plot is surrounded by railings). There are inscriptions on all four sides of the memorial, to his parents and to his children. The panel furthest from the road has the following inscription to his memory:
DENIS FLORENCE MACCARTHY/ 26 MAY 1817 7 APRIL 1882/ MEMBER OF THE SPANISH AND IRISH/ ROYAL ACADEMIES

Donnchadh Ruadh Mac Conmara 1715-1810

Not a great deal is known about him but it is thought he came originally from County Clare. His best known work is a poem, *Eachtra Ghíolla an Amaráin*, about the life of an emigrant in

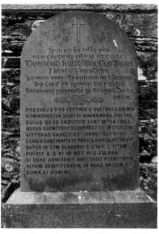

Newfoundland. It involved the hardships of fishing, curing the fish and then having a good time afterwards. He also wrote the elegy for Tadhg Gaelach Ó Súilleabháin.

He is buried in the graveyard in Newtown, 2 kilometres east of Kilmacthomas, County Waterford, on the road to Carrick-on-Suir. There is a gravestone on the left of the entrance, against the wall. This didn't seem a likely location for the grave and I left the churchyard a bit dissatisfied. I went then to Ballylaneen where I met Mary Ann Coffey and she told me that he is actually buried at the back of the church close to the sacristy window. Apparently when the new gravestone was being erected by a committee, the local priest didn't want cartloads of tourists traipsing round the back while he was getting ready for services.

This visit should be combined with a trip to Ballylaneen to visit the grave of Tadhg Gaelach Ó Súilleabháin (q.v.).

Aindrias MacCraith 1710-1795

Born in County Limerick. He was a poet and wandering minstrel known as An Mangaire Súgach — The Wandering Peddlar. He was one of the leading poets of the Maigue school. Like many of these Gaelic poets, they supported the Jacobean cause and got themselves into trouble with women and were forced to leave the neighbourhood. One of his most famous works was the eulogy to his fellow poet Seán Ó Tuama. He is buried in the graveyard of the ruined collegiate parish church of SS Peter and Paul in Kilmallock, County Limerick, in the grave of the Hawthorne family. Go in the main gate and it is situated by the wall facing you between the two paths. There is a headstone with the lettering beginning to wear. The inscription reads: AINDRIAS MACCRAITH/"AN MANGAIRE SÚGACH"/IN DE PHRÍOMH-FHILÍ NA MÁIGHE/D'ÉAG 1795/FÉACH AN TATSTAL DO PHEACAIGH FÁ/ "THRI AR A TUIS/A DHÉ DHIL AICIM DÉ SCARAS DE/OLÉ NA HÚRD/MARAON LE PEADAR AN MANGAIRE/SCAOIL IT DHÚN/

There is a plaque at the base of the stone with the following inscription: UAIGH AN FHILE/GRAVE OF 18TH CENT POET/ AINDRIAS MAC CRAITH ("AN MANGAIRE SÚGACH")/CEANN D'FHILÍ MÓRA NA MÁIGHE/CHUM SÉ ÁN DÁN CÁILIÚIL "SLÁN LE MÁIGHE"/MUINTIR UÍ CHOILEÁIN AGUS/MUINTIR SHEOIGHE A BHRONN

Andrew MacCurtain (Aindrias Mac Cruitín) c. 1650-1738

Born in County Clare. MacCurtain was hereditary ollamh (the highest grade of poet), to the O'Briens. His most famous poem was addressed to the chief of the Tuatha Dé Danann. He is buried in the churchyard of the fifteenth century church of St Laichtin in Kilfarboy, County Clare. There is no plaque to mark the grave and no mention of him anywhere. Michael Comyn (*q.v.*) is buried in the same cemetery.

Hugh MacCurtain (Aodh Buidhe Mac Cruitín) c. 1680-1755

Born in Kilmacreehy, Corcomroe, County Clare. He was a schoolmaster, a poet, a writer and an antiquarian. He published *The Elements of the Irish Language, Grammatically Explained in English* at Louvain in 1728. He also published the first *English—Irish dictionary* in 1732. He is buried in an unmarked grave at Kilmacreehy Cemetery, County Clare. The cemetery is located just before you come to Liscannor on the road from Milltown Malbay. It overlooks the bay but I wouldn't recommend going out of the way to visit it.

Seán Clárach MacDomhnaill 1691-1754

Born in Charleville, County Cork. He was one of the leading poets in Munster and his farm was a gathering point for other

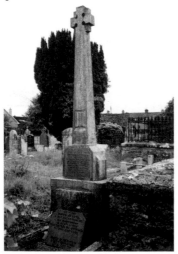

poets and was known as the Court of Poetry. Despite this, he didn't always get along with his fellow poets and one of his satires on the death of a landlord, caused enough annoyance locally that he was forced to leave the area. He is buried in the ruined church of Ballysallagh 300 metres south of the centre of Charleville (Rathluirc), County Cork. As you go in the main gate there is the wall of the old church in front of you and the grave is situated behind that. It is the tallest structure in the area. The old stone has the following inscription:

JOHANES MCDONALD COGNO/MINATUS CLARAG VIR VERE/
CATHOLICUS ATQ TRIBUS LINGUIS/ORNATUS NEMPE GRAECA
LATINA/ET HYBERNICA NON VULGARIS/INGENII POETA
TUMULATUR/AD HUNC CIPPUM OBIT AETATIS/ANNO 63 SAUTIS
1754/REQUESCAT IN PACE

A more modern stone is higher up and there is an even more modern stone, on the grave itself. The inscription reads: 1691–1991/MUINTIR AN RATHA/A CHUIR SUAS AN PHLAIC SEO/MAR CHUIMHNEACHAN/AR BHREITH AN FHILE/SEÁN CLÁRACH MACDOMHNAILL/TRÍ CHEAD BLIAIN Ó SHIN/ERECTED BY THE PEOPLE OF/AN RATH (CHARLEVILLE)/14TH JULY 1991

Donagh MacDonagh 1912-1968

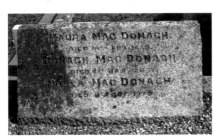

Born in Dublin. He was the son of Thomas MacDonagh. He practised law and was made a District Justice in 1941. His most successful work was a play, *Happy as Larry*, that was translated into many languages. His other works include plays, short stories and poems: *Veterans and Other Poems, God's Gentry, The Hungry Grass* and *A Warning to Conquerors*. With Lennox Robinson he edited *The Oxford Book of Irish Verse* (1958). He is buried in grave number 137-AO-North, Deansgrange Cemetery, Dublin. *(See map page 250)*. The inscription on the gravestone reads: MAURA MACDONAGH/DIED 18TH FEB 1939/DONAGH MACDONAGH/DIED 14TH JAN1968/NUALA MACDONAGH/DIED 11TH OCT 1970

Thomas MacDonagh 1878-1916

Born in Cloughjordan, County Tipperary. He helped to establish St Enda's in Rathfarnham and the Irish National Theatre. He trained the Volunteers and fought in Jacob's Factory during the Easter Rising. He was one of the signatories of the Proclamation. He was also a poet, a playwright and critic whose works include *April and May, The Golden Joy, Songs of Myself, Lyrical Poems* and *When the Dawn is Come*. He is buried with the other executed leaders of 1916 in the Church of the Sacred Heart, Arbour Hill, Dublin. *(See map page 255)*. The graves are located close to the back wall of the churchyard.

He was married to **Muriel Gifford** who is buried in Glasnevin Cemetery. *(See map page 246)*.

127

Patrick MacGill 1891-1963

Born near Glenties in County Donegal. He was hired out at the age of twelve and two years later was working on the potato fields in Scotland. He wrote several books of poetry - *Gleanings from a Navvy's Scrapbook, Songs of a Navvy* and *Songs of the Dead End* - which earned him the title of the Navvy Poet. However it was his novels based on his experiences — *Children of the Dead End* and *The Rat Pit* - that brought him major success. He used his War experiences in novels such as *The Great Push* and *The Red Horizon*. Altogether he wrote nearly 20 novels. In 1930 he went to America, where he remained until his death.

He was buried initially in the Notre Dame Cemetery, Fall River, Massachusetts, USA. His remains were re-interred in St Patrick's Cemetery, Fall River after the death of his wife who was buried there along with a grandchild that had recently died at a very young age. His wife was also a writer and they are buried in Section 22 Lot 3844. The inscription reads: PATRICK MACGILL 1890-1963/ HIS WIFE MARGARET 1887- 1972/VEDA PEARL MONIZ/ DECEMBER 3, 1972.

On the other side there is a Celtic cross design and the inscription: MACGILL/MONIZ/THE OLD LIFE FAILS BUT THE NEW LIFE COMES.

The cemetery is located on Robeson Street. Go in the gate and walk down the central road and turn left at St Thomas Avenue. The grave is on the left about one third way down.

Cathal Buí MacGiolla Ghunna c. 1680-1756

Probably born in County Fermanagh. Like most of the travelling poets of the time he was fond of the wine, women and song. The best known of his poems is about a bittern which has died of thirst, so he determines not to let the same fate befall him. The poem that is mentioned on the plaque on the wall of the churchyard where he is buried is about the Day of Judgement. The poet acknowledges that among the crowd assembled he is the worst of all of them, but will offer up a creed which will be acceptable so that in God's presence he will be found not guilty.

He is buried in Donaghmoyne Churchyard, County Monaghan. The churchyard is signposted on the right-hand side of the road just outside Castleblayney on the road to Monaghan. Drive to the village of Donaghmoyne and turn right. There is

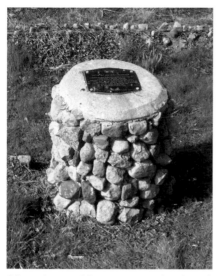

another signpost for St Patrick's Church of Ireland. It is about two kilometres from the village on the left-hand side of the road. The grave is on the right of the path close to William Steuart Trench (*q.v.*).

The plaque on the stone reads: Cathal Buí Mac Ghiolla Ghunna (circa 1680-1760)/ A noted poet in the Irish Language, was born in the barony of Tullyhaw in County Cavan. Much of his adult life was spent in County Monaghan and he was reputed to have been buried in Donaghmoyne graveyard. He was the author of "An Bonán Buí" and "Aithreachas Chathail Bhuí".

Seosamh MacGrianna 1901-1990

Born in Ranafast, County Donegal. He qualified as a teacher and later he worked as a translator for An Gúm. His own work is considered among the finest in modern Irish writing. He suffered from poor mental health and wrote almost nothing in his last 50 years. His works include *Dochartach Dhuibhlionna agus Scéalta Eile, An Grá agus An Ghruaim, Pádraic Ó Conaire agus Aistí Eile, Mo Bhealach Féin* and *An Druma Mór*. He died in Letterkenny. He is buried in the cemetery attached to the Catholic church in Annagary, County Donegal. The grave is

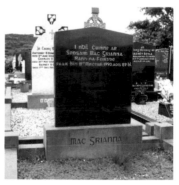

located on the path closest to the church hall and about three quarters way down on the right-hand side. His parents and another well-known brother Séan Bán are also buried in the grounds in the area behind the church. I was informed it was a very friendly cemetery, everyone knows everyone else in it.

Walter Macken 1915-1967

Born in Galway. He was a member of the Abbey Company and played the lead role on Broadway in *The King of Friday's Men*. He wrote plays, short stories and novels. His works include *Rain on the Wind, Hero, Seek The Fair Land, The Silent People, The Scorching Wind* and

Brown Lord of the Mountains. His story *Flight of the Doves* was made into a successful film.

He is buried in Bohermore Cemetery, Galway. Go in the main gate and follow the road around to the right towards the church. Look for the tallest cross on the left-hand side. About 18 graves behind it on the same row is the grave of Walter Macken. The inscription on the gravestone reads: IHS/ TO THE MEMORY OF/ WALTER MACKEN/ WRITER/ MENLO GALWAY/ 1915– 1967/ AND/ HIS WIFE/ PEGGY/ 22ND APRIL 1992/ R.I.P./ "PEOPLE ARE THE CORNERSTONE/ OF THE WORLD"

Charles Macklin c. 1697–1797

Born Cathal MacLochlainn in Culdaff, County Donegal. He used the name Charles Macklin when he went to London. He was considered one of the best actors of the age and is reputed to have been one of the greatest Shylocks of all time. Alexander Pope said of his performance "This is the Jew that Shakespeare drew." He was also a dramatist and his works include *The True Born Irishman, The Man of the World* and *Love à la Mode*. In 1755 he killed another actor in an argument over a wig in Drury Lane Theatre. His stick went into the man's eye. He was found guilty of manslaughter but only a nominal punishment was imposed.

He was buried in a vault under the chancel of St Paul's, Covent Garden, London. The inscription on the coffin read:

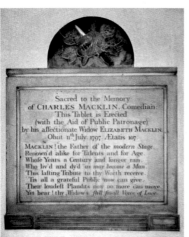

MR CHARLES MACKLIN, COMEDIAN, DIED THE 11TH JULY 1797. AGED 97 YEARS. There is a tablet on the wall on the right-hand side of the church. Above the tablet there is a carving of the tragic drama mask which has a dagger through the eye, a reference to the dispute reported above. The tablet reads: SACRED TO THE MEMORY/OF CHARLES MACKLIN, COMEDIAN:/ THIS TABLET IS ERECTED/ (WITH THE AID OF PUBLIC PATRONAGE)/ BY HIS AFFECTIONATE WIDOW ELIZABETH MACKLIN/ OBIIT 11TH JULY 1797. AETATIS 107/ MACKLIN! THE FATHER OF THE MODERN STAGE/ RENOWNED ALIKE FOR TALENTS AND FOR AGE/ WHOSE YEARS A CENTURY AND LONGER RAN/ WHO LIV'D AND DY'D AS "MAY BECOME A MAN"/ THIS LASTING TRIBUTE TO THY WORTH RECEIVE/ TIS ALL A GRATEFUL PUBLIC NOW CAN GIVE/ THEIR LOUDEST PLAUDITS NOW NO MORE CAN MOVE/ YET HEAR! THY WIDOW'S "STILL SMALL VOICE OF LOVE".

Micheál MacLiammóir 1899-1978

Born Alfred Willmore in London. He was an actor and a brother-in-law of Anew McMaster whose company he joined in 1927. There he met Hilton Edwards and they went on to set up their own theatre – The Gate. He played his one-man entertainment – *The Importance of Being Oscar* – nearly 1,400 times. He was made a Freeman of the City of Dublin in 1973. He wrote poems, plays, novels and autobiographies. His works include: *All for Hecuba, Ill Met By Moonlight* and *Enter a Goldfish*. He is buried with Hilton Edwards in St Fintan's Cemetery, Sutton, Dublin. *(See map page 256)*. Go in the gate and take the second road to the left. Look for the lettering on the kerb on the right-hand side and go to row K. The grave is on the second row.

Edward MacLysaght 1887-1986

Born at sea. He was brought up in Clare. He worked as a farmer, a journalist and with the Irish Manuscripts Commission. He was Keeper of Manuscripts at The National Library, Chief Herald and Genealogical Officer and also a senator during his long life. He is best known as a genealogist. His works include three volumes on *Irish Families: Their Names, Arms and Origins, Guide to Irish Surnames, Irish Life in the Seventeenth Century*, an autobiography and several novels.

He is buried in the graveyard attached to St Cronan's church (10th century), in Tuamgraney, County Clare. Go in the gate and turn left. Go along the wall and the grave is situated nearly at the end.

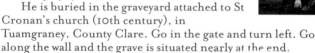

Bryan MacMahon 1909-1998

Born in Listowel, County Kerry. He was a schoolteacher and was one of the founders of the Listowel Drama Group and the Writers Week. He wrote short stories, novels and plays. He also wrote the pageant that was staged in Croke Park to celebrate the 50th anniversary of the Easter Rising. He translated Peig Sayers' autobiography and his works include: *The Lion Tamer, The Sound of Hooves, Children of the Rainbow, The Honey Spike, The Red Petticoat* and his autobiography *The Master*.

He is buried in the cemetery located on the Tarbert road opposite the library, in Listowel. There is an old church tower in the grounds. Go in the main gate, past the

intersection and it's third row back on the left-hand side, almost opposite a squat tomb erected by Daniel Brown of Listowel. John B Keane's *(q.v.)* grave is almost directly behind MacMahon's grave towards the football stand.

Francis MacManus 1909-1965

Born in Kilkenny. He worked as a teacher until he joined RTÉ in 1948. He wrote over a dozen novels, as well as short stories and biographies. His works include *Stand and Give Challenge, Candle for the Proud, Men Withering, The Fire in the Dust* and *The Greatest of These*. He is buried in grave number 441, St Patrick's Deansgrange Cemetery, Dublin. *(See map page 250).*

Michael Joseph MacManus 1888-1951

Born in Carrick on Shannon in County Leitrim. He was literary editor for the *Irish Press*. His works include *A Green Jackdaw, A Jackdaw in Dublin, So This is Dublin* and several books of poetry including *Connaught Songs* and *Rackrent Hall*.

He is buried in grave number LD 19 St Paul's Section, Glasnevin Cemetery, Dublin. *(See map page 249).* Go in the main gate, take the second road on the left and it is about a third of the way down the section on the right-hand side and 25 stones in. There is no mention of his name on the gravestone.

The inscription reads: IN/ LOVING MEMORY OF/ MY DARLING WIFE/ BRIGID MCMANUS/ WHO DIED AT/ 2 PARKVIEW AVENUE, HAROLD'S CROSS DUBLIN/ 2ND DECEMBER 1918 AGED 29 YEARS/ ON HER SWEET SOUL MAY GOD HAVE MERCY. He was the first to publish Brendan Behan who always remembered him for that. It is claimed that Behan followed the funeral in his bare feet.

Seumas MacManus 1869-1960

Born at Inver, County Donegal. He worked as a teacher for some years before leaving for America. He wrote short stories, novels, plays and folklore. His works include *The Townland of Tamney, In Chimney Corners: Merry Tales of Irish Folklore, A Lad of the O'Friels, The Woman of Seven Sorrows, Donegal Fairy Stories, Top of the Morning, The Story of the Irish Race* and the autobiographical *The Rocky Road to Dublin*. In 1901 he married Ethna Carbery *(q.v.)* who died the following year. He himself died in New York when he fell from a window in a

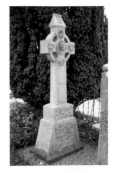

nursing home. He is buried in the same grave as his wife, Ethna Carbery, in Frosses, County Donegal. The grave is located in front of you as you go in the gate.

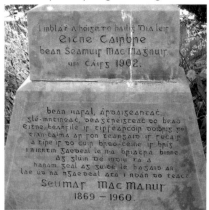

In 1969 the *Donegal Democrat* ran a series of articles to commemorate the centenary of his birth. One article concerned the year of his birth. A birth certificate mentions it as 1867 but his family was adamant it was 1869. Another article by Brian MacMahon concerned the body being brought home from America. MacMahon had asked PEN if he could represent them at Shannon when the remains arrived at the airport. There seemed to be a mix up about arrival times and before MacMahon was in a position to meet the coffin, he saw, from a distance, a long oblong box being lowered onto a trolley and being taken to the luggage sheds. A young man hitched a ride and sat on the box with his hands in his pocket and whistling a tune. MacMahon thought it hardly appropriate but when the plane, the coffin and a flying flag all came into alignment, he thought it a typical MacManus moment.

Brinsley MacNamara 1890-1963

Born John Weldon in Delvin, County Westmeath. He became an actor with the Abbey Theatre in 1909. His novel, *The Valley of the Squinting Windows*, was published in 1918, causing uproar and forcing his schoolteacher father to leave the area. He wrote other novels and plays including *The Clanking of Chains, The Mirror in the Dusk, The Glorious Uncertainty, Look at the Heffernans, Margaret Gillan* and *The Various Lives of Marcus Igoe*. He was a founder member of the Irish Academy of Letters. He is buried in

grave number 54 O, St Brigids, Deansgrange Cemetery, Dublin. *(See map page 250 – the grave is on a path between two roads and is four graves down from the top of the section).*

Louis MacNeice 1907-1963

Born in Belfast. He worked as a feature writer and a producer for the BBC 1941-1946. He spent most of his life in England. He was part of a circle that included Auden, Spender and Cecil Day-Lewis. Besides being a major poet, he also wrote plays,

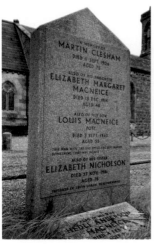

translations, travel books and literary criticisms. These include *Blind Fireworks, Autumn Journal, Autumn Sequel, Holes in the Sky, The Dark Tower* and *The Strings are False, an Unfinished Autobiography.*

The funeral service took place in St John's Wood Church, London. The coffin was delayed by the heavy traffic caused by crowds attending the final of the Gillette county cricket competition. The hymn *Who Would True Valour See* was sung. He was cremated in London and his ashes taken across the sea and placed in the Carrowdore churchyard grave of his mother and maternal grandfather, in County Down. The Church of Ireland, Christchurch, is located just beyond the town on the Woburn Road. Go through the village with the castle on the right-hand side. Woburn Road is located at the large castellated structure and the church is just over a kilometre down this road. The entrance is at the old stone church hall. There is a long driveway up to the church. The grave is located at the left-hand side of the church about six rows from the back gate. It is beside the roadway and is facing away.

The inscription for Louis MacNeice reads: ALSO OF HER SON/ LOUIS MAC NEICE/ POET/ DIED 3 SEPT 1963/ AGED 55/ THIS MAN WITH THE SHY SMILE HAS LEFT BEHIND/ SOMETHING THAT WAS INTACT

Derek Mahon paid his tribute to MacNeice in the poem *In Carrowdore Churchyard.* Denis Ireland dedicated his book *From the Jungle of Belfast* "to my wife/ for her part in it/ especially for spotting/ the fox at Louis MacNeice's grave".

Eoin MacNeill 1867-1945

Born in Glenarm, County Antrim. In 1893, an article of his led to the formation of the Gaelic League. In 1913 he called for the formation of Irish Volunteers in response to the Ulster Volunteer Force. In 1916 he cancelled the orders for the Easter Rising. After prison he served in several different ministries. He was pro-Treaty and sat on the Boundary Commission, becoming unpopular after its deliberations became public. He wrote on a wide range of topics but his most important works include *Phases of*

Irish History, Celtic Ireland, St Patrick and *Early Irish Laws and Institutions*. He is buried in Kilbarrack Cemetery, Dublin Road, Kilbarrack, Dublin. *(See map page 256)*. He is buried with other members of his family including his brother James who was appointed Governor General of Ireland in 1928. The grave is located at the front of the ruined church. The inscription on the stone mentions the names and birth and death dates of Eoin MacNeill and six relatives, including his brother James.

Terence MacSwiney 1879-1920

Born in Cork. He founded the Cork Dramatic Society with Daniel Corkery in 1908. He wrote poetry, plays and essays and his works include *The Revolutionist, Despite Fools' Laughter, Battle Cries* and *Principles of Freedom*. He helped found the Cork Volunteers and became their full-time organiser. He was elected Lord Mayor of Cork after Tomás MacCurtain was murdered. He was arrested by the British and went on hunger strike. He was transferred to Brixton Prison where he died after 74 days without food. He is buried in the Republican Plot in St Finnbarr's Cemetery, Cork. His death shocked the country.

Moirin Chavasse in her biography of MacSwiney chronicles the events surrounding his funeral. The coffin was brought to Southwark Cathedral and over 30,000 people filed past. The following day, thousands lined the streets as the funeral procession, headed by a piper, made its way to Euston Station. At Holyhead the Black and Tans took possession of the coffin to ensure that it wouldn't go through Dublin. Eventually it was taken off at Cobh and MacSwiney lay in state in Cork City Hall. The queue of people wanting to pay their respects stretched for over a mile. After Requiem Mass, thousands more followed the coffin to the Republican Plot in St Finnbarr's Cemetery. After the Last Post was sounded, a volley of shots was fired over the grave.

Éamonn MacThomáis 1927-2002

Born in Dublin. He left school at 13. He later became a clerk. He was interned in the Curragh, 1957-58. In the 1970's he edited *An Phoblacht* and was imprisoned for IRA membership.

He was a writer, lecturer and broadcaster whose works include *Me Jewel and Darlin' Dublin, Gur Cakes and Coal Blocks, The Labour and the Royal* and *Janey Mack Me Shirt is Black*. He is buried in Glasnevin Cemetery, Dublin. *(See map page 246)*.

Richard Robert Madden 1798-1886

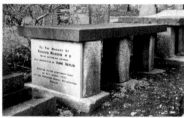

Born in Dublin. He trained in medicine and spent many years in Jamaica, Cuba and Africa where his job was to supervise the anti-slavery legislation. He returned to Dublin in 1850. He wrote poetry, a biography of Countess Blessington and many other books and essays on his work and travels. He is chiefly remembered though, for his work *The United Irishmen - Their Lives and Times*, in seven volumes. He is buried in Donnybrook Churchyard, Main Street, Donnybrook, Dublin. *(See map page 256)*. A map on the left-hand side as you go in to the cemetery indicates the position of the grave.

The inscription on the upright tablet reads:
TO THE MEMORY OF/RICHARD MADDEN M.D./IRISH HISTORIAN AUTHOR/AND BENEFACTOR OF ANNE DEVLIN/ ERECTED IN THE CENTENARY YEAR OF HIS DEATH 1986/BY THE NATIONAL GRAVES ASSOCIATION/DUBLIN

William Maginn 1793-1842

Born in Cork. He contributed to *Blackwoods Magazine* and co-founded *Fraser's Magazine* which published his *Homeric Ballads*. He also wrote novels, poetry and criticisms. By 1840 his fortune and reputation were ruined by drink and in 1842 he was arrested and put in the Fleet Prison in London for debt. His funeral was attended only by a very few friends. He is buried in Walton-on-Thames Parish church in London but the exact spot where his remains lie is unknown.

John Pentland Mahaffy 1839-1919

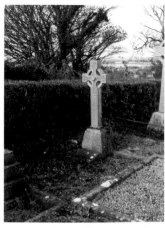

Born near Vevay in Switzerland. He was Professor of Ancient History 1869-1899 and Provost of Trinity 1914-1919 and first President of the Irish Georgian Society. He was well-known as a wit and raconteur. Gogarty described him as the "finest talker in Europe". He also befriended the young Oscar Wilde. His works include *The Principles of the Art of Conversation, Kant's Critical Philosophy for English Readers, Social Life in Greece from Homer to Menander, The Silver Age of the Greek World* and *An Epoch of Irish History*. He is buried in St Fintan's Cemetery, Sutton, County Dublin. *(See map page 256)*.

The grave is in the second section from the top, the one with the ruins of an old church. If you approach from the lower section, the grave is in the top right-hand corner three rows from the top. The stone at the foot of the cross has the following inscription· IN GRATEFUL MEMORY OF/ JOHN PENTLAND MAHAFFY/ 1839-1919/ DD GBE CVO DCL/ SCHOLAR FELLOW AND PROVOST/ OF TRINITY COLLEGE 1858-1919/ HE DEVOTED HIS LIFE TO LEARNING/ AND TO THE EDUCATION OF HIS/ FELLOW COUNTRYMEN

James Clarence Mangan 1803-1849

Born in Dublin. He worked as a copy clerk for ten years and then barely made a living by writing. He contributed to various publications including the *Nation*. He wrote poems based on translations from the German and other languages, including Irish which he didn't know. His poems include *Dark Rosaleen, The Nameless One* and *The Woman of Three Cows*. A bust of him by Oliver Sheppard stands in St Stephen's Green in Dublin. He had poor health and was addicted to alcohol and opium and died during the cholera epidemic. Bodies were usually buried immediately but it was three days before Mangan was buried in Glasnevin Cemetery, Dublin. *(See map page 246)*. About six rows past the Atkinson and Gilbert crosses there is a large grave with the letters JB engraved on the side of the stone. The Mangan grave is about fifteen rows in.

The funeral was attended by only five of his closest friends. There is a death mask of him in the Civic Museum in Dublin. The grave is cared for by The National Graves Association and the inscription reads: TO THE MEMORY OF/ JAMES CLARENCE MANGAN/ WHO DIED 21ST JUNE/ 1849, AGED 46 YEARS/ IRELAND'S NATIONAL POET/ "O MY DARK ROSALEEN DO/ NOT SIGH, DO NOT WEEP"

The words of the poem were only added in 1981. William Fitzpatrick in *History of the Dublin Catholic Cemeteries* (1900) noted that "the pilgrims to his shrine sometimes outnumber those who kneel in the O'Connell crypt".

Joseph Marmion 1858-1923

Born in Dublin. He was a Benedictine monk whose mission was to bring God to people and people to God. He studied at Clonliffe College Dublin and the Irish College in Rome and was ordained in 1881. He spent a year in Dundrum, County Dublin, as a curate and then was appointed Professor of Philosophy at Clonliffe. The lure of a contemplative life took him to the Benedictines in Maredsous in Belgium and he was professed as Dom Columba in 1891. Three of his books have become classics – *Le Christ, Vie de l'âme, Le Christ dans ses mystères* and *Le Christ, idéal du moine* – and they have been translated into more than a dozen

137

languages. He was beatified on September 3rd 2000 by Pope John Paul II in Rome. He is buried at the Maredsous Abbey in Southern Belgium. Since 1963 his body has reposed in the chapel of St Gregory in the Abbey church. The grave is situated along the wall on the left-hand side as you go in.

A Belgian friend advised me that it is not easy to get to the Abbey by public transport so he brought me in his car instead. After the visit to the grave we lunched in the restaurant and sampled some of the excellent beer that the monks brew. Not very far away from here is the town of Huy where Patrick Sarsfield is buried.

Edward Martyn 1859-1924

Born in Tulira, County Galway. He was one of the founders of the Irish Literary Theatre and his plays were some of the earliest produced there. He was one of the founders of the Feis Ceoil and he also established the Palestrina Choir. His works include *The Heather Field, Maeve, The Tale of a Town* and *The Dream Physician*. He left instructions in his will that his body was to be given to Cecilia Street Medical School for dissection and the remains to be buried with paupers. The funeral took place a few weeks after his death and along with six other bodies he was laid to rest in the General Poor Ground in Glasnevin Cemetery, Dublin. The Palestrina Choir sang the Benedictus at the interment. The grave is unmarked.

Charles Robert Maturin 1782-1824

Born in Dublin. He was ordained and served as an Anglican clergyman in Loughrea and Dublin. He was a writer of novels of mystery and horror. His *Melmoth the Wanderer* inspired Balzac and Baudelaire. He also wrote *The Wild Irish Boy, The Fatal Revenge* and *The Milesian Chief*. Oscar Wilde took the name Sebastian Melmoth after his release from prison. Maturin was buried in St Peter's Church, Dublin, which has since been demolished.

Rutherford Mayne 1878-1967

Born Samuel Waddell in Japan. He spent most of his working life in the Irish Land Commission. He was a brother of Helen Waddell and married a sister of Joseph Campbell. He wrote plays and his works include *The Drone, The Turn of the Road, The Troth, Bridge*

Head and *Peter*. He is buried in grave number 92 C, North Section, Deansgrange Cemetery, Dublin. *(See map page 250)*.

The grave is on the path edge and is beside a Celtic cross over the Caulfield plot). See entry for **Joseph Campbell**.

Justin McCarthy 1830-1912

Born in Cork. He worked as a journalist on a number of Irish and English papers including the *Cork Examiner*, the *Morning Star* and the *Daily News*. He wrote a number of successful novels and histories. He was elected MP for Longford in 1879 and was leader of the Irish Parliamentary Party until 1896. He led the anti-Parnell faction after the divorce case. His works include *History of Our Own Times* (five volumes), *Dear Lady Disdain*, *Red Diamonds*, *Camiola – A Girl With a Fortune*, *A Fair Saxon*, *Mononia* and over a dozen others. See next entry.

Justin Huntly McCarthy 1860-1939

Born in London. Like his father, he was an Irish Nationalist MP and writer of novels. These include *A London Legend*, *The God of Love*, *If I Were King*, *Calling the Tune*, *The Flower of France* and *The Fair Irish Maid*. They are buried in the same grave, number 433 C, in Hampstead Cemetery, London.

Go in the main entrance and it is on the left-hand side of the road, about 50 graves past the twin spires. The numbers are visible on many of the stones in the area.

The inscription is in three parts:
IN LOVING MEMORY OF/ JUSTIN MCCARTHY/ IRISH PATRIOT HISTORIAN/ BORN 22ND OF NOVEMBER 1830/ DIED 24TH OF APRIL 1912/ MY HEART DOTH JOY THAT IN ALL MY LIFE/ I FOUND NO MAN BUT HE WAS TRUE TO ME/ REQUIESCAT IN PACE

TO/ THE DEARLY LOVED MEMORY OF/ JUSTIN HUNTLY MCCARTHY/ DRAMATIST POET NOVELIST/ DIED MARCH 1939

IN MEMORY OF/ LOULLIE SILVIA GIMSON/ WIDOW OF JUSTIN HUNTLY MCCARTHY/ AND THE DEARLY BELOVED WIFE OF/ JOSEPH FORSYTH GIMSON/ WHO DIED ON JULY 16TH 1966

Thomas D'Arcy McGee 1825-1868

Born in Carlingford, County Louth. He went to America at an early age and became editor of the *Boston Pilot*. He returned to Ireland and wrote for the *Nation* but after the Young Ireland rising he escaped to America. In 1857 he moved to Montreal and took Canadian citizenship. He became an MP and then Minister of Agriculture. He was assassinated after his opposition to the Fenian invasion of Canada. His published works include *A Popular History of Ireland From the Earliest Period to Emancipation of the Catholics, The Irish Writers of the Seventeenth Century* and his collections of poems. His poem, *Am I Remembered In Erin*, was read at Ronald Reagan's funeral in June 2004.

McGee was given a state funeral and the day of the funeral was declared a public holiday. Thousands of people visited his home where his body lay in state and by nine o'clock in the morning of the day of the funeral, over 60,000 mourners had packed the streets. The stores and offices were closed and over 20,000 people are said to have marched in the funeral procession which took nearly three hours to pass by. He is buried in the Cemetery of Côte des Neiges, Montreal, Canada.

The photograph was taken by David Wilson, Professor of Celtic Studies at the University of Toronto. The night before he visited the grave he met a man who earlier in the day had been doing some maintenance work inside the mausoleum. This man recounted how the coffin had a glass panel over the face area but fortunately the glass was frozen in the cold morning air.

The man accused of killing him, **Patrick James Whelan**, was tried, convicted and then hanged in front of thousands of people. It was the last public hanging in Canada. Whelan protested his innocence and claimed he did not even support the Fenians.

Apparently he swore that no grass would grow over his grave. He was buried in what is now a parking lot attached to a hostel. So he was right! Pierre Braulte wrote a one-man play based on Whelan's trial and performed it in Ireland in March 2003. There

is a move to have Whelan pardoned and to have his remains exhumed and buried in Notre Dame Cemetery, Montreal.

The *Irish Times* in April 2004 reported vandalism in Selskar Abbey, Wexford town. One of the graves damaged was that of McGee's parents.

Michael Francis McLaverty 1904-1992

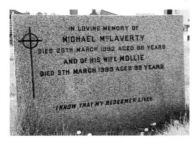

Born in Carrickmacross, County Monaghan. He became a teacher and retired as Headmaster of St Thomas's Secondary School, Belfast. He was also a well-known writer whose novels and collections of short stories include *Call My Brother Back*, *Lost Fields*, *The Three Brothers*, *The Road to the Shore* and *Collected Stories*.

He is buried in Kilclief outside Strangford, County Down. The graveyard is located about seven kilometres from Strangford. Go out the Shore Road and at the Keep, take the road to the right. Take the sign for St Malachy's Church and it's about two kilometres further on, on the left. Go in the gate and follow the path around. Take the path opposite the large crucifix and then the second path on the left. The grave is four in on the right-hand side and one row back.

Father Charles Patrick Meehan 1812-1890

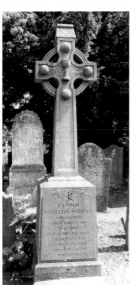

Born in Dublin. A memorial in the church of SS Michael and John, Dublin, described him as a Priest, Patriot and Scholar. He attended the dying James Clarence Mangan and later edited his works. His own works include *The Confederation of Kilkenny*, *The Rise and Fall of the Irish Franciscan Monasteries*, *The Poets and Poetry of Munster* and *The Fate and Fortunes of Hugh O'Neill, Earl of Tyrone and Rory O'Donnell, Earl of Tyrconnell*. He was buried in grave number OD16, Glasnevin Cemetery, Dublin. (*See map page 246 — the grave is six rows from the path leading to the Republican Plot*).

I searched many times in the area marked on O'Duffy's map (*Historic Graves in Glasnevin*) but could find no trace of the tomb. And then on my final visit, Fr Meehan appeared to me, or at least his gravestone did. The inscription reads: CAROLO/PATRITIO MEEHAN/PRESBITERO/ AMICI MOERENTES/POSUERE/NATUS QUART IDUS/IUL MD CCC XII/DECESSIT IN PACE/PRID IDUS MART MD CCC XC

The stone is by Denneny.

Vivian Mercier 1919-1989

Born in Clara, County Offaly. He taught at various universities in America. His works include *A Thousand Years of Irish Prose, The Irish Comic Tradition* and *Beckett/Beckett*. He was married to Eilís Dillon (*q.v.*) and is buried with her in Clara, County Offaly.

Brian Merriman died 1805

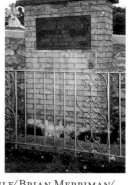

Born sometime between 1740-1749 in Ennistymon, County Clare. He was a farmer and schoolteacher. He is remembered for his poem *The Midnight Court (Cúirt an Mheán-Oíche)*. The poem has been translated into English by various people, including Frank O'Connor. For many years the poem and all its translations were banned.

He is buried in Feakle, County Clare, although his grave is not identified. There is a tall vertical memorial outside the cemetery against the wall in the car park.

The inscription reads: OMÓS DON FHILE/BRIAN MERRIMAN/+1805/A CHUM/CÚIRT AN MHEÁN OÍCHE/SA DÚICHE SEO

Alice Milligan 1866-1953

Born at Gortmore, near Omagh, County Tyrone into a Methodist and unionist background but she devoted her life to

Ireland and all things Irish. She wrote a number of plays, novels and poetry. These include *The Last Feast of the Fianna, The Daughter of Donagh, A Royal Democrat, The Wake Feast* and *Hero Lays*. She also published the early writings of James Connolly. She inspired both Yeats and MacDonagh among others but she gradually disappeared from public life. Perhaps she is best known for her poem *When I Was a Little Girl*, when the children would be warned that if they didn't behave the Fenians would come but her response was "when the Fenians come, I'll rise and go after".

She is buried in Drumragh Churchyard near Omagh, County Tyrone. Her father **Seraton Forrest Milligan 1836-1916** who contributed many articles to the journal of the Royal Society of Antiquaries is buried here as well. Alice co-wrote *Glimpses of Erinn* with him.

As you come to Omagh from the Belfast direction take the Ballynahatty Road to the left just before the speed limit sign at the entrance to Omagh. Continue down that road and over the

bridge. Alternatively if you are in Omagh take the Kevlin Road from the town and drive to the end and at the junction turn right and drive over the bridge. The grave is in the newer cemetery which is accessed by the first gate on the right-hand side. As you enter, the grave is on the left-hand side towards the back wall and in from the path. It has the tallest cross in the area. It rained on the day of her funeral.

Her grave was allegedly attacked with a hammer in an attempt to destroy the Irish inscription and on another occasion explosives were used. Her grave in 2002 didn't show much sign of this attention.

The inscription on her gravestone reads: ALICE L. MILLIGAN/ NÍOR CAR FÓD EILE AC ÉIRINN/ SHE LOVED NO OTHER PLACE BUT IRELAND/ BORN OMAGH SEPTEMBER 1866/ DIED OMAGH APRIL1953

Richard Millikin 1767-1815

Born in Castlemartyr, County Cork. He is best known for his poem *The Groves of Blarney*, although it was Francis Sylvester Mahony (Father Prout) who added the verse about kissing the stone. He is buried in the burial ground surrounding St Luke's Church, Douglas, County Cork. The grave is against the south wall and the inscription on the altar tomb over the grave, reads: READER/ WHILST SCIENCE, GENIUS AND WIT SHALL BE ADMIRED/ AND MERIT, CHARITY AND WORTH BELOVED/ THE MEMORY

OF/ RICHARD ALFRED MILLIKIN/ WILL NOT BE FORGOTTEN/ HE DIED THE 16TH DAY OF DECBR 1815/ STRANGER PASS ON, E'EN FRIENDS MAY HENCE DEPART/ NOR GAZE IN VAIN NOR SIGNS OF GRIEF IMPART/ STRANGER TO SELF BE TIMELY WISE AND JUST/ SWEET FRIENDS FORBEAR NOR TAUNT THY KINDRED DUST/ HE WHO LIES HERE BUT SHARES WHAT'S DUE TO ALL/ HE EARLY KNEW 'TWERE HIS TO 'BEY THAT CALL/ WHICH SUMMONS MAN TO HIS ETERNAL REST/ AND BIDS HIS SOUL TO PERISH OR BE BLEST

Go in the gate with the house beside it and follow the path around the church in a clockwise direction and you come to the grave. If you take the path to the left just before the grave, a little further up on

the left-hand side as the path bends, is the grave of local antiquarian and historian **Richard Caulfield 1823-1887**. At his request he was buried beside his fellow antiquarian and historian the **Rev Samuel Hayman 1818-1886**.

John Mitchel 1815-1875

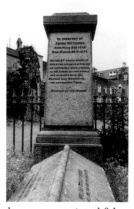

Born at Camnish, near Dungiven, County Derry. He was a nationalist and journalist who edited the *Nation*. In 1848 he founded the *United Irishman* which became known for its militant content. This led to him being convicted of treason in 1848 and sentenced to 14 years transportation. He escaped to America in 1853 and published a year later his most famous work - *Jail Journal or Five Years in British Prisons*. He supported the Southern cause during the American Civil War and was imprisoned after the end of the war. He was elected as MP for Tipperary in 1875 but was disqualified as he was a convicted felon. He stood again, and won the seat a second time but died before he could be unseated a second time. He wrote other books besides his *Jail Journal*. These include *The Last Conquest of Ireland (Perhaps)* and *The History of Ireland*.

He is buried in the Unitarian Cemetery, Old Meeting House Green, High St, Newry.

The Unitarian cemetery is located beside the convent and has a wooden door under an arch. The cemetery is locked but a key may be obtained locally. The grave is behind railings.

The inscription reads: IN MEMORY OF/JOHN MITCHEL/BORN NOVR 3RD 1815/DIED MARCH 20TH 1875/AFTER 27 YEARS SPENT IN/EXILE FOR THE SAKE OF IRELAND/HE RETURNED WITH HONOUR/TO DIE AMONG HIS OWN PEOPLE/AND HE RESTS WITH HIS/FATHER AND MOTHER IN/THE ADJOINING TOMB/ERECTED BY HIS WIDOW.

The funeral was attended by his friend and brother-in-law **"Honest" John Martin 1812-1875** who also spoke at the funeral.

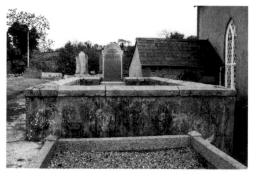

Martin was a nephew of **James Harshaw** *(q.v.)* and a Young Irelander. His *Diary* is held in the Public Record Office of Northern Ireland. He was so overcome with grief at Mitchel's death that he had

to be brought back to the same house where Mitchel had died. Nine days later he himself died. He is buried in the family grave in the grounds of Donaghmore Church of Ireland, County Down. Donaghmore is signposted on the A1 not far from Newry. The grave is situated on the left-hand side of the church about half way down. The inscription for him reads JOHN MARTIN/ BORN 8TH SEPTEMBER 1812/ DIED 29TH MARCH 1875/ HE LIVED FOR HIS COUNTRY, SUFFERED/ IN HER CAUSE, PLED FOR HER WRONGS/ AND DIED BELOVED AND LAMENTED BY/ EVERY TRUE HEARTED IRISHMAN.

Every public body in Ireland sent a representative to the funeral.

Susan Mitchell 1866-1926

Born in Carrick-on-Shannon, County Leitrim. She was a journalist and poet whose works include *The Living Chalice, Aids to the Immortality of Certain Persons in Ireland Charitably Administered* and *Secret*

Springs of Dublin Song. She is buried in grave number C115-4013, Mount Jerome Cemetery, Dublin, in the same grave as the two women who brought her up after the family was forced to split up. *(See map page 252)*. Go in the main cemetery entrance and take the second turn on the right, along the crescent shaped path. The grave is located just after the Boyse grave which has railings and is on the left path edge. Two graves past Boyse, turn left and the grave is about eight rows back. The grave to the right contains her cousins.

The main inscription on the stone is to Col John Wegg and the inscription to Susan Mitchell is on the base beneath the main panel.

The latter inscription reads: IN LOVING MEMORY OF/ SUSAN LANGSTAFF MITCHELL/ SECOND DAUGHTER OF MICHAEL MITCHELL/ AND KATHERINE THERESA HIS WIFE/ BORN IN CARRICK ON SHANNON 5TH DECEMBER 1866/ DIED IN DUBLIN 4TH MARCH 1926/ ONLY IN CLAY THE ROOT OF LOVE CAN GROW/ ONLY IN HEAVEN THE FLOWER OF LOVE CAN GROW

Michael Joseph Molloy 1914-1994

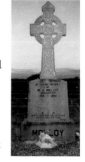

Born in Milltown, County Galway. His birthdate is usually given as 1917 but his brother puts the birth date as 1914. He entered a seminary but a serious illness forced him to leave and he returned home to work on a farm. His first play *The Old Road* was produced in the Abbey in 1943. Other plays include *The Wood of the Whispering, The Visiting House* and his most famous play *The King of Friday's Men*. The death notice for M. J. (Joe) Molloy referred to him as "Playwright and Folklorist". He is buried at

Kilclooney Cemetery, County Galway. It is situated ten kilometres from Tuam just before Milltown, on the right-hand side of the road. Go in the main gate and the grave is on the left-hand side, on the path side, about eight rows down. The inscription reads: IN LOVING MEMORY/OF/M.J. MOLLOY/DRAMATIST/1914-1994/R.I.P./WOE TO THEM WHO CALL GOOD EVIL/AND WHO CALL EVIL GOOD/(ISAIAH)

Brian Moore 1921-1999

Born in Belfast. He emigrated to Canada in 1948 where he became a journalist. He wrote several best selling crime novels before he made the breakthrough with more serious writing. He moved to New York in 1959 and a few years later he settled down in California. Moore was a widely acclaimed writer and won many major prizes, including the James Tait Black Memorial Prize, the W.H. Smith Award and the Heinemann Award. His books include *Judith Hearne, The Feast of Lupercal, The Emperor of Ice Cream, I am Mary Dunne, The Doctor's Wife, Catholics* and *Black Robe.* He died and was cremated in California. In her biography of Moore,

Patricia Craig tells the story of where Moore wished to be buried. He had been walking through the cemetery at Gurteen, not far from Roundstone, County Galway when he came across the grave of Bulmer Hobson, a northern nationalist. He felt this was the perfect spot to be buried. The cemetery is by the beach and very similar to the one where Muiris Ó Súilleabháin is buried. At the time of going to press, his ashes are not yet laid to rest here. The photograph shows the back of the grave of the painter Maurice MacGonigal and to the left of this grave, horizontal on the ground and almost covered by sand and grass, is the grave of Bulmer Hobson.

George Augustus Moore 1852–1933

Born in Ballyglass, County Mayo. He wrote novels, short stories

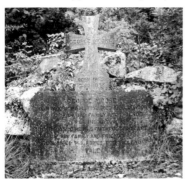 and plays and was part of the Irish literary revival. He wasn't a popular figure and although he loved Ireland, he didn't care so much for its people. His works include *Esther Waters, Hail and Farewell, The Lake, A Drama In Muslin, The Brook Kerith, Heloise and Abelard* and many others. He made his own funeral arrangements, wanting his ashes scattered on Castle Island and "mind the wind that it doesn't blow the ashes back into the boat".

He was cremated at Golders Green Crematorium, London. A small group, including the Prime Minister Ramsay MacDonald, attended the service. According to Adrian Frazier's biography, *George Moore 1852–1933*, the minister was somewhat inebriated and mixed the words of the burial service and the Lord's Prayer together. Some of the mourners came back from the funeral helpless with laughter. James Joyce sent a wreath.

Frazier goes on to relate that the ashes were put in a copy of a Bronze Age urn made especially for him. A cavity was made on the rocky foreshore of Castle Island at the north end of Lough Carra which Moore had used as the setting for his controversial novel *The Lake*. The cavity containing the urn was cemented over and stones from the ruins of the old Barrett castle on the island were piled in a cairn. The parish priest urged the local people to stay away from the funeral as it was rumoured that it would be a pagan one. As a result, there were not enough boatmen to row the mourners over to the island and Oliver St John Gogarty had to lend a hand. The funeral oration was written by George Russell and delivered by Richard Irvine Best. A memorial stone surmounted by a cross was erected over the grave.

The inscription reads: GEORGE MOORE/BORN MOORE HALL 1852 DIED 1933 LONDON/HE FORSOOK HIS FAMILY AND HIS FRIENDS/FOR HIS ART/BUT BECAUSE HE REMAINED FAITHFUL TO HIS ART/HIS FAMILY AND FRIENDS/RECLAIMED HIS ASHES FOR IRELAND/VALE

It is not an easy grave to visit, as it requires a boat journey. I hired a boat from James O'Reilly of Carra boats. His grandfather had been one of those who had helped bring the mourners across. He told me that the boat trade has been hit badly over the last ten years with more and more people buying their own boats and with the new regulations on passenger safety it would soon be even more difficult to visit the grave. Close by is Moore Hall and Kiltoom Cemetery where Moore's father is buried. Frazier's biography gives a graphic account of that funeral and it is very easy to imagine the procession through the woods and Fr Lavelle mounting the tomb to address the mourners.

Thomas Moore 1779-1852

Born in Dublin. He was one of the first Catholics to attend
Trinity College Dublin. He gained early success in London with
his singing, playing and poetry. His reputation was assured when
he put words to ancient Irish airs. *Moore's Melodies* were published

in ten volumes from 1808-1834. His
works include *The Meeting of the Waters,
Irish Melodies, National Airs and Sacred
Songs, Lalla Rookh, The Harp that once
through Tara's Halls, She wore a Wreath of
Roses, Oft in the Stilly Night, O Breathe Not
His Name, She is Far From the Land,*
biographies of Sheridan and Byron
and a *History of Ireland*. He is also
remembered for burning Byron's
memoirs. His five children all
predeceased him and this affected
his mental state in his last years.

There was a demand for
Moore to be buried in Ireland but
Bessy his wife wanted him buried
with his two children in the vault in
Bromham. Only one coach followed
the funeral. He is buried in St
Nicholas Churchyard, Bromham,
Sloperton near Devizes, Wiltshire. My brother Donal made the
mistake of telling me he was going for a few days holiday to
Weston-Super-Mare. I persuaded him that he should hire a car
and take in the sights of Bromham, including Thomas Moore's
grave. He found it so interesting that he volunteered to go to
Coxwold to photograph Laurence Sterne's grave for me.

When McDonagh (*Irish Graves in England*) visited the grave in
1887 he described the grave as "lying three feet from the gable
end of the church. It was marked by a long narrow stone slab,

lying flat, two inches above
the ground, surrounded
by strong and high iron
railings". The photo to the
right shows a postcard of
the grave as McDonagh
described it.

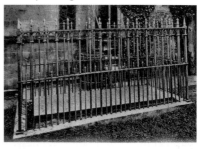

The inscription is as
follows: ANASTASIA MARY
MOORE/BORN MARCH
16TH 1813/DIED, MARCH
8TH 1829/ALSO/HER BROTHER/JOHN RUSSELL MOORE/WHO
DIED NOV 23RD/1842/AGED 19 YEARS./AND THEIR FATHER/
THOMAS MOORE/TENDERLY BELOVED BY ALL WHO KNEW/THE
GOODNESS OF HIS HEART/THE POET AND PATRIOT OF HIS
COUNTRY/IRELAND/BORN MAY 28TH 1779/SANK TO REST, FEBY
25TH, 1852/AGED 72/GOD IS LOVE/ALSO HIS WIFE/BESSY
MOORE/WHO DIED 4TH SEPTEMBER 1865/AND TO THE MEMORY
OF THEIR SON/THOMAS LANSDOWNE PARR MOORE/BORN 24TH

October 1818/Died In Africa, January 1846.

The spot was chosen in order to fulfil his wish that he be buried as near as possible to Bromham bells. The grave was later surmounted by a five metre high Celtic cross. Below the cross is the inscription: Thomas Moore/Born 28 May 1779 Died 25 February 1852/Dear Harp Of My Country In Darkness I Found Thee/The Cold Chain Of Silence Had Hung O'er Thee Long/When Proudly My Own Island Harp I Unbound Thee/And Gave All Thy Chords To Light, Freedom And Song.

On the back is the inscription: THE POET OF ALL CIRCLES/ AND THE IDOL OF HIS OWN/ BYRON

The Thomas Moore Window is situated in the west of the nave. Underneath is the inscription: This Window Is Placed In This Church By The Combined Subscriptions Of Two Hundred Persons Who Honour The Memory Of The Poet Of All Circles And The Idol Of His Own, THOMAS MOORE.

There is another window, in the chancel, dedicated to his wife Bessie.

Moore's parents are buried in St Kevin's Churchyard, Camden Row, Dublin. *(See map page 255)*. It is now a public park and the grave is marked on a map at the entrance. The inscription reads: Sacred To The Memory Of John Moore Esq/Formerly Barrack Master Of Islandbridge/In The County Of Dublin/Who Departed This Life December 17th 1825/Aged 84 Years/Here Is Also Interred Anastasia Moore/Alias Codd The

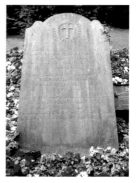

Beloved Wife/Who Departed This Life May 8th 1832/Aged 68 Years/Also Six Of Their Children Who Died Young/ And Their Beloved Daughter Ellen/Who Died February 14th 1846/Deeply Mourned By Her Brother Thomas Moore/The Bard Of His Much Beloved Country Ireland

Lady Sydney Morgan c. 1776-1859

The story goes that she was born on the mail boat crossing the Irish Sea. She herself said she was born in 'Ould Dublin'. She revealed no more about her birthplace and even less about the date. She became well-known for her novel *The Wild Irish Girl*. Other works include *O'Donnel – A National Tale, The O'Briens and the O'Flahertys, Florence Macarthy – An Irish Tale* and controversial but popular books on France and Italy. She was also a well-known socialite in Dublin and when her popularity declined she went to London and hosted a successful salon there.

She is buried in Brompton Cemetery, London. Volume 30 of *The Builder* (published 1872), page 710 describes "the grave of Lady Morgan, upon which rests an effigy of an Irish harp, above which are two volumes, inscribed 'Wild Irish Girl' and 'France'." The tomb was designed by Westmacott. When Michael McDonagh (*Irish Graves in England*) visited the grave in the 1880's he knew more or

less where it was situated and thought he would have no difficulty finding such a striking monument. In the end he had to seek help from one of the cemetery officials who asked if he meant the one with the harp? They found the grave but the harp and the books were no longer there. McDonagh reckons they were not replaced after the last burial in 1880. The superintendent had no information about the whereabouts of these objects.

Permanent Londoners, published in 2000, refers to the tomb "which shows two of her books" which implies that either they were restored at some time, or perhaps the authors had not visited the grave.

So armed with a sketch of the tomb and a guidebook showing the location, I presumed I would have no bother finding the grave. Alas, like McDonagh, over 100 years before, I had to admit defeat and ask assistance from the superintendent. He knew of it and that it was wrongly located in the cemetery guidebook. So he went back to the records and pinpointed its location. There was no sign of an Irish harp or the two books. There was no legible inscription on it either. The original inscription

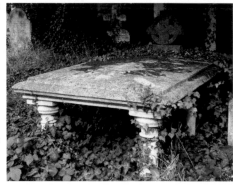

read: HERE LIES INTERRED/SYDNEY LADY MORGAN/WHO DIED APRIL, 1859/ALSO HER NIECE/SYDNEY JANE/WIDOW OF THE REV EDWARD INWOOD JONES/RECTOR OF/NEWTON, MONMOUTHSHIRE/WHO DIED AUGUST 21ST 1882.

There is a small diamond shaped slab inserted in front of the tomb which had the following inscription: GERALDINE ENDOR JEWSBURY/DIED SEPTEMBER 23RD 1880/AGED 63.

Miss Jewsbury was a companion of Lady Morgan in her latter years.

It was said that Lady Morgan's coffin was hardly larger than that of an infant child. This is not surprising as McDonagh had described her as "hardly more than four feet high with a spine not quite straight".

Iris Murdoch 1919-1997

Born in Dublin. She was brought up in London and educated in England. From 1948-1963 she was Fellow and tutor in philosophy at St Ann's College Oxford. She published a number of philosophical works such as *The Fire and The Sun, Good Over Other Concepts, Christ's Shadow in Plato's Cave* and a later work *Metaphysics as a Guide to Morals* (1992). Her literary career included 26 novels. Her novel

The Sea, The Sea won the Booker Prize and she won many other literary prizes. Her books include *Under the Net, The Bell, The Red and the Green, A Severed Head, The Nice and the Good, A Fairly Honourable Defeat* and many others. Her remains were cremated at Oxford Crematorium and her ashes scattered in the grounds beyond the J8 flowerbed.

Michael Joseph Murphy 1913-1996

Born in Liverpool of Irish parents who returned to Armagh in 1922. His death notice described him as a folklorist, broadcaster and author. He collected over 100 volumes of folklore from all over Ulster. He broadcast with the BBC and Radio Éireann and worked with Sam Hanna Bell. He had plays produced at the Abbey and the Belfast Group theatre and he wrote stories. His works include *At Slieve Gullion's Foot, My Man Jack, Now You're Talking —*

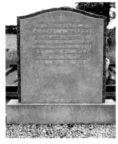

Folk Tales from the North of Ireland, The Hard Man and *Dust Under Our Feet*. He is buried in the cemetery adjoining St Michael's Church, Darver, Castlebellingham, County Louth. Coming from the Dublin direction, take the motorway exit to Castlebellingham and Ardee and follow the signs for Ardee. There is a signpost for Darver on this road. Go in the main gate of the cemetery and the grave is located 15 rows up on the right-hand side. The inscription reads: IN LOVING MEMORY OF/ MICHAEL J. MURPHY/ WRITER AND FOLKLORIST/ DRUMINTEE SOUTH ARMAGH/ AND WALTERSTOWN COUNTY LOUTH/ 1913-18TH MAY 1996/ HIS WIFE ALICE/ 1910-23RD MAY 1999

Séamus Murphy 1907-1975

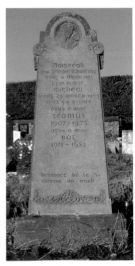

Born near Mallow, County Cork. He was a well-known sculptor and stone carver who became Professor of Sculpture, RHA. His autobiographical *Stone Mad* was well received. He also carved many of the headstones that are featured in this book. Seán Ó Tuama said of him that "he was a sculptor who set headstones dancing with his carefree lore". He is buried in Rathcooney graveyard, Cork City. There are two graveyards and Séamus Murphy is buried in the one with the remains of a church. Go in the pedestrian gate furthest from the ruins. Go almost to the end of the path and on the left-hand side four rows behind the tallest cross in the area is the Murphy plot. The stone is also by Séamus Murphy.

John Fisher Murray 1811-1865

Born in Belfast. He graduated from Trinity College Dublin and wrote many articles and poems for various journals. His works include *The Viceroy, The Irish Oyster Eater, River Thames and Its Western Course, The World of London, Father Tom and the Pope: Or a Night at the Vatican* and *Picturesque Tour of the Thames.* He died in London but he is buried in Glasnevin Cemetery, Dublin. *(See map page 246 – the grave is three rows from the road).* The inscription on the front of the monument reads: ERECTED BY HANNAH MURRAY IN MEMORY OF HER BELOVED HUSBAND JOHN FISHER MURRAY BORN FEBRUARY 11TH 1811

The inscription on the right side of the monument reads: AN HONOURABLE LIFE HARD PRESSED/BY SORE TEMPTATION, YET MAINTAINED/THE CONSCIOUS VIRTUE OF THE BREAST/THE NARROW THORNY PATH RETAINED

On the other side the inscription reads: A SIMPLE LIFE AN HONEST HEART/A CHEERFUL HOSPITABLE GRACE/COURAGE TO ACT A MANLY PART/SPIRIT TO FEEL FOR HUMAN RACE

On the back of the monument is the inscription: WHAT NOW SHALL CHEER THE DREADFUL DAY/WHAT NOW IRRADIATE THE GLOOM/ACCOMPANY IN DEATH'S DARK WAY/CONTENTED LEAD US TO THE TOMB

Thomas Cornelius Murray 1873-1959

Born in Macroom, County Cork. He became a teacher and was headmaster of the Model Schools in Inchicore. He was considered one of the best of the Abbey playwrights. His work includes *Birthright, Maurice Harte, Spring, Aftermath, Autumn Fire, Michaelmas Eve* and the novel *Spring Horizon.* He is buried in grave number DK 58 St Patrick's, Glasnevin, Dublin. *(See map page 246 – Go in the main gate and turn left. Walk beside the wall until you come to the letters HK on the wall. Turn right and the grave is on the left, one section down).*

Cardinal John Henry Newman 1801-1890

Born in London. He was a leader of the Oxford Movement but turned towards Roman Catholicism and was converted in 1845. He came to Ireland and was made Rector of the Catholic University of Ireland 1854-8. He was responsible for building the chapel beside what is Newman House today in St Stephen's Green. He is best known for *Apologia pro Vita Sua,* his poem *The Dream of Gerontius* and the hymn *Lead kindly light.* He was made a cardinal in 1879. At his request he is buried in the same grave as

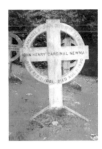

his friend Ambrose St John in the graveyard of the country house of the Oratory Fathers in Rednal, Birmingham. Take the bus to the terminus at Rednal. Opposite is Leach Green Lane. Go up this road and take the first turn on the left and the next turn on the right. There are two wooden gates on the right-hand side. The cemetery is situated on the right-hand side of the house and is only open on Wednesday and Sunday afternoons.

Eibhlín Dubh Ní Chonaill c. 1743-c. 1800

Born in Derrynane, County Kerry. She was an aunt of Daniel O'Connell. Despite her family's wishes she married Art Ó Laoghaire, who was somewhat notorious for his escapades. He incurred the enmity of the High Sheriff of Cork who eventually had him declared an outlaw under the Penal Laws for not selling him a horse.

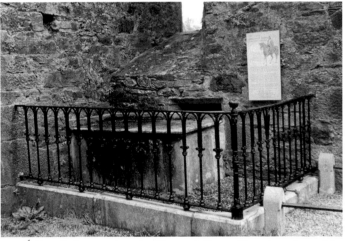

Ó Laoghaire was shot dead by a soldier at Carraig an Ime. His riderless horse, drenched in his blood, came back home and Eibhlín Dubh mounted it and rode to Carraig an Ime where she found her husband dead. She began to write a lament for him, *Caoineadh Airt Uí Laoghaire*. Her lament, which ran to over 400 lines, has been translated into other languages. Little is known of what happened to her after Ó Laoghaire's death.

Art Ó Laoghaire is buried in the southeast angle of the nave at Kilcrea Abbey, County Cork. At the grave there is a tourist information board which gives the inscription on his tomb as: LO ARTHUR LEARY, GENEROUS/ HANDSOME BRAVE, SLAIN IN/ HIS BLOOM, LIES IN THIS HUMBLE/ GRAVE. DIED 4TH MAY 1773/ AGED 26 YEARS. The board gives an account of his life and the part of the lament sung by his wife at Art's Burial in Kilcrea Abbey. It quotes the lines that were probably sung by Eibhlín at Art's funeral in the Abbey – My Love And My Beloved/ Your

Corn-Stalks Are Standing/ Your Yellow Cows Milking/ Your Grief Upon My Heart/ All Munster Couldn't Cure/ Nor The Smiths Of Oileán Na bhFionn/ Till Art Ó Laoghaire Comes/ My Grief Will Not Disperse/ But Cram My Heart's Core/ Shut Firmly In/ Like A Trunk Locked Up/ When The Key Is Lost

Patrick O'Brian 1914-2000

His real name was Richard Russ and he was born in Chalfont St Peter in Buckinghamshire. He was the author of over 30 books. He is best known for the Aubrey Maturin series of novels. He encouraged the world to think that he was Irish and it was appropriate that he at least died in Ireland, in a Dublin hotel. He was awarded the CBE in 1995. He is buried in the Cimetière Communal de "La Croette", Collioure, France next to his wife. His death had been kept secret and he was buried nine days later at a private ceremony attended by the local mayor and a few close friends and family. The cemetery is in the hills overlooking the harbour.

Charlotte Grace O'Brien 1845-1909

Born in Cahirmoyle, County Limerick. She was the daughter of William Smith O'Brien. She was a botanist as well as a writer. She also became involved in the work to relieve the conditions on the coffin ships and in the tenements in New York. Her works include *A Tale of Venice, Light and Shade, Lyrics* and *Oliver Dale*.

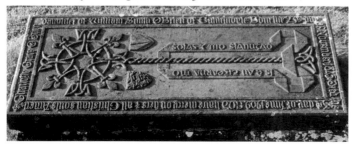

She is buried in the cemetery at Knockpatrick overlooking Foynes, County Limerick.

Knockpatrick Cemetery is well signposted on the road from Ardagh to Foynes on the left-hand side. The path to the cemetery from the road is about a kilometre in length. The grave is situated beside the church wall that overlooks the bay. The inscription is in both English and Irish: CHARLOTTE GRACE O'BRIEN/ DAUGHTER OF WILLIAM SMITH O'BRIEN CAHERMOYLE/ BORN ON THE 23RD DAY OF NOVEMBER 1845/ DIED THE/ THIRD DAY OF JUNE 1909/ GOD HAVE MERCY ON HERS AND ALL CHRISTIAN SOULS

Fitz-James O'Brien 1828-1862

Born in County Cork. After the death of his father, the family moved to Limerick. He wrote poetry and his first poem appeared

in the *Nation*. At the age of 21 he moved to London. He wrote a large number of poems, stories and articles which appeared in English, Scottish and Irish periodicals. After he squandered his fortune he emigrated to America where he continued to write. His reputation is based on a number of fantastic tales most notably *The Diamond Lens, What Was It?* and *The Wondersmith*. He joined the Union Army at the outbreak of the Civil War and was wounded in early 1862. The wound wasn't properly treated, tetanus set in and he died April 6th 1862. His funeral to Green-Wood Cemetery, Brooklyn, New York was attended by a guard of honour, his editor, his literary executor and various friends. In November 1874, the remains were re-interred in the same cemetery, in grave 1183, Lot 17,263.

The photograph was taken especially for this book by Jeffrey Richman, who has written an excellent book on Green-Wood Cemetery. He has also provided the following directions to the grave. Enter the cemetery at the main entrance, 25th Street and Fifth Avenue. Drive through the brownstone gates and bear right, along Landscape Avenue; right on Lake Avenue; right on Sylvan Avenue; left onto Maple Avenue. O'Brien's stone is on the right side of Maple Avenue, just to the left of a flight of concrete steps, about 50 feet before Maple Avenue starts its turn to the left. It is shown in the middle of the photograph above

Flann O'Brien 1911-1966

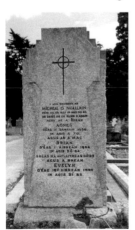

Born Brian O'Nolan in Strabane, County Tyrone. He also used the pseudonym Myles na gCopaleen. He was a civil servant who eventually became principal officer for town planning in the Department of Local Government. In his spare time he wrote a satirical column for the *Irish Times* under the title of *An Cruiskeen Lawn*. After early retirement in 1953 he wrote full-time. His works include *At Swim-Two-Birds, The Third Policeman, The Dalkey Archive, An Béal Bocht* and *The Hard Life*. His death was reported on 1st April and many of his friends thought it was a practical joke and didn't believe the news. A substantial number of nuns and priests attended the funeral and a rosary was recited at the graveside but there was no oration.

He is buried in the family plot, grave number 20 A, West Section, in Deansgrange Cemetery, Dublin. *(See map page 250 - the*

grave is on a corner site opposite the Republican Plot).

The inscription on the gravestone reads: I NDIL CHUIMHNE AR/MÍCHEAL Ó NUALLAIN/D'ÉAG 29 IÚL 1937 IN AOIS DO 62/ AR DHEIS DE GO RAIBH A ANAM/AGUS AR AN BHEAN/AGNES/ D'ÉAG 11 SAMHAIN 1956/IN AOIS A 70/AGUS AR A MAC/BRIAN/ D'ÉAG I AIBREÁN 1966/IN AOIS DÓ 54/SOLAS NA BHFLAITHEAS DÓIBH/AGUS A BHEAN/EVELYN/D'ÉAG 18Ú AIBREÁN 1995/IN AOIS DÍ 85

Kate O'Brien 1897-1974

Born in Limerick. She became a full-time writer in 1926 after the successful production of her play *Distinguished Villa*. Her first novel *Without My Cloak* won the James Tait Black Memorial Prize and the Hawthornden Prize. Further works established her as a leading Irish writer. These works include *Mary Lavelle, Pray for the Wanderer, The Land of Spices, The Last of Summer, That Lady, For One Sweet Grape* and *The Flower of May.*

She is buried in grave no H340, Lover Lane Cemetery, Faversham. As you enter the main gate of the cemetery, the grave

is situated on the right, more or less in line with the porch of the church. The inscription reads: KATE O'BRIEN F.R.S.I./ B. 3 DEC. 1897/ D. 13 AUG 1974/ IRISH NOVELIST/ PRAY FOR THE WANDERER

There is a regular train service from Victoria Station, London.

Kate Cruise O'Brien 1948-1998

Born in Dublin. She worked for a period as literary editor with Poolbeg Press. Her works include *A Gift Horse* and *The Homesick Garden*. She is buried in Glasnevin Cemetery, Dublin. *(See map page 246 - the grave is on the road edge).*

William O'Brien 1852-1928

Born in Mallow, County Cork. He became a journalist and edited the *United Ireland* 1881-1882 and was imprisoned for his views. From 1883-1918, he served as MP for various Cork constituencies. He joined with John Dillon to force landlords to reduce their rents and he was imprisoned again. He founded the United Irish League in 1898 and formed the All Ireland League in 1910 to promote conciliation between the nationalist and unionist traditions. He did not contest the 1918 elections. His best known works include *When We Were Boys, A Queen of Men, Irish Ideas, Golden Memories: The Love*

Letters and *The Prison Letters of William O'Brien* and *The Irish Revolution.*

William O'Brien is buried in the graveyard of St Mary's Church in Mallow. The cemetery cannot be seen from the main road. Go in the gate and go down the left-hand side of the church. At the back, take the path on the right directly behind the church and the grave is against the wall facing you. Thankfully the local Thomas Davis Commemoration Society erected a stone on the grave just before I visited it, otherwise it would have been very difficult to spot as the name on the gravestone is at the very end of the Mansfield family plot. The inscription on the gravestone reads:
THE BURIAL PLACE / OF / PIERCE MANSFIELD / AND FAMILY. HE DEPARTED / THIS LIFE ON 21ST OF FEBRY / 1833 AGED 51 YEARS MAY / HIS SOUL REST IN PEACE / AMEN / JAMES W O'BRIEN / DIED 9TH JUNE 1869 AGED 47 YEARS / HIS SON WILLIAM O'BRIEN / BORN IN MALLOW 2 OCTOBER 1852 / DIED IN LONDON 25 FEB 1928

The grave has been tidied up and a white slab dedicated to William O'Brien lies on top. It has the following inscription:
WILLIAM O'BRIEN M.P. / BORN 2ND OCTOBER 1852 / DIED 25TH FEBRUARY1928 / AUTHOR / LEADER / PATRIOT / "ALL FOR IRELAND / AND / IRELAND FOR ALL" / AR SON CIRT AGUS CINE / THOMAS DAVIS COMMEMORATION SOCIETY 2002

William Smith O'Brien 1803-64

Born in Dromoland, County Clare. After having served as a Conservative MP for Ennis and Limerick, he joined the Young

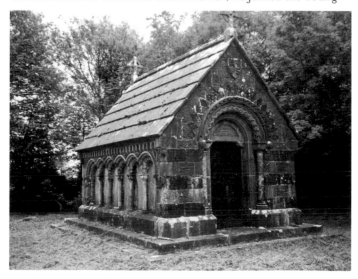

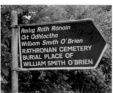

Irelanders and in 1847 founded the Irish Confederation. He took part in the last incident of the 1848 rebellion and was sentenced to death, later commuted to penal servitude for life. He was released in 1854 provided he left the jurisdiction. This restriction was lifted in 1856 and he returned to Ireland but played no more part in politics. He wrote *Principles of Government or Meditations in Exile*.

His family wanted a quiet funeral but the crowds came out in their thousands to pay their respects. He is buried in Rathronan Cemetery near Cahermoyle, County Limerick. On the road from Ardagh to Shanagolden, there is a signpost for the burial place and the cemetery is on the right-hand side. The mausoleum is the biggest structure in this small cemetery. There are a number of inscriptions for his son and other members of the family.

The one for him reads: WILLIAM SMITH O'BRIEN/BORN 17TH OCTOBER/1803/DIED 18TH JUNE/1864

T.D. Sullivan wrote *Ode Written for the Demonstration at the Tomb of William Smith O'Brien*.

Cathal O'Byrne 1876-1957

He was born in County Down. As his gravestone states, he was a fine singer and he performed throughout Ireland and Britain. He is perhaps best known for his book *As I Roved Out*. The book is a collection of stories about the streets and back lanes of Belfast and its people. The book was immensely popular when it was first published in 1946 and it is still in print. Other works include: *Ashes on the Hearth, Pilgrim in Italy* and books of poems and short stories.

He is buried in Milltown Cemetery, Belfast. The inscription reads: IN THANKFUL REMEMBRANCE OF/CATHAL O'BYRNE/SINGER, POET AND WRITER/WHO BROUGHT JOY INTO THE LIVES OF OTHERS/DIED 1ST AUGUST 1957.

Go in the main gate and the grave is located down the second path on the left after the roundabout area. Look for a large memorial to several priests about half way down on the right-hand side and it is back a few rows. It is often covered by shrubbery. When I last visited it at the end of May 2003, it was completely covered and it took me 15 minutes to find. However, there is a regeneration plan to clean up the cemetery over the next few years.

Máirtín Ó Cadhain 1906-1970

He was born near Spiddal, County Galway. He became a teacher but lost his job when he joined the IRA. He was interned in the Curragh Camp from 1940-44. After working in the Government Translation Service, he obtained a position as a Junior Lecturer in 1956 and he became Professor of Irish at Trinity College Dublin in 1969. He is considered one of the most outstanding writers in the Irish language in the 20th century. His works include *Cré na Cille, Idir Shúgradh agus Dáiríre agus Scéalta Eile, An Braon Broghach, Cois Caoláire, An tSraith ar Lár* and *An tSraith Dhá Tógáil. The Road To Bright City* is a collection of his short stories translated by Eoghan Ó Tuairisc. He is buried in grave number CRB+4-465-37967, Mount Jerome Cemetery, Dublin. *(See map page 252).* Go up about 45-50 rows on the main road adjoining the section and on the left-hand side go in at McWade and go seven rows back. The grave is facing away. The gravestone has the following inscription: MÁIRIN BEAN I CHADHAIN/ 1965/ PÁDRAIC Ó RODAIGH/ SAGART/ 1966/ MÁIRTÍN Ó CADHAIN/ 1970

John Cornelius O'Callaghan 1805-1883

Born in Dublin. He was a writer who is best known for *History of the Irish Brigades in the Service of France*. He is buried in Glasnevin Cemetery, Dublin. The inscription reads: OF YOUR CHARITY/ PRAY FOR THE SOUL OF/ JOHN CORNELIUS O'CALLAGHAN/ WHO DIED/ ON THE 24TH APRIL 1883/ AGED 77 YEARS/ R.I.P. *(See map page 246).* The grave is two or three rows past the Atkinson and Gilbert (q.v.) crosses and about three rows in although it is the first monument in the row.

Turlough O'Carolan 1670-1738

Born in Newtown, near Nobber, County Meath. He became blind in his youth due to smallpox. After being taught how to play the harp, he travelled the country making up tunes and

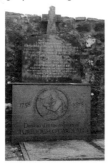

playing them. More than 200 of his melodies have survived. His wake lasted four days and was attended by people from all over Ireland.

He is buried in the MacDermot Roe family chapel, Kilronan graveyard which is situated about four kilometres south east of Ballyfarnon on the Keadue to Ballyfarnon road, County Roscommon. The inscription on his gravestone, in Irish and English, reads: IN GRATEFUL MEMORY OF/ TURLOUGH O'CAROLAN/ HARPER,

COMPOSER, POET, SINGER/ "OUR GREAT SOLACE IN OUR GREAT NEED"/ BORN AT NOBBER 1670/ DIED AT ALDERFORD 1738/ R.I.P.

Above the entrance to the graveyard is a stone which reads: WITHIN THIS CHURCHYARD/ LIES INTERRED/ CAROLAN/ THE LAST OF THE IRISH BARDS/ HE DIED MARCH 25TH 1738/ R.I.P. There is a memorial to him in St Patrick's Cathedral, Dublin.

Seán O'Casey 1880-1964

Born in Dublin. He came from a poor Protestant working class family. He worked from a young age and was largely self-taught. He became Secretary of the Irish Citizen Army but left in 1914. His first three plays established him as a major dramatist – *The Shadow of a Gunman*, *Juno and the Paycock* (for which he was awarded the Hawthornden Prize) and *The Plough and the Stars*. A growing-apart with the new Irish State sent him into exile and his subsequent work never achieved the success of his earlier plays. Other works include *The Silver Tassie, Cock-a-Doodle Dandy, The Bishop's Bonfire, The Drums of Father Ned* and a six-volume autobiography.

David Krause in his book, *Seán O'Casey and His World*, says he was cremated in Torquay and his ashes dispersed in the Garden of Remembrance at the Golders Green Crematorium, London in an area between the Shelley and Tennyson rosebeds. This was where his son's ashes had been scattered seven years before. A cemetery official in Golders Green told me he was cremated at Golders Green and his ashes scattered in the Cedar Lawn West area – this is the bed closer to the Tennyson bed.

Seán Ó Coileáin 1754-1817

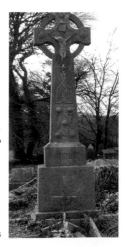

Born in County Cork. He was a schoolmaster and one of the last of the poets of the old tradition. He is remembered mostly for two poems *An Buachaill Bán* and *Machtnamh an Duine Dhoilíosaigh*. The latter is a lament on the ruins of Timoleague Abbey. He is buried in the cemetery attached to Christ Church, Kilmeen. Take the road from Clonakilty to Dunmanway and follow the sign for Rossmore. Go through the village and take the first turn on the left and the church is further down on the left-hand side. Go in the gate and take the gravel path to the end. The grave is situated to the left. The cross was erected by the parishoners in the 1960s

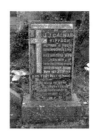

after the first one was damaged. Also buried in the same cemetery is the local poet and author, **J.J. Calnan 1874 - 1929** – HOW WELL HE SANG OF BALLYGURTEEN AND OF THE HURLERS OF KIELMEEN. His grave is located a few rows behind Ó Coileáin at the far left corner near the back wall.

Pádraic Ó Conaire 1882-1928

Born in Galway. He left Ireland to work in London in 1899 and became a civil servant. He married and had children but his alcoholism caused problems. He won prizes for stories at the Oireachtas in 1904 and 1909. In 1914 he went back to Ireland and spent a great deal of time wandering around the country and writing about what he found. His works include *Nóra Mharcuis Bhig*

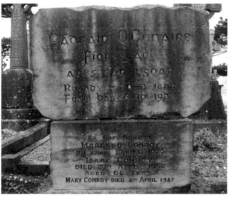

agus Sgéalta Eile, An Chéad Chloch, Bairbre Rua agus Drámaí Eile, M'Asal Beag Dubh, Deoraidheacht and *Scothscéalta*. There is a statue of him in Eyre Square, Galway. He is considered one of the finest writers in Irish. He died impoverished in the Richmond Hospital, Dublin.

He is buried in Bohermore Cemetery, Galway.

The inscription on the head stone reads: PÁDRAIC Ó CONAIRE/FÍOR-GHAEL/AGUS SÁR-UGHDAR/RUGADH 20-2-1882/ FUAIR BÁS 6-10-1928/ER COF ANNWYL/MARGRED CONROY/BU FARW EBRILL 1927/ISAAC CONROY DIED 27TH APRIL 1942/AGED 64 YEARS/MARY CONROY DIED 2ND APRIL 1987

The limestone headstone was erected on the centenary of his birth. It was paid for by the people of Galway and was unveiled over his grave by Máirtín Ó Direáin.

Peter O'Connell 1746-1826

Born in Carne near Killimer, County Clare. He was a school-teacher who spent much of his life compiling an Irish dictionary. Eugene O'Curry, who had been one of his pupils, described it as the most comprehensive Irish-English dictionary in existence.

He is buried at Killimer, County Clare. Turn right when you come off the ferry and the cemetery is located not far away on the left-hand side. The newer part is across the road on the sea side. Go up the steps leading into the older part and the grave is two away from the steps. There is an upright stone with a plaque. The plaque reads: PETER O'CONNELL/1746-1826 IRISH SCHOLAR TEACHER AND/LEXICOGRAPHER HE COMPILED/A MOST

IMPORTANT IRISH-/ ENGLISH DICTIONARY BETWE/EN 1765 AND 1826/THANKS TO HIS KINDNESS THE/BODY OF ELLEN HANLEY (THE/COLLEEN BAWN) WAS BURIED/IN HIS FAMILY GRAVE 1819/HE WAS

REMEMBERED HERE BY/RELATIVES, ADMIRERS AND/THE PEOPLE OF HIS NATIVE/PLACE/BEANNACHT DHÍLIS DÉ/LE HANAMANN' NA MARBH/ERECTED 1987

The horizontal stone is to Peter O'Connell. The inscription reads: THIS TOMB WAS ERECTED/BY ANTHONY O'CONNELL IN/MEMORY OF HIS UNCHEL (Sic)/PETER O'CONNELL WHO WAS/A PROFESSOR OF LANGUAGES/AND A TEACHER OF PHILOSO/PHY HE LIVED RESPECTED/AND DIED REGRETTED BY/HIS NUMEROUS FAMILY/AND FRIENDS ON THE 24TH/OF FBRY 1826 AGED 71 YEARS/MAY HIS SOUL REST IN/PEACE AMEN.

As the plaque above states, **Ellen Hanley 1803-1819, The Colleen Bawn**, is buried in the same grave. She was a poor girl from Croom in County Limerick who eloped with John Scanlan of Ballycahane House. Scanlan later had her murdered and her body was eventually washed up at Moneypoint, County Clare. Scanlan was tried and despite being from a well-to-do family and being defended by Daniel O'Connell, he was found guilty and subsequently executed. His manservant, Steven Sullivan, was later apprehended and suffered the same fate, admitting that he had killed Ellen on Scanlan's orders. The story was made famous by Gerald Griffin who used it as the plot for his novel *The Collegians*. Boucicault used the story for his play *The Colleen Bawn.*

So many people took souvenirs from the original gravestone that it completely disappeared.

Frank O'Connor 1903-1966

Born Michael O'Donovan in Cork. He was a pupil of Daniel Corkery. He fought in the War of Independence, was anti-Treaty and was interned for a period. He then entered the library service and eventually he became a journalist and broadcaster. While he wrote plays and criticism, he was considered Ireland's

finest short story writer. Yeats said of him that "he was doing for Ireland what Chekhov did for Russia". His works include *Guests of The Nation, Bones of Contention, Crab Apple Jelly*, the novels *The Saint and Mary Kate* and *Dutch Interior*, the autobiographical *An Only Child* and *My Father's Son*, a biography of Collins — *The Big Fellow* — and translations including *Kings, Lords and Commons*.

He is buried in grave number 79/80-N-St Patrick's, Deansgrange Cemetery, Dublin. *(See map page 250 - the grave is on the path edge)*. The funeral oration was given by Brendan Kennelly. Patrick Kavanagh and Flann O'Brien were among the mourners. Flann O'Brien is buried a few hundred metres away on the other side of the cemetery.

Up until 2003 there was only a small loose memorial stone marking the grave. The inscription reads: MICHAEL O'DONOVAN (FRANK O'CONNOR) 1903-1966. In the centenary year of his birth a new memorial was erected over the grave.

T(homas) P(ower) O'Connor 1848-1929

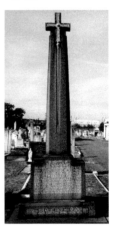

Born in Athlone, County Westmeath. He was a journalist and a Member of Parliament, representing Galway from 1880-1895 and Liverpool from 1895 until his death. He founded the *Star* in 1887, *T.P.'s Weekly* in 1902 and the *Sun* which failed due to financial difficulties. He became the first film censor for the UK in 1917 and was for many years the Father of the House of Commons. His books include *Life of Beaconsfield, Gladstone — Parnell, and The Great Irish Struggle, The Parnell Movement* and *Memoirs of an Old Parliamentarian.* He is buried in grave number 986X NE, St Mary's Roman Catholic Cemetery, Kensal Green, London. The grave is situated on the left-hand side of the road after the office.
The inscription reads: IN MEMORY OF/T.P. O'CONNOR/ ORATOR-STATESMAN-JOURNALIST/IRISH PATRIOT-TRIBUNE OF THE PEOPLE/BORN AT ATHLONE 5 OCT 1848 DIED 18/NOV 1929 + MEMBER OF PARLIAMENT/FOR SCOTLAND DIVISION OF LIVERPOOL/FROM 1885 TO 1929 PRIVY COUNCILLOR/+ CITIZEN OF THE WORLD WHOSE DEEP/SYMPATHY AND UNTIRING ZEAL FOR THE/WELFARE OF HIS FELLOW MEN WON FOR/HIM UNIVERSAL LOVE AND DEVOTION/ETERNAL REST GRANT UNTO HIM O LORD AND/LET LIGHT PERPETUAL SHINE UPON HIM

Tomás (Thomas O'Crohan) Ó Criomhthain 1856-1937

Born on the Blasket Islands. He was a fisherman who lived all his life on the island. Encouraged by Brian Ó Ceallaigh he wrote about his life and experiences in *Allagar na hInise*. This was followed by *An tOileánach (The Islandman)* which quickly became a classic of Irish literature. He is buried in the little churchyard of Baile an

Teampaill, Dun Chaoin. The cemetery is located in the village of
Dun Chaoin (Dunquin) and it is very overgrown.

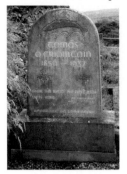

Ó Criomhthain's grave is one of the few
that is tended. It is on the right-hand side
as you go in the gate, not far away. The
stone is by Séamus Murphy RHA. The
inscription reads: TOMÁS/Ó
CRIOMHTHAIN/1856 −1937/MAR NA
BEIDH ÁR LEITHEIDÍ/ARÍS ANN AN
TOILEÁNACH/BEANNACHT DÉ LENA
ANAM

Brian Ó Ceallaigh 1889-1936 was a
schools inspector who, more than any
other, was responsible for encouraging
Tomás Ó Criomhthain to write. He died
of poliomyelitis on 28th December 1936. He was buried in the
municipal cemetery of Lovrinac just outside Split. Muiris Mac
Conghail relates in his book on the Blaskets how he and his wife
visited the grave in 1986. The grave was identified by number and
there was a dilapidated cross. There was no name on the grave.

Eugene O'Curry 1794-1862

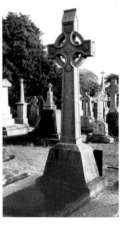

Born near Carrigaholt, County Clare. He
worked in the Ordnance Survey with John
O'Donovan who was his brother-in-law.
He became Professor of Irish Language
and Irish Archaeology at the Catholic
University. His works include *On the Manners
and Customs of the Ancient Irish* and *Lectures on the
Manuscript Materials of Ancient Irish History*. He
also travelled with George Petrie to the
Aran Islands to collect Irish airs and
words. Before his death he was working on
translating the *Ancient Laws of Ireland* along
with O'Donovan. He died in poverty and
was buried in Glasnevin Cemetery, Dublin.
(See map page 246 - the grave is on the path edge).
 The inscription reads:
IS BEANNAIGHTHE NA MAIRBH/ NOCH DO GHEIBH BÁS IS IN
TIGEARNA/ PRAY FOR THE SOUL OF/ EUGENE O'CURRY/
PROFESSOR OF IRISH HISTORY AND ARCHAEOLOGY/ IN THE
CATHOLIC UNIVERSITY OF IRELAND 1854-1862/ BORN 11TH
NOVEMBER 1794/ DIED 30TH JULY 1862/ MAY HE REST IN PEACE.

 On the other side is the inscription: TO THIS RESTING PLACE
OF HIS FATHER/ WERE REMOVED IN JULY 1905/ BY THE
SOLICITUDE OF/ JOHN E O'CURRY AND HIS SON EUGENE/ THE
REMAINS OF ANNE/ WIFE OF THE AFORESAID/ PROFESSOR
O'CURRY/ ALSO ANNE EUGENE AND HENRY/ THEIR CHILDREN/
AND ANNE DILLON O'CURRY/ BELOVED WIFE OF AFORESAID
JOHN E/ BORN AT BUENOS AYRES ARGENTINE REPUBLIC/ DIED IN
PARIS 4TH JUNE 1905 AGED 49 YEARS/ R.I.P.

Seán/Séamus Ó Dalaigh 1750-1810

He was one of the Maigue poets. He is buried in Mungret cemetery which is situated just off the main road from Limerick to Foynes on the R510. The graveyard is very overgrown. I spent a fruitless hour looking for the grave in 2002 before giving up.

Then Matt Tobin sent me a paragraph from *Limerick the Rich Land* which states "A few yards from the north-eastern end of the church is an old tombstone erected in memory of James Daly (1750-1810), the Loughmore poet, better known as Seamus O'Dálaigh, a tailor of Croom". Armed with this knowledge I set off back to the graveyard. I don't often give compass directions in this book as I don't know anyone other than hill walkers who carry compasses, and most people without a compass can't tell which way is north. But I brought a compass with me and I spent another fruitless half an hour looking for the grave and examining every stone in the vicinity. I was about to leave when it dawned on me that I might be reading the compass the wrong way. I went to the other side of the church and found the grave quite quickly despite it being covered with grass. So that is another reason why I am reluctant to give compass directions in this book.

The inscription reads: INA LUÍ SA CHRÉ ANSEO/ AG FEITHEAMH LEIS AN AISEIRÍ/ TÁ SÉAMUS Ó DÁLAIGH/ ÓN LOCH MÓR/ DUINE DE FHILÍ NA MAIGHE A/ BHÍODH AR CHÚIRT EIGSE/ CROMADH AN tSUBHACHAIS/ AGUS A FUAIR BÁS AR AN/ DEIREADH FÓMHAIR 1810

This translates roughly as: Lying in this soil awaiting the resurrection is Séamus Ó Dálaigh from Loch Mór, one of the Maigue poets and a member of the bardic court of Croom, who died in October 1810.

Máirtín Ó Direáin 1910-1988

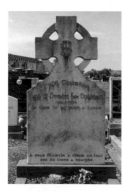

Born in Inishmore on the Aran Islands. He worked in various government departments until he retired in 1975. He is known as one of the major poets in modern Irish writing. He wrote nine volumes of poetry and one book of essays containing much biographical material. He won many prizes and honours including the Irish-American Cultural Institute Award in 1967, an Hon D.Litt from The National University of Ireland in 1977 and in the same year he received the Ossian Preis for poetry from the Freiherr von Stein Foundation in

Hamburg. His works include *Coinnle Geala, Dánta Aniar, Rogha Dánta, Ó Mórna agus Dánta Eile, Ceacht an Éin* and the autobiography *Feamainn Bhealtaine*. He is buried in grave number A22 447-43793, Mount Jerome Cemetery, Dublin. *(See map page 252 – the grave is on the path edge)*. The grave is located seven rows down from the path at the top of the section and three rows in.

Peadar Ó Doirnín died 1769

His birth date is given as anything between 1682 and 1704. He was born in County Louth or perhaps County Tipperary. He seems to have been employed as a tutor to Arthur Brownlow's children in Lurgan and after falling out with him he went to Forkhill and became a schoolteacher. He was a writer of poems and verses on a variety of topics in both English and Irish.

He is buried in the Churchyard at Urney, Dundalk, County Louth. It is not an easy graveyard to find. The first time I visited it, there were signposts but these seem to have disappeared since then. Take the R177 from Dundalk to Middleton. There is a bridge about two kilometres from Dundalk. Go under the bridge

and after about three kilometres there is a church on the left-hand side. It is set back a bit from the road. A kilometre further on is the Barleycorn pub. About half a kilometre further, there is a staggered junction. Turn right and after approximately two kilometres, there is a dormer bungalow with a lane-way running down its side leading eventually to a large parking area. The lane-way is barely wide enough for a car. I have visited this graveyard in both summer and winter and would recommend the use of wellingtons. As you go in the graveyard, the gravestone is situated near the back of the hedge facing you.

Niall Ó Dónaill 1908-1995

Born at Loch an Iúir, County Donegal. He is remembered for his standard work *Foclóir Gaeilge-Béarla* published in 1977. He also wrote a biography of John Mitchel and *Forbairt na Gaeilge* on the standardisation of the Irish language. He is buried in grave

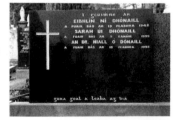

number XF 18½, St Paul's, Glasnevin Cemetery, Dublin. *(See map page 249)*. Go in the main entrance, take the first road to the right and go through the next intersection. The numbers go in ascending order from the left. However, in this case, the grave is to the right of the path towards the end of the row.

Séafraidh Ó Donnchadha (O'Donoghue) c. 1620-c. 1667

Born at Killaha Castle, near Killarney, County Kerry. He was one of the Four Kerry Poets and his home at Killaha Castle had a warm welcome for poets and writers. His surviving poetry was published in 1902. He is buried in the O'Donoghue tomb in the choir in Muckross Abbey, Killarney.

John Francis O'Donnell 1837-1874

Born in Limerick. He worked as a journalist on many papers in both Ireland and England. He was one of the most prominent Irish poets of the latter half of the 19th century, particularly noted for his national poems. His works include the poems *On the Rampart, The Question, The Emerald Wreath: A Treasury of Stories, Legends, &c* and *Memoirs of the Irish Franciscans*. His novels include *Sadlier the Banker or the Laceys of Rathcore*.

He is buried in St Mary's R.C. Cemetery, Kensal Green, London. When he died in 1874, an obituary in the *Nation* expressed the hope that the Irish people, for whom O'Donnell lived and laboured, would not let his remains mingle with the earth of London but would give them a place and a memorial in the land which the bard so devotedly loved.

Michael McDonagh, *Irish Graves in England*, first visited the grave in 1887 and described it as being marked by a stone "small and mean, half of it has sunk in the earth and on it no name can be traced. The stone is composed of sand and the outer coating which bore the inscription has been almost completely eaten away by the ravages of comparatively few years." Some of the letters JOHN

F. O'DONNELL could then be read but the years in which he was born and died, his age and the name (A. Itzstein buried 1875) of a German relative of his through marriage, who is also buried in the same grave, were obliterated. The only part of the inscription that remained was PRAY FOR THE SOUL beneath which there was a representation of a cross. His son, John, is also buried in the grave (1916).

As a result of McDonagh's book and his lectures, a committee was formed and this led to the publication of O'Donnell's poems in 1891. McDonagh was luckier than I was, for when I visited the cemetery in 2002, I couldn't even determine the exact gravesite despite having the number (8926).

In November 2003, I was in the vicinity of the cemetery and called in on the Superintendent, Jerry Guerin. I asked was there any way of locating the exact gravesite. He felt it would be very difficult as many stones had disappeared with passing time and those that remained were hard to read. However he had an unpublished manuscript relating to notables buried in the cemetery and under O'Donnell's name was the word "ledger", implying that there was a stone memorial different to that described by McDonagh. So armed with his records he accompanied me to the general area. Using the stones we could read, it took us over 30 minutes before he could accurately give an exact location. And there was a monument. It was extremely difficult to make out any kind of inscription but with some water and cleaning, the inscription on both sides came clear. On one side it reads: IN MEMORY OF/JOHN FRANCES O'DONNELL/THE IRISH POET/BORN IN THE COUNTY OF LIMERICK/DIED IN LONON MAY 7 1874

The other side repeats the inscription in Irish.

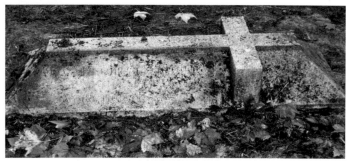

To reach the grave, go in the main gate and take the first turn on the left. Go past the toilets and further down on the left-hand side there are new graves. About two thirds down the last section, St Anthony's, there is a grave to a Michael Lyons. Almost directly opposite this grave, on the other side of the path and a few rows back is the grave of O'Donnell. The grave is in the middle of the photograph on the previous page.

Peadar O'Donnell 1893-1986

Born in Meenmore, County Donegal. He was a trade union organiser and fought with the IRA against the Treaty. He spent

two years in jail. He was elected as a Sinn Féin TD while in prison. He was editor of *An Phoblacht* in 1924 and published his first novel *Storm — A Story of the Irish War*, in 1926. His other works include *Islanders, Adrigoole, The Knife, On the Edge of the Stream, The Big Windows* and *Proud Island*. His autobiographical books include *The Gates Flew Open, Salud!, An Irishman in Spain* and *There will be Another Day*. He fought for the Spanish Republic 1936-7.

His remains were cremated at Glasnevin Cemetery, Dublin. According to Peter Hegarty's biography, O'Donnell requested that no speeches, music or religious ritual should take place at the cremation. A convoy of cars accompanied the urn through Mullingar where hundreds of mourners turned out. The ashes were then taken to Kilconduff Cemetery outside Swinford, County Mayo and placed in the family grave of his wife Lile O'Donel. A short ceremony followed. Take the road out of Swinford to Ballina and just before the end of town before the railway bridge turn right and left immediately. It is signposted to Killasser. Turn right again almost immediately. There is a sign on the wall to Rathscanlon. The cemetery is located further down on this road on the right-hand side.

There are two gates into the cemetery. Go in the one with the bigger pillars. Go up the path and at the top, almost in front of you, there is a little house type structure. The O'Donnell stone is on the right-hand side of this tomb and the plaque for O'Donnell is on top of the low wall in front of the stone. It reads: LILE AND PEADAR O'DONNELL.

John O'Donovan 1809-1861

Born at Attateemore, County Kilkenny. In 1829 he was employed at the department of the Ordnance Survey of Ireland to investigate the names of places and their historical associations. He recorded over 60,000 such names in Irish. In 1840 he was co-founder of the Irish Archaeological Society. In 1849 he was made Professor of Irish History and Archaeology at

Queen's College, Belfast. His finest achievement was the editing and translation of *The Annals of the Four Masters* in seven volumes. Along with his brother-in-law, Eugene O'Curry, he began work on translating the *Ancient Laws of Ireland*. His *Letters*, from his fieldwork, were edited by Father Michael O'Flanagan and published in 50 volumes. Other works include the translation of

The Tribes of Ireland and *A Grammar of the Irish Language*. He died in poverty but the Glasnevin Cemetery Committee provided free grave space and a tombstone was erected 15 years later by his admirers. *(See map page 246)*. The inscription on one side reads: HIS EMINENCE AS A CELTIC SCHOLAR WAS RECOGNISED/ IN THE HONORARY DEGREE OF LL.D. CONFERRED ON HIM BY THE UNIVERSITY OF DUBLIN/ THE HONORARY MEMBERSHIP OF THE ROYAL ACADEMY OF SCIENCES AT BERLIN/ AND THE CUNNINGHAM GOLD MEDAL AWARDED TO HIM BY IRISH ACADEMY/ BY THE MEMORIAL WHICH BEARS THIS INSCRIPTION/ SOME OF HIS FELLOW COUNTRYMEN HAVE DESIRED TO MAKE THE REVERENT GRATITUDE/ FOR HIS DISTINGUISHED SERVICE TO LEARNING AND TO IRELAND.

On the front is the inscription: JOHN O'DONOVAN LLD/ BORN AT ATTATEEMORE COUNTY KILKENNY/ IN JULY MDCCCIX/ DIED IN DUBLIN/ LX DEC MDCCCLXI

And on the other side is the inscription: BY HIS IRISH GRAMMAR, HIS EDITION OF THE ANNALS OF THE FOUR MASTERS/ HIS LABOURS ON THE TRANSCRIPTION AND TRANSLATION OF THE BREHON LAWS/ AND HIS INVALUABLE CONTRIBUTIONS TO OUR KNOWLEDGE OF THE TOPOGRAPHY AND LOCAL HISTORY/ OF HIS COUNTRY MADE DURING HIS CONNECTION WITH THE ORDNANCE SURVEY/ HE LAID A SURE FOUNDATION FOR SOUND AND SCIENTIFIC CELTIC STUDIES/ AND ESTABLISHED HIS POSITION AS A MASTER OF IRISH PHILOLOGY AND ARCHAEOLOGY

Jeremiah O'Donovan Rossa 1831-1915

Born in Rosscarbery, County Cork. He was involved in politics in Skibbereen before he joined the Irish Republican Brotherhood. He was arrested and imprisoned in 1859 for eight months. From 1863-65 he was business manager of the *Irish People* but the rise of Fenianism alarmed the Government and in September 1865 O'Donovan was one of the leaders arrested. He was sentenced to life imprisonment for conspiracy to rebel against the Crown. His time

in prison was particularly difficult as he refused to conform. He was released in 1871 but forced to remain outside the country for the rest of his sentence. He continued to promote his views which

were considered quite extreme and he was respected more for his courage than his politics. His works include *O'Donovan Rossa's Prison Life* and *Rossa's Recollections*. He died in America and his body was brought back to Ireland where it lay in Dublin's City Hall for some days. His funeral was stage managed for maximum effect and Patrick Pearse gave the oration which contained the following phrase: "The fools, the fools, the fools, they have left us our Fenian dead and while Ireland holds these graves, Ireland unfree shall never be at peace". He is buried in Glasnevin Cemetery, Dublin. *(See map page 246 – the grave is on the path edge of the Republican Plot)*.

The grave is covered with gravel and has concrete kerbing around the edges. The name O'Donovan Rossa is at the top and the date 1915 at the bottom.

Pádraig Ó Duinnín 1860-1934

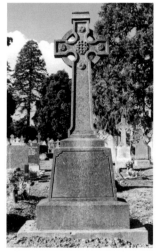

Born in Rathmore, County Kerry. He joined the Jesuit order and taught in various schools. He joined the Gaelic League and was allowed to leave the Jesuits in 1900 although he remained a priest all his life. He edited the works of the four Kerry Poets as well as Céitinn's *Foras Feasa ar Éirinn*. He wrote plays and novels including *Cormac Ó Conaill* and *Creideamh agus Gorta*. However, his best known work is his classic Irish-English dictionary.

He is buried in Glasnevin Cemetery, Dublin. *(See map page 246 – the grave is three rows from the road edge)*.

The inscription reads: I Ndíl-Chuimhne Ar/An/Athair Pádraig Ua Duinnín/M.A. D.Litt/A Rugadh San Ráth Mhóir/I gConndae Chiarraighe,/An 26 Lá De Mhí Na Nodlag 1860/Agus A Fuair Bás/I mBaile Átha Cliath/An 29 Lá De Mheadhon Fhóghmair 1934/Go Ndéanaidh Dia Trócaire Ar A Anam

Eileen Ó Faoláin 1900-1988

Born in Cork. She married Seán Ó Faoláin in Boston in 1928. She wrote stories for children – *The Little Black Hen* and *The King of the Cats*. She also wrote *Irish Sagas and Folktales* and *Children of the Salmon and other Irish Folktales*. She donated her body to Trinity College Dublin for scientific research.

Seán Ó Faoláin 1900-1991

Born in Cork. He left Ireland in 1926 to study and teach in America and England but returned in 1932 to write full-time. His early short stories were considered his best. He also wrote biographies of Daniel O'Connell (*King of the Beggars*) and Hugh

O'Neill (*The Great O'Neill*) and an autobiography *Vive Moi*. He
edited *The Bell* from 1940-1946. Other work includes novels,
criticism, travel books and prose. His *Collected Stories* appeared in
three volumes in 1980-2. He donated his body for scientific
research to Trinity College Dublin.

Tomás Ó Fiaich 1923-1990

Born in Crossmaglen, County Armagh.
He lectured in history in Maynooth
before he became its president in 1974.
He was made Primate in 1977 and a
cardinal two years later. He was an expert
on the early Irish Christian missionaries.
His works include *Art MacCumhaigh, In Pursuit
of an Ideal: Ireland, Christianity and Europe* and *Irish
Cultural Influence in Europe VIth to XIIth Century*.
He is buried in the grounds of the Catholic Cathedral in Armagh.

Liam O'Flaherty 1896-1984

Born on Inishmore, Aran Islands. He fought in the British Army
during the First World War and was discharged after being
wounded in 1917. After some years of drifting, he became a full-
time writer and over the next 30 years he wrote over a dozen
novels and 150 short stories. These include *Insurrection, The Assassin,
The Pedlar's Revenge: Short Stories, The Black Soul, The Informer, Skerrett* and
Famine. He won the James Tait Black Award for *The Informer*. Some
of his stories were made into films. He also wrote three volumes
of autobiography. His remains were cremated in Glasnevin
Cemetery, Dublin.

Father Eugene O'Growney 1863-1899

Born in Ballyfallon, County
Meath. He was Professor of
Irish in Maynooth in 1891
and Vice President of the
newly formed Gaelic League
in 1893. He wrote *Simple
Lessons in Irish* which was
extremely popular and sold
well. He originally was buried
in Los Angeles but his
remains were re-interred in
Maynooth, County Kildare.
The cemetery is located at the
back of the main university
building in Maynooth, close
to the playing field. The
grave is to the right of the
entrance. In the same
cemetery is buried **Nicholas
Callan**, the inventor of the
induction coil.

John O'Hagan 1822-1890

Born in Newry, County Down. He was a
barrister who defended Gavan Duffy among
others after the 1848 Rising. In 1881, he
became chief of the Irish Land Commission.
He wrote under the name of 'Sliabh Cuilinn',
contributing poems to the *Nation*. He also
translated the *Song of Roland*. He is buried in
Glasnevin Cemetery, Dublin. *(See map page
246 – the grave is on the path edge)*.

Martin O'Hagan 1950-2001

Both his father and grandfather served in the British Army and
Martin spent some of his childhood in military bases in
Germany. He was educated in Lurgan. He became involved with
the Official IRA and was interned in 1971. After his release, he
was later jailed for seven years for transporting guns. He then
began to work for local newspapers. As a journalist with the *Sunday
World*, he exposed the drug dealing and sectarianism of various
paramilitary factions. He was interrogated by the IRA, forced to
leave the north in 1992 by the LVF and was eventually murdered
by the Red Hand Defenders outside his home while he was
walking home with his wife.

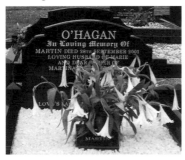

A few months previous to
my visit to this grave I had
met a Lurgan couple, Jim
and Ann McCann, in
Glasnevin Cemetery. I gave
them a tour of the cemetery
and they offered to bring me
to this grave when I was next
in Lurgan. Despite the fact
that I rang Jim the evening
before I was due to come, he
dropped everything the next
day, met me and took me to the grave. He knew Martin and had
spoken with him often, his father had also known Martin's
father. As we stood in the wind and rain we lamented the death of
an honest, courageous man who had spoken out about the evils in
his society and had been murdered for the words he wrote. He
left a wife and three young children. It was the saddest of all the
graves I have visited for this book.

Writing can be a dangerous occupation and many of the
writers featured in this book have suffered disapproval,
censorship, exile or imprisonment. Very few have died as a result
of what they have written. However, in the last decade alone, two
writers have suffered this fate. Veronica Guerin's reputation has
grown considerably over the years and she has been rightly
honoured in many different ways. In contrast, Martin O'Hagan
has been largely forgotten.

Martin is buried in Lurgan Cemetery, County Armagh. In
the centre of Lurgan, find Union Street and keep going until you
come to the cemetery. Go in the main gate and turn left and

there are two paths close together at the end of the buildings. Take the second of these paths and the grave is located near the back on the left-hand side.

Sylvester O'Halloran 1728-1807

Born in Limerick. He helped to found the County Limerick Infirmary. He wrote important works on glaucoma and gangrene

as well as historical works. These include *A New Treatise on the Glaucoma or Cataract*, *Proposals for the Advancement of Surgery in Ireland* (which led to the setting up of the Royal College of Surgeons of Ireland), *An Introduction to the Study of the History and Antiquities of Ireland*, *A General History of Ireland* and *Ierne Defended*. He is buried in a vault in Kileely Cemetery, Limerick. It is a very difficult cemetery to find as it is completely enclosed by housing, except for a small path leading in to it. There is a gate which on two previous visits was locked and no one could tell me where to get a key. Eventually I found the lady in question who informed me that the cemetery had been cleaned up a bit and was often left unlocked for visitors. Sure enough it was indeed open. It took me half an hour to find the vault which is located in the very centre of the cemetery. The inscription reads: SYLVESTER O'HALLORAN/HISTORIAN SURGEON/ANTIQUARY PATRIOT/HIS COUNTRY'S HONOUR AND GOOD NAME EVER/FOUND HIM A READY AND UNFLINCHING CHAMPION/ERECTED BY ST SENAN'S HISTORICAL SOCIETY

Canon John O'Hanlon 1821-1905

Born in Stradbally, County Laois. He is chiefly remembered for his *Lives of the Irish Saints*. He also wrote a history of his native county. Other works include *Legends and Lays of Ireland* and *Irish Local Legends*. Joyce mentions him by name in the Nausicaa chapter of *Ulysses*. He is buried in Glasnevin Cemetery, Dublin. *(See map page 246 – the grave is eight rows from the road and three rows in)*. The inscription on the cross is in both English and Irish: SACRED TO THE MEMORY OF/THE V REV JOHN CANON O'HANLON M.R.I.A./PARISH PRIEST OF SANDYMOUNT AD 1880-1905/ AUTHOR OF THE LIVES OF THE IRISH SAINTS/AND OF MANY OTHER HISTORICAL WORKS/WHO DIED 15TH MAY 1905 AGED 85 YEARS/THIS MONUMENT HAS BEEN ERECTED/BY HIS PARISHIONERS AND FRIENDS/TO RECORD THEIR SORROW FOR HIS LOSS AND/THEIR

VENERATION FOR HIS LEARNING AND HOLINESS/ R.I.P./
WHEREFORE I ALSO HEARING OF YOUR FAITH THAT IS IN THE
LORD JESUS/ AND OF YOUR LOVE TOWARDS ALL THE SAINTS/
CEASE NOT TO GIVE THANKS FOR US EPH 1 15 16

Michael O'Hanrahan 1877-1916

Born in New Ross, County Wexford. He
was a clerk with the Irish Volunteer
Office. He fought in Jacob's Factory. He
also wrote two plays which were published
posthumously – *A Swordsman of the Brigade*
and *When the Normans Came*. He was executed
by the British after the Easter Rising. He
is buried with the other executed leaders
of 1916 in the Church of the Sacred
Heart, Arbour Hill, Dublin. *(See map page 255 – the grave is on the path
edge)*. The graves are located near the back wall of the churchyard.

Breandán Ó hEithir 1930-1991

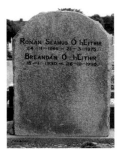

Born on the Aran Islands. He was Irish
Editor of the *Irish Press* 1957-63, editor of
Comhar, was a television presenter on the
current affairs programme *Féach* and wrote
a popular column for the *Irish Times* and the
Sunday Press. He wrote novels and other
books. As the *Irish Times* obituary reported,
his novel *Lig Sinn I gCathú* was the only Irish
language novel to top the hard back best
sellers list. It was translated by the author
and released as *Lead Us Into Temptation*.
Another novel *Sionnach Ar Mo Dhuán* was somewhat controversial for
its sexual content. He received the Butler Prize of £10,000 from
the Irish American Cultural Institute for his work. He also wrote
Over the Bar and *The Begrudger's Guide to Irish Politics*. His remains were
cremated at Glasnevin Cemetery, Dublin. Quite by chance I came
across the gravestone in Deansgrange Cemetery, Dublin in St
Paul's Section, Row N1, grave number 10. *(See map page 250 – the
grave is on the road edge)*.

Liam Dall O hIfernáin c. 1720-1790

Born in County Tipperary. He was a hedge
schoolteacher, a poet and scholar. Only
some of his poems still exist. In one of these
he gives to Ireland the name of Caitlín Ní
Uallacháin. He is buried in Ballycohey,
County Tipperary. The cemetery is on the
main road and the grave easily spotted. The
plaque reads: LIAM DALL O'HIFFERNÁIN/
HEDGE SCHOOL TEACHER/ POET AND
SCHOLAR/ C.1720-1790

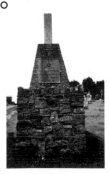

Brian O'Higgins 1882-1963

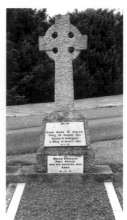

Born in Kilskyre, County Meath. He was a
writer and poet who was involved in the
republican movement and this is reflected
in his works which include *By a Hearth in
Eirinn, Songs of Glen-na-Móna, Hearts of Gold, The
Little Book of Ireland* and many others in the
'Little Book' series. He is buried in
Glasnevin Cemetery, Dublin. *(See map page
246)*. The inscription on the top plaque
reads: GUÍ AR/ANNA BEAN UÍ UIGINN/
D'ÉAG 3Ú EANAIR 1958/BRIAN O H-
UIGINN/A D'ÉAG 10 MARTA 1963/R.I.P.

Another plaque at the foot of the cross
reads: BRIAN O'HIGGINS/POET, WRITER/
AND HIS DEVOTED WIFE/ANNA/R.I.P.

John O'Keefe 1747-1833

Born in Dublin. He was a very successful playwright. His most
popular play, *Wild Oats*, was regularly produced for over 100 years
and was successfully revived in both London and Dublin in the
1970s and again in 1996. He wrote over 60 pieces for the theatre
as well as recollections. His works include *Tony Lumpkin in Town, The
Castle of Andalusia* and the comic opera *Merry Sherwood* which contains
the song *I am a Friar of Orders Grey*. He died in Southampton and was
buried in All Saints churchyard. This graveyard is now a multi-
storey car park.

Fr Owen O'Keefe (Eoghan Ó Caoimh)
c. 1655-1726

He was born in County Cork. He was a famous Gaelic poet and
scholar. His life is recorded in his tombstone. He is buried in
front of the ruin of the old church of Rossdoyle in Old Court
Cemetery which is at the other end of Doneraile from where

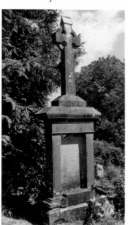

Canon Sheehan lies. The cemetery is
out further on the left. It is signposted.
Go in the gate nearest the town. Follow
the path until you come to a British war
grave for J Ryan. Directly across to your
left is the grave of Owen O'Keefe. The
inscription on the front of the cross
reads: THE BURIAL PLACE OF/THE
REVD OWEN O'KEEFE.

There is an inscription on the back
which is very difficult to decipher. It
reads: HERE LYETH THE BODY OF THE/
REVD MR OWEN KEEFE OF THE/
FAMILY OF GLEANPHRIAHANE/HE WAS
FIRST MARRIED AND AFTER/THE
DECEASE OF HIS WIFE HE/ENTERED
INTO HOLY ORDERS. HE/WAS(?)

COURTEOUS/ HOSPITIOUS NEVER ANGRY NOR DRUNK. FINALLY
HE WAS THE/ SCRIBENER AND ONE OF THE BEST/ IRISH
HISTORIANS OF HIS TIME/ DEPARTED THIS LIFE THE 18TH
APRIL/ ANNO DOM 1726 AGED 70

There is a skull and crossbones at the end of the inscription.
At the very bottom there is another stone with the inscription:
THIS ENDURING MEMORIAL WAS ERECTED BY SUBSCRIPTIONS
OBTAINED BY THE REV C BUCKLEY/ JORDANSTOWN, BUTTEVANT
TO PRESERVE FROM DECAY THE/ ENCLOSED VENERABLE
HISTORIC TOMBSTONE OF THE REKNOWNED/ GAELIC SCHOLAR
- FR OWEN O'KEEFE- COMMONLY STYLED THE POET PRIEST OF
DONERAILE.

It proceeds to list the names of those who contributed to the
monument.

Seumas O'Kelly c. 1875-1918

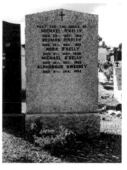

Born in Loughrea, County Galway. He
was a journalist who worked for
numerous papers and edited the *Leinster
Leader* and *Nationality*. He was a writer of
novels, short stories and plays which
include *The Lady of Deer Park, Wet Clay,
Meadowsweet, Hillsiders, Rhymes and Ballads, The
Shuiler's Child, The Bribe* and *The Parnellite*. It is
his short stories that he is best
remembered for, especially *The Weaver's
Grave* and *The Leprechaun of Kilmeen*. He died
of a heart attack in the offices of the *Nationality* during a raid by
British troops. He is buried in the family plot, number NB48, in
St Paul's Section of Glasnevin Cemetery, Dublin. *(See map page
249)*. Go in the main gate and take the first road to the left. Go
through two intersections and the grave is eleven rows down on the
right-hand side and seven graves in. The inscription reads: PRAY
FOR THE SOUL OF/ MICHAEL O'KELLY/ DIED 25TH OCT 1913/
SEUMAS O'KELLY/ DIED 14TH NOV 1918/ NORA O'KELLY/ DIED
6TH MAY 1939/ MICHAEL O'KELLY/ 16TH DEC 1955/ ALPHONSUS
SWEENEY/ DIED 9TH JAN 1984

Monsignor James O'Laverty 1828-1906

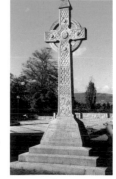

Born in Lecale, County Down. He is best
known for his *Historical Account of Down and
Connor* in five volumes. He was made
Monsignor in 1904.

He is buried in the churchyard in
Holywood where he was parish priest for
over 30 years. Coming from Belfast, take
the slip road for the town centre. Go past
Palace Barracks and Sullivan Upper school
and the church is on the right-hand side.
The grave is to the right of the church and is
the largest in the area.

The inscriptions reads: ERECTED BY

DEVOTED FRIENDS AND ADMIRERS/TO THE MEMORY OF/RT
REVD MONSIGNOR O'LAVERTY M.R.I.A./WHO DEPARTED THIS
LIFE 18TH APRIL 1906 AGED 78/FOR 40 YEARS PASTOR
COLUMBKILLES CHURCH, HOLYWOOD/EMINENT AS SCHOLAR,
HISTORIAN & ARCHAEOLOGIST/PRE-EMINENT FOR SIMPLICITY,
SANCTITY & GOODNESS/"ON WHOSE SOUL SWEET JESUS HAVE
MERCY/LE VERBE MONTE SUR LA CROIX SE SACRIFIE

John O'Leary 1830-1907

Born in Tipperary town. He was an
active Fenian and edited the *Irish
People*. He was arrested in 1865 and
sentenced to 20 years imprisonment.
He served five years in Portland and
had to spend the next 15 years in Paris
before he was allowed to return
home. He spent much of his time
writing. His memoirs were published
as *Recollections of Fenians and Fenianism*.
Other works include *What Irishmen
Should Know* and other works in the
same vein. He had a love of books
and owned over 10,000. Yeats said of
him "From O'Leary's conversations
or from the books he lent or gave me has come all I have set my
hand to since". W.B. Yeats also wrote that Romantic Ireland was
dead and gone and was with O'Leary in the grave. According to
O'Duffy "his funeral, despite the inclement weather, united men
of divergent views who admired the old chief for his staunch
adherence to the ideals of his early days".

He is buried in Glasnevin Cemetery, Dublin. *(See map page
246)*. The inscription in Irish on the front is still legible:
MAR CHUIMHNE/AR/SHEAGHÁN UA LAOGHAIRE/CEANNPHORT
NA BFÉINNINIDHE/A CUIREADH ANNSO SHIOS/ AN 19ADH LÁ
MARTA 1907/ I N-AOIS A 78 BLIADHNA/AGUS NA MÍLTE
ÉIREANNACH GHA CHAOINE/AGUS MIONNA AGUS MÓIDE GHA/
DTABHAIRT ACA A CHUID OIBRE DO CUR CHUM CINN

On the left-hand side is the inscription: EMMET DESIRED THAT
HIS EPITAPH/SHOULD NOT BE WRITTEN/UNTIL HIS COUNTRY
WAS FREE/STRIVE WITH MIGHT AND MAIN TO BRING/ABOUT THE
HOUR WHEN HIS EPITAPH/CAN BE WRITTEN/I HAVE NOTHING
MORE TO SAY BUT I/AND ALL OF YOU HAVE VERY MUCH/TO DO/
JOHN O'LEARY'S SPEECH/EMMET CENTENARY 1903

The other side of the monument has the following
inscription: I HAVE BEEN FOUND GUILTY/OF TREASON
TREASON FELONY/TREASON IS A FOUL CRIME/DANTE PLACES
TRAITORS IN THE/NINTH CIRCLE OF HIS HELL/I BELIEVE THE
LOWEST CIRCLE/BUT WHAT KIND OF TRAITORS ARE THESE/
TRAITORS AGAINST KIN COUNTRY FRIENDS/AND BENEFACTORS,
ENGLAND IS NOT/MY COUNTRY AND I BETRAYED NO FRIEND/
OR BENEFACTOR. SIDNEY WAS A LEGAL/TRAITOR, A TRAITOR
ACCORDING TO THE/LAW AND SO WAS EMMET: AND JEFFRIES/
AND NORBURY WERE LOYAL MEN/I LEAVE THE MATTER THERE/

John O'Leary's Speech From The Dock/ December 6th 1865
And on the rear side is the inscription: SACRED/ TO THE MEMORY/ OF/ JOHN O'LEARY, THE FENIAN LEADER/ WHO WAS LAID TO REST HERE ON THE/ 19TH MARCH 1907 IN THE 76TH YEAR OF HIS AGE/ AMIDST THE GRIEF/ OF THOUSANDS OF HIS COUNTRYMEN/ WHO VOWED TO PERPETUATE/ THE WORK OF HIS LIFE/ R.I.P.

Ernie O'Malley 1898-1957

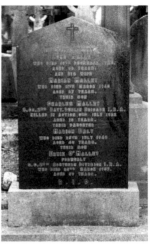

Born in Castlebar, County Mayo. He fought in the Easter Rising and the War of Independence. His book *On Another Man's Wound* recorded the events of that latter period and was widely praised for its literary merits. He took the anti-Treaty side and was severely wounded. His other works include *The Singing Flame* and *Raid and Rallies*. He is buried in Glasnevin Cemetery, Dublin. *(See map page 246 - the grave is on the path edge)*. The inscription reads: IN LOVING MEMORY OF/ LUKE MALLEY/ WHO DIED 18TH DECEMBER 1945/ AGED 83 YEARS/ AND HIS WIFE/ MARIAN MALLEY/ WHO DIED 11TH MARCH 1960/ AGED 87 YEARS/ THEIR SON/ CHARLES MALLEY/ B.CO. 2ND BATT DUBLIN BRIGADE I.R.A./ KILLED IN ACTION 3RD JULY 1922/ AGED 18 YEARS/ THEIR DAUGHTER/ MARION DALY/ WHO DIED 25TH JULY 1948/ AGED 45 YEARS/ THEIR SON/ ERNIE O'MALLEY/ FORMERLY/ O.C. 2ND SOUTHERN DIVISION I.R.A./ WHO DIED 25TH MARCH 1957/ AGED 59 YEARS/ R.I.P.

I came across his grave by chance and found it hard to believe that there was no mention of him in any of the cemetery guides. I had to confirm it in the *Irish Times* death column to be sure.

Moira O'Neill 1865-1955

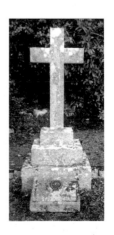

Born Agnes Nesta Skrine in Cushendun, County Antrim. She wrote *Songs of the Glens of Antrim* and *More Songs of the Glens of Antrim* which were very popular and went into many editions. She also wrote *An Easter Vacation, The Elf-Errant* and *Collected Poems*. She was the mother of Molly Keane. She is buried in St Anne's Church of Ireland Graveyard, Killanne, County Wexford. Go in the gate, turn left, and the grave is situated at the very back on the left-hand side. The inscription reads: IN THANKFUL REMEMBRANCE OF WALTER CLARMONT SKRINE OF BALLYRANKIN, DIED 28TH JUNE 1930. AGNES SHAKESPEAR SKRINE DIED 22ND JAN 1955/

The Lord Himself Is Thy Keeper.

The inscription is badly faded and barely discernible. There is a stone at the bottom with the name Moira O'Neill. In the graveyard opposite, is the grave of **Captain John Kelly** (Kelly the Boy from Killanne) and the graves of many others who died in the 1798 rebellion. A book on the history of both graveyards is available locally.

Séamus Ó Néill 1910-1981

Born in Clarkhill, near Castlewellan, County Down. He was Professor of History at Carysfort College of Education for over 40 years. He wrote poetry, short stories, plays and novels. His novel *Tonn Tuile*, about marital break-up, was a bestseller. Other works include *An Sean-Saighdiúir agus Scéalta Eile*, *Iníon Rí Dhún Sobhairce* and *Faill ar an Bhfeart*. He is buried in grave number 49M, St Oliver's, Deansgrange Cemetery, Dublin. *(See map page 250)*.

Aodhagán Ó Rathaille c. 1670-c. 1728

Born in the Sliabh Luachra district of County Kerry. After the Treaty of Limerick many Gaelic chiefs left Ireland and the new Anglo Irish who replaced them had little in common with the wandering poets. Ó Rathaille found some response still in Munster but lived his later life in poverty. His poems though were widely distributed and kept alive "the noble qualities of Ireland's chieftains and poets". He was one of the Four Kerry Poets.

He is buried in the nave in the far right-hand corner, below the plaque to the four poets, in Muckross Abbey, Killarney.

The plaque has the following inscription:
I Gcuimhne Ceathrair/ Sáir-Fhile Chiarraighe/ Séafradh Ua Donnchadha, Dhéag 1677/ Aodhagán Ua Rathghaile, Dhéag 1728/ Eoghan Ruadh Ua Súilleabháin, Dhéag 1784/ Piaras Feiritéar, A Crochadh 1653/ D'adhlacadh An Chead Triúr/ I Roilig Na Mainistreach Seo/ Crocdadh Piaras Tall I gCilláirne/ Le Linn Ár nDaoirse B'aoibhinn, Cóir/ Gach Éigeas Díobh Ag Ríomhadh Ceoil/ An tAth. P. Ua D./ Súaimhnéas Síoraidhe Dóibh Uile

John Boyle O'Reilly 1844-1890

Born in Dowth Castle, County Meath. He was a journalist who joined the Fenians in 1863. He then joined the British Army to recruit for the Fenians but was eventually caught and sentenced to death. This was commuted to life imprisonment and he was sent to Australia. He escaped and went to America where he was successful as a journalist, newspaper proprietor and poet. His works include the novel *Moondyne Joe – A Story from the Underworld* and several volumes of poems – *Songs, Legends and Ballads, The Cry of the Dreamer and Other Poems* and *Statues in the Block*.

The American President John F. Kennedy claimed him as his favourite poet.

He is buried in Holyhood Cemetery, Newton, Massachusetts. A huge boulder marks his grave. On the boulder there is a plaque with a bust in relief and the inscription: JOHN/ BOYLE/O'REILLY/BORN DOWTH CASTLE DROGHEDA/IRELAND IVNE XXVIII AD MDCCCXLIV/DIED HVLL MASSACHVSETTS/ AVGVST X MDCCCLXXXX/JOHN DONOGHVE FECIT

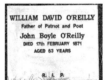

A stone was placed recently on his father's grave in Glasnevin Cemetery. *(See map page 246)*.

Seán Ó Ríordáin 1916-1977

Born in Ballyvourney, County Cork. His working career with the local authority in Cork was interrupted and eventually cut short by

illness. He was one of the most important Irish poets of the 20th century. His works include: *Eireaball Spideoige, Brosna* and *Línte Liombó*. He is buried in the graveyard of St Gobnait's, Ballyvourney. The grave is the third one on the right past St Gobnait's mound on the path towards the Protestant church.

The inscription reads: SEÁN/Ó RÍORDÁIN 1916-1977/NÍL IONAM ACH BALL/DE CHÓIR SAN MO SHINSIR

I had been travelling all day through Limerick and Kerry on my grave hunts and I came to the cemetery around nine o'clock on an August evening. All day it

had been drizzling and there was little light left for a photo. I still had to go to Cork city that night and I was hoping the graves I was seeking would be easily found. Seán Ó Riada is also buried in the cemetery. When I saw the size of the cemetery however, I almost gave up. But out of the gloom came a mother and daughter, and the young girl knew immediately where both graves were. So as the light faded fast and the drizzle got heavier, and the sweet heavy scent of heather from Ó Riada's grave filled the air and the long drive to Cork still looming, I took my photographs and felt it was a good end to a long day's hunting.

William Orpen 1878-1931

Born in Dublin. He was considered to be the finest portrait painter of his time. He was also a war artist and was the official painter at the signing of the Treaty of Versailles. His written works include *The Outline of Art, An Onlooker in France 1917 - 1919* and *Stories of Old Ireland and Myself*. He is buried in Putney Vale Cemetery, London.

Take the metro to Putney Bridge station and then take bus number 85 or 265 to Putney Vale Cemetery. The bus journey takes about 25 minutes. Go in the pedestrian entrance on the Kingston road and turn right onto Central Drive. About half way down this road there is a meeting of six roads. Take the first road to the left, Scofield Road and the grave is in the second section on the left, Section O, about half way along. It is number 168 and is one row back from the road. The inscription reads: WILLIAM/ORPEN/1878-1931/R.I.P.

Before he died, Orpen gave to James Sleator, his assistant of ten years, his large studio palette. Sleator bequeathed it to Maurice MacGonigal and it was buried with MacGonigal in 1979. See entry for Brian Moore.

James Orr 1770-1816

Born in Ballycarry, County Antrim. He was a United Irishman who had to flee to America after the defeat in 1798 but was allowed back after a number of years. He was a writer and poet in the Ulster Scots dialect. His works include *Poems on Various Subjects* and *The Posthumous Works of James Orr*. He also founded the local Masonic Lodge. He is buried in Templecorran Graveyard, Ballycarry, County Antrim. There is a detailed map of the cemetery at the entrance

from the car park. It is the large monument to the left of the entrance. The inscription is badly worn.

Pádraig Ó Siochfhradha 1883-1964

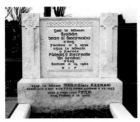

Born near Dingle, County Kerry. He was a member of the Gaelic League and the Irish Volunteers and was interned 1918-1922. He worked as a teacher and became a civil servant after the establishment of the State. He wrote novels and short stories and a number of his works were very popular. These include *An Baile Seo 'Gainne, Seáinín nó Eachtra Mic Mí-rialta* and *Jimín Mháire Thaidhg*. He is buried in grave number 183Q, St Patrick's, Deansgrange Cemetery, Dublin. (*See map page 250*).

The inscription reads: GUIDH LE HANAM/SHIOBHÁN/BEAN Uí SHIOCHFHRADHA/D'ÉAG/FEABHRA A 3, 1958/AGUS LE HANAM/A FIRCHÉILE/PÁDRAIG Ó SIOCHFHRADHA/"AN SEABHAC"/D'ÉAG/SAMHAIN A 19, 1964/R.I.P./AGUS LE HANAM MONICA (NÉE KEENAN)/BEANCHÉILE A MIC SIÚD D'ÉAG DEIRE FÓMHAIR A 28, 1993

Eoghan Rua Ó Súilleabháin 1748-1784

Born at Meentogues, County Kerry. He was one of the Four Kerry Poets. He had a fondness for the women which forced him to flee on several occasions. He served in the British Navy and the Army before he died from wounds inflicted by a servant of a landowner he had satirised. It was said of him that "he dignified labour by his sparkling genius, his wit and humour relieved the tedium of the winter nights". His best known aisling is *Ceo Draíochta*. It was 1901 before his poems were published.

He is buried in Muckross Abbey, Killarney, in the choir, under the third slab out from the arched O'Sullivan Mor tomb recess in the right-hand wall.

Muiris Ó Súilleabháin (Maurice O'Sullivan) 1904-1950

Born on the Blasket Islands. He was sent to an orphanage on the mainland after his mother died when he was just one year old. When he came back to the island after six years he had little Irish. The English academic George Thomson encouraged him to write. He wrote one book of note - *Twenty Years A-Growing*. He became a garda but left in 1934 to take up writing full-time. Unfortunately he was unable to repeat the success of his first book and he rejoined the Gardaí again shortly before his death. He drowned at Salthill in 1950.

He is buried in the graveyard of Barr an Doire in Carraroe, County Galway. Coming from Galway, take the first road on the

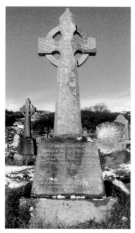

left past the church in Carraroe. After approximately four kilometres take the road to the left which has a signpost for Reilig Bharr an Doire. When the road forks take the right one and drive all the way down to the beach. The graveyard is quite crowded and there are no regular paths. The best way to find the grave is to take the concrete path on the beach and enter the graveyard by the concrete steps. Look ahead and where the ground on the right-hand side slopes away, at the bottom of the slope is the grave of Muiris Ó Súilleabháin. The inscription to him is badly worn.

It reads: I nDíl Cuimhne/Muiris Uí Shúilleabháin/An Bhlascáid Mhór Ciarraighe/ Údar Fiche Blian ag Fás/ A Fuair Bás 25 de Meitheamh 1950/ A croídhe Ró Naomhtha Íosa/Déan Trócaire Air/ Curtha Suas ag a Bhean Cáit

Tadgh Gaelach Ó Súilleabháin 1715-1795

Born in Drumcollogher, County Limerick. He spent much of his early life in Munster, particularly Cork. Some of his poems survive from this period but in middle age he went to Dungarvan and began to write religious poems which were sung as hymns long after his death. He is buried in the churchyard, Ballylaneen, five kilometres south east of Kilmacthomas, Waterford, with a Latin epitaph by his friend Donnchadh Ruadh Mac Conmara.

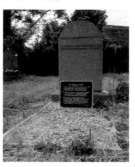

Follow the signpost for Kilmacthomas and Bunmahon. Ballylaneen is situated on the R677 on the road to Bunmahon. The cemetery is located on the right-hand side just before the village. You will almost certainly miss it, unless you are coming from the Bunmahon direction.

I missed it and searched instead for a few minutes in the churchyard in the village. Rather than waste too much time I called into the local shop and asked for help. The lady in the shop told me I was in luck, as the best person to assist me was Mary Ann

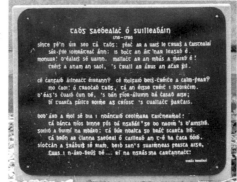

Coffey and she was just inside on a visit. I was introduced to her and explained my request. She dropped what she was doing, took me in her car to the cemetery and brought me to the grave. The grave is located in the top right-hand area of the cemetery. She spoke the verses in Irish on the plaque and translated them for me. She told me the grave used to have an iron Celtic cross which had been made by the local blacksmith. It was commissioned by one of the poet's relatives visiting from America. The present stone was erected in the early part of the last century, probably on the bicentenary of his birth.

There are many such villages in Ireland who still hold their local poet in reverence and as long as there are people like Mary Ann, the man who mows a path to the grave, the local priest and the others who organise the summer school, then these poets will live on for future generations.

Combine this visit with a trip to the grave of Donnchadh Ruadh Mac Conmara (*q.v.*).

Seán Ó Tuama c. 1706-1775

Born near Kilmallock, County Limerick. He was a school-teacher and a leading member of the Poets of the Maigue. He also ran an inn that became a well-known meeting place for the local poets. The inn is opposite the church where he is buried.

His best known poem is *A Chuisle na hÉigse*. He died in Mungret and his body was brought back to the Church of Ireland in Croom for burial. A local man told me the grave is marked by a stone beside the Lyons vault which is over by the right-hand wall as you come in, towards the back. There is a cross beside the vault. I searched all of the stones in the immediate vicinity but was unable to identify it.

I went back the following year and called in at a pub asking

for the exact location. I was directed to the local historian but unfortunately he wasn't in. I went to another pub and was given the same information. The last place I went to, I met Robert Moloney. He didn't know the location but he offered to accompany me to the churchyard to search for it. Much work had been carried out recently and the knee-high grass had been cut and all the stones were clearly visible. The inscriptions that we could read did not belong to O'Tuama. So Robert left to get further information and brought back Jack Breen. We searched again in vain and then Robert went off once more. I thought I could make out some lettering that looked promising, on an old stone and cleaned it up with water. Sure enough the inscription came out. Shortly after, Robert returned to inform us that we had the right grave. There had been a recent burial in it and it was beside the Walsh headstone. The inscription reads: SAM(?) WELCH ERECTED/THIS STONE IN MEM/ORY OF HIS GRANDFATHER/JOHN TOOMY DEPARTED/THIS LIFE AUGUST THE 30TH 1775/AGED 65 YEARS

This stone illustrates the difficulty in finding a particular grave and then deciphering the inscription. When I had cleaned it up I thought the inscription read IN MEMORY OF THE OLD HEATHEN. It didn't seem entirely inappropriate to the person in question but it seemed strange to find it on a stone. Even when I had scanned in the photograph and blew it up, that was all I could see in the lettering until a friend pointed out the more obvious interpretation. The grave is on the left in the photograph.

Eoghan Ó Tuairisc (Eugene Watters) 1919-1982

Born in Ballinasloe, County Galway. He worked as a teacher until 1969. He wrote in both English and Irish. The sudden death of his first wife affected him badly. His subsequent marriage to Rita Kelly was the stimulus for another body of work. His works include *Murder in Three Moves*, *L'Attaque*, *The Weekend of Dermot and Grace*, *Dé Luain*, *De Réir na Rúibricí*, *Rogha an Fhile*, *Aisling Mhic Artáin*, *An Lomnochtán*, *Dialann sa Díseart* (a joint collection with Rita Kelly) and *Infinite Variety*. The last book, I bought as a remainder and it introduced me to the world of music hall in late 19th century Dublin. It stimulated me to seek out the graves of Dan Lowrey, Managing Director of the Star Theatre and the trapeze artist Artois who died in a fall in what is now the Olympia. They are both buried in Mount Jerome Cemetery and Ó Tuairisc is buried in Ballinasloe, County Galway.

The cemetery is located on the main road on the right-hand side coming from the Dublin direction. There is an old ruined church with graves all around and there is an extension at the back.

When I went to Ballinasloe the first time, I only knew he was buried in a local cemetery and this seemed the most likely one. However I couldn't find the grave so on my next visit I contacted the local council. Mary Molloy told me more or less where it was but after a thorough search I still couldn't locate it. So Mary called down to the cemetery and showed me the grave. No wonder I had missed it. The inscription was barely legible and indeed wouldn't have been legible at all had Mary not asked

the local stonemason to clean the stone and had the grass cut around it for my visit. His first wife, Una, who was an artist, is buried in the same grave and Mary told me that her father had known Eoghan and had written to him to sympathise on the death of Una. He had sent him back an acknowledgement and a drawing by Una as a memento of her. The inscription reads: HIC/ HUMUS CARRISSIMA/ QUAM HABIT AVERUNT/ EUGENE & UNA

Go in the main entrance, which is on the side road and take the second road on the left. Go down about ten rows and the grave is about five rows from the back of this section. It has a small stone and may not be easy to find. Behind it is a grave to Thomas Watters and behind that is another Watters grave.

Stewart Parker 1941-1988

Born in Belfast. After graduation he taught in America and returned to Belfast in 1969 to write. His first major success was *Spokesong* which was produced at the 1975 Dublin Theatre Festival before going on to London. In 1978 he went to live in Edinburgh and later he settled down in London. He won many awards for his work which includes *Catchpenny Twist, Northern Star, Heavenly Bodies, Pentecost, The Kamikaze Ground Staff Reunion Dinner* and *I'm a Dreamer, Montreal.* He died in London and his remains were brought back to Belfast where they were cremated at Roselawn Crematorium, Belfast.

Thomas Parnell 1679-1718

Born in Dublin. He was ordained in 1700 and was appointed Archdeacon of Clogher in 1706. He wrote songs, ballads, poetry and essays. His works include *Poems on Several Occasions, A Night-piece on Death, A Hymn to Contentment* and *The Hermit.* His *Complete Poems* were first published in 1985. He coined the phrase *Pretty Fanny's Way*.

He was buried at Holy Trinity Church, Chester. The exact spot in which the poet is buried is unknown. The old church was pulled down in 1865-6 and a new one erected. McDonagh records in his book, *Irish Graves in England,* that he called to the rector, a Rev. E. Marston, who informed him that "he had been rector during the last years of the old church, that the present edifice had been erected under his

THE END

supervision and that he had never seen a memorial of any kind to
the poet in the old church. He was often told that it had never
contained one and during the excavations for the new building,
nothing was discovered to indicate the place of the poet's
interment." The parish register does record his burial —
"Thomas Parnell D.D., 18th October 1718."

The church is now the Guild Hall.

Patrick Henry Pearse 1879- 1916

Born in Dublin. He was a poet and a teacher.
He established St Enda's School in 1908. In
1913 he formed, with others, the Irish
Volunteers and later joined the Irish
Republican Brotherhood. He delivered the
funeral oration at the graveside of
O'Donovan Rossa. At Easter 1916, he read
out the Proclamation and took charge of the GPO during the
Rising. He was one of the signatories of the Proclamation and
was executed in May 1916. His political and literary works include
*From a Hermitage, Ghosts, The Separatist Ideal, The Spiritual Nation, The
Sovereign People, The Murder Machine and Other Essays, The Singer and Other
Plays, Iosagán agus Sgéalta Eile* and *An Mháthair agus Sgéalta Eile*. His
Collected Works is still in print. He is buried with the other executed
leaders of 1916 in the Church of the Sacred Heart, Arbour Hill,
Dublin. *(See map page 255)*. The graves are located close to the back
wall of the churchyard.

He is reported to have said in the spring of 1916 - "If we do
nothing else we shall rid Ireland of three bad poets".

Thomas Percy 1729-1811

Born in Bridgenorth, England. He was chaplain to George III
before becoming Bishop of Dromore in 1782. He published
translations of several Chinese books and *Runic Poetry from the
Icelandic Language*. His best known work is *Reliques of Ancient English
Poetry*. He is buried in the transept of Dromore Cathedral,
County Down. There is a plaque on a
pillar near where he is buried. The
inscription reads: NEAR THIS PLACE
ARE INTERRED THE REMAINS OF/THE
RIGHT REVEREND THOMAS PERCY,
D.D./LORD BISHOP OF DROMORE/TO
WHICH SEE HE WAS PROMOTED IN
MAY MDCCLXXXII/FROM THE
DEANERY OF CARLISLE IN ENGLAND./
THIS ELEVATED STATION HE FILLED
NEARLY THIRTY YEARS/RESIDING
CONSTANTLY IN HIS DIOCESE/AND
DISCHARGING THE DUTIES OF HIS
SACRED OFFICE/WITH VIGILANCE AND
ZEAL!/INSTRUCTING THE IGNORANT,
RELIEVING THE NECESSITIOUS/AND
COMFORTING THE DISTRESSED WITH

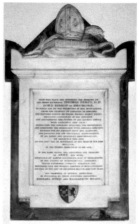

PASTORAL AFFECTION/REVERED FOR
HIS EMINENT PIETY AND LEARNING
AND BELOVED FOR HIS UNIVERSAL
BENEVOLENCE/BY ALL RANKS AND
RELIGIOUS DENOMINATIONS/HE
DEPARTED THIS LIFE/ON THE XXXTH
DAY OF SEPTEMBER IN THE YEAR OF
OUR LORD/MDCCCXI/IN THE
EIGHTY THIRD YEAR OF HIS AGE/IN
THE SAME GRAVE ARE DEPOSITED THE
REMAINS/OF ANNE HIS WIFE/DAUGHTER OF BARTIN
GOODRICHE ESQR OF DESBOROUGH/IN THE COUNTY OF
NORTHAMPTON ENGLAND/WHOSE ESTIMABLE CONDUCT
THROUGH LIFE/RENDERED HER THE WORTHY PARTNER FOR
SUCH A HUSBAND/SHE DIED ON THE XXXTH OF DECEMBER
MDCCCVI AGED LXXIV YEARS/THIS MEMORIAL OF DUTIFUL
AFFECTION/IS INSCRIBED BY THEIR SURVIVING DAUGHTERS/
BARBARA ISTED AND ELIZABETH MEADE

George Petrie 1789-1866

Born in Dublin. He was an archaeologist, musician, illustrator and water-colourist. His archaeological work with the Ordnance Survey brought together O'Donovan, O'Curry and Mangan. His works include *The Ecclesiastical Architecture of Ireland: An Essay On the Origins and Uses of the Round Towers of Ireland, On the History and Antiquities of Tara Hill* and *The Petrie Collection of the Ancient Music of Ireland,* which contains 147 airs including *The Derry Air.* He is credited with ensuring treasures like The Annals of the Four Masters, the Cross of Cong, the Ardagh Chalice and the Tara Brooch are preserved in Irish museums. He is buried in Mount Jerome Cemetery, Dublin. *(See map page 252).* With your back to the chapel, go six rows down to the Webber plot on the left-hand side. Petrie's grave is in a direct line from there. The stone is horizontal on the ground.

Laetitia Pilkington 1712-1750

Born in Dublin. She married a poor clergyman, was unfaithful to him and then followed him to London. She spent time in a debtor's prison, ran a bookshop before it failed and eventually returned to Dublin. Her *Memoirs* are particularly important for their description of Swift's last days. She is buried in St Ann's Church in Dawson Street, Dublin. *(See map page 255).* There is plaque on the back wall. It has

189

the following inscription: IN THE CRYPT/ OF THIS CHURCH, NEAR/ THE BODY OF HER HONOURED FATHER/ JOHN VAN LEWEN MD/ LIES THE MORTAL PART OF/ MRS LAETITIA PILKINGTON/ WHOSE SPIRIT HOPES FOR/ THAT PEACE THRO' THE INFINITE MERIT OF/ CHRIST, WHICH A CRUEL & MERCILESS/ WORLD NEVER AFFORDED HER./ DIED JULY 29TH 1750

James Plunkett 1920-2003

Born James Plunkett Kelly in Dublin. He worked as a trade union official before joining Radio Éireann and then Telefís Éireann. He wrote plays, short stories and novels. His works include *Homecoming, The Risen People, The Trusting and the Maimed, Strumpet City, Farewell Companions* and *The Gems She Wore*. His remains were cremated after a service in Mount Jerome Cemetery, Dublin.

Joseph Mary Plunkett 1887-1916

Born in Dublin. He was a journalist, critic, poet and editor of *The Irish Review.* In 1914 he joined the IRB and the Volunteers. He accompanied Roger Casement to Germany to obtain guns. He was one of the signatories of the Proclamation and fought in the GPO during Easter Week. His works include *The Circle and the Sword,* the poem *I See His Blood Upon the Rose,* and the collection *The Poems of Joseph Mary Plunkett.* He is buried with the other executed leaders of 1916 in the Church of the Sacred Heart, Arbour Hill, Dublin. *(See map page 255).* The graves are

located close to the back wall of the churchyard.
He married Grace Gifford the night before his execution. **Grace Plunkett** is buried in the Plunkett family plot in Glasnevin Cemetery, Dublin. *(See map page 246 – the grave is on the path edge).*

Reverend James Porter 1753-1798

Born near Ballindrait, County Donegal. He was a Presbyterian minister who wrote a series of satirical articles about local corruption. These were published as *Billy Bluff and Squire Firebrand* in 1796. He also published *Sermon, Wind and Weather*. The 1798 Rebellion gave his enemies the opportunity for revenge. He was arrested for allegedly intercepting a despatch and was hanged in front of his own church in Greyabbey, County Down. He is buried in the graveyard in front of the abbey. Go in the gate and walk towards the hedge at the far end. About eight rows from the hedge and about six rows over to the left is the low raised horizontal slab over the grave. There is a new slate covering the old stone and it

has a plaque recently put on it.

The inscription reads:
SACRED TO THE MEMORY OF/
THE REVEREND JAMES PORTER/
DISSENTING MINISTER OF
GREYABBEY/WHO DEPARTED THIS
LIFE JULY/2, 1798 AGED 45 YEARS/
ALSO HIS WIFE ANNIE PORTER/
ALIAS KNOX/WHO DIED 1823
AGED 70 YEARS/ALSO ELIZA
PORTER A CHILD

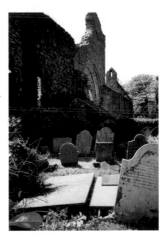

The photograph on the right shows the location of the grave. It is the horizontal stone with the plaque just behind the upright stone in the foreground.

Richard Power 1928-1970

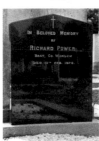

Born in Dublin. He worked as a civil servant. His works include the autobiographical *Úll i mBarr an Ghéagáin, The Land of Youth* (which was awarded Book of the Month by the Booksellers Guild of America), and his best known book — *The Hungry Grass*.

He is buried in grave number 208 CO, St Brigid's, Deansgrange Cemetery, Dublin. *(See map page 250 — It is four graves in from the road and eight rows down from the top of the section)*.

Tyrone (William Grattan) Power 1797-1841

Born in Waterford. He was a successful actor who also wrote novels and comedies. These include *The King's Secret, St Patrick's Eve or the Order of the Day* and *O'Flannigan and the Fairies*. He died returning from America aboard the steamship President, when it sank and all aboard were lost. His body was not recovered. The film actor of the same name was a great grandson.

Robert Lloyd Praeger 1865-1953

Born in Holywood, County Down. He was a civil engineer who later worked with the National Library, retiring as it's chief librarian. He wrote many papers and books on the flora and fauna and the landscape of Ireland and received medals from various societies for his work. His works include *Flora of the County Armagh, The Botanist in Ireland, The Natural History of Ireland* and the book that

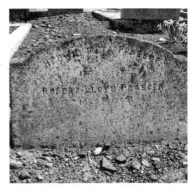

attracted general readers – *The Way that I Went*. He is buried in grave number 6 Q, St Nessan's, Deansgrange Cemetery, Dublin. *(See map page 250 – It is five paths in from the road and on the right, three graves down).*

The inscription is worn but can still be read: HEDWIG META PRAEGER/1872-1932/ROBERT LLOYD PRAEGER/1865-1953

Father Prout (Francis Sylvester Mahony) 1804-1866

Born in Cork. He studied at Paris and Rome in order to become a Jesuit. He was appointed to the staff of Clongowes but after a drunken episode with students he had to resign from the order. He was ordained in Rome but left the priesthood after a disagreement with his bishop in 1834. He moved to London and contributed to a number of magazines. His *Reliques of Father Prout* established his reputation. He moved to Paris in 1848 and died there. He is best remembered for his lines on the Bells of St Anne's, Shandon. The obituary notice in the *Cork Constitution* stated "The mortal remains of the late Rev Francis Mahony were brought to this city on Sunday evening from Paris and were taken to St Patrick's chapel, King Street. At 8 o'clock yesterday morning they were put on a bier and headed by a number of Roman Catholic clergy, taken to the graveyard of St Anne's, Shandon, where they were deposited in the vault of the O'Mahonys to which Father Prout belonged. He was aged 61 years". His tomb lies just outside the main entrance of the church in the graveyard. When I visited the grave in summer of 2002, there was graffiti on the tomb but I was informed that there was an intention to clean up the graveyard and surrounding area. The grounds are usually locked but the church is a tourist sight and there are regular opening hours. Sam Beckett came to visit Prout's grave before he went to live permanently in Paris.

Anthony Raftery c. 1784-1835
(Antoine Ó Reachtura, Reafteiri, Raifteri, Rafteraí and many other spellings)

Born in the town land of Killedan, near Kiltymagh, County Mayo. He was the last of the Gaelic bards. He went blind at the age of nine from smallpox. He was taught to play the fiddle but was never a very good player, relying instead on his gift of poetry. He was unable to write and his poems were memorised and written down by others. Douglas Hyde published a number of his poems in *Songs Ascribed to Raftery* in 1903. His best known poem is *Mise Raifterai*. The board erected by the Western Regional Tourism and Bord Fáilte at his grave states: "He had a marvellous gift of

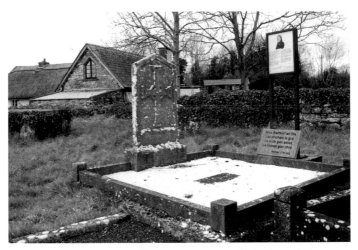

language and could mould the Irish tongue to the heart's desire, in rhythmic lines of poetry and song. His themes embraced religious and political struggles of his time, as well as the traditional ones of love and praise, sorrow, satire and repentance – a poet indeed who knew how to touch the condition of men, in the common language of the people".

He is buried in Killeeneen, County Galway. In Craughwell, coming from the Dublin direction, take the first left past the level crossing and drive just over four kilometres. The graveyard is situated on the right-hand side. The grave is at the end of the path on the left-hand side of the church as you look at it.

The burial was delayed due to the presence of a large stone and the digging continued after dark. Tradition has it that candles were sent out and despite a sharp breeze, they stayed lit. He was eventually laid to rest later that night.

In 1900, Lady Gregory went to the area to locate the grave of Raftery. She paid for a gravestone to be erected. Along with the local priest and Douglas Hyde she instituted an annual feis where Irish would be sung and recited by the grave. The gravestone was made by a local man, Patrick Deely, who had also been involved in the collecting of Raftery's material.

When I was looking for the cemetery in 2002, I stopped in Craughwell and asked for directions to the cemetery at several locations. Despite the advertising boards stating this was Raftery country, no one claimed to have heard of him, even in the pub named after him! Eventually I met a young man who gave detailed directions to the cemetery.

Buried in the same cemetery are the Poets of Carheenadiveane **Mark Callanan 1789-1846** and **Patsy Callanan 1791-1865**.

Rudolf Eric Raspe 1737-1794

He came originally from one of the German states where he was a
professor of archaeology and Keeper of the National Library.

Unfortunately some of the items in his trust went missing and
he went missing too. After a spell in England where he published
a book on mineralogy, he
went to Scotland and again
had to leave under a cloud.
He came to Ireland to
manage the copper mines on
the Herbert Estate in
Killarney. However he is best
known and remembered for
being the author and the
compiler of the Baron

Munchausen tales – *Baron Munchausen's Narrative of his Marvellous Travels
and Campaigns in Russia*. Raspe died from typhoid.

He is buried in Killarney, County Kerry. Coming from
Killarney on the road to Muckross village, not far past Muckross
Abbey, there is a post office. A lane runs up behind it to
Killeaghy Hill, where a small tree ringed burial ground
overlooks the Killarney Lakes. Somewhere in the tangled
undergrowth is his grave.

Another possible location for the burial is in the grounds of
St Mary's Killarney.

Charles Read 1841-1878

Born in Kilsella House, near Sligo. He ran a business for a while
in Rathfriland, County Down and after it failed he went to work
in a publishing house in London. He wrote two novels which were
quite popular *Aileen Aroon* and *Savourneen Dheelish*. He is best
remembered for *The Cabinet of Irish Literature*. T.P. O'Connor edited
the fourth and final volume after Read's death. He died in
Thornton Heath, Surrey.

The *Croydon Times* on January 26th 1878 reported:
"DEATH OF MR CHARLES A REED – We regret to record
the loss of Mr Charles A Reed, who died at his residence at
Thornton Heath on Wednesday last. The incidence of Mr
Reed's Life were few. Literature was his delight and with a
vivid imagination and facile pen, he produced a number of
works of fiction, several of which attained to popularity,
especially in Ireland. He contributed also to the periodicals
and was at the last engaged on an important work of
standard value, *The Poets and Poetry of Ireland*. This, unhappily,
remains unfinished, scarcely more than half having been
completed. It was a work to which he gave his heart, for he
loved poetry and was proud of the productions of his
countrymen and it was the one hope of his life that he
might be spared to erect this monument to Erin's poets –
an unfortunate race, the very names of many of whom he
hoped to rescue from oblivion. It was not to be. Ardent
desire and indefatigable industry were alike baffled: the

end came too soon. Nothing could avert it. A voyage to Australia was undertaken a few years since, when the first seeds of disease began to develope and with temporary good results, but the return to England brought back the old symptoms and our unfortunate friend sank slowly, until he breathed his last on Wednesday night at his house at Thornton Heath, where he had removed from the Loughborough road (he resided previously at Sydenham) for what was recommended as purer and more bracing air. To the many who know him, the announcement of his death will be a source of sincere regret, for his kindly nature and generous heart won him many friends and those whom his geniality drew to him were fascinated by his intellectual vigour and the high moral qualities which enforced respect. He leaves a widow and four children to mourn his loss. The funeral will take place on Monday at three o'clock, at the Croydon Cemetery."

He is buried in number 9316 Plot HH, Queen's Road Cemetery, Croydon, London. The cemetery is about a fifteen-

minute walk from the underground station. Go in the main entrance on Queen's Road. The cemetery office offered to mark the grave if I gave three or four days notice. Unfortunately I was unable to do this and I went to the cemetery on the chance that I would be able to find the grave with just the number. The cemetery is very large and I gave up almost immediately. I rang the office and they told me where I could find the section and the part where the grave was likely to be. However they had no information about any memorial. Although the cemetery is quite big, there are not that many stones still around. Even the ones in the last 50 years are badly weathered and there are more vacant plots than stones. There are information boards in various parts of the cemetery. The one on the main road through the cemetery has a map with the sections marked on it. The sections are not very clearly identifiable on the ground and it took me a while to eventually find the short sections of paving stones that distinguish one section from another. I found the appropriate section and the quarter where the grave was supposed to be. Most of the inscriptions are too badly faded to be readable. So I took photographs of the general area and then packed away my cameras. I took one final look at a stone and unbelievably it was the gravestone of Charles Read. All the lettering has gone but it was possible to just make out the outline of the inscription. It

reads: IN AFFECTIONATE REMEMBRANCE/ OF/ CHARLES ANDERSON/ READE F.R. HIST. SOC./ WHO DIED JANUARY 23RD 1878/ AGED 36 YEARS/ THIS MEMORIAL IS ERECTED BY HIS FRIENDS/ ALSO OF/ REBECCA HARRIETTE/ READE/ WIDOW OF THE ABOVE/ WHO DIED APRIL 10TH (?) 1920 (?)/ AGED 77 YEARS.

Forrest Reid 1875-1947

Born in Belfast. He studied at Cambridge where E.M. Forster encouraged him to write. He wrote over a dozen novels on his return to Belfast where he spent the rest of his life. His books are mostly studies of boyhood and adolescence. His best known novel was *Peter Waring*. The third part of his trilogy of Tom Barber novels – *Young Tom* – won the James Tait Black Memorial Prize. Other works include *The Garden God: A tale of Two Boys, A Garden By The Sea, Uncle Stephen, At the Door of the Gate* and two autobiographies.

He is buried in grave number C5- 481, Dundonald Cemetery, Belfast. Go in the main gate and take the first road on the left. Then take the second road on the right, go past the intersection and the grave is seven rows up on the left-hand side on the road edge.

The lettering is fading and reads: FORREST REID/ 1875-1947

Thomas Mayne Reid 1818-1883

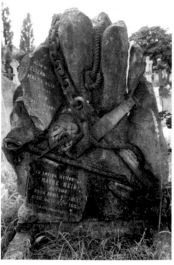

Born Thomas Mayne in Ballyroney, County Down. He went to America in 1838 where he had a very varied work experience, working as a slave overseer, an Indian fighter, a teacher, an actor, a storekeeper and a journalist. After being badly wounded in the Mexican-American War he wrote his first novel. He returned to England and wrote over 30 boys' adventure novels which were hugely successful. These include *The Scalp-hunters, The Rifle Rangers, Boy Hunters, The Headless Horsemen, The Castaways* and *The White Chief, A Legend of Northern Mexico*.

He is buried in grave number 28963/153/3, Kensal Green Cemetery, London. Coming from the St Mary's direction towards the church, go to the path that splits Section 153. Turn left and the grave is three rows in and about a quarter of the way down the section.

The inscription reads: In Loving Memory/ Mayne Reid/ Author/ Born April 4th 1818/ Died Oct. 22nd 1883/ Gone To His Dreamless Sleep

Another inscription reads: Also Of/ Elizabeth/ Mayne Reid/ His Wife/ Died/ Dec 29 1904/ Aged 65

Go back to the path and continue in the same direction until you come to Section 182. On the edge of the section is the grave of the Irish chess player **Alexander MacDonnell 1798-1835**. This grave was never easy to find as the inscription had worn away. I was delighted to see a new plaque has recently been added to the front of the stone.

Esmé Stuart 'Lennox' Robinson 1886-1958

Born in Douglas, County Cork. He was a dramatist and manager of the Abbey Theatre. He was the Editor of *The Oxford Book of Irish Verse* and his works include *The Clancy Name*, *The Whiteheaded Boy*, *The Far Off Hills*, *Drama at Inish*, *The Lost Leader*, *Ever the Twain* and *Church Street*. He also wrote *Ireland's Abbey Theatre* and two volumes of autobiography. He is buried beside Denis Johnston in St Patrick's Close, Dublin, in the graveyard attached to the Cathedral. *(See map page 255)*

The inscription on the gravestone reads: Lennox/ Robinson/ 1886-1958/ Dramatist/ And His Wife/ Dolly

W(illiam) R(obert) Rodgers 1909-1969

Born in Belfast. He was a Presbyterian minister in Loughgall from 1934-1946 before he left the ministry and joined the BBC as a scriptwriter and producer. In 1966 he went to America where he was writer-in-residence at various colleges. His works include *Awake! and Other Poems*, *Europa and the Bull* and *Collected Poems*. He died in California but he is buried in Cloveneden Presbyterian churchyard, near Loughgall, County Armagh. The churchyard is situated just off the Cloveneden Road which is located on the left of the Armagh to Loughgall road just before the village. The church is on the left-hand side of Cloveneden Road and 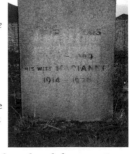 is on a height. Go in the gate of the churchyard and the grave is located almost opposite the door about five rows back. The inscription reads: William Rodgers/ Poet and Preacher/ 1909-1969/ His wife Marianne/ 1914-1976

William Rooney 1873-1901

Born in Dublin. He used the pen name of 'One of the People'. His first verses appeared in 1891 and he contributed prose and verse to various journals including *United Ireland*, *Seanachaidhe*, *The Shamrock*, the *Northern Patriot* and the *Shan Van Vocht*. He was a founder of the *United Irishman*. His works invoked the heroes of Ireland's past and were extremely popular. He also was a great promoter of the Irish language. His coffin was covered in wreaths from various literary societies and after his funeral, a meeting in the cemetery agreed to erect a cross and to publish his collected works. He is buried in Glasnevin Cemetery, Dublin. Go in the main gate and turn left. Walk beside the wall until you come to the letters HK on the wall. Turn right and walk a considerable distance until the road nearly meets another road just before the

wall. On the right-hand side three rows in is the grave with the tallest Celtic cross in the area. *(See map page 246)*

The inscription is still readable: UILLIAM O'MAOLRUANAIGH/ (FEAR NA MUINTIRE)/ FILE, ÚGHDAR, TÍR-GHRÁHDUIGHTHEÓIR/ RUGADH/ DEIREADH FÓGHMAIR 20, 1873/ FUAIR BÁS BEALTAINE 6, 1901/ TRÓCAIRE DÉ AR A ANAM

O'Duffy mentions that in 1915, on the anniversary of his death, flowers were lovingly strewn on his grave by his admirers who marched in procession to the cemetery to reverence his memory.

Amanda McKittrick Ros 1860-1939

Born in Drumaness, County Down. She is known as "the world's worst writer". Her novels and poetry include *Irene Iddesleigh, Delina Delaney, Helen Huddleson, St Scandalbags* and *Fumes of Formation*. Her idiosyncratic writing attracted the likes of Aldous Huxley, Louis MacNeice and Mark Twain and clubs sprang up in Oxford, Cambridge, London and even America to enjoy her writing. She wrote scathingly of lawyers and critics. She is buried in the graveyard attached to the Church of Ireland church in Seaforde,

County Down. Three times I searched the graveyard without finding the grave. I did find the family burial ground. It was completely overgrown, with a bush taking up the entire plot and covering the stone which only mentioned the father. I contacted quite a few people but they were unable to help. Eventually I was given the name of a local minister, Rev. Bailey, who informed me that she was buried in the family plot and that her name was not recorded there. The grave is located on the left-hand side of the church as you approach it from the road. It is near the back.

Richard Rowley 1877-1947

Born Richard Valentine Williams in Belfast. After the collapse of the family business in 1931 he became Chairman of the Assistance Board. He founded the Mourne Press which published works by Michael McLaverty, Sam Hanna Bell, Forrest Reid and by himself. His works include *The City of Refuge, Ballads of Mourne* and *Apollo in Mourne*. He is buried in Christ Church,

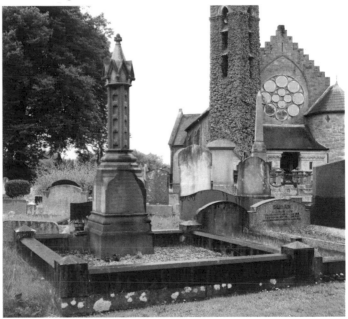

Church of Ireland, Derriaghy, Belfast. Go out the Lisburn Road and at the roundabout after Dunmurray take the road for Milltown. The church is further up on the left-hand side. Go in the main vehicular entrance and the Williams family plot is almost immediately on the left-hand side. The inscription to Richard Rowley is on the right-hand side panel.

George William (AE) Russell 1867-1935

Born in Lurgan, County Armagh. He worked with the Irish Agricultural Organisation Society and edited its journal from 1905-1923. He became one of the leading figures in the

Co-operative movement. He edited the *Irish Statesman* from 1923-1930. His house was a meeting place for the artists and intellectuals of the time. He wrote on mysticism, economics and politics as well as writing poems and plays. His works include *The Candle of Vision, The National Being, Some Thoughts on an Irish Polity, Vale and Other Poems, The Avatars, The Interpreters, Song and Its Fountain* and *Deirdre*. He died in England and his remains were brought back to Ireland where they lay in state in Plunkett House, 84 Merion Square, Dublin, in the place where he had worked for many years. The funeral cortege to Plunkett House was more than two kilometres in length. He is buried in Mount Jerome Cemetery, Dublin. *(See map page 252 – The grave is about six rows in and three rows to the right of the small pathway)*. Frank O'Connor gave the oration and the mourners included Jack and William Butler Yeats, William Cosgrave and Éamon DeValera.

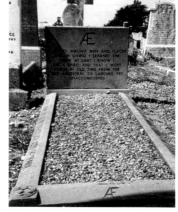

The inscription reads: AE/ I MOVED AMONG MEN AND PLACES/ AND IN LIVING I LEARNED THE/ TRUTH AT LAST. I KNOW I/ AM A SPIRIT AND THAT I WENT/ FORTH IN OLD TIME FROM THE/ SELF-ANCESTRAL TO LABOURS YET/ UNACCOMPLISHED

On one side of the stone surround there is the inscription: GEORGE W RUSSELL POET PAINTER ECONOMIST WHO DIED JULY 17TH 1935 AGED 68 YEARS

And on the other side: AND VIOLET HIS WIFE WHO DIED 3RD FEBRUARY 1932 AGED 64 YEARS

Violet Russell 1868-1932 wrote *Heroes of the Dawn,* a popular book in its day.

Sir William Howard Russell 1820-1907

Born in Tallaght, County Dublin. He is recognised as the first modern war correspondent – Russell of The Times. He reported on wars in the Crimea ("the thin red line"), the Indian Mutiny, the American Civil War, the Franco-German War and the Zulu War. He was also in Egypt during Arabi Pasha's revolt and the beginning of the British occupation in 1882. He founded and edited the *Army and Navy Gazette* which he owned to the end of his life. He was knighted in 1895. His works include *The Adventures of Dr Brady, Hesperothen* and *A Visit to Chile*.

He is buried at Brompton Cemetery, London. The grave number is BR 16827 and a map may be obtained from the Friends of Brompton office in the cemetery. The grave is accurately marked on the one page map. However it is impossible to find without help as it is overgrown and there is no marking on it. The superintendent traced the grave by those on either side of it.

Coming from the colonnaded area the grave is situated on the right-hand side in section U, sixteen rows up and five in. The grave on the path directly in front of it belongs to Henry Newbury and the graves either side of Russell belong to Stopford and Webber. However at the very front of the grave is a stone which is half buried. There is a name on it that does not correspond to anyone buried in the Russell plot. The grave is the one visible in the second row of the photograph above.

Cornelius Ryan 1920-1974

Born in Dublin. He worked as a war correspondent with the *Daily Telegraph* during the Second World War, covering the D-Day landing and the subsequent events. After the war he went to America and worked for various publications. From 1950

onwards he devoted his life to research and writing. His three books sold many millions of copies and *The Longest Day* was made into a very successful film. His other two books were *The Last Battle* and *A Bridge Too Far*. He is buried in Ridgebury Cemetery, Ridgefield, Connecticut beneath a stone that simply states CORNELIUS RYAN REPORTER. According to the cemetery manager of St Mary's Catholic Cemetery, Ryan wanted to be buried under a tall evergreen at Ridgebury Cemetery because he felt it was the town's most beautiful graveyard. The size of the plot suggests that his wife, the writer, Kathryn Morgan Ryan, who worked closely with him, was also to be buried with him. However, she moved away from town some time after his death. This information and the photographs come from Jack Sanders, a local newspaper editor. I found his e-mail address on the internet and wrote to him asking if he knew where Ryan was buried and if there was anyone who could take a photo for me. He wrote back that Ridgefield was currently under two metres of snow but he would try and locate the grave when the snow melted. A month later he sent me on the photos.

John Ryan 1925-1992

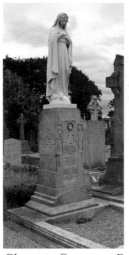

Born in Dublin. The inscription on his gravestone describes him as a writer and an artist. He also founded and edited *The Envoy* and it was a special Joyce issue that led to the first Bloomsday celebrations in 1954, the 50th anniversary of Leopold Bloom's wanderings through Dublin on the 16th June. Others involved in the first celebrations included Patrick Kavanagh, Anthony Cronin, Flann O'Brien, Tom Joyce and a few other friends and colleagues. Ryan also edited *The Dublin Magazine* 1970-1975 and was editor of *A Bash in the Tunnel*. His other works include *Remembering How We Stood* and *A Wave of the Sea*. He is buried in

Glasnevin Cemetery, Dublin. *(See map page 246 - the grave is on the path edge)*.

Stephen Rynne 1901-1980

Born of Irish parents in Hampshire. He was a writer and broadcaster whose works include *All Ireland, The Green Fields* and a biography of Father John Hayes. He was married to Alice Curtayne. They are buried together in Killybegs Cemetery, Prosperous, County Kildare. For directions, see entry for **Alice Curtayne**.

Blanaid Salkeld 1880-1959

Born in India. Her prose and poetic works include *Hello Eternity, A Dubliner, The Fox's Covert* and *Experiment in Error*. She shares a grave in Glasnevin Cemetery, Dublin, with her son, **Cecil French Salkeld**, the artist, poet and playwright and Brendan Behan *(q.v.)* who married her granddaughter Beatrice. *(See map page 246)*.

Bobby Sands 1954-1981

Born in Belfast. He was a member of the IRA and was imprisoned on a number of occasions. He was leader of the hunger strike for political status and while on strike was elected to Westminster. He died after 66 days. He wrote of his prison experiences in *One Day in My Life*. An anthology of his writings can be found in the book *Skylark, Sing Your Lonely Song* which includes his best known songs *McIlhatton* and *The Voyage* (*I Wish I Were Back Home in Derry*).

He is buried in the Republican Plot in Milltown Cemetery,

Belfast. Nearly 100,000 people attended the funeral. The gravestone also contains the names of another hunger striker, Joe McDonnell and of Terence O'Neill who was shot by the RUC in 1980.

The gravestone was one of nearly 20 damaged in an attack on the Republican Plot in January 2004. The stone was broken into four pieces. The attack was claimed by a group calling themselves "Hoods in West Belfast". This was not the first time that the Republican Plot was attacked and stones damaged.

Peig Sayers 1873-1958

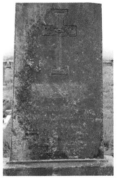

Born Dunquin, County Kerry. She worked in domestic service before marrying a man from the Great Blasket Islands where she lived for over 40 years. She wrote her autobiography, simply called *Peig* and a second volume *Beatha Pheig Sayers*, both of which she dictated to her son Mícheál as she was unable to write Irish herself. Another book of recollections was called *Machtnamh Seana-Mhná (An Old Woman's Reflections)*. She and her son Mícheál left the Island in 1942 and the island was depopulated in 1953. She also provided hundreds of folk tales and songs for the Irish Folklore Commission.

She is buried with her son Mícheál in the new graveyard at Dunquin looking out over the island. Coming from the Slea Head direction the cemetery is just before the village of Dunquin on the right-hand side. The grave is up the main path on your right at the edge. The inscription reads: PEIG SAYERS/ 1873-1958/ GO RABHAIMID/ I GCOMHLUADAR A CHÉILE/ I RIOCHT DÉ/ A MAC AN FILE/ MÍCHEÁL Ó GAOITHÍN/ 1901-1974

Mícheál Ó Gaoithín 1901-1974 was born on the Blasket Islands. As well as taking down his mother's recollections he also wrote an autobiography *Is Trua ná Fanann an Óige (A Pity Youth does not Last)* and a book of poems *Coinnle Corra*.

George Bernard Shaw 1856-1950

Born in Dublin. A shy boy growing up, he showed great determination and self-belief in becoming a full-time writer despite a lack of success for many years. He spoke out against the First World War and against the reprisals taken after Easter Week.

He also spoke up for Casement. He was awarded the Nobel Prize for Literature in 1925. He was made a Freeman of Dublin shortly before he died. His works include *Arms and the Man*, *Back to Methuselah*, *Man and Superman*, *Pygmalion*, *Saint Joan*, *Heartbreak House*, *John Bull's Other Island* and *The Doctor's Dilemma*. A bequest in his will to the National Gallery of Ireland allowed the purchase of many valuable pictures for the gallery. A statue of him used to be in the grounds of the Gallery.

He was cremated at Golders Green Crematorium, London and according to the National Trust leaflet on his house, his ashes and those of his wife Charlotte were scattered throughout the garden and around his revolving writing hut at his home in Ayot St Lawrence, Hertfordshire. However one of the guides told me that both sets of ashes were mixed together on the sideboard and were mostly scattered in the rose bed beneath the Joan of Arc statue. They were discovered there when work was being carried out on the rose bed. The house and gardens are open to the public but it is wise to check the opening days and times in advance of any visit. At present the best day to go is Sunday when there is a connecting bus from St Albans to the village. Otherwise take the bus to Hitchin and get off at Gustardwood. There is a footpath to the village of Ayot St Lawrence. It is a very pleasant walk on a sunny day and takes about 30 minutes.

The day I visited the house, there was a middle aged English couple admiring the revolving work hut where Shaw wrote many of his works. The husband demonstrated how it moved and the wife insisted that he provide her with a similar one when they got home. He replied that when he got home he would give her a few glasses of wine and promised not only would her shed revolve but the house itself would as well!

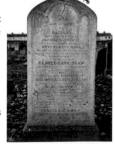

Shaw's father, **George Carr Shaw,** is buried in Mount Jerome Cemetery, Dublin. *(See map page 252)*. Where seven roads meet, walk about 40 metres and on the left-hand side on the road edge are two

gravestones. The second one is to Hodgins and behind this is the Shaw grave.

His mother's remains were cremated in Golders Green Crematorium.

Canon Patrick Augustine Sheehan 1852-1913

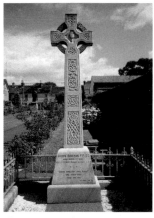

Born in Mallow, County Cork. He became parish priest of Doneraile in 1894 and remained there until his death. He used his novels as a means to promote and preserve Catholicism and to encourage his parishioners at a time of great social change. His best known works include *Glenanaar, The Graves of Kilmorna, Luke Delmege, My New Curate* and *Lisheen*.

He died in Doneraile and is buried in the churchyard. His headstone is in the shape of a white Celtic cross on the left side of the churchyard near the entrance to the sacristy. As you come into Doneraile, from the Buttevant direction, the church is on the left-hand side although it is easy to miss it as it is set back from the road and there are buildings in the way. The inscription reads: CANON SHEEHAN P.P. D.D./ BORN MARCH 17 1852/DIED ON ROSARY SUNDAY OCTOBER 5 1913/R.I.P./"WHERE DWELLEST THOU, RABBI/AND JESUS SAID:/ COME AND SEE"/ST JOHN 1.36.35

Francis Sheehy-Skeffington 1878-1916

Born in Bailieborough, County Cavan. He wrote for quite a few papers and co-founded the *National Democrat*. His works include a biography of Michael Davitt, a one-act play *The Prodigal Daughter* and a novel called *In Dark and Evil Days*. He was a socialist and pacifist. He took no part in the 1916 Rising and was out preventing looting when he was arrested. He was executed without trial the following day. The killing eventually caused uproar at Westminster. The officer responsible, Major Bowen-

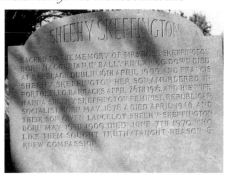

Colthurst, was found guilty of murder but insane and was sentenced to 18 months in a military hospital.

Sheehy-Skeffington is buried in Glasnevin Cemetery, Dublin. (*See map page 246 - the grave is a couple of rows in from the path*).

He is buried with his wife **Hanna** who fought for the rights of women, the underprivileged and prisoners.

The inscription reads: SHEEHY SKEFFINGTON/ SACRED TO THE MEMORY OF MRS ROSE SKEFFINGTON/ BORN MAGORRIAN IN BALLYKINLAR COUNTY DOWN DIED/ AT RANELAGH DUBLIN 16TH APRIL 1909 AND FRANCIS/ SHEEHY SKEFFINGTON HER SON MURDERED IN/ PORTOBELLO BARRACKS APRIL 26TH 1916. AND HIS WIFE/ HANNA SHEEHY SKEFFINGTON, FEMINIST, REPUBLICAN/ SOCIALIST. BORN MAY 1878 DIED APRIL 1946 AND/ THEIR SON OWEN LANCELOT SHEEHY SKEFFINGTON/ BORN MAY 19TH 1909 DIED JUNE 7TH 1970 WHO/ LIKE THEM SOUGHT TRUTH/ TAUGHT REASON &/ KNEW COMPASSION

Richard Brinsley Sheridan 1751-1816

Born in Dublin. He managed the Drury Lane Theatre for 30 years and was a member of parliament from 1780-1812. His works include *The Rivals, The School for Scandal, The Duenna* and *The Critic*.

Although he died in poverty he was given a magnificent funeral to Westminster Abbey where he is buried in Poet's

Corner. His pallbearers included the Duke of Bedford, the Bishop of London and Earl Spencer. The mourners included dukes, marquesses, earls, viscounts and other noble ranks. The funeral procession was so long that the coffin had reached the Abbey before all the mourners had left the starting point at Peter Moore's house in Great Georges Street. His grave is marked by a stone on the floor just two away from Thomas Hardy. The inscription on the black marble stone reads: RICHARD BRINSLEY SHERIDAN/ BORN 1751/ DIED 7TH JULY 1816/ THIS MARBLE IS THE TRIBUTE OF/ HIS ATTACHED FRIEND/ PETER MOORE

Byron was in Italy at the time of the death and he expressed his feelings in *Monody on the death of the Right Hon Richard Brinsley Sheridan*.

Dora Sigerson Shorter 1866-1918

Born in Dublin. She was the daughter of George Sigerson. She wrote over a dozen books of poetry and two novels, all very much influenced by the nationalist spirit of the time. While she was popular in her day, her work is largely forgotten today. Her works include *The Tri-colour: Poems of the Irish Revolution, The Fairy Changeling, Mudge Linsey* and *Love of Ireland: Poems and Ballads*. Several more volumes were published after her death. She designed the 1916 pieta style memorial in Glasnevin Cemetery. She is buried close to her father in the same cemetery. *(See map page 246).*

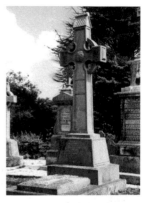

The inscription on the front of the cross reads: IN MEMORY OF/ DORA SIGERSON/ THE BELOVED WIFE OF/ CLEMENT SHORTER/ WHO DIED/ FOR HER DREAM OF IRELAND A NATION/ 6TH JANUARY 1918

On one side is the inscription: IRELAND/ I WAS THE DREAM OF A GOD/ AND THE MOULD OF HIS HAND/ THAT YOU SHOOK NEATH HIS STROKE/ THAT YOU TREMBLED AND BROKE/ TO THIS BEAUTIFUL LAND/ HE MADE YOU ALL FAIR/ YOU IN PURPLE AND GOLD/ YOU IN SILVER AND GREEN/ TIL NO EYE THAT HAS SEEN/ WITHOUT LOVE CAN BEHOLD

On the other side the inscription reads: DARK IS THE TOMB/ YET HOLDETH BUT ONE FEAR/ IN ALL ITS CHILL AND SILENT MAJESTY/ LEST I SHOULD LIE DIVORCED/ FROM ALL HELD DEAR/ AN EXILE YET AND EVER STILL TO BE/ I NEVER TROD UPON A FOREIGN SHORE/ BUT IN MY HEART/ A FLITTING SHADE WOULD RISE/ TO WHISPER HASTE/ ELSE THOU RETURN NO MORE/ WHO COULD NOT REST/ SAVE UNDER NATIVE SKIES/ DORA SIGERSON SHORTER

And on the rear there is another inscription: UPON THE RIVERS OF BABYLON/ THERE WE SAT AND WEPT/ WHEN WE REMEMBER ZION/ PSALM CXXXVI

George Sigerson 1836-1925

Born in Holy Hill, Strabane, County Tyrone. He was a physician, translator and writer whose works include *Poets and Poetry of Munster*, *The Mountains of Pomeroy*, *History of the Land Tenures and Land Classes of Ireland*, *Modern Ireland*, *Songs and Poems* and *Bards of the Gael*

and Gall, as well as other translations from the Irish. He also translated Charcot's *Lectures on Diseases of the Nervous System*. He helped found the Feis Cheoil. He influenced the work of many poets of his own and the next generation. He was the father of Dora Sigerson Shorter.

He is buried in Glasnevin Cemetery, Dublin. *(See map page 246)*.

The inscription on the stone reads: SACRED TO THE MEMORY OF/ GEORGE PATRICK SIGERSON M.D./ BORN AT HOLY HILL CO. TYRONE DIED IN DUBLIN/ FEB 17 1925 AGED 89/ ALSO OF HIS WIFE/ HESTER (VARIAN)/ BORN IN CORK CITY/ DIED APRIL 15 1898 AGED 70/ AND OF THEIR SONS/ GEORGE PATRICK SIGERSON M.A./ DIED JULY 1ST 1901 AGED 36/ AND WILLIAM RALPH/ WHO DIED IN CHILDBIRTH 1864

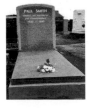

Paul Smith 1920-1997

Born in Dublin. He left school at an early age and worked in various unskilled jobs. He travelled widely in America, Australia and Europe and began writing in his twenties. His first novel, *Esther's Altar* (revised later as *Come*

Trailing Blood) was published in America and was well received there. It was banned in Ireland. Other works include *The Countrywoman* and *Summer Sang in Me*. He is buried in grave number C8-48145, Mount Jerome Cemetery, Dublin. *(See map page 252 - the grave is on the road edge)*.

The inscription reads: PAUL SMITH/ NOVELIST AND PLAYWRIGHT/ THE COUNTRYWOMAN)/ 1920-1997

Annie M.P. (Mary Patricia) Smithson 1873-1948

Born in Sandymount, Dublin. She was a nurse for many years and secretary of the Irish Nurses Organisation from 1929-1942. An immensely popular romantic writer in her day, her works include *Her Irish Heritage, By Shadowed Ways, The Walk of a Queen, For God and Ireland* and *Wicklow Heather*. She also wrote an autobiography — *Myself and Others*. She is buried in the Church of Ireland, Whitechurch Road, Rathfarnham, County Dublin. *(See map page 256)*. To reach the church, take the Willbrook Road with the Yellow House on the left until the roundabout at Taylor's Lane. Turn left along Taylors Lane and turn right at the golf club at the lights. Bear left, around the wall, until you come to the Moravian graveyard on your left. Another few hundred metres on the left is the Church of Ireland.

Stand in front of the church and take the path around the left-hand side. At the back, close to the wall and oblique to the path is the grave. It is marked by a shield type stone on top of a similar stone. The inscription reads: THIS STONE/ WAS ERECTED BY/ MARGARET LOUISA SMITHSON/ IN LOVING REMEMBRANCE/ OF HER BROTHER IN LAW/ JOHN SMITHSON/ WHO DEPARTED THIS LIFE APRIL 24TH 1879/ AGED 30/ COME UNTO ME ALL YE/ THAT ARE WEARY AND HEAVY LADEN/ AND I WILL GIVE YOU REST/ I SHALL GO TO HIM/ BUT HE SHALL NOT RETURN TO ME/ ALSO/ ANNIE M.P. SMITHSON/ DIED 21ST FEBRUARY 1948/ AGED 74 YEARS/ REST IN PEACE

Edith Somerville 1858-1949
Martin (Violet Florence Martin) Ross 1862-1915

Somerville was born in Corfu and Ross at Ross House, County Galway. They were cousins who came together to write under the names of Somerville and Ross. Their works include *The Real Charlotte, Some Experiences of an Irish R.M., Further Experiences of an Irish R.M.* and *In Mr Knox's Country*. After the death of Violet of a brain tumour in 1915, Edith was convinced she was still in communication with Violet and wrote 15 more books that were attributed to Somerville and Ross. These include *Irish Memories* and *The Big House at Inver*.

Gifford Lewis reports in her book *Somerville and Ross: The World of The Irish R.M.* that Edith, on the morning of Violet's funeral made

the letter E from violets to put in the coffin before it was closed. She did not feel up to attending the funeral and went instead to the orchard where she wept for her friend and cousin. They are buried side by side in the Churchyard of St Barrahane, Church of Ireland, Castletownsend, County Cork. The graves are located at the back of the church. The inscription on the Ross stone reads: IN DEAR MEMORY OF/VIOLET FLORENCE/MARTIN/YOUNGEST DAUGHTER OF/JAMES MARTIN/OF ROSS, COUNTY GALWAY/OBIIT DECEMBER 21 1915/THE SOULS OF THE RIGHTEOUS ARE IN/THE HAND OF GOD IN THE SIGHT OF THE UNWISE/THEY SEEM TO DIE BUT/THEY ARE IN PEACE WISDOM 3

On the back of the cross the inscription reads: MARTIN ROSS/SIC ITUR AD ASTRA

The inscription on the Somerville stone reads:
FOR REMEMBRANCE/EDITH OENONE SOMERVILLE/HON. LITT. D/OF DRISHANE HOUSE/1858-1949

Gifford Lewis states in her biography that there were problems on the day of Edith's funeral. She had chosen to be buried beside her cousin but unlike the soft ground in the neighbouring grave, the gravediggers encountered solid rock which they eventually had to remove with dynamite obtained from the local Garda station. The adjoining cross was broken at the base.

Sir Richard Steele 1672-1729

Born in Dublin. He was a dramatist and essayist whose works include *The Christian Hero, The Funeral, The Conscious Lovers* and *The Tender Husband.* He is best known for promoting the 'periodical'. He published *The Tatler* in 1709 and along with Addison, he founded *The Spectator* in 1711 and *The Guardian* in 1713.

He is buried in St Peter's Church, Carmarthen, Wales. A brass tablet commemorates Sir Richard Steele on the south wall in the Consistory Court. He was married to a local woman, Mary Scurlock and was buried in the Scurlock vault in the Town Chancel "about four foot from the little south door of the church, a little to the right-hand on entering"

(Spurrell – *Carmarten and its Neighbourhood*). Some years earlier, according to Kerrigan, *Who Lies Where, A guide to famous graves*, he had arranged a burial in Westminster Abbey for his wife.

In 1876, while the tessellated flooring was being laid, the vault was accidentally uncovered along with the decaying coffin and remains. The skull was in a well-preserved condition and had a peruke (wig) tied at the back with a black ribbon bow.

In 2000, during excavations, the vault was again uncovered and within, there was a lead box inscribed with the words "Supposed to be the Scull of Sir Richard Steele discovered in 1876".

The inscription on the tablet reads: SIR RICHARD STEELE KNIGHT/AUTHOR ESSAYIST/FIRST CHIEF PROMOTER OF THE PERIODICAL PRESS OF ENGLAND/BORN IN DUBLIN MARCH 12 1671/BURIED IN THIS CHURCH AND BELOW THIS TABLET/EXTRACT FROM THE/REGISTER OF BURIALS 1729/SEP 4 SR RICHARD STEEL/(CERTIFIED) LATIMER. M JONES VICAR/THIS MONUMENT WAS ERECTED AT THE SUGGESTION AND EXPENSE OF VALENTINE DAVIS ESQ/AUGUST 1876

James Stephens 1880/1882-1950

Born in Dublin. He claimed he was born on 2nd February 1882, the same birth date as James Joyce. He was a poet, novelist and short story writer and in his later years his radio talks earned him great popularity. He is best known for *The Charwoman's Daughter, The Crock of Gold* and *Here are Ladies. The Insurrection in Dublin* was his eyewitness account of the events of the Easter Rising of 1916. Other works include *Etched in Moonlight, The Demi-Gods, Reincarnations, Deirdre* and *Kings and the Moon*.

He is buried in the graveyard attached to St Andrew's in Kingsbury, London. Take the metro to Wembley Park and walk from there. The minister, Reverend John Smith, invited me to a weekday morning service, and the small but vibrant congregation made me welcome. Afterwards, I was given tea and biscuits before being shown the grave. The church records state that the grave has a rough granite headstone with Celtic cross, with kerbs and crazy paving infill.

The cemetery was extremely overgrown some years ago but much work has been done in the meantime and most of the paths are now clear. The grave is number Ex A100. It is not easily found without directions. There is an old building in the graveyard and at the time of the visit, November 2002, it was being brought back into use. If you stand at the front door of this structure, to the left and behind, there is a very large cross to Ernest Ford and behind that, a

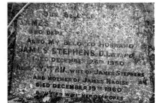

grey obelisk. There is a hedge behind that and beyond this hedge there is a path going away from the church. On the right-hand corner of this path is a grave marked Harvey and six rows down on the same side is the grave of James Stephens.

The part of the inscription that is still legible reads: OUR BELOVED SON/JAMES NAOISE STEPHENS/WHO DEPARTED DEC 24TH 1932/ALSO MY BELOVED HUSBAND/JAMES STEPHENS D. LITT POET/DIED DECEMBER 26TH 1950/ALSO CYNTHIA WIFE OF JAMES STEPHENS/AND MOTHER OF JAMES NAOISE/DIED DECEMBER 19TH 1960/REUNITED WITH HER DEAR ONES

Laurence Sterne 1713-1768

Born in Clonmel, County Tipperary. After an education in Cambridge he was ordained and became Vicar of Sutton-on-the-Forest from 1739-1760. His wife went insane, allegedly because of his philandering. It was after this period that he began to write full-time. His works include *A Sentimental Journey, The Life and Opinions of Tristram Shandy, Gentleman* and *The Sermons of Yorick.*

He was originally buried in St George's Burial Ground in Bayswater Road, London but his grave was not marked. The cemetery was mostly for the poor of the parish and the funeral was attended by only two gentlemen. According to McDonagh, *Irish Graves in England*, a stone was erected the following year although the exact location of the grave was unclear. The stone was placed about half a metre from the western boundary wall of the grounds and contained the following inscription: NEAR TO THIS PLACE LIES THE/BODY OF/

THE REVEREND LAURENCE STERNE, A.M./DIED SEPTEMBER 13TH, 1768/ AGED 55 YEARS/AH MOLLITER OSSA QUIESCANT/IF A SOUND HEAD, WARM HEART AND BREAST HUMANE/ UNSULLIED WORTH AND SOUL WITHOUT A STAIN,/IF MENTAL POWERS COULD EVER JUSTLY CLAIM/THE WELL WON TRIBUTE OF IMMORTAL FAME/ STERNE WAS THE MAN, WHO WITH GIGANTIC STRIDE/MOW'D DOWN LUXURIANT FOLLIES FAR AND WIDE/ YET WHAT, THO KEENEST KNOWLEDGE OF MANKIND/UNSEALED TO HIM THE SPRINGS THAT MOVE THE MIND,/ WHAT DID IT COST HIM?-RIDICULED, ABUSED,/BY FOOLS INSULTED AND BY PRUDES ACCUSED-/IN HIS MILD READER, VIEW THY FUTURE FATE,/LIKE HIM DESPISE WHAT 'TWERE A SIN TO HATE,/THIS MONUMENT STONE WAS ERECTED BY TWO BROTHER/MASONS, FOR THOUGH HE DID NOT LIVE TO BE A MEMBER OF/THEIR SOCIETY, YET AS ALL HIS INCOMPARABLE PERFORMANCES/ EVIDENTLY PROVE HIM TO HAVE ACTED BY RULE AND SQUARE,/ THEY REJOICE IN THIS OPPORTUNITY OF PERPETUATING HIS

HIGH/AND
IRREPROACHABLE
CHARACTER TO AFTER
AGES. W AND S

The monument was still in good condition when McDonagh, visited it 20 years later, the letters clear and distinct. In 1893 the Sterne estate erected another stone. When the burial ground was built over, his remains were removed by the Laurence Sterne Trust in 1969, to the churchyard of St Michael's, Coxwold, North Yorkshire, where he had been vicar from 1760 until his death. He was reburied outside the south wall of the nave.

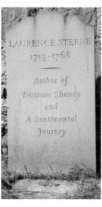

It was rumoured that his body was disinterred shortly after his death by resurrectionists and that it ended up on a dissecting table in Cambridge University and was recognised by a student. The professor is supposed to have hidden the mutilated remains, although the head was returned to the grave in St George's. When the site was being redeveloped a skull was dug up and it had been expertly sawn in half. The dimensions measured those of a bust made while Sterne was still alive. The original headstones are also in St Michael's.

Abraham (Bram) Stoker 1847-1912

Born in Dublin. He joined the Civil Service where he wrote a standard work on *Duties of the Clerks of Petty Sessions in Ireland*. He was manager for the American actor Henry Irvine 1878-1905. He also wrote short stories and over a dozen novels. His most famous story is *Dracula* which was translated into many languages and has spawned many films. Other works include *The Lair of the White Worm* and *Personal Reminiscences of Henry Irving*.

His remains were cremated at Golders Green, London. His ashes, along with his son's, are in an urn in the East Columbarium, Golders Green. The columbarium is locked and you will have to seek permission from the office to visit. Members of staff have been most helpful to me on more than one occasion.

Bram Stoker's wife, **Florence Stoker**, instructed that her ashes be scattered in the Garden of Rest in front of the Ernest George Columbarium. Bram's father, **Abraham Stoker**, is buried in the English Cemetery, in Naples and his mother, **Charlotte Stoker**, is buried in the vaults of St Michan's in Dublin.

Francis Stuart 1902-2000

Born in Townsville, Queensland, Australia, of Ulster parents.
He was educated at Rugby. In 1920, he married Iseult Gonne.
He fought in the Civil War on the anti-Treaty side and was
interned. His early works include poems, novels and plays such as
*We Have Kept the Faith, Women and God, Men Crowd Me Round, The Angel of
Pity* and *The White Hare*. Following marital difficulties, he went to
Germany as a lecturer and stayed there for the duration of the
war, making occasional broadcasts. He was interned for this after
the war and only returned to Ireland in 1959. His novel *Black List
Section H* brought renewed interest but his war years still proved
controversial. He remarried in 1954 and again in 1987. Other
writings include *The Pillar of Cloud, Redemption, Memorial* and *A
Compendium of Lovers*.

He is buried in Fanore Cemetery, County Clare. The
graveyard is situated outside the town on the road from
Lisdoonvarna. Go in the main gate and the grave is situated on
the right-hand side about half way down. His funeral was simple.
The coffin was carried from the local church to the cemetery

overlooking the sea. The day was sunny with strong breezes. A local man informed me that Francis Stuart was a lover of cats and his favourite cat Manna died in the same week and was laid out with him and that it accompanied him to the grave.

The inscription on the grave is taken from his poem *The Octogenarian*. It reads: the Isles of Gree/ce, the isles of G/reece I travelle/d there and ca/me home lame/following a go/at herd to her s/hack a lOng a t/reacherous m/ountain track/the Halls of/ Fame, the Halls/of Fame I asked/for entrance ca/me home lam/e after a bOun/cer at the door/ had caught me/squarely on the/jaw the Haunt/s of Love the Ha/unts of Love I w/ent there seeki/ng for a dove/and brOught/her home aga/against my/chest thinki/ng at last I w/ould have rest/t, by fondling/her the whole/night lOng u/ntil she moan/ed and cried a/nd came, but i/n the morning I/I was lame/ FRANCIS/born 29.4.1902/the Halls of Fam/e the Halls of Fa/me, I asked for en/trance came/hOme lame a/fter a bouncer/at the door ha/d caught me s/quarely on the/jaw the Hau/nts of Love the /Haunts of LOv/e I went there/seeking for a d/dove and/brought h/er home ag/ainst my ch/est, thinking/g at last I w/ould have/rest by fon/STUART/died 2.2.2000/dling her th/he whOle /night long/until she m/moaned a/and cried a/and came/but in the mOrning /I was lame/The Isles of/Greece The/e Isles of G/reece

On my most recent visit to Clare I took a detour to see the grave. It was late evening and the sun was shining and I decided to stay in Clare for the night. I rang numerous B & Bs but they had no vacancies. I was about to give up when I realised I was actually outside one which had a Vacancies notice in the window. So I had breakfast next day looking out over the cemetery. The landlady told me that Finola Graham, who was married to Francis Stuart lived only a few hundred metres away. I paid a visit and she was very welcoming and was receptive to the idea of a photograph of the grave on the cover of this book. She told me that she had chosen the wording for the stone and the work was carried out by Barbara Roder.

A(lexander) M(artin) Sullivan 1829–1884

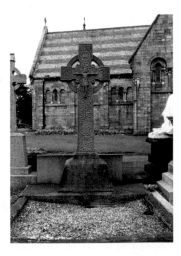

Born in Bantry, County Cork. He was an influential journalist who eventually owned the *Nation*. He spent some months in jail in 1867 for an article on the Manchester Martyrs. He was called to the Bar in 1876 and went to London a year later to practise there. He also represented Louth as an MP for six years. His writings include *New Ireland* and *Story of Ireland*. He also edited a book on *Speeches from the Dock*. He is buried in Glasnevin Cemetery, Dublin.

(See map page 246 – the grave is on the path edge).

The inscription reads: PRAY/ FOR THE REPOSE OF THE SOUL/ OF/ ALEXANDER M SULLIVAN/ BORN AT BANTRY 15TH MARCH 1829/ DIED 17TH OCT 1884

Alexander Martin Sullivan 1871-1959

Born in Dublin. He was a son of the above. He was a skilled advocate and the last King's Serjeant in Ireland. He was against political violence though he defended Roger Casement. He moved to England in 1922. His published works include two books of reminiscence – *Old Ireland* and *The Last Serjeant*. He died in

Beckenham, Kent. He is buried in Glasnevin Cemetery, Dublin. *(See map page 246 – the grave is on the path edge).*

The inscription reads: SULLIVAN/ HERE SLEEPS OUR LOVELY LITTLE SON/ MAURICE JOSEPH/ GIVEN TO US ON THE 31ST MAY 1918/ TAKEN AWAY ON THE 17TH MARCH 1919/ BLESSED BE THE NAME OF THE LORD/ ON THE 14TH MAY 1952 IN HER 76TH YEAR/ JOINED BY HIS MOTHER/ MARY HELEN PIA/ AND/ ON THE 9TH JAN 1959, IN HIS 88TH YEAR/ BY HIS FATHER/ ALEXANDER MARTIN/ LAST OF THE SERJEANTS OF THE KINGDOM OF IRELAND/ PRAY THAT UNITED IN DEATH/ BY THE INFINITE MERCY OF GOD/ THEY SLEEP IN PEACE

Timothy Daniel Sullivan 1827-1914

Born in Bantry, County Cork. He was the older brother of A. M. Sullivan and became editor of the *Nation* in 1876. He was a Nationalist MP from 1880-1887. In 1887 he was imprisoned. He wrote a number of songs including *God Save Ireland* and *The Song of the Canadian Backwoods (Ireland, Boys, Hooray)*. Other works include *Dunboy, Blanaid, Green Leaves – A Volume of Irish Verse, Lays of the Land League, Prison Poems; or Lays of Tullamore* and *Recollections of Troubled Times in Irish Politics*. He is buried in Glasnevin Cemetery, Dublin. *(See map page 246 – the grave is on the path edge).* The grave was covered with a shrub and the cross was covered with ivy up until recently. The grave has since been tidied up.

The inscription on the cross reads: IN MEMORY OF/ TIMOTHY DANIEL SULLIVAN/ WHO DIED ON THE 31ST DAY OF MARCH 1914/ AND HIS WIFE CATHERINE/ WHO DIED ON THE 3RD DAY OF NOVEMBER 1899/ HIS FATHER AND MOTHER/ AND BROTHER DONAL/ ALSO LIE IN THIS GRAVE/ MAY THEY REST IN PEACE.

Dean Jonathan Swift 1667-1745

Born in Dublin. After obtaining his degree from Trinity College Dublin only by "special grace" he went to England where he became secretary to Sir William Temple, at whose house he first met Esther Johnson. He returned to Ireland, was ordained and served in a number of parishes, before going back again to London. He supported the Tories but in return he received only the deanery of St Patrick's Cathedral. After the death of Queen Anne in 1714, he returned to Ireland to

live out the rest of his life. Swift was one of the great satirists and his commentary on political life and human kind in general brought him a wide audience in his own lifetime. His work is still in print and today has a worldwide audience. His best known works include *A Tale of a Tub, Gulliver's Travels, Drapier's Letters, The Battle of the Books* and *Journal to Stella*. He is buried in St Patrick's Cathedral, Dublin. *(See map page 255)*. He left instructions that he was to be buried "in the great aisle on the south side under the pillar next to the monument of Primate Narcissus Marsh, three days after my decease, as privately as possible and at twelve o'clock at midnight". Swift wrote his own epitaph which is on the wall close by his grave. It was to be erected seven feet from the ground, fixed to the wall and the inscription to be carved in large letters, deeply cut and strongly gilded. It reads: HIC DEPOSITUM EST

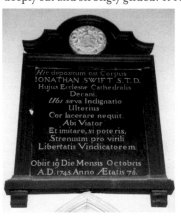

CORPUS/JONATHAN SWIFT S.T.D./HUJUS ECCLESIAE CATHEDRALIS/DECANI/UBI SAEVA INDIGNATIO/ULTERIUS/ COR LACERARE NEQUIT/ABI VIATOR/ET IMITARE, SI POTERIS/STRENUUM PRO VIRILI/LIBERTATIS VINDICATOREM/OBIIT 19 DIE MENSIS OCTOBRIS/A.D. 1745 ANNO AETATIS 78

There is a translation of this on the wall: HERE IS LAID THE BODY/OF JONATHAN SWIFT D.D./DEAN OF THIS CATHEDRAL CHURCH/WHERE

FIERCE INDIGNATION CAN NO LONGER/REND THE HEART/GO TRAVELLER AND IMITATE, IF YOU CAN/THIS EARNEST AND DEDICATED/CHAMPION OF LIBERTY/HE DIED ON THE 19TH DAY OF OCTOBER/1745 A.D. AGED 78 YEARS

A bust of Swift is below this plaque and a death mask is in a glass case nearby. After his death he was laid out in an open coffin for the ordinary people of Dublin to pay their respects. However after a lock of his hair was cut off, the public viewing was ended. At his request, a private funeral was held in the chapel.

Esther Johnson 1682-1728 was Swift's **Stella**. He was her tutor and she later became his friend and companion. Swift was so overcome with grief at her death that he moved out of his usual rooms to avoid seeing her funeral lights in the Cathedral's windows. He was too ill to attend her funeral which took place at night. This was not unusual in those days. Stella left money for a monument but Swift probably felt unable to bring himself to write the inscription. Beneath the plaque to Swift is another one to Stella. It is not known who wrote the inscription. It reads: UNDERNEATH LIE/ INTERRED THE MORTAL REMAINS OF MRS HESTER JOHNSON BETTER/ KNOWN TO THE WORLD BY THE NAME OF STELLA/ UNDER WHICH

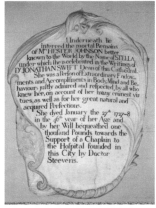

SHE IS CELEBRATED IN THE WRITINGS OF/ DR JONATHAN SWIFT DEAN OF THIS CATHEDRAL./ SHE WAS A PERSON OF EXTRAORDINARY ENDOW-/ MENTS AND ACCOMPLISHMENTS IN BODY, MIND AND BE-/ HAVIOUR, JUSTLY ADMIRED AND RESPECTED, BY ALL WHO/ KNEW HER, ON ACCOUNT OF HER MANY EMINENT VIR-/ TUES, AS WELL AS FOR HER GREAT NATURAL AND/ ACQUIRED PERFECTIONS./ SHE DYED JANUARY THE 27TH 1727-8/ IN THE 46TH YEAR OF HER AGE AND/ BY HER WILL BEQUEATHED ONE/ THOUSAND POUNDS TOWARDS THE/ SUPPORT OF A CHAPLIN TO/ THE HOSPITAL FOUNDED IN/ THIS CITY BY/ DOCTOR/ STEEVENS.

The graves of Swift and Stella are side by side in the south aisle of St Patrick's Cathedral, Dublin and are marked on the floor with separate inscriptions: SWIFT/ DEAN 1713/ OBT 19 OCT 1745/ AET 78 Stella's grave has the inscription: ESTHER/ JOHNSON/ (STELLA)/ OB/ 28 JAN 1728

J(ohn) M(illington) Synge 1871-1909

Born in Rathfarnham, County Dublin. He took his degree at Trinity College Dublin where he learned Irish. He spent time in Paris but on the advice of Yeats, he went to the Aran Islands and spent five successive summers there. He collected much material that he later used in his work. His works include *In The Shadow of the Glen, Riders to the Sea, The Well of the Saints, The Playboy of the Western World* (which caused a riot when first produced in the Abbey), *The Tinker's Wedding* and *Deirdre of the Sorrows*. He is buried in Mount Jerome Cemetery, Dublin. *(See map page 252).*
There is a small concrete path, just beside the Hudson tomb which

is on the road edge. Take the right fork and follow the path. On the fourth path to the left, the grave of JM Synge is facing two rows in. It has a white stone on a plinth.

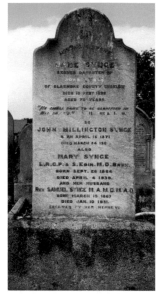

Yeats wrote that the funeral was 'small but select'. W.J. McCormack in his biography of Synge, reported that the cortege with the grieving family members was met at the gates of Mount Jerome by Synge's friends and colleagues. The two groups didn't mix. His beloved, Molly Allgood, didn't attend. She was, as Yeats recorded, dazed with grief. Some time earlier Synge had written about such a situation in a poem – 'I asked if I got sick and died would you/ With my black funeral go walking too/ If you'd stand close to hear them talk and pray/ While I'm let down in that steep bank of clay/ And No, you said, for if you saw a crew/ Of living idiots pressing round that new/ Oak coffin – they alive, I dead beneath/ That board – you'd rave and rend them with your teeth.'

The inscription on the stone reads: IN/ LOVING MEMORY/ OF/ JANE SYNGE/ SECOND DAUGHTER OF/ JOHN SYNGE/ OF GLANMORE COUNTY WICKLOW/ DIED 10TH FEBY 1895/ AGED 70 YEARS/ "HE SHALL COME TO BE GLORIFIED IN/ HIS SAINTS" 11 THESS 1. 10/ ALSO/ JOHN MILLINGTON SYNGE/ BORN APRIL 16 1871/ DIED MARCH 24 1909/ ALSO/ MARY SYNGE/ L.R.C.P. & S.EDIN. M.D. BRUX/ BORN SEPT. 26 1864/ DIED APRIL 4 1939/ AND HER HUSBAND/ REV. SAMUEL SYNGE M.A.M.D.M.A.O./ BORN MARCH 15 1867/ DIED JAN 10 1951/ ERECTED BY HER NEPHEWS

Synge anticipated his fate in a poem written shortly before his death: 'There'll come a season when you'll stretch/ Black boards to cover me/ Then in Mount Jerome I will lie, poor wretch/ with worms eternally'.

His mother **Katherine Synge** and father **John Hatch Synge** are also buried in Mount Jerome Cemetery, in grave number 96-177-4218. The grave is located three rows before the Bunting (*q.v.*) grave and eight monuments to the left.

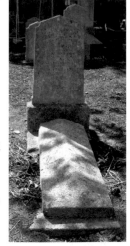

Molly Allgood (pseudonym Máire O'Neill) 1887-1952 played Pegeen Mike in the first production of *The Playboy of the Western World* and had a very successful career. She died in a Basingstoke hospital from burns received when she fell near a fire in her London flat. She was buried in Brompton Cemetery, London.

Cyril and Maureen Cusack, Joseph Tomelty, Margaret Burke Sheridan and Paul Vincent Carroll were among those who sent a floral crucifix arrangement to the funeral.

The grave is situated in Compartment I, East Section. Go in the main gate from Old Brompton Road and the grave is situated on the first section on the left. Go past the Pankhurst grave and it is about 15 metres from the end of this section. On the road edge, there is a grave to Mary Manley, another to Martha Elizabeth Holland behind that and Molly Allgood's plot is in the next row at a right angle to these graves. The headstone is very low and was completely covered when I visited it. I only found it after the superintendent of the cemetery precisely measured it out on the map.

The inscription reads: MAIRE O'NEILL/ DIED NOVEMBER 2ND 1952/ SISTER OF/ SARA ALLGOOD/ DIED IN HOLLYWOOD.

A mistake in the cemetery records meant she was not listed under either Allgood or O'Neill but when I insisted that she was buried there, the record was eventually located through the burial date.

Nahum Tate 1652-1715

Born in Dublin. He was a playwright who also produced "improved" and "happier" versions of several of Shakespeare's tragedies. Together with Nicholas Brady, he compiled a metrical version of the psalms. He wrote the hymn *While Shepherds Watched their Flocks by Night*. He became Poet Laureate in 1692. He was buried in the graveyard of St George the Martyr, Southwark, London. When I inquired whether the grave still existed, the Reverend Tony Lucas wrote to me stating that it was unlikely that a gravestone had ever been erected as he had died a pauper, hiding from his creditors. Over 100 years ago a road was driven through the churchyard cutting it in half. The larger part, now known as St George's Gardens, had all the remaining stones removed and stood against the walls. Since then, they have almost all eroded or been broken beyond repair.

I had read in a BBC website that Tate was actually buried in St Paul's Cathedral. However I went to St Paul's and they could find no record of this.

Jeremy Taylor 1613-1667

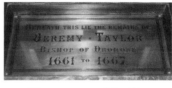

Born in Cambridge, England. He took holy orders and held a number of positions before he became Bishop of Down and Connor in 1660 and Administrator of Dromore in 1661. His works are considered to be some of the finest sacred writings in English. These include *The Liberty of Prophesying*, *52 Sermons*, *Ductor Dubitantium*, *Rule and Exercises of Holy Living* and *Rule and Exercises of Holy*

Dying. He is buried in a vault in the chancel of Dromore Cathedral. When this vault was opened during renovations in 1868 there were five skulls which were presumed to belong to the four bishops buried there and a woman who was presumed to be the wife of Jeremy Taylor. There were only bones scattered around and there were no coffins or coffin plates. All the remains were gathered together and placed in the southwest corner of the vault.

I had made inquiries with the local tourist board and other organisations about when I would find the cathedral open but nobody seemed to know. I went on chance on a wet miserable day (there were quite a lot of such days during the course of researching this book) and as I tried the various doors, I was approached by a gentleman who asked if he could be of any help. I explained what I was looking for and despite the fact he had to meet his wife, he opened the cathedral, gave me a guided tour, turned on the lights and pointed out the plaques. So my thanks to the Reverend Stephen Lowry, Rector of the Cathedral and my apologies to his wife for delaying him.

Sam Thompson 1916-1965

Born in Belfast. He worked in Belfast shipyard but became a playwright, his most famous play being *Over the Bridge*. The play was not staged for a few years because of its content which exposed the sectarianism in the shipyard. Other works include *The Evangelist* and *Cemented with Love*.

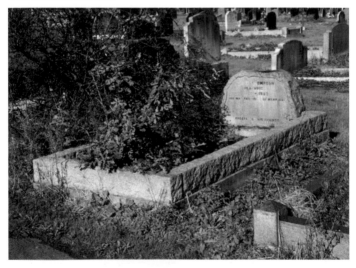

He is buried in grave number C1-31 in the newer part of the City Cemetery, Belfast. The grave is located on the path side between C1 and D1 and a few rows from section W. The *Irish Times* of the day reported that the funeral, at the last minute, made a detour so that the cortege could pass "over the bridge". The mourners got out and walked over Queen's Bridge before resuming their journey to the City Cemetery.

The inscription on the gravestone has letters missing.
It reads: SAM THOMPSON/ PLAYWRIGHT/ 1916-1965/ HIS WAS THE
VOICE OF MANY MEN/ ERECTED BY HIS FRIENDS

Katherine Thurston 1875-1911

Born in Cork. She was married for a number of years to the
writer E. Temple
Thurston. She was a
very popular writer
whose works include
John Chilcote M.P., *The
Gambler* and *The Fly on
the Wheel*. She died
rather suddenly in a
hotel in Cork. She is
buried in St Joseph's
Cemetery, Cork. Go
in the main gate and
keep to the right of
the internal walled
enclosure. Stay by the

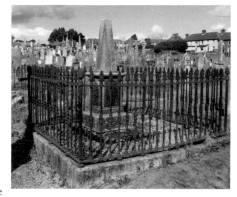

wall and turn left when it finishes. The grave is a little further, on
the right-hand side.

Thomas Tickell 1686-1740

Born at Bridekirk, Carlisle. He came
to Ireland around 1723 and got
married, living in Kildare for some
years before moving to Dublin. He
was a poet whose works include *On the
Prospect of Peace*, *On the Death Of Mr Addison*
and a translation of Book One of the
Iliad. He also edited the Works of
Addison. Although he died in
England he was buried in St Mobhi's,
Glasnevin, Dublin. *(See map page 256).*
There is a plaque to Tickell inside the

church about half way up on the left-hand side above the pulpit.
The inscription reads: SACRED/ TO/ THE MEMORY/ OF/ THOMAS
TICKELL ESQ./ WHO WAS BORN IN 1686/ AT BRIDEKIRK IN
CUMBERLAND/ HE MARRIED IN 1726 CLOTILDA EUSTACE/ DIED
IN APRIL 1740 AT BATH/ AND WAS BURIED IN THIS CHURCHYARD/
HE WAS FOR SOME TIME UNDER SECRETARY IN ENGLAND/ AND
AFTERWARDS FOR MANY YEARS/ SECRETARY TO THE LORDS
JUSTICES OF IRELAND/ BUT HIS HIGHEST HONOR WAS THAT OF
HAVING BEEN/ THE FRIEND OF ADDISON/ THE SD CLOTILDE
EUSTACE/ WAS THE DAUGHTER AND ONE OF THE COHEIRESSES/
OF/ SIR MAURICE EUSTACE/ OF HARRISTOWN IN THE COUNTY OF
KILDARE/ SHE DIED IN JULY 1792/ IN THE 92ND YEAR OF HER
AGE/ AND WAS ALSO BURIED IN THIS CHURCHYARD

The church is usually only open on Sundays for services.

Pat Tierney 1957-1996

Born in Galway. He was known as Pat the Poet. He had a pitch in Grafton Street where he would recite his own and other poems for a fee. He was an activist in his adopted community of Ballymun where he introduced poetry to a generation of school children. His works include his autobiography *The Moon On My Back* and books of poems *Sheets to the Wind, My First Wake* and *Sweet-Talker.* He was dying from AIDS when he committed suicide making his intentions known to the *Sunday Tribune* the week before. He was cremated and his ashes were paraded through Grafton Street on a Saturday afternoon. The parade was led by a group of musicians and after stopping at his pitch where some ashes were scattered, the rest of his ashes were given a drum salute in Temple Bar before being dispersed into the Liffey from the Ha'penny Bridge.

Mary Tighe 1772-1810

Born in County Wicklow. She is remembered for her long poem *Psyche, or the Legend of Love,* which was extremely popular and was reprinted after her death. The poem was much admired by Keats and is said to have influenced his *Endymion*. She died at Woodstock House, Inistioge, County Kilkenny and was buried in the mausoleum in the grounds of the local St Mary's Church of Ireland. There is a sculpture of her, by John Flaxman, on the sarcophagus. A plaster model of the monument was in the keeping of the Tighe family until 1989 when it was given to the Kilkenny Archaeological Society.

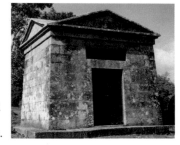

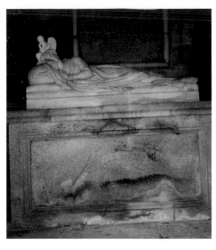

It is possible to obtain the key to the mausoleum. The inscription on the back wall of the interior reads: BENEATH THIS BUILDING/ AWAITING A JOYFUL RESURRECTION/ LIE THE REMAINS OF/ MARY TIGHE/ WIFE OF HENRY TIGHE ESQ. OF KILCARRY COUNTY CARLOW/ AND DAUGHTER OF THE/ REVD WM BLACHFORD AND THEODOSIA TIGHE HIS WIFE/ SHE DIED AT WOODSTOCK IN THIS PARISH/ ON THE 24TH DAY OF MARCH 1810 IN THE 37TH YEAR OF HER AGE/ IF ON THIS EARTH SHE PASSED IN MORTAL GUISE/ A SHORT AND PAINFUL PILGRIMAGE, SHALL WE/ HER SAD SURVIVORS GRIEVE, THAT LOVE DIVINE/ REMOVED HER TIMELY TO PERPETUAL BLISS?/ THOU ART NOT LOST IN CHASTEST SONG AND PURE/ WITH US STILL LIVES THY VIRTUOUS MIND AND SEEMS/ A BEACON FOR THE WEARY SOUL, TO GUIDE/ HER SAFELY THROUGH AFFLICTION'S WINDING PATH/ TO THAT ETERNAL MANSION GAINED BY THEE

John Tobin 1770-1804

Born in Salisbury, Wiltshire. He was a dramatist whose works include The *School for Authors* and *The Honey Moon.* He is buried in the ruined churchyard of Clonmel, Cobh, County Cork. There is a plaque above the grave. The inscription reads: SACRED TO THE MEMORY/ OF/ JOHN TOBIN ESQ. OF LINCOLNS INN/ WHOSE REMAINS ARE DEPOSITED UNDER/ THE ADJACENT TURF/ HE DIED AT SEA/ NEAR

THE ENTRANCE OF THIS HARBOUR/ IN THE MONTH OF DECEMBER/ 1804/ ON HIS PASSAGE TO A MILDER CLIMATE/ IN SEARCH OF BETTER HEALTH/ AGED 35/ THAT WITH AN EXCELLENT HEART/ AND A MOST AMIABLE DISPOSITION/ HE POSSESSED A VIGOROUS IMAGINATION/ AND A CULTIVATED UNDERSTANDING/ HIS DRAMATIC WRITINGS/ FULLY EVINCE

Tobin's grave is situated on the right-hand corner at the back of the church.

Joseph Tomelty 1911-1995

Born in Portaferry, County Down. He was a co-founder of the Ulster Group Theatre and was its manager until 1951. His plays and novels include *Red is the Port Light, The Apprentice, Barnum Was Right,*

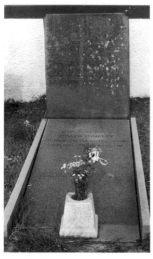

Right Again Barnum, The End House, All Souls' Night and *Is the Priest at Home?* He was also a well-known actor in both television and film. He wrote and acted in the radio serial *The McCooeys*. A serious car crash in 1951 put a premature end to his writings.

He is buried in St Patrick's Cemetery, Ballyphilip, Portaferry, County Down. Go out towards Portaferry harbour and turn left just before the harbour onto Cook Street. Go up the hill and continue until you come to the church which will be on the left. Turn into Ballyphilip Road and go in the main entrance. The grave is situated on the right of the church beside the wall that separates the grounds from the car park and just before the grotto. The inscription on the gravestone reads: IN LOVING MEMORY OF/JOSEPH TOMELTY/AUTHOR PLAYWRIGHT ACTOR/MARCH 5TH 1911 JUNE 7TH 1995/PRAY FOR THE DEAD THAT THEY MAY BE LOOSED FROM THEIR SINS/PRAY FOR THE LIVING THAT THEY MAY BE LOOSED FROM THEIR GREED/ALL SOULS NIGHT 1980/REQUIESCAT IN PACE

Theobald Wolfe Tone 1763-1798

Born in Dublin. He was the father of Irish Republicanism, but of a kind that sought to bring together Catholic, Protestant and Dissenter. He organised the Back Lane Parliament. He was wearing the uniform of a French colonel when he was captured and sentenced to death. He died in prison before the execution was carried out. His writings include *Review of The Conduct of the*

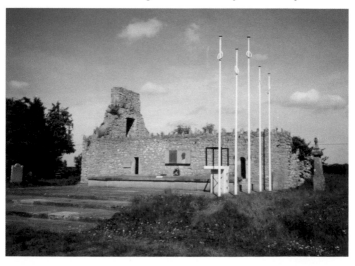

Administration, Argument on Behalf of the Catholics of Ireland, his journals published in various editions and under different titles, his letters and an early novel *Belmont Castle*.

He is buried in the graveyard at Bodenstown, County Kildare. Take the road from Clane to Sallins and about four kilometres out turn left. It is signposted. A little further on, on the right-hand side is the ruined church and cemetery. The memorial is at the back and cannot be missed.

His grave was almost forgotten until Thomas Davis got the local blacksmith to clear the weed-covered grave. Davis commissioned a simple black marble slab for the grave. The inscription read: THEOBALD WOLFE/ TONE/ BORN 20TH JUNE 1763/ DIED 19TH NOVEMBER 1798/ FOR/ IRELAND.

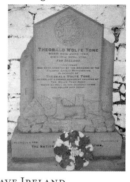

This stone was taken to Bodenstown but was not erected and was eventually damaged. Another stone was erected in 1873. A line drawing of it appears in Molony's biography of Thomas Davis. The inscription read: THE ORIGINAL SLAB/ BEEN ACCIDENTALLY BROKEN/ THE MEMBERS OF THE DUBLIN/ WOLFE TONE BAND/ IN RESPECT TO THE MEMORY OF THEIR/ NOBLE PATRON/ ERECTED THIS SLAB 14 SEPT 1873/ GOD SAVE IRELAND

A vertical stone over the grave had the inscription: THIS BURIAL PLACE BELONGS TO/ WM TONE AND HIS FAMILY. HERE/ LIETH THE BODY OF THE ABOVE/ WHO DEPARTED THIS LIFE 24TH/ APRIL 1766 AGED 60 YEARS/ ALSO THREE OF HIS CHILDREN

Another stone is presently located inside the church behind the railings. The inscription reads: THEOBALD WOLFE TONE/ BORN 20TH JUNE 1763/ DIED 19TH NOVR 1798/ FOR IRELAND/ THIS STONE/ HAS BEEN ERECTED BY THE MEMBERS OF THE/ KILDARE GAELIC ASSOCIATION/ IN MEMORY OF/ THEOBALD WOLFE TONE/ TO REPLACE A FORMER MONUMENT ERECTED BY/ THE WOLFE TONE BAND/ WHICH AS WELL AS THE ORIGINAL STONE/ HAS FALLEN INTO DECAY.

This stone was damaged in an explosion in 1969.

The quotation on the plaque on the wall of the church above the grave is taken from Pearse: NÍ SÍOCHÁIN GAN SAOIRSE/ THINKER AND DOER/ DREAMER OF THE IMMORTAL/ DREAM AND DOER OF THE/ IMMORTAL DEED. WE OWE TO/ THIS DEAD MAN MORE THAN/ WE CAN EVER REPAY HIM / TO HIS TEACHING WE OWE IT/ THAT THERE IS SUCH A THING/ AS IRISH NATIONALISM AND TO THE MEMORY OF THE DEED/ HE NERVED HIS GENERATION/ TO DO, TO THE MEMORY OF/ '98 WE OWE IT THAT THERE/ IS ANY MANHOOD LEFT IN/ IRELAND. P.H PEARSE

One of the stones in the surround quotes from Tone: OUR INDEPENDENCE MUST BE HAD AT ALL HAZARDS. IF THE MEN OF PROPERTY WILL NOT SUPPORT US THEY MUST FALL. WE CAN SUPPORT OURSELVES BY THE AID OF THAT

NUMEROUS AND RESPECTABLE CLASS OF THE COMMUNITY THE
MEN OF NO PROPERTY.

The National Graves Association took over the care of
Bodenstown and are presently still repairing and upgrading
the site.

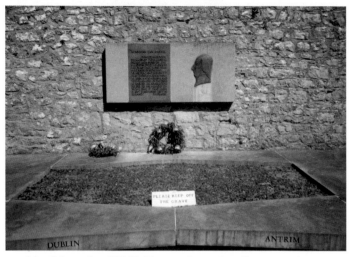

Matilda, wife of Wolfe Tone, is buried in Greenwood
Cemetery in the Bronx, New York. A commemoration is held
each year at the grave.

Reverend Richard Chenevix Trench 1807-1886

Born in Dublin. He was a
philologist and poet. His works in
both fields went into many editions.
He was ordained in 1833 and was
Dean of Westminster Abbey 1856-
1864 and Archbishop of Dublin
1864-1884. The project that
became *The Oxford English Dictionary* was
begun at his suggestion. His works
include *Study of Words, English Past and
Present, Justin Martyr* and *Poems from
Eastern Sources*. He is buried in the
centre of the Nave at Westminster
Abbey, London. His grave is marked
by a black stone on the floor in front
of David Livingstone's grave. The inscription is in Latin.

William Steuart Trench 1808-1872

Born near Portarlington, County Laois. He was a land agent who
wrote an account of his experiences before, during and after the
Famine in *The Realities of Irish Life*. The book was sympathetic to the
agent and his portrayal of the peasants caused much anger in
Ireland. He is buried in Donaghmoyne Churchyard, County

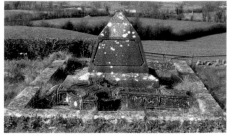

Monaghan. The churchyard is situated on the right-hand side of the road just outside Castleblayney on the road to Monaghan. It is signposted. Drive to the village of Donaghmoyne and turn right. There is another signpost for St Patrick's Church of Ireland. It is about two kilometres from the village on the left-hand side of the road. The grave is on the right of the path against the wall. MacGiolla Ghunna is also buried there.

The inscription reads: IN MEMORY OF/WILLIAM STEUART TRENCH/WHO DIED 4TH AUGUST 1872/AGED 63 YEARS/ALSO IN MEMORY OF HIS ELDEST SON/THOMAS WELDON TRENCH/WHO DIED 15TH AUGUST 1872/AGED 30 YEARS/DEPARTED TO BE WITH CHRIST WHICH IS FAR BETTER

Robert Tressell 1870-1911

Born Robert Noonan into a middle-class family in Dublin. He emigrated to South Africa but after his wife died he sailed to England where he worked as a house painter and signwriter in Hastings. He wrote *The Ragged Trousered Philanthropists* in his spare time. The book reflects the conditions and attitudes he experienced but he couldn't find a publisher. On his way to Canada in 1911, he took ill in Liverpool and died in a workhouse there. The book was eventually published in an abridged version in 1914, and in full in 1955.

His life is shrouded in mystery and much would have remained uncovered had it not been for the work of F.C. Ball who carried out extensive research into his life and death. Ball traced his grave to plot no T.11 in the cemetery belonging to Liverpool Parish Church and formerly the burial ground of the Overseers of the Poor for Liverpool. The cemetery is adjacent to Walton Park Hospital which in 1911 was Walton Workhouse and is now part of the Rice Lane City Farm. In 1970 the BBC made a programme about his life and the exact grave location was paced out, after consulting the cemetery plan, by an official. Tressell was buried along with 12 other paupers. There is a signboard that shows the location of the grave.

In 1977, the *Liverpool Daily Post* of the 20th June reported that "On Saturday leading trade unionists together with several Merseyside Labour M.P.s headed a thousand strong march

to the site where Mrs Joan Johnson, Tressell's grand-
daughter, unveiled a polished black head-stone to his
memory."

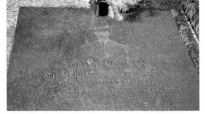

Robert Tressell is
almost ignored in his own
country. A plaque was
unveiled in 1991 on his
birthplace in Wexford
Street, but basically he
remains unrecognised. My
research for this book
brought me into contact with Reg Johnson, Joan's husband, and it
is the intention in the near future to mount a major exhibition so
that Robert Tressell might at last attain the recognition he is due.

The inscription reads: ROBERT NOONAN/ 18TH APRIL 1870
3RD FEBRUARY 1911/AUTHOR AS ROBERT TRESSELL OF/"THE
RAGGED TROUSERED PHILANTHROPISTS"/THROUGH SQUALID
LIFE THEY LABOURED/IN SORDID GRIEF THEY DIED/THOSE
SONS OF A MIGHTY MOTHER/THOSE PROPS OF ENGLAND'S
PRIDE/THEY ARE GONE, THERE IS NONE/CAN UNDO IT. NOR
SAVE OUR SOULS/FROM THE CURSE/BUT MANY A MILLION
COMETH/AND SHALL THEY BE BETTER OR WORSE?/IT IS WE
MUST ANSWER AND HASTEN/AND OPEN WIDE THE DOOR/FOR
THE RICH MAN'S HURRYING TERROR/AND THE SLOW FOOT
HOPE OF THE POOR.

There are 12 other names then listed on the gravestone.

Katharine Tynan 1868-1931

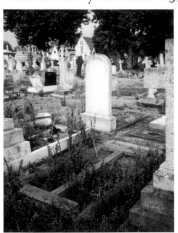

Born in Dublin. She was one
of the most prolific of Irish
writers. Her works include
over 100 novels, short story
collections, plays, poetry
collections, memoirs, essays,
and volumes of autobiography
and reminiscences. She was a
leading poet of the Irish
literary revival and was a good
friend of W.B. Yeats. She had
a reputation as a journalist
and promoted women's rights
and other social issues. Her
works include *Louise de la Valliere
and Other Poems, Ballads and Lyrics,
She Walks in Beauty, Twenty-Five
Years, Cuckoo Songs, The Sweet Enemy, The Adventures of Alicia, The Wind Among
the Trees* and *The House in the Forest.*

She is buried in St Mary's R.C. Kensal Green Cemetery,
London. She is recorded in the records under Hinkson, grave
number 2543NE. The grave in front belongs to Alice Meynell,
the English poet and essayist. Go past the office and take the path
before T.P. O'Connor (*q.v.*). The grave is down on the right-hand
side and it is the one in the photograph with the fallen cross.

Pádraig Ua Maoileoin 1913-2002

Born in Comineól, Corca Dhuibhne, County Kerry. He was the grandson of Tomás Ó Criomhthain. He joined An Garda Síochána in 1935 and spent much of his time in Headquarters in Dublin translating legal documents and law books from English into Irish. Many of his early works were written while he was a member of the force. He retired after 30 years' service. He was then employed by the Department of Education as assistant editor on the *Foclóir Gaeilge-Béarla* (1977). His novels include *Bríde Bhán* and *De Réir Uimhreacha*. He edited Ó Criomhthain's *An tOileánach* as well as other works but his best known work is probably *Na hÁird Ó Thuaidh*.

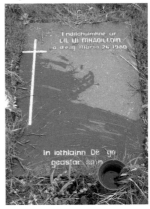

He is buried in grave number, D41, St Barrachs, St Fintan's Cemetery, Dublin. (*See map page 256*). Go in the main gate and take the second road on the right. Locate the row number by the lettered stones on the right-hand edge of the road and the grave is on the right-hand side of the row. His name is not yet recorded on it as the photo was taken shortly after his death.

Helen Waddell 1889-1965

Born in Tokyo. She was a writer best known for *Peter Abelard* which was translated into many languages and went into over 30 editions. She wrote many other works including *The Wandering Scholars, Medieval Latin Lyrics, Beasts and Saints, The Desert Fathers, The Spoilt Buddha* and *The Abbé Prévost*.

The funeral service was held in Magherally Presbyterian

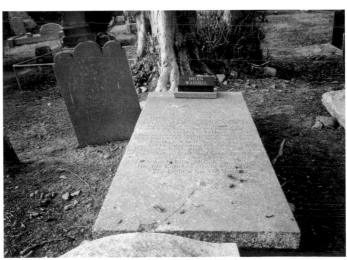

Church, County Down and the cortege went up the winding path to the graveyard of the ruined church of Magherally. The sun was shining and the snow was still visible on the ditches. Take the main path in the old churchyard and before it swings around to the left, the grave is in front of you about four metres in.

The inscription mentions her grandparents and herself: HERE ALSO RESTS THEIR GREAT GRAND DAUGHTER/ HELEN WADDELL, M.A. D. LITT. YOUNGER DAUGHTER OF/ REV HUGH WADDELL TOKIO, JAPAN/ BORN 31ST MAY 1899 DIED 5TH MARCH 1965/ SCHOLAR AUTHOR POET SHE LIFTED A VEIL ON THE PAST/ HER PROSE MADE ITS SAINTS AND SCHOLARS LIVE AGAIN/ HER ENGLISH VERSE/ MADE LOVELY LYNES OF THEIR LATIN SONGS/ HER LIFE ENRICHED ALL WHO KNEW HER/ "THE LIGHT IS ON THY HEAD"

To get to the cemetery, take the A1 from Belfast in the Newry direction and near to Banbridge, there is a sign for Magherally old churches.

Luke Wadding 1588-1657

Born in Waterford. He established the College of San Isodore for Irish Franciscans in Rome and the Ludovisi College for Irish secular clergy. His major work was an eight-volume history of the Franciscan order — *Annales Minorum*. He also edited the works of Duns Scotus.

He is buried in the church of San Isodore in Rome.

There are a number of memorials to him in the church. The marble plaque is in the floor of the church at the entrance to the sanctuary. There are two others directly below in the crypt. One

is shown on the left and the other one has a practically illegible inscription. This was another grave I nearly gave up on until I was put in touch with Tony Bissett who arranged for Fr Ken Laverone to take the pictures. Father John Wright, Superior, gave the necessary permissions for the photos.

Mervyn Wall 1908-1997

Born in Dublin. He spent his working life in the Civil Service.

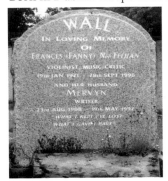

He wrote short stories, novels and plays including *A Flutter of Wings, The Unfortunate Fursey, The Return of Fursey, Leaves for the Burning, No Trophies Raise, Alarm among the Clerks, The Lady in the Twilight* and a history of the Forty Foot bathing spot. He is buried in grave number 58, Row G1, St Laurence's Section, Shanganagh Cemetery, Dublin. *(See map page 256 – the section is immediately in front of you as you enter the cemetery and the grave is over to the left).*

Edward Walsh 1805-1850

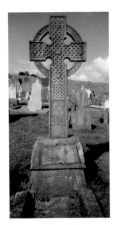

Born in Derry. He was not a man afraid to express his opinion or show his political disposition and as a result ended up in prison and losing several jobs. He worked mostly as a teacher. He wrote a number of poems but is perhaps remembered for his translations. His works include *Reliques of Irish Jacobite Poetry* and *Irish Popular Songs.* He is buried in St Joseph's Cemetery, Cork. Go through the arch and to your right. A large Celtic cross about five rows back and about half way down, facing away and slightly lopsided, marks the grave. The cross has the inscription: EDWARD WALSH/THE POET AND TRANSLATOR/DIED AUG 6 1850 AGED 45 YEARS/ERECTED TO HIS MEMORY/BY A FEW ADMIRERS OF THE PATRIOT AND THE BARD/GOD REST HIS SOUL/FRANCES AND JOHN WALTERS

The stone on the ground has the inscription: THE/BURIAL PLACE OF/EDWARD WALSH AND FAMILY followed by a very faded inscription in Irish.

Maurice Walsh 1879-1964

Born at Ballydonoghue, County Kerry. He worked for 20 years in the Customs and Excise service in Scotland before returning to Ireland after the establishment of the State. It was then that he began to devote himself to writing. He wrote many books and short stories, one of which, *The Quiet Man,* was made into a well-known film. His other works include: *The Key Above the Door, While Rivers Run, Blackcock's Feather, Son of the Sword Maker, Danger Under the Moon* and *A Strange Woman's Daughter.* He is buried in

Esker Cemetery, Lucan, County Dublin. *(See map page 256)*

There are two cemeteries on the Newlands Road. The one on the right, coming from Lucan village is the Old Esker Cemetery, where Maurice Walsh is buried. Go in the gate and turn right and take the first path on the left. Seven graves down on the left-hand side is the grave of Maurice Walsh. It has a small granite stone.

The inscription is beginning to wear away and is not easily visible from a distance. It reads: MAURICE WALSH/ AUTHOR/ BORN CO. KERRY 1879 DIED DUBLIN 1964/ WITH HIM LIE HIS WIFE/ CAROLINE 1886–1940/ AND HIS DAUGHTER/ ELIZABETH DIED 1932/ AGED 3 MONTHS/ REST IN PEACE

Sir James Ware 1594-1666

Born in Dublin. He succeeded his father as Auditor General (1632-1649) and was MP for the University of Dublin. He was imprisoned during the English Civil War and exiled to France. He was later allowed to return to Ireland where he took up his old position of Auditor General. He was also an antiquarian whose collection of Gaelic manuscripts and books now resides in the Bodleian Library. His works include *The Antiquities and History of Ireland, History of Ireland* and *A View of the Present State of Ireland*. His son published *The Whole Works of Sir James Ware* in three volumes. He is buried in the vaults of St Werburgh's, Dublin. *(See map page 255)*. The photograph shows the entrance to the vaults.

Alfred John Webb 1834-1908

Born in Kinsale, County Cork. He wrote a number of essays to bring about a greater understanding between political opponents. These include *Opinions of Some Protestants Regarding their Catholic Fellow-Countrymen* and *The Alleged Massacre of 1641*. He is best remembered for his *Compendium of Irish Biography*. This was the first of its kind and was a standard work for many years. He is buried in the Friends Burial Ground, Temple Hill, Blackrock, County Dublin. *(See map page 256 — Standing in front of the Meeting House, the grave is located on the right-hand side, seven rows down and seven graves in)*. All gravestones in the cemetery are of standard size and shape.

The inscription reads: ALFRED WEBB/ DIED/ 30TH OF SEVENTH MONTH 1908/ AGED 74 YEARS

James White 1913-2003

Born in Dublin. He was the art critic for the *Irish Press* 1950-59 and the *Irish Times* 1959-62. He was curator of the Dublin Municipal Gallery 1960-64 and Director of the National Gallery from 1964-1980. He was also chairman of the Arts Council 1978-1983. His publications include *Irish Stained Glass* (with Michael Wynne), *The National Gallery of Ireland, Jack B. Yeats, John Butler Yeats and the Irish Renaissance, Masterpieces of The National Gallery of Ireland, Pauline Bewick: Painting a Life* and *Gerard Dillon, A Biography*. His body was donated for medical science.

William John (Jack) White 1920-1980

Born in Cork. He worked with the *Irish Times* for over 20 years. He was also a broadcaster and worked in various posts in RTÉ before

becoming Controller of Television Programmes 1974-77. He wrote radio scripts, plays, a number of novels and a study on Protestants in the Republic of Ireland. His works include *One for the Road, The Devil You Know, The Last Eleven* and *Minority Report*. He died in Stuttgart while attending a conference. He is buried in grave number 119 H, St Nessan's, Deansgrange Cemetery, Dublin. *(See map page 250 – Take the last path before the gates and the grave is situated eight rows down and three rows in on the left)*. The inscription, which is worn, reads: IN MEMORY/ OF/ JACK WHITE/ MARCH 1920-APRIL 1980

Lady Jane Wilde (Speranza) 1826-1896

Born in Dublin. She wrote patriotic poetry and verse under the name of 'Speranza' for the *Nation*. She married William Wilde in 1851 and was the mother of Oscar. She hosted very successful salons in Dublin and later, after the death of her husband, in London. Under her own name she completed the work of her husband in books on folklore and she herself wrote on other subjects. Her works include *Men, Women and Books, Ancient Legends of Ireland, mystic Charms and superstitions of Ireland* and *Ancient Cures, Charms and Usages of Ireland.*

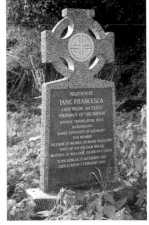

She sought permission for Oscar, who was in prison at the time, to visit her on her deathbed but this was refused. On the night she died Oscar claimed to have heard the Banshee's cry and to have seen her in his cell.

According to Ellman, in *Oscar Wilde*, she had not wished to be buried beside some common tradesman, preferring to be thrown into the sea or buried near a rock on some wild coast. Instead she was buried in Kensal Green Cemetery, London. She left a private letter requesting that no one should come to the funeral, which her son Willie arranged and the costs of which were paid for by Oscar. No headstone was erected and no fees were paid so that after seven years, her body was moved to an unmarked grave in the poor ground.

The grave remained unmarked until 2000. Andrew McDonnell of the Oscar Wilde Literary Trust was able to establish that the Kensal Green Cemetery Company knew the exact sites of the graves of both Lady Wilde and her son William. McDonnell, along with Merlin Holland and an anonymous donor, designed the Celtic cross in Kilkenny Blue limestone. The Trust organised the unveiling on October 13th 2000 by Vanessa Redgrave.

The inscription reads: REQUIESCAT/JANE FRANCESCA/LADY WILDE, NÉE ELGEE/"SPERANZA" OF "THE NATION"/WRITER, TRANSLATOR, POET,/NATIONALIST/EARLY ADVOCATE OF EQUALITY/FOR WOMEN/AUTHOR OF WORKS ON IRISH FOLKLORE/WIFE OF SIR WILLIAM WILDE/MOTHER OF WILLIAM, OSCAR AND ISOLA/BORN DUBLIN 27 DECEMBER 1821/DIED LONDON 3 FEBRUARY 1896

William Robert Kingsbury Wills Wilde 1852-1899 was buried in a common grave with at least 20 other people in Kensal Green Cemetery, London. The grave number 37378 was located in square 225. This area is now covered by the crematorium.

Willie's wife and their daughter, **Dolly Wilde**, are buried in grave number 47570 165 3, Kensal Green Cemetery, London. Coming from the St Mary's direction towards the church, go past Section 165 and turn right. The grave is a few rows down and three rows in. There is an obelisk to Lake on the roadside and a grave belonging to Jack Wall. The Wilde grave is behind the Wall grave. The inscription reads: TO THE MEMORY OF/

SOPHIA TEIXEIRA/DE MATTOS/DIED 7TH OCTOBER/1922/AND OF HER DAUGHTER/DOROTHY IERNE/WILDE/DIED 10TH APRIL 1941

Oscar Fingal O'Flahertie Wills Wilde 1854-1900

Born in Dublin. He was a poet, playwright, wit and writer of fairy stories. At Oxford he graduated with first class honours in classics. His aestheticism, style of dress and his ready wit attracted huge attention. His relationship with Alfred Lord Douglas was his downfall. Goaded by Douglas to sue his father, Lord Queensbury, Wilde lost the case and following this he was tried

for homosexual offences and found guilty. In 1895, he was sentenced to two years penal servitude in Reading Jail. Shortly after, he was declared bankrupt. After his release he went to Paris where he died. His works include *The Happy Prince, The Picture of Dorian Gray, Lady Windermere's Fan, A Woman of No Importance, An Ideal Husband, The Importance of Being Earnest, Salomé, The Ballad of Reading Gaol* and *De Profundis*.

The funeral left the Hotel d'Alsace for mass in the church of St Germaine-des-Prés. About 50 people attended. Four carriages made the journey then to the cemetery where Ross had arranged a temporary concession. Ellman, in *Oscar Wilde*, mentions a jostling at the graveside with Douglas almost falling into the grave. Robert Ross and about a dozen others attended. Douglas agreed to pay the funeral expenses.

He was initially buried at Bagneux Cemetery, eleventh grave, seventh row, seventeenth section. It had a stone with an iron railing around it. The inscription on the stone read: OSCAR WILDE/ OCT 16TH 1854 – NOV 30TH 1900/ VERBIS MEIS ADDERE NIHIL AUDEBANT/ ET SUPER ILLOS STILLABAT ELOQUIUM/ MEUM/ JOB XXIX/ R.I.P. (To my words they durst add nothing and my speech dropped upon them – Douai Version). A photograph of this grave appears in Merlin Holland's *The Wilde Album*.

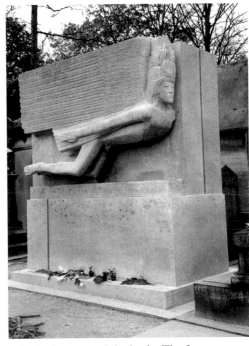

In 1909, in July, his remains were transferred to their present position in Père Lachaise Cemetery, Paris. At the time of the death Ross had been advised that Wilde should be buried in quicklime so that only the bones would remain making it easier for the skeleton to be removed. However when they opened the coffin, it was discovered that instead it had preserved the body. The face was readily identifiable and the hair and beard appeared to have grown long. Perhaps if Oscar had been more religious he may have been declared a saint!

Ross had intended the body to be moved to Père Lachaise in a magnificent coffin but the cemetery officials insisted that it be moved in a simple oak coffin made in the cemetery. In addition,

the name on the silver plate was misspelt as OSCARD WILDE. Robert Ross, Wilde's son Vyvyan Holland and Sir Coleridge Kennard attended the re-interment in Père Lachaise Cemetery.

The monument over the grave is by Jacob Epstein and was paid for by Mrs Carew, mother of Sir Coleridge Kennard. The monument was commissioned in 1909 and in 1912, when it was nearly finished it was positioned over the grave. The sculpture depicts a winged messenger which some see as Wilde himself though Epstein denied this. However a certain part of the sculpture was considered indecent by the cemetery officials. Some time later it was covered with a tarpaulin and a gendarme was placed to guard it and prevent further work on it. This situation continued for a while and a large plaque was attached to the figure, acting as a fig leaf. The tarpaulin eventually came down at the start of the First World War.

In 1922 it attracted further attention from local students, and the plaque and what was underneath were broken off. It was rumoured that the offending part was later used as a paperweight by the curateur of the cemetery. Even today the tomb attracts hordes of visitors many of whom kiss the surface and leave a red lipstick impression.

The inscription on the back of the tomb includes a list of his academic achievements, the verse on the first gravestone and the following lines from *The Ballad of Reading Gaol*: AND ALIEN TEARS WILL FILL FOR HIM/PITY'S LONG BROKEN URN/FOR HIS MOURNERS WILL BE OUTCAST MEN/AND OUTCASTS ALWAYS MOURN.

Constance Wilde 1858-1898 was the daughter of Horace Lloyd, a wealthy Cork Barrister. She married Oscar when she was 26 and he was already an established writer and public figure. After Oscar's trial and conviction she fled England and went to live abroad, ending up in a villa on the coast outside Genoa. She changed her name to Holland. She died unexpectedly after surgery on her spine and was buried in Staglieno Cemetery, Genoa. The funeral was simple and neither of her sons, nor Oscar, were in attendance.

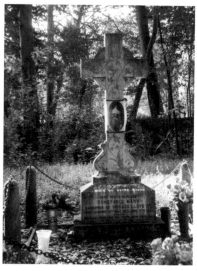

After his release in 1897, Oscar did not go to stay with his wife and he never saw her again. On hearing of her death he claimed to be in great grief and that his way back to hope and a new life ended in her grave. She left him £150 a year from her estate.

In early 1899 Oscar stopped off in Nice and made the journey down the coast to Genoa. He wept bitter tears of remorse and covered her grave with red roses. He was disappointed to find no mention of him

on the gravestone. Eventually "Wife of Oscar Wilde" was added to the memorial in 1963. On the centenary of her death, Merlin Holland, the grandson of Constance and Oscar, and members of the Oscar Wilde Society re-dedicated the restored grave of Constance. The inscription reads: HERE RESTS IN PEACE/ CONSTANCE MARY/DAUGHTER OF HORACE LLOYD Q.C./BORN JANUARY 2ND 1859 DIED APRIL 7TH 1898/THE LORD SHALL WIPE AWAY ALL TEARS FROM THEIR EYES.

There is a bus service directly to the cemetery from outside the railway station. There is a guidebook given out at the cemetery entrance and the map shows the location of her grave. If you go in the first entrance rather than the main one and continue on until you come to the English chapel (the name is on it), the grave is on the same side, on the path edge, about three rows past the chapel.

Her second son, **Vyvyan Holland**, became a writer whose works include *Oscar Wilde and His World*. His remains were cremated at Golders Green, London. The first-born son, **Cyril Holland**, who served as a captain in the Royal Field Artillery, was killed by a sniper in May in 1915. He is buried in grave number I.A.1 in St Vaast Post Military Cemetery, Richebourg-L'Avoue Pas de Calais, France.

Robert Ross 1869-1918 was a son of the Attorney General of Canada and after his father's early death the family came to live in London. Both he and Wilde acknowledged that Ross was Wilde's first homosexual partner. He remained friendly with Wilde and became his literary executor. He was cremated at Golders Green, London and his ashes placed in a specially created niche in Wilde's tomb in Père Lachaise Cemetery, Paris. He had asked Jacob Epstein to put in such a niche when he was making the memorial. Ross anticipated the difficulties he might have with the authorities and the ashes were only placed there on the 50th anniversary of Wilde's death on November 30th 1950.

Sir William Wilde 1815-1876

Born in Castlerea, County Roscommon. He was the father of Oscar. He was a talented man in the medical, scientific, literary and archaeological fields. His works include *The Beauties of the Boyne and the Blackwater, Lough Corrib and Lough Mask, The Epidemics of Ireland, The Closing Years of the Life of Dean Swift* and three volumes on the contents of the Royal Irish Academy Museum. He is buried in Mount Jerome Cemetery, Dublin. *(See map page 252)*. The funeral was attended by Oscar and Willie, as well as by another son Henry Wilson. The Lord Mayor, the Lord Chancellor of Ireland, Professor Mahaffy and many other academic and church dignitaries also attended. The front of the monument reads: SIR WILLIAM WILDE/M.D./F.R.C.S.I./SURGEON OCULIST TO HER MAJESTY/QUEEN VICTORIA/CHEVALIER OF THE ROYAL SWEDISH ORDER OF/THE NORTH STAR/THE FOUNDER OF ST MARK'S/ OPTHALMIC HOSPITAL/AND THE AUTHOR OF MANY WORKS/ ILLUSTRATIVE OF THE HISTORY AND/ANTIQUITIES OF IRELAND/ BORN AT CASTLEREA COUNTY ROSCOMMON/MARCH 1815/DIED/

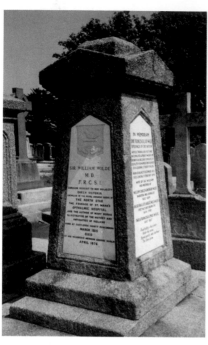

At His Residence
Merrion Square
Dublin/April 1876
 The side of the
monument has the
following inscription:
In Memoriam/Jane
Francesca, Lady
Wilde/"Speranza" Of
'The Nation'/Writer,
Translator, Poet
And/Nationalist,
Author Of Works On/
Irish Folklore, Early
Advocate Of/
Equality For Women
And Founder/Of A
Leading Literary
Salon/Born 27
December 1821/Died
London 3 February
1896/Wife Of Sir
William/And Mother
Of/William Charles
Kingsbury Wilde/
Barrister And Journalist/1852-1899/Oscar Fingal
O'Flahertie Wills Wilde/Poet Wit And Dramatist/1854-
1900/Isola Francesca Emily Wilde/1857-1867/Tread
Lightly, She Is Near/Under The Snow/Speak gently, She
Can Hear/The Lilies Grow

Isola Wilde is buried in St John's Church of Ireland
Cemetery, Edgeworthstown, County Longford. There is a
mention of this at the gate but it states her grave is not known.
Oscar wrote a poem called *Requiescat* in her memory. The first
verse of the poem is the one quoted on the monument above. He
kept to his death an envelope containing "My Isola's Hair".

 The other side has the inscription: To The Memory/Of/
Emily/Daughter Of/John Fynn/And Wife Of/Thomas
Wilde M.D./Of Castlerea
Co. Roscommon/She Died In
Dublin/January 20th 1844/
Aged 68 Years

 Sir William Wilde also had a
number of illegitimate children
before his marriage to
'Speranza'. In November 1871
his two daughters **Mary** and
Emily attended a ball at
Drumaconnor in County
Monaghan. As the event was
finishing, the host asked Emily
to dance. Her swirling skirt
brushed against the open fire in

the hearth and caught fire. Her sister raced to her assistance and her dress too caught fire. The host pushed them outside and rolled them in the snow. But it was too late and they both died. His social position precluded Sir William from attending the funeral. Sometime after it was over, he went to Monaghan and his groans could be heard even outside the house.

The girls were buried in the local Church of Ireland graveyard and their tombstone was inscribed: IN MEMORY OF/ TWO LOVING AND BELOVED SISTERS/ EMILY WILDE AGED 24/ AND/ MARY WILDE, AGED 22/ WHO LOST THEIR LIVES BY ACCIDENT/ IN THIS PARISH NOVR 1871/ "THEY WERE LOVELY AND PLEASANT IN/ THEIR LIVES AND IN THEIR DEATHS/ THEY WERE NOT DIVIDED" Ll SAMUEL CHAP L V.23

For 20 years after, a woman dressed in black would arrive from Dublin and hire a car to drive her to the graveyard. The sexton was unable to say whether it was the girl's mother or Lady Jane Wilde.

Drumaconnor House is situated five kilometres from Monaghan town and accepts guests. Drumsnatt Church of Ireland is situated off the main Monaghan to Clones road. Outside the town of Monaghan take the R 189 for Newbliss and Three Mile House. Go through the village of Three Mile House and at the top of a small hill take the road on the right. You will come to a lake on the right-hand side opposite Drumsnatt monastic site and cemetery but this is not it. Travel on a bit and you will see the church on the left-hand side. Go in the gate and follow the path and then go around the church and the grave is almost opposite, close to the hedge. I visited the grave on a beautiful mild spring day and as I sat at the graveside, it was hard not to be moved by the tragic events of a cold snowy winter day over 130 years before.

Florence Mary Wilson 1874-1946

Born in Lisburn, County Antrim. She was a friend of Alice Milligan and wrote pieces for *Irish Homestead* and other journals and papers. Her book of poems *The Flight of the Earls* was very popular, especially in America. She is best remembered for her poem *The Man from God Knows Where*, about Thomas Russell. She is buried in grave number 1B 142, Bangor Cemetery, Newtownards Road, Bangor, County Down. Section 1B is located on the left-

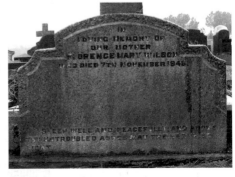

hand side as you go in the gate and is marked. The grave is near the farther end of this section, a few rows in from the main road.

Robert Arthur Wilson 1820-1875

Born in County Donegal. He was a journalist who was extremely popular for his humourous writings under the name of 'Barney Maglone'. These include *Almeynack for All Ireland an' Whoever Else Wants It* and *The Reliques of Barney Maglone* which were compiled after his death. He died in Belfast having celebrated too enthusiastically the O'Connell centenary events in Dublin.

He is buried in grave number B 49 in the older part of Belfast City Cemetery. The grave is between the B and C sections on the path edge, about half way down. The monument and grave are covered with bushes and vegetation. The inscription reads: IN MEMORY/ OF/ ROBERT A WILSON/ AN ABLE JOURNALIST/ A GIFTED POET/ A FEARLESS AND UNFLINCHING/ ADVOCATE OF THE RIGHTS/ OF THE PEOPLE/ OBIIT 10TH AUGUST 1875/ THEN HIS DUST TO THE DUST/ AND HIS SOUL TO IT'S REST/ BUT HIS MEMORY TO THOSE/ WHO CAN CHERISH IT BEST/ (R.A.WILSON)

It is worth recalling his poem about his own corpse:

And when they have picked every bone, ochone
As smooth and as bare as a hone, Maglone,
And have emptied the skull
That of nonsense was full
They'll say: 'Come boys, It's time to be gone – come on
He was mighty poor picking, Maglone'.

Rev Charles Wolfe 1791-1823

Born in County Kildare. He was a clergyman and poet although he is chiefly remembered for one poem only – *The Burial of Sir John Moore*. He is buried in a grave overgrown with brambles, in the north west corner of the church in the ruined churchyard of Clonmel, Cobh, County Cork. The tomb is situated on the very left-hand corner of the church as you enter. The inscription reads: HERE LIE/ THE REMAINS OF THE REV CHARLES WOLF/

LATE CURATE OF DONOUGH/ WHO DIED AT COVE 21 FEB 1823/ AGED 31/ THE RECORD OF HIS GENIUS/ PIETY AND VIRTUE/ LIVES IN THE HEARTS/ OF ALL WHO KNEW HIM/ LOOKING UNTO JESUS HE LIVED/ LOOKING UNTO JESUS HE DIED/ HE IS NOT DEAD BUT SLEEPETH

Jack B. Yeats 1871-1957

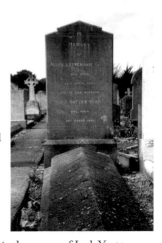

Born in London. He was the brother of William and is recognised as one of Ireland's finest painters, but he also illustrated books and wrote prose, plays and reminiscences. His works include *Sailing, Sailing Swiftly, The Amaranthers, Harlequin Positions, La La Noo, In Sand* and *Ah, Well.* He is buried in Mount Jerome Cemetery, Dublin. *(See map page 252).* Find the Synge grave *(q.v.).* Return to the main path and continue in the direction you were going. Take the second path to the right and at the corner just past the second pathway to the left-hand side is the grave of Jack Yeats.

The inscription reads: IN/ MEMORY/ OF/ MARY COTTENHAM YEATS/ WHO DIED/ 28TH APRIL 1947/ AND OF HER HUSBAND/ JACK BUTLER YEATS/ WHO DIED/ 28TH MARCH 1957

John Butler Yeats 1839-1922

Born at Tullylish, County Down. He was the father of W.B. and of Jack and of Lily and Lolly. He was called to the Bar but became a painter. He also wrote essays for *Harpers Weekly*. His works include *Essays Irish and American, Passages from the Letters of John Butler Yeats* and *Early Memories: Some Chapters of Autobiography*. He is buried in Jeanne Foster's family plot in the Rural Cemetery, Chestertown, New York, U.S.A. The inscription on the monument reads: IN REMEMBRANCE OF/ JOHN BUTLER YEATS/ OF DUBLIN IRELAND/ PAINTER AND WRITER/ BORN IN IRELAND MAR. 16. 1839/ DIED IN N.Y. CITY FEB, 3. 1922

In 2001, Declan Foley organised a very successful seminar at Chestertown in honour of John Butler Yeats. Arising from the

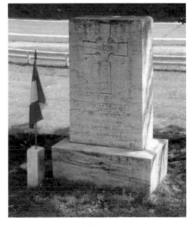

seminar, a book was published entitled *Prodigal Father Revisited : Writers and Artists in the world of John Butler Yeats.* Declan put me in touch with Cathy Fagan in New York who sent me on some photos of the grave.

John Butler Yeats' wife, **Susan Pollexfen Yeats** is buried in grave number 13, Row E Section I, Acton Cemetery, London. The cemetery is not very far from the North Acton underground station. Go in the main entrance and turn to the right. The road ends in a turning area. The grave is

situated a few rows behind and to the left of this turning area, almost parallel with the chapel.

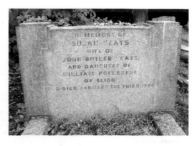

The inscription reads: IN MEMORY OF/ SUSAN YEATS/ WIFE OF/ JOHN BUTLER YEATS/ AND DAUGHTER OF/ WILLIAM POLLEXFEN/ OF SLIGO/ WHO DIED JANUARY THE THIRD 1900.

Elizabeth (Lolly) 1868-1940 and Susan (Lily) Yeats 1866-

1949 were sisters of W.B. and Jack and helped to financially support W.B. until 1902. They set up Dun Emer, an arts and crafts industry. Lolly ran the Cuala Press, while Lily was an embroiderer. Both sisters are buried in the church of St Naithi's, Churchtown Road, Dundrum, County Dublin. (*See map page 256*). Stand in front of the church and the grave is located at the very back of the cemetery on the left-hand side. The cemetery is now visible from under the new bridge.

William Butler Yeats 1865-1939

Born in Dublin. He was one of the major poets of the 20th century and was awarded the Nobel Prize for Literature in 1923. He was a leading figure in the Celtic literary revival and in the setting up of the Abbey Theatre. Throughout his life he was interested in spiritualism and oriental philosophy. Maud Gonne was the love of his life and she inspired many poems. He later married an English woman, **Georgie Hyde Lees 1892-1968**, who brought order to his life. His many works include poems, prose, plays, folk stories and autobiographies. These include *The Wind Among the Reeds, In the Seven Woods, The Green Helmet and Other Poems, Responsibilities, The Wild Swans at Coole, Michael Robartes and the Dancer, The Tower, The Winding Stair and Other Poems, Cathleen Ni Houlihan* and *Autobiographies*.

Yeats died at Cap Martin in the South of France and was buried at nearby Roquebrune in the graveyard of the church of St Pancras on 31st January 1939. James Joyce sent a wreath. The Irish Government wanted the body brought back to Ireland and the French Government offered a destroyer to bring the coffin back but the war eventually intervened.

Yeats had wished to be buried in Drumcliffe and in 1948 his remains were eventually brought from France to Galway Bay aboard an Irish naval vessel. The immediate family was piped aboard and then the funeral procession made its way to

Drumcliffe, County Sligo, where he was reinterred in the presence of a military guard of honour and Irish government representation. His wife, Georgie Hyde Lees, is also buried there. The stone has the inscription: CAST A COLD EYE/ON LIFE, ON DEATH/HORSEMAN, PASS BY!/W. B. YEATS/JUNE 13TH 1865/JANUARY 28TH 1939

A certain doubt lingers about whether the grave contains the

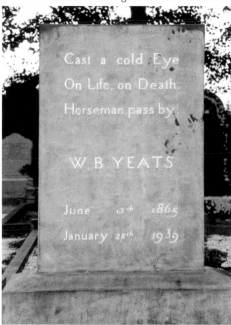

remains of Yeats or those of an Englishman called Alfred Hollis who died a few weeks after Yeats, or the bones of numerous Frenchmen. The graves of Yeats and Hollis were dug up during the war and the bodies buried in a common grave. The grave was partially cleared in 1941 and fully cleared in 1946 and all the bones put in the ossuary. It was custom to separate the skull and the limbs. The remains of Yeats were identified because the local doctor remembered that Yeats had worn a truss. However, Hollis also wore a truss and hence the controversy. The Yeats family was satisfied beyond doubt that their relative was now at Drumcliffe. Brenda Maddox gives a full account of the story in her biography of Yeats and the controversy was raised again most recently in an article by Louise Foxcroft in the *London Review of Books*. An edited version of this article appeared in the *Guardian* in September 2000. The *Irish Times* ran its own article on October 11th 2000.

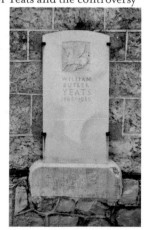

The original Yeats grave was on the second terrace of the cemetery. It had a small stone with the inscription: W.B. YEATS 1865-1939. His friends Edith Heald, Edmund Dulac and Helen Beauclerk discovered the lack of a grave in 1947 and they erected a stone against the wall of the ossuary. The ossuary is situated at the far end of the graveyard near the north entrance. The Yeats gravestone is

reached by using the main (south) entrance. Go up the steps and turn left at Carré C. The stone is at the end of the plot before Carré O on the west side of the graveyard, just before the steps going to Carré O.

Anne Butler Yeats 1919-2001 was the daughter of W.B. who wrote *A Prayer for My Daughter* in 1919. She was assistant designer and then chief designer at the Abbey 1940-46. She began painting in 1947 and had a number of one-person shows as well as taking part in group shows in many different countries. She is buried in grave number 154, St Helen's Section, Row B9, Shanganagh Cemetery, County Dublin. *(See map page 256).*

Go in the main gate and turn left and St Helens section is located a couple of hundred metres down on the left.

Zozimus (Michael Moran) 1794-1846

Born Michael Moran in Dublin. He was known as the Blind Bard of the Liberties. He was renowned for his recitations and ballad writing, the best known of which are *St Patrick was a Gentleman* and *The Finding of Moses*. He was buried in a pauper's grave in Glasnevin Cemetery, Dublin. *(See map page 246).* The grave is situated about 15 rows from the road adjoining C.S. Parnell's grave.

It is said that on his deathbed he stated: "I'll not permit a tombstone stuck above me". Despite this, a memorial was placed on his grave in 1988 by the Smith Brothers, Submarine Bar, Crumlin and the Dublin City Ramblers.

The inscription reads: ZOZIMUS/ TO THE MEMORY/ OF/ MICHAEL MORAN/ POET/ STREET SINGER/ BORN 1794/ DIED 3-4-1846/ R.I.P./ "SING A SONG FOR OUL ZOZIMUS/ AS ALWAYS FROM THE HEART/ YOUR NAME WILL FOREVER LIVE/ AS A DUBLINER APART"/ UNVEILED BY MARY MOONEY T.D./ APRIL 6TH 1988 MILLENNIUM YEAR/ ERECTED BY/ SMITH BROS. SUBMARINE BAR CRUMLIN/ & THE DUBLIN CITY RAMBLERS

ABBREVIATIONS

BBC	British Broadcasting Corporation
CBE	Companion of the British Empire
CEO	Chief Executive Officer
CIE	Córas Iompair Éireann
GPO	General Post Office
IRA	Irish Republican Army
IRB	Irish Republican Brotherhood
LVF	Loyalist Volunteer Force
MP	Member of Parliament
PEN	A worldwide association of writers
QC	Queen's Counsel
RC	Roman Catholic
RHA	Royal Hibernian Academy
RTÉ	Radio Telefís Éireann
RUC	Royal Ulster Constabulary
TD	Teachta Dála
UCD	University College Dublin
UK	United Kingdom

LAST WORDS

There were many I chased but didn't find, their secret safe for the moment behind a "funeral strictly private" notice, no cemetery given, or the trail gone cold after too long a time. So first found, first bound. But there's another 4,000 graves waiting to be visited, enough to keep me gong until I myself fulfil the criteria for admission in a future volume.

GLASNEVIN CEMETERY MAP

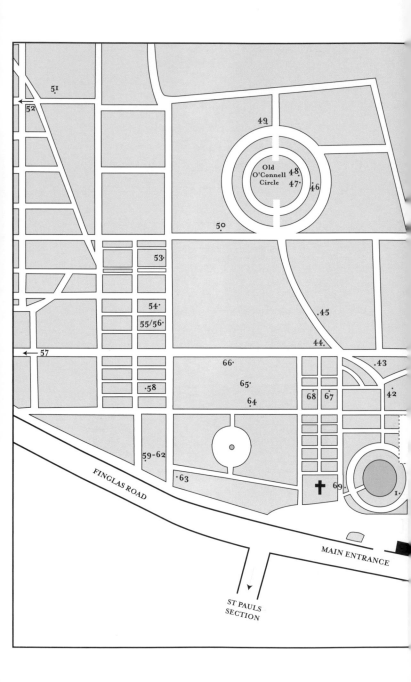

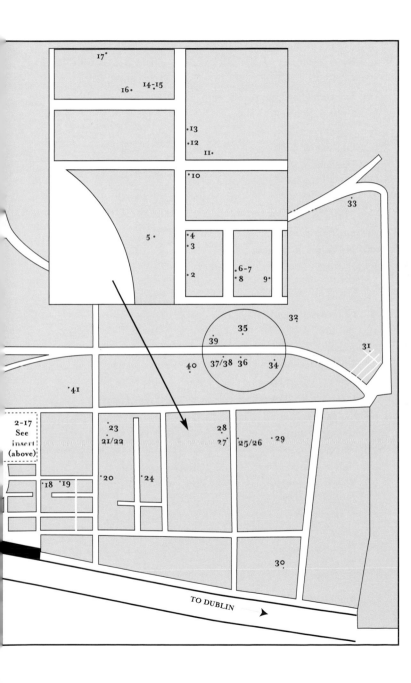

GLASNEVIN CEMETERY INDEX

St Paul's Glasnevin

1. Brown, Christy
2. Ó Dónaill, Niall
3. MacManus, M.J.
4. O'Kelly, Seumas

Deansgrange Cemetery Index

DEANSGRANGE CEMETERY MAP

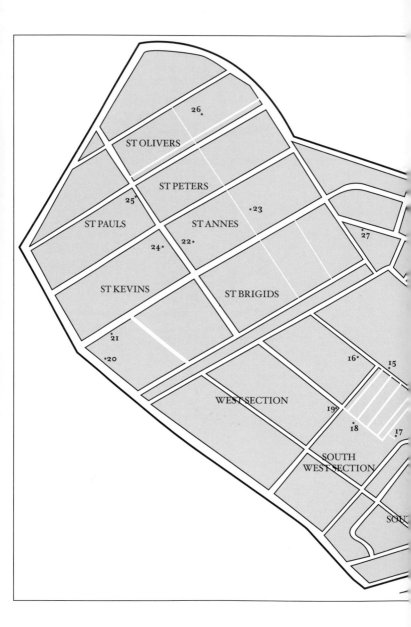

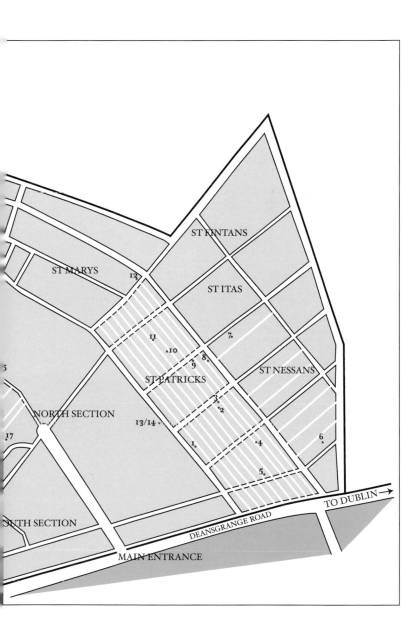

ST FINTANS

ST MARYS
12

ST ITAS

11
·10
7·

3
9
8·

ST PATRICKS

ST NESSANS

3·
·2

NORTH SECTION

13/14 ·

·17

1·
·4
·6

5·

SOUTH SECTION

DEANSGRANGE ROAD

TO DUBLIN →

MAIN ENTRANCE

MOUNT JEROME CEMETERY MAP

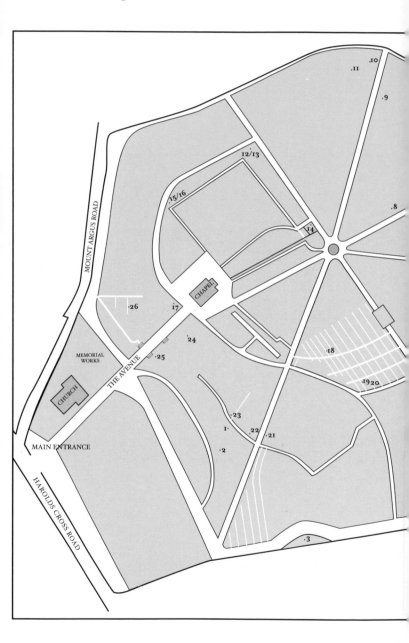

MOUNT JEROME CEMETERY INDEX

DUBLIN CITY CENTRE CEMETERY INDEX

DUBLIN CITY CEMETERIES MAP

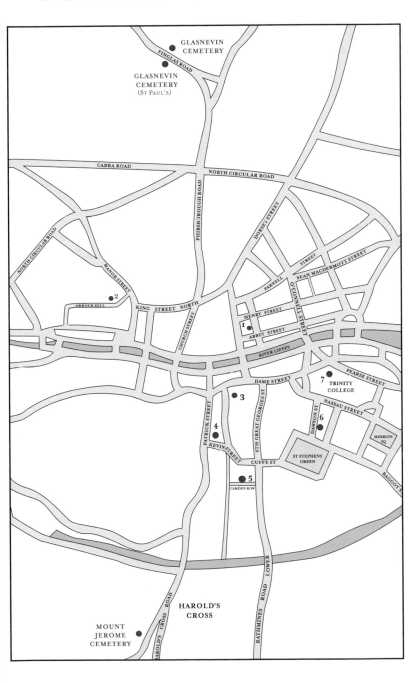

DUBLIN AREA CEMETERIES MAP

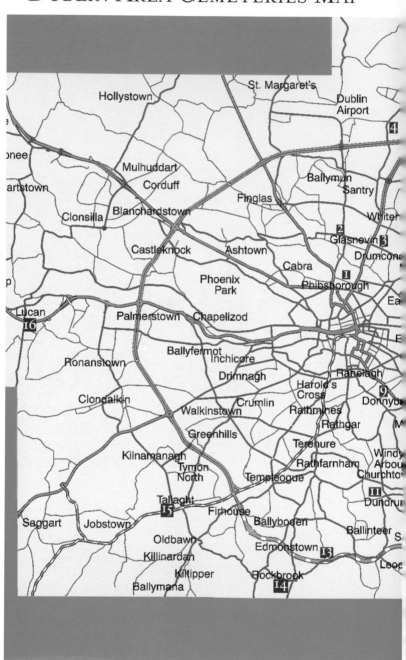

Based on Ordnance Survey Ireland and Government of Ireland
Permit No. MP007764

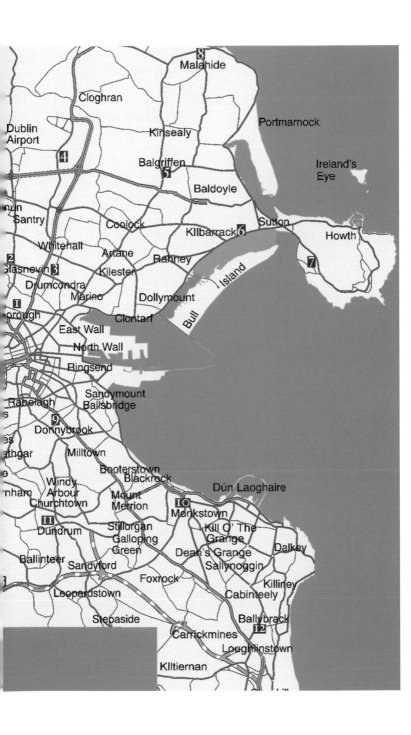

DUBLIN AREA CEMETERY INDEX

Grave detail in Straide, Co. Mayo

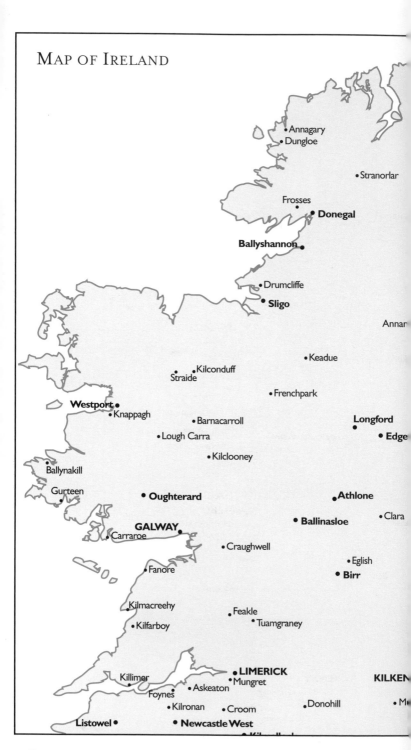

MAP OF IRELAND

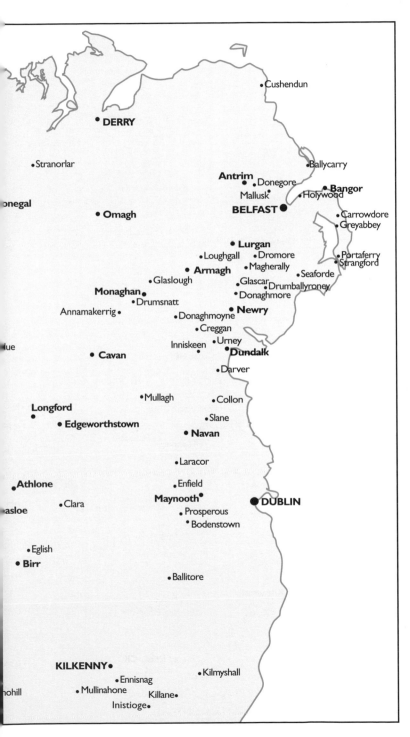

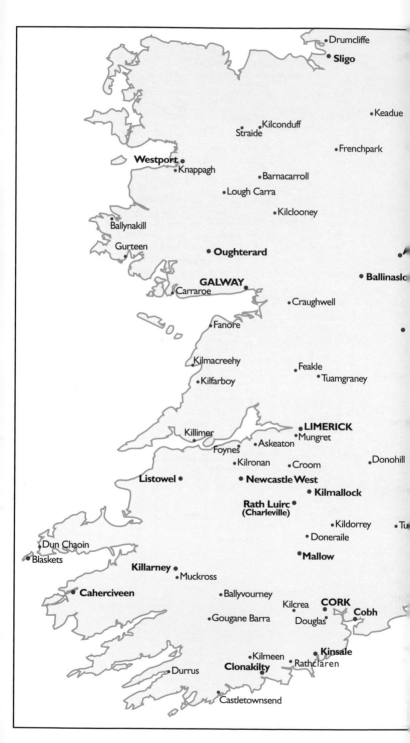

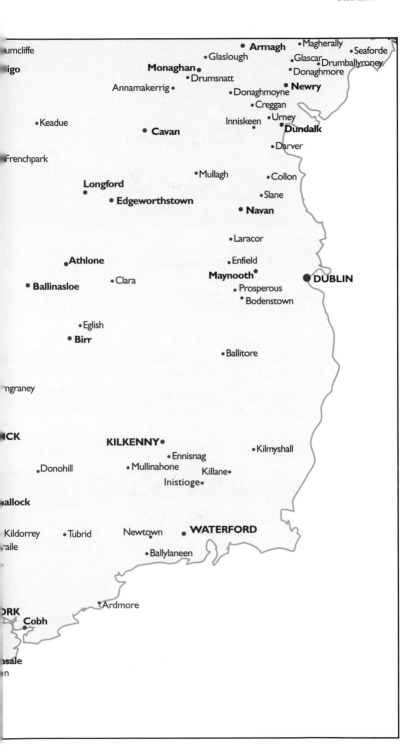

IRELAND

Antrim

Antrim	Irvine, Alexander
Ballycarry	Orr, James
Cushendun	Hewitt, John
Donegore	Ferguson, Samuel
Lisburn	Cree, Sam
Mallusk	Bigger, Francis Joseph
Mallusk	Hope, Jemmy
Mallusk	Hope, Luke

Belfast

City Cemetery	Lynd, Robert
City Cemetery	Lynd, Sylvia
City Cemetery	Thompson, Sam
City Cemetery	Wilson, Robert
Clifton Street	Drennan, William
Derriaghy	Rowley, Richard
Dundonald	Reid, Forrest
Milltown	Davis, Francis
Milltown	O'Byrne, Cathal
Milltown	Sands, Bobby

Armagh

Armagh	Ó Fiaich, Tomás
Creggan	Mac A Liondain, Padraic
Creggan	MacCooey, Art
Creggan	MacMurphy, Seamus
Loughgall	Rodgers, W.R.
Lurgan	O'Hagan, Martin

Cavan

Cavan	Bedell, William
Mullagh	Brooke, Henry

Clare

Fanore	Stuart, Francis
Feakle	Merriman, Brian
Kilfarboy	Comyn, Michael
Kilfarboy	MacCurtain, Andrew
Killimer	Hanley, Ellen
Killimer	O'Connell, Peter
Kilmacreehy	MacCurtain, Hugh
Tuamgraney	MacLysaght, Edward

Cork

Ballyvourney	Dunne, Seán
Ballyvourney	Ó Ríordáin, Seán
Castletownsend	Ross, Martin
Castletownsend	Somerville, Edith
Charlesville	MacDomhnaill, Seán
Cobh	Tobin, John
Cobh	Wolfe, Charles

Galway

Ballinakill	Gogarty, Oliver
Ballinasloe	Ó Tuairisc, Eoghan
Carraroe	Ó Súilleabháin, Muiris
Craughwell	Raftery, Anthony
Craughwell	Callanan Brothers
Galway City, Rahoon	Barnacle, Thomas
Galway City, Rahoon	Bodkin, Michael
Galway City, Rahoon	Feeney, Michael
Galway City, Bohermore	Concannon, Helena
Galway City, Bohermore	Gregory, Lady
Galway City, Bohermore	Killanin, Lord
Galway City, Bohermore	MacBeth, George
Galway City, Bohermore	Macken, Walter
Galway City, Bohermore	Ó Conaire, Pádraic
Gurteen	Hobson, Bulmer
Gurteen	Moore, Brian
Kilclooney	Molloy, M.J.
Oughterard	De Bhailís, Colm

Kerry

Blaskets	Flower, Robin
Caherciveen	Clifford, Sigerson
Dun Chaoin	Ó Gaoithín, Mícheál
Dun Chaoin	Sayers, Peig
Dun Chaoin	Ó Criomhthain, Tomás
Listowel	Keane, J.B.
Listowel	MacMahon, Brian
Muckross	Feiritéar, Piaras
Muckross	Ó Donnchadha, Séafraidh
Muckross	Ó Rathaille, Aodhagán
Muckross	Ó Súilleabháin, Eoghan Rua
Muckross	Raspe, Eric

Kildare

Ballitore	Leadbeater, Mary
Bodenstown	Tone, Wolfe
Enfield	Brayton, Teresa
Maynooth	O'Growney, Eugene
Prosperous	Curtayne, Alice
Prosperous	Rynne, Stephen

Kilkenny

Ennisnag	Butler, Hubert
Inistioge	Tighe, Mary
Kilkenny	Banim, John
Kilkenny	Banim, Michael

Limerick

Askeaton	De Vere, Aubrey
Croom	Ó Tuama, Seán
Foynes	O'Brien, Charlotte

Grave slab, St Peter's, Drogheda

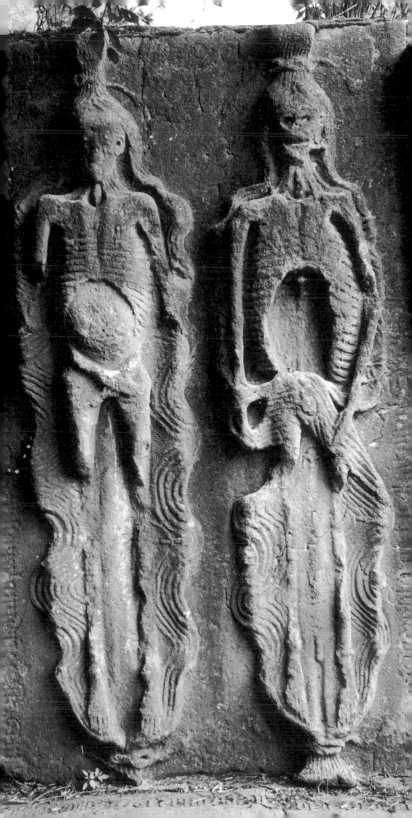

Kilmallock	MacCraith, Aindrias
Limerick	Glynn, Tom
Limerick	Hogan, Michael
Limerick	Lenihan, Maurice
Limerick	O'Halloran, Sylvester
Mungret	O'Dalaigh, Seán
Newcastle West	Hartnett, Michael
Rathronan	O'Brien, William Smith

Longford
Edgeworthstown	Edgeworth, Maria
Edgeworthstown	Edgeworth, Richard Lovell
Edgeworthstown	Wilde, Isola
Longford	Brooke, Charlotte

Louth
Collon	De Blácam, Aodh
Darver	Murphy, M.J.
Dundalk	Galt, Agnes
Urney	Ó Doirnín, Peadar

Mayo
Barnacarroll	Bourke, Ulick
Castle Island	Moore, George
Kilconduff	O'Donnell, Peadar
Knappagh	Cross, Eric
Straide	Davitt, Michael

Meath
Laracor	Higgins, F.R,
Navan	Lavin, Mary
Slane	Archdall, Mervyn

Monaghan
Annamakerrig	Guthrie, Tyrone
Donaghmoyne	MacGiolla Ghunna, Cathal Buí
Donaghmoyne	Trench, William Steuart
Drumsnatt	Wilde, Mary and Emily
Glaslough	Leslie, Shane
Inniskeen	Kavanagh, Patrick

Offaly
Birr	Bell Nicholls, Rev
Clara	Dillon, Eilís
Clara	Mercier, Vivian
Eglish	Bulfin, William

Roscommon
Frenchpark	Hyde, Douglas
Keadue	O'Carolan, Turlough

Sligo
Drumcliffe	Yeats, W.B.

Tipperary

Ballycohey	O'hIfearnáin, Liam Dall
Donohill	Breen, Dan
Mullinahone	Kickham, Charles
Tubrid	Céitinn, Seathrún

Tyrone

Omagh	Milligan, Alice
Omagh	Milligan, Seraton Forrest

Waterford

Ardmore	Keane, Molly
Ballylaneen	Ó Súilleabháin, Tadgh Gaelach
Newtown	MacConmara, Donnchadh Ruadh
Waterford	Deevy, Teresa

Westmeath

Athlone	Broderick, John

Wexford

Killanne	O'Neill, Moira
Kilmyshall	Booth, Elenor

Mount Jerome Cemetery, Dublin

London

Acton	Yeats, Susan Pollexfen
Brompton	Allgood, Molly
	Blackburn, Helen
	Croker, Thomas Crofton
	Morgan, Lady Sydney
	Russell, William
Covent Garden	Centlivre, Susannah
	Macklin, Charles
Croyden	Read, Charles
Golders Green	Connell, James
	O'Casey, Seán
	Stoker, Bram
Hampstead	Brooke, Stopford
	Gore-Booth, Eva
	McCarthy, Justin
	McCarthy, Justin Huntly
Kensal Green	Darley, George
	Hector, Annie French
	Jameson, Anna Brownell
	Lover, Samuel
	Reid, Mayne
	Wilde, Dolly
	Wilde, Jane
	Wilde, William
Kensal Green R.C.	O'Connor, T.P.
	O'Donnell, John Francis
	Tynan, Katherine
Kingsbury	Stephens, James
Lewisham	Dermody, Thomas
Piccadilly	Delany, Mary
Putney Vale	Cheyney, Peter
	Fahy, Francis
	Orpen, William
Southwark	Tate, Nahum
Temple	Goldsmith, Oliver
Trafalgar Square	Farquhar, George
Twickenham	Clive, Kitty
Walbrook	Croly, George
Walton on Thames	Maginn, William
West Molesey	Croker, John Wilson
Westminster	Denham, John
	Sheridan, Richard Brinsley
	Trench, Richard Chenevix

England (excluding London)

Addlestone	Hall, Anna Maria
	Hall, Samuel Carter
Ayot St Lawrence	Shaw, G.B
Beaconsfield	Burke, Edmund

Birmingham	Newman, Cardinal
Bromham	Moore, Thomas
Bromley	Carroll, Paul Vincent
Chester	Parnell, Thomas
Coxwold	Sterne, Laurence
Faversham	O'Brien, Kate
Formby	French, Percy
Haworth	Brontë, Patrick
Liverpool	Tressell, Robert
Mells	Birmingham, George
Northampton	Joyce, Lucia
	MacAmhlaigh, Donall
Oxford	Berkeley, George
	Cary, Joyce
	Lewis, C.S.
	Murdoch, Iris
Shoreham	Dunsany, Lord
Southampton	Coffey, Brian
	O'Keefe, John
Stinsford	Day-Lewis, Cecil

WALES

Carmarthen	Steele, Richard

Oratory Fathers, Rednal, Birmingham — Cardinal Newman

MAP OF ENGLAND AND WALES

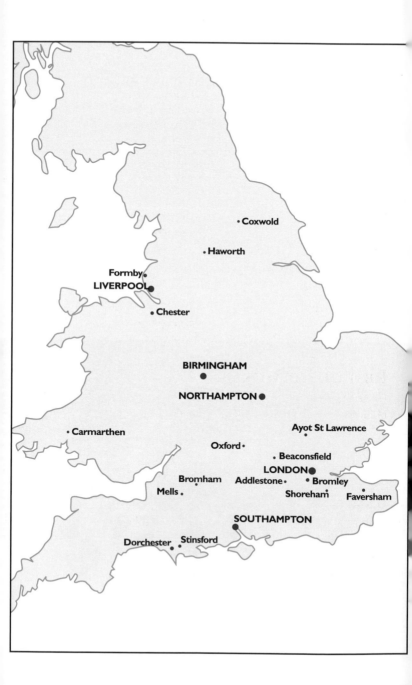

EUROPE

Belgium

Artillery Woods	Ledwidge, Francis
Maredsous	Marmion, Dom

France

Collioure	O'Brian, Patrick
Richebourg-L'Avouep	Holland, Cyril
Thiepval	Kettle, Thomas
Nice	Harris, Frank
Paris	Beckett, Samuel
	Wilde, Oscar
	Ross, Robert

Italy

Genoa	Wilde, Constance
Padua	Gregory, Robert
Rome	Wadding, Luke
Trieste	Joyce, Stanislaus
	Lever, Charles

Switzerland

Zurich	Joyce, James
	Barnacle, Nora

REST OF THE WORLD

Canada

Montreal	McGee, Darcy

Japan

Tokyo	Hearn, Lafcadio

U.S.A.

Boston	O'Reilly, John Boyle
California	Ingram, Rex
Chestertown N.Y	Yeats, John
Connecticut	Ryan, Cornelius
Fall River	MacGill, Patrick
Hastings on the Hudson N.Y	Boucicault, Dion
New York	Doheny, Michael
New York	Gilmore, Patrick Sarsfield
New York	O'Brien, Fitz-James

ACKNOWLEDGMENTS

In the end, not only my friends but complete strangers began to avoid me. Invariably I would ask them "And where are you going on holidays? Any chance of going to the local cemetery and getting a photograph for me?"

In all honesty everybody was very obliging. I would have spent twice as long researching this book and finding the graves had it not been for all the courteous, patient and excellent people who work in libraries, tourist offices and especially cemeteries. It must be something about working in a cemetery that makes the staff so kind and helpful.

I begin with those that I have called upon on more than one occasion and who have gone way beyond the call of duty – Matthew Shaw, Brompton Cemetery; Jerry Guerin, St Mary's R.C. Cemetery, Kensal Green; Sandy Wickenden, Kensal Green; Frank Smith, St Fintan's Sutton; John Robbins, Ann Kinsella and Bernie Murphy, Deansgrange Cemetery; and the staff of Glasnevin Cemetery, Mount Jerome Cemetery, St Finnbarr's Cemetery, Cork, Rahoon Cemetery, Galway, Dundonald Cemetery, City Cemetery, Belfast, Cimitiere de Caucade, Golders Green, Hampstead Cemetery and Wolvercote Cemetery.

No older cemetery can flourish without it's organisation of committed volunteers that do so much to preserve and make known an aspect of our heritage and culture that is under acknowledged. I offer my appreciation and gratitude to the Friends of Brompton Cemetery, Kensal Green, Faversham Cemetery, the volunteers of St Columb's Cathedral, Derry, St Anne's Shandon, Mount Jerome, Glasnevin and the National Graves Association of Ireland.

I have also visited many churches and churchyards, and found the same welcome there as there is in cemeteries. I would like to mention Rev Caw, Beaconsfield; the vergers of St James' Piccadilly,

Brompton Cemetery London

St Martin in the Fields and St Paul's Covent Garden; and especially Vicki Wood of Westminster Abbey who organised permission for me to photograph in the Abbey by kind permission of the Dean and Chapter of Westminster Abbey.

Libraries are great places to find local knowledge. Many have local history and heritage societies, and they are very willing to share their knowledge. Some tourist offices, like the one in Mallow have an excellent series of leaflets on a variety of local personalities and can often provide directions to the out of the way cemeteries. I would especially like to thank the staff of the libraries in Lewisham, Ballitore, Monaghan, Athlone, Clonakilty, Cork, Longford, the Dublin City libraries, in particular the Central Library; and of course the staff of the National Library.

I have spent most of the time grave hunting alone. While I enjoy it immensely the pleasure is enhanced with good company. Those that accompanied me on one or more of my many journeys include Sean and Carol McKay; David Neary; George Bateson; Ursula Doherty; Orla Bateson and Mark Smith; Róisín and Phil Bateson. In addition I would very much like to pay my appreciation to my very good friend John Yeudall who has made me so welcome all the times I visited his house in London. Without his generosity and friendship I would not have been able to include most of the London graves. In addition we spent some wonderful days visiting Shaw's house in Ayot St Lawrence and the graves of George Birmingham and Cecil Day-Lewis in Dorset and Somerset.

I have little Irish and not a great knowledge of writers in Irish. Gerry Oates, whom I have known since my university days, provided valuable information and advice regarding the writers and the inscriptions in the Irish language in the text of this book.

A number of people read the text, pointed out errors and made suggestions. These include Emer Shelley, George Bateson, Claude Delaney, Sean McKay, Róisín Bateson and Mary Scales. I didn't always take their advice so any errors in the book are mine and mine alone.

A whole host of other people who helped in so many different ways include Kieran Burke, Mrs Dunford, Mary McMahon, Liam Ryan, Charlie Brown, Castle Leslie, Matt and Lisa O'Connor, Jane Wagner, Dermot Foley, Gerry McGowan and all those people who have given me support and encouragement over a long period of time especially Pauline and John Morris, and Therese Curran.

Lastly I would like to thank Mary Guinan, of the Temple of Design, who was responsible for the design and layout of the book and who also provided valuable assistance, advice and support.

PHOTOGRAPHS

The main purpose of the photographs is to show what the grave looks like so that it is easier to spot in the cemetery. Although I would have liked to have visited every single one of the graves featured in this book, it just wasn't physically or financially possible. I have had to call

on family, friends, colleagues, acquaintances, friends of friends and complete strangers who have gone so willingly to photograph those graves I was unable to visit. The following photographs are copyrighted to those very obliging people:

George Berkeley © Orla Bateson, my daughter who accompanied me on several cemetery visits.

Dion Boucicault © Doug Garcia who was volunteered by a mutual friend Angie McFadzean.

Patrick Brontë © Scott McElvain whom I met through the web.

J.J. Calnan © Carrie and Christine Moore, who were volunteered by a mutual friend.

Joyce Cary, CS Lewis and Iris Murdoch © Cathy McClelland, a friend of my daughter Orla. She spent several weekends finding and photographing the graves.

Peg Woffington © Eve Gamble whom I met by chance in Teddington.

Brian Coffey © Joanne Henry, daughter of my friend and colleague Sharon.

Michael Comyn © Donal De Barra whom I met through the web. He sent me a CD of photographs of the grave and other material.

Michael Doheny © Joe Grogan via Joe Kenny who runs a website on Fethard.

Patrick Sarsfield Gilmore © Michael Cummings, courtesy of Boston Irish Tourist Association

Robert Gregory © Bruno Paganelli, a friend and colleague who went out on successive weekends to track down the grave.

Lafcadio Hearn © Keiko Nakamura, a friend and colleague, who waited patiently for the spring to take a wonderful series of photographs for me.

James Joyce original grave © Fritz Senn

Stanislaus Joyce and Charles Lever © Luisella Salvini, a cousin of my friend and colleague Laura Donisetti and her daughter Leonie.

Tom Kettle © Liam Dodd

Francis Ledwidge © Marco Hoveling whom I met through his fine website on the First World War unfortunate-region.org.

Charles Lever inscription © Pierluigi Struzzo

Donall MacAmhlaigh and Lucia Joyce © Peter Mulligan whom I met through the web and have corresponded with ever since.

Patrick MacGill and John Boyle O'Reilly © Jude Scales

Darcy McGee © David Wilson, author and academic.

Thomas Moore and Laurence Sterne © Donal Bateson, my brother who has sent me other photos and articles over the years.

Cardinal Newman © Marie Barry a friend who has sent me photographs of many other graves not eligible for this book.

Fitz-James O'Brien © Jeffrey I. Richman a fellow grave hunter and author of Brooklyn's Green-Wood Cemetery: New York's Buried Treasure.

Seán Ó Coileáin © Roger Owen

Thomas Parnell © Angela King a friend and colleague who also accompanied me to Maredsous and Huy.

Cornelius Ryan © Jack Sanders, newspaper editor.

Robert Tressell © Julia Taylor, a friend and colleague whose husband sent me a lovely painting of a church and cemetery.

Luke Wadding © Father John Laverone via Tony Bissett and Mary Hanlon.

John Butler Yeats © Cathy E. Fagan.

W.B. Yeats © Michel Chambefort who went to Roquebrune and searched out the original gravestone. Richard Grey put me in touch with Michel.

All other photographs © Ray Bateson.

SOURCES

I have found the grave locations through a combination of reading biographies, reference books, local histories, travel books and cemetery guides; consulting death notices; searching church registers and cemetery records; talking to cemetery officials and local people; systematically examining thousands of gravestones; and sometimes coming upon them just by chance.

I have taken the brief biographical information from obituaries, appreciations and biographies.

I have checked the book titles from the libraries and catalogues of the National Library, Trinity College Dublin, Dublin City Council, many other libraries and many booksellers.

Websites are another source of information but they are often full of errors, copied from other sources and there is no guarantee of longevity. However one website stands out and that is www.pgil-eirdata.org – the website for the Princess Grace Irish Library in Monaco. It contains biographies, criticisms, and other information on over four and half thousand Irish writers.

BIBLIOGRAPHY

Adams, B. *Denis Johnston: A Life*, The Lilliput Press, 2002

Allen, N. *George Russell (AE) and the New Ireland*, Four Courts Press, 2003

Amor, A. *Mrs Oscar Wilde A Woman of Some Importance*, Sidgewick and Jackson, 1983

A Ramble through Dromore (pamphlet)

Arnold, B. *Orpen Mirror to an Age*, J. Cape, 1981

Atik, A. *A Memoir of Samuel Beckett*, Faber and Faber, 2001

Bailey, C. *Harrap's Guide to Famous London Graves*, Harrap, 1975

Baker, J. *From Bodysnatchers to Bombs – The History of Clifton Street Cemetery Belfast*, Glenravel Local History Project, 1998

Ball, F. *One of the Damned, The Life and Times of Robert Tressell*, Lawrence and Wishart 1973

Barrington, T.J. *Discovering Kerry – Its History, Heritage and Topography*, Third Printing, 1986

Bateson, R. *Dead and Buried in Dublin, An Illustrated guide to the Historic Graves of Dublin*, Irish Graves Publications, 2002

Belford, B. *Bram Stoker – A Biography of the Author of Dracula*, Weidenfeld & Nicholson, 1996

Bentley, J. *The Importance of Being Constance – A Biography of Oscar Wilde's Wife*, Robert Hale, London, 1983

Bogle, J. *Who Lies Where – A Guide to the Resting Places of the Famous*, Lamp Press, 1989

Borland, M. *Wilde's Devoted Friend – A Life of Robert Ross*, Lennard 1990

Boylan, H. *A Dictionary of Irish Biography*, Gill and MacMillan, 1998

Brady, A.M. & Cleeve, B. *A Biographical Dictionary of Irish Writers*, The Lilliput Press, 1985

Buried at Brompton, South Lodge

Byrne, A. & McMahon, S. *Lives 113 Great Irishwomen and Irishmen*, Poolbeg, 1990

Camden History Society *Buried in Hampstead*, 1986

Cannon, J. *The Road to Haworth, The Story of the Brontës' Irish Ancestry*, Weidenfeld and Nicholson, 1980

Chavasse, M, *Terence MacSwiney*, Clonmore & Reynolds, 1961

Conradi, P. *Iris Murdoch – A Life*, Harper and Collins, 2001

Coote, S. *W.B. Yeats – A Life*, Hodder & Stoughton, 1997

Costello, P. & Van de Kamp, P. *Flann O'Brien An Illustrated Biography*, Bloomsbury, 1987

Cowell, J. *Dublin's Famous People and where they lived*, The O'Brien Press 1996

Cowell, J. *Where they lived in Dublin*, The O'Brien Press, 1980

Craig, P. *Brian Moore: A Biography*, Bloomsbury 2002

Cremin, V. *Deansgrange Cemetery*, Foxrock Local History Club, 1989

Cronin, A. *Samuel Beckett The Last Modernist*, Harper-Collins, 1996

Culbertson, J. & Randall, T. *Permanent Londoners, An Illustrated Biographical Guide to the Cemeteries of London*, Robson Books, 1991

Culbertson, J. & Randall, T. *Permanent Parisians*, Robson Books, 1991

Davies, S.Gébler *James Joyce A Portrait of the Artist*, Davis-Poynter Ltd., 1975

De Burgh Daly, Mrs E. (editor) *Chronicles and Poems of Percy French*, The Talbot Press Limited, 1922.

Delaney, F. *Who's Buried Where?* (updated and corrected by Ian Godfrey), Dean and Chapter of Westminster, 1999

Delaney, T. *John Keegan Selected Works* Salmon Press 1997

De Vere White, T. *Parents of Oscar Wilde*, H&S, 1967

De Vere White, T. *Tom Moore The Irish Poet*, Hamish Hamilton, 1977

Dublin Cemeteries Committee *Glasnevin Cemetery An Historic Walk*, 1997

Dublin Public Libraries *Directory of Graveyards in the Dublin Area*, 1990

Dunleavy, J. Egleson and G W. *Douglas Hyde A maker of Modern Ireland*, University of California Press, 1991

Eagle, D. and Carnell, H. (editors). *The Oxford Literary Guide to the British Isles*, Oxford University Press, 1977

Ellman, R. *Oscar Wilde*, Knopf, 1988

Ellman, R. *James Joyce*, Oxford University Press 1982

Fawkes, R. *Dion Boucicault A Biography*, Quartet Books, 1979

Fitzpatrick, W. *History of the Dublin Catholic Cemeteries*, Dublin Catholic Cemeteries, 1900

Frazier, A. *George Moore 1852-1933*, Yale University Press, 2000

Funeral Art and Architecture (XIX-XX), Dublin, Genova, Madrid, Torino, Con el patrocino Comisión Europea

Gardiner, J. *The Brontës at Haworth – The World Within*, Clarkson Potter/ Publishers, 1992

Ginger, J. *The Notable Man The Life and Times of Oliver Goldsmith*, Hamish Hamilton, 1977

Glasnevin Cemetery Travellers Guide, Morrison Books, 1997

Glendenning, V. *Elizabeth Bowen Portrait of a Writer*, Phoenix, 1993

Greenwood, D. *Who's buried where in England*, Constable 3rd edition, 1999

Guide to Creggan Parish Churchyard. Ballymac Enterprises 1995

Hayden, R. *Mrs Delany her life and her flowers*, Colonade, 1980

Hayward, R. *Munster and the City of Cork*, Phoenix House, 1964

Hegarty, P. *Peadar O'Donnell*, Mercier, 1999

Holland, M. *The Wilde Album*, Fourth Estate Limited, 1997

Holland, V. *Oscar Wilde and his world*, Thames and Hudson, Revised edition, 1966

Hyde, H. M. *Oscar Wilde*, Q.B.C., 1975

Igoe, V. *A Literary Guide to Dublin*, Methuen, 1999

Irvine, A. *My Lady of the Chimney Corner*, Appletree Press, 1980

Johnston, S. *Alice A Life of Alice Milligan*, Colourpoint Press, 1993

Joyce, W. St J. *The Neighbourhood of Dublin*, Gill and MacMillan, 1912

Kavanagh, P. *Patrick Kavanagh 1904-1967: A Life Chronicle*, Kavanagh Handpress, 2000

Kelly, L. *Richard Brinsley Sheridan A Life*, Sinclair Stevenson 1997

Keon, J. *Frank O'Connor – A Life*, Mainstream Publishing, 1998

Kerrigan, M. *Who Lies Where, a guide to famous graves*, BCA, 1995

Kiely, D. A. *John Millington Synge A Biography*, Gill and MacMillan, 1994

Kirby and Duncan, *The Monumental Inscriptions of St Mary Lewisham*, 1889

King, D. *Patrick O'Brian - A Life Revealed*, Hodder & Stoughton, 2000

Knowlson, J. *Damned to Fame The Life of Samuel Beckett*, Bloomsbury, 1997

Kohfeldt, M. L. *Lady Gregory - The Woman behind the Irish Renaissance*, Andre Deutsch, 1985

Krause, D. *Sean O'Casey and his world*, Thames and Hudson, 1976

Lanigan, Mrs T.G. *The Tomb of the Banim Brothers*, Old Kilkenny Review 1961, No 13 Pages 27-29

Levenson, L. *The Four Seasons of Mary Lavin*, Marino, 1998

Levenson, S. *Maud Gonne A Biography of Yeats' Beloved*, Cassell, 1977

Lewis, G. *Somerville and Ross The World of the Irish R.M.*, Viking, 1985

Lewis, S. *A History and Topography of Dublin City and County*, Mercier, 1837

Lodwick, J. and V. *St Peter's Parish Church, Carmarthen - A Guide Book*, Carmarthen, Revised Edition, 2002

Loudan J. *O Rare Amanda: The Life of Amanda McKittrick Ros*, London, Chatto and Windus, 1969

Lysaght, S. *Robert Lloyd Praeger: The Life of a Naturalist*, Four Courts Press, 1998

MacConghail, M. *The Blaskets - A Kerry Island Library*, Country House, 1987

Maddox, B. *George's Ghosts - A New Life of W.B. Yeats*, Picador, 1999

Maddox, B. *Nora, A Biography of Nora Joyce*, Penguin Books, 2001

Martin, B. *John Henry Newman His Life and Works*, Paulist Press Geoffrey Chapman Mowbray, 1982

Matthews, J. *Voices A Life of Frank O'Connor*, G & M, 1983

McCormack, W.J. *Sheridan LeFanu*, Lilliput Press, 1991

McCormack, W.J. *Fool of the Family A Life of J.M. Synge*, Weidenfeld and Nicholson, 2000

McRedmond, L. *Modern Irish Lives*, Gill and MacMillan, 1996

McDonagh, M. *Irish Graves in England*, Evening Telegraph Reprints VI, 1888

Mellor, H. *London Cemeteries - An Illustrated Guide and Gazetteer*, Avebury, 1981

Molony, J. N. *A Soul Came Into Ireland Thomas Davis A Biography 1814-1845*, Geography Publications, 1995

Moore, D. *Off Beat Ireland*, Nomad Books, 1981

Mount Jerome Historical Project *Mount Jerome A Victorian Cemetery*, 1997

Murphy, R. & Binions, G. *Killanne Memorials to the Dead*, 2001

Neary, B. *Irish Lives*

Newmann, K. *A Dictionary of Ulster Biography*, Institute of Irish Studies, Queens University, Belfast, 1993

O'Brien, C.C. *Edmund Burke*, New Island Books, 1997

O'Byrne, C. *As I Roved Out*, At The Sign of the Three Candles, 1957

O'Ceirin, K. & C. *Women of Ireland*, TirEolas, 1996

O'Dowd, B. *The World of Percy French*, Blackstaff Press, 1981

O'Duffy, R.J., *Historic Graves in Glasnevin Cemetery*, James Duffy and Company Ltd., 1915

Ó Glaisne, R. *Denis Ireland*, Coiscéim, 2000

O'Hara, B. (editor) *Maigh eo Mayo*, The Archaeological, Historical and Folklore Society, Regional Technical College, Galway, 1982

O'Shea, S. *Death and Design in Victorian Glasnevin*, Dublin Cemeteries Committee, 2000

O'Sullivan, M. *Brendan Behan - A Life*, Blackwater Press, 1997

Phelan, J. *The Ardent Exile - The Life of Thomas D'Arcy McGee*, The MacMillan Company of Canada Limited, 1951

Pyle, H. *Red Headed Rebel Susan L Mitchell Poet and Mystic of the Irish Cultural Renaissance*, The Woodfield Press, 1998

Quin, A, *Patrick Kavanagh*, Gill and MacMillan, 2001

Quinn, R.J. & Baker, J. *Milltown Cemetery*, Glenravel Publications, 2002

Ring, J. *Erskine Childers*, John Murray, 1996

Ross, I. C. *Laurence Sterne A Life*, Oxford University Press, 2001

Shannon-Mangan, E. *James Clarence Mangan A Biography*, Irish Academy Press, 1996

Sayer, G. *Jack: A Life of C.S. Lewis*, Hodder & Stoughton, 1997

Share, B. & Bolger, W. *Irish Lives*, Figgis, 1971

Sherard, R. *The Life of Oscar Wilde*, T. Werner Laurie, 1928

Spurrell, *Carmarthen and its Neighbourhood*

Schenker, J. *The Unsettling Story of Dolly Wilde, Oscar's Unusual Niece*, Da Capo Press 2000

Stallworthy, J. *Louis MacNeice*, Faber & Faber, 1995

Stringer, J. *The Oxford Companion to Twentieth Century Literature in English*, Oxford, 1996

The Belfast Telegraph – death columns, obituaries and articles

The Donegal Democrat – death columns, obituaries and articles

The Guardian – death columns, obituaries and articles

The Friends of Bromham and Sandy Lane Churches *Bromham, The Parish and its Churches*

The Friends of Kensal Green Cemetery *Paths of Glory*, 1997

The Irish Independent – death columns, obituaries and articles

The Irish Press – death columns, obituaries and articles

The Irish Times – death columns, obituaries and articles

The Royal Parks *Brompton Cemetery*, 2000

The Times – death columns, obituaries and articles

Wallace, V. *A Life of the Hymn Writer Mrs Alexander 1818-1895*, Lilliput Press, MCMXCV

Ward, M. *Maud Gonne Ireland's Joan of Arc*, Pandora, 1990

Warner, A. *William Allingham*, Bucknell University Press, 1975

Welch, R. (editor) *The Oxford Companion to Irish Literature*, Oxford, 1996

Westminster Abbey Official Guide, 1997 Dean and Chapter of Westminster

White, K. *The Churchyard of St Mary the Virgin*, 1992

Wilson, A.N. *C.S Lewis A Biography*, Collins, 1990

Wilsdon, B. *The Sites of the 1798 Rising in Antrim and Down*, The Blackstaff Press, 1997

Wright, G.N., *An Historical Guide to the City of Dublin*, Four Courts Press, 1825

THE END